THE VALUE OF A GOOD IDEA

PROTECTING
INTELLECTUAL
PROPERTY IN AN
INFORMATION ECONOMY

SILVER LAKE PUBLISHING
LOS ANGELES, CALIFORNIA

The Value of a Good Idea
Protecting Intellectual Property in an Information Economy
First edition
Copyright © 2002 by Silver Lake Publishing

Silver Lake Publishing
2025 Hyperion Avenue
Los Angeles, California 90027

For a list of other publications or for more information, please call 1.888.663.3091. In Alaska and Hawaii and outside of the United States, please call 1.323.663.3082.

Library of Congress Catalogue Number: pending

The Value of a Good Idea
Protecting Intellectual Property in an Information Economy.
Includes index.
Pages: 436

ISBN: 1-56343-745-7
Printed in the United States of America.

ACKNOWLEDGMENTS

The Silver Lake Editors who worked on this book include Kristin Loberg, Megan Thorpe and James Walsh. Connie Nitzschner, Christina B. Schlank and Steve Son also contributed case studies, research and other efforts. For more than a decade, the Silver Lake Editors have been producing books on topics in insurance, economics and business management.

Jeffrey A. Barker, a Los Angeles-based attorney who specializes in intellectual property issues, provided valuable assistance during the early stages of the development of this book.

Thanks also goes to: Sander Alvarez, Irwin "Tex" Meyerson, Steve Peden and Albert J. Quigley. All are attorneys or experienced businesspeople who offered essential feedback and reaction to the book in its various stages of development.

The Value of a Good Idea is the ninth book in Silver Lake Publishing's "Taking Control" series—aimed at helping small business owners and managers compete on an even footing with larger competitors.

This book uses actual case studies from various U.S. regulatory agencies and courts of law to illustrate legal and business issues involving intellectual property. However, these case studies may be overturned or made moot by future court decisions or revisions to the law. No reader of this book should attempt to take any legal, administrative or regulatory action based on cases described in this book without first consulting with the appropriate regulatory agency or a qualified attorney.

TABLE OF CONTENTS

Introduction: What Is Intellectual Property?

Every business thrives on good ideas. They are the cornerstones of huge corporations, mid-sized companies and even mom-and-pop shops that sell widgets and digits, service your vehicle or groom your dog. Businesses like IBM, Starbucks, Amazon.com, Nantucket Nectars and your corner drug store continue to survive on executing at least one good idea.

Ideas can take a variety of forms: a novel business model; a new product or a new feature for an existing product; a new or improved manufacturing process; a new or better personal or professional service; an advertising or marketing campaign; or a concept for a new Web site design, game, novel, song or script.

But a good idea is, in the words of former U.S. Supreme Court Justice Louis D. Brandeis, as "free as the air" if the right steps are not taken to protect its value. This protecting is a critical element in commerce. As Brandeis went on to write: "An essential element of individual property is the legal right to exclude others from enjoying it."[1]

In the Information Age, when reams of information are only a mouse-click away, knowing the rules for protecting your own intellectual property (and for legitimately accessing someone else's) has become more important than ever.

Exactly what is intellectual property? The term *intellectual property* is a peculiar expression. The word "intellectual" relates to the human mind,

[1]See *International News Serv. v. Associated Press* (1918); Justice Brandeis, dissenting.

while "property" implies some kind of ownership. In a basic sense, intellectual property refers to any product of human intellect that someone claims to own, hoping it holds some commercial value. It refers to information derived from creative ideas. It refers to unique, new and unobvious inventions, identifying symbols and artistic expressions. And, it refers to intangible assets, or assets that can be similarly bought, sold, traded, licensed, exchanged and given away like real or personal property.

Intellectual property is largely intangible, though. Unlike real or personal property, intellectual property cannot be defined or identified by its own physical parameters; rather, it must be expressed in some discernible manner that the law recognizes as protectable.

The most commonly recognized types of intellectual property are copyrights, trademarks and patents. Although based on different statutory schemes and designed to promote different goals, these three areas of the law overlap in many respects. As author Marshall Leaffer notes in his book *Understanding Copyright Law*:

> All forms of intellectual property share similarities. First, as to its nature, all intellectual property involves property rights to information: copyright (expressive information); patent (technological information); and trademark (symbolic information). Second, as to its administration by the federal government, a large body of intellectual property law is governed by federal statutes, and specific federal agencies are involved in administering patents, trademarks, and copyrights. Third, as to its international dimension, intellectual property is found in its most developed form in Western industrialized countries and is the subject of international conventions. Fourth, as to its esoteric subject matter, although intellectual property becomes more and more important from a practical, economic standpoint in our information age, this body of law is woefully misunderstood and shunned by the non-specialist.[2]

[2]Leaffer, Marshall A.; *Understanding Copyright Law* (New York: Matthew Bender 2d ed. 1995).

Introduction: What Is Intellectual Property?

Most people think about copyrights when they think about intellectual property. It's the oldest form of intellectual property, dating back to the early 18th Century. Since then, copyrights have evolved with technology, and have come to significantly affect global economies. When it comes to economic growth and trade, no other U.S. sector can compare with the industries built on copyrighted materials. They are the fastest growing segment of the U.S. economy—eclipsing any single manufacturing sector.

Today, the copyright industries account for almost 5 percent of the Gross Domestic Product, exceeding $450 billion annually. Internationally, the numbers are equally large, as U.S. copyrighted material maintains a surplus balance of trade with every country in the world. In 1999, for example, the copyright industries amassed more foreign sales and exports than all major industry sectors including agriculture, automobiles and auto parts and the aircraft industry.

But the scope of copyright protection is limited, and cannot cover all forms of intangible assets. Let's say you invent a better way to dispense butter or margarine, something you call the Butterfly in your start-up kitchen appliance company. You can copyright your infomercial, your Butterfly's user guide and your company's technical manual, reference guide, interactive CD-ROM, cookbooks and the material posted on your Web site…but you'll have to file a patent for the actual device.

And suppose you develop a whole line of products based on the Butterfly's success. You come up with a crafty slogan for an advertising campaign, such as Kitchen Bugs! for Better Living. You might want to file a trademark. Before long, your company may be or will be a household name and you wouldn't want someone else capitalizing on your hard-earned brand.

Nonetheless, as with all business-related activities, economics play a pivotal role in the decisions you make as an entrepreneur or business manager. Although there's a risk involved with not protecting your intellectual property, obtaining copyrights, trademarks and patents comes with a price. It's not about simply filing the paperwork and obtaining a legal trademark or patent, as though it's a reward for your time, energy and research. To

the contrary, it's about realizing the value of your good idea and doing something useful with it. You must weigh the potential value of your intellectual property right against: 1) the probability of reaching that value in real life; and 2) the costs of securing, enforcing and maintaining that right.

And there's nothing more subjective than *value*; what you may think is valuable is probably worthless to someone else.

The boom of the Internet Age gives us a new delivery system for transmitting business ideas—books, software, corporate data, customer lists, advertising campaigns, manufactured products, professional services, professional publications, manuals, music, etc. It also gives rise to complicated issues amid a confusing blur of legal topics. Because the Internet itself is a marketplace for the exchange of ideas, protecting those ideas, as well as the goods and services that result, becomes a challenge. The Digital Millennium Copyright Act and related laws aim to regulate the use of ideas online. But laws don't always resolve commercial confusion.

Even if your business doesn't rely solely on the Internet, basic intellectual property questions remain. Among these: Can you safeguard a list of suppliers and vendors by a copyright? Does the way you physically build your restaurant and formulate a distinguishing menu come under design patent or trademark? Can you post a Web site for your small business if your domain name sounds confusingly similar to another site that has nothing to do with your line of business? (For example, you launch www.kitchenbugs.com not knowing that www.kitchenbug.com already exists. Then you find out that the other site is hosted by a well-known company that exterminates household bugs…and it doesn't like you or your bugs.) Lastly, if your cinematographer friend uses your personal photographs without permission in the next Tom Cruise movie, can you sue for your right to privacy?

This book answers these questions, and attempts to resolve those fuzzy lines between the various types of intellectual property. You need to know how to best protect your intellectual property, and how to best prevent yourself from getting into trouble with multimillion dollar companies that will go after your fledgling business for things like infringement, unfair competition, misappropriation, breach of contract, dilution, damage to repu-

tation and attorneys' fees, among myriad other business-threats. The list of possible accusations can be long and ugly, and in an instant, your great idea and business could be locked up forever.

Copyrights vs. Trademarks and Patents

It's important to understand from the start that copyrights, trademarks and patents tend to be mutually exclusive things. In other words, if your creation is protectable under copyright law, it probably will not qualify for protection under either trade dress or patent law (or vice-versa). This is because each of these categories is meant to cover different types of intellectual property, for different durations and for different reasons. In general, copyrights cover expressive information; patents cover technological information; and trademarks cover symbolic information.

Copyright law protects expressive and creative works such as books and videotapes for a fairly lengthy period of time—the life of the author plus 70 years,[3] because there is no impact on competition or a serious limitation on anyone else's creativity in doing so. In contrast, because competition (and consumers) suffer if only one company can make and distribute useful inventions (and preclude others from making improvements to the invention), patents are given a more limited number of years of protection. (Generally, utility and plant patents last 20 years, design patents have a 14-year term.) Patent law reflects the thorniest kind of intellectual property; the subject matter of most modern patents has flummoxed courts as high as the U.S. Supreme Court.

Finally, trademarks are awarded only to the source or manufacturer of goods or services. Trademark protection lasts as long as the owner's mark continues to be used. Coca-Cola, for example, won't have to file an extension on its "Coke is it!" mark next year. But, it might at some point have to extend the copyright to its advertising copy.

[3]This refers to individually-authored works created on or after January 1, 1978. Joint works are measured by the life of the longest living author. Corporate works are measured by the shorter of 95 years from publication or 120 years from creation. See Appendix B for more information.

The Value of a Good Idea

This book explains in simple terms the types of intellectual property that exist, and provides a working knowledge of how you can protect your good ideas from others. Whether your idea is big or small, every idea has intrinsic value. Whether you are an enterprising individual or the owner of a small business, some form of intellectual property is probably valuable to you and your ability to compete in the marketplace. By the same token, if you are thinking about using or improving upon ideas or information that you have come across either on the Internet or in daily life, you don't want to inadvertently use someone else's intellectual property without their permission. You'll want to be informed about things like derivative works, fair use and perhaps trade dress.

Why should you care about intellectual property laws—besides copyright? To operate a business successfully and safely in the current marketplace, you need to understand more than the basics of copyright law because most businesses operate with more than one type of intellectual property. You must also understand the protections and pitfalls of trademark, patent, trade secrets, unfair competition, defamation and publicity laws. Although there is no substitute for a knowledgeable lawyer if you want to make sure that you have done all you can to protect your intellectual property (or to make sure that you don't get sued), this book will help you identify whether you have assets (or problems) that you should talk with a lawyer about. And, if you don't want to spend the money on a lawyer and you think your situation is fairly clear cut, this book provides some leads about where you can go and who you can contact in order to register your intellectual property yourself.

There's no easy way to simplify the often complex and esoteric matters of intellectual property, particularly patents. There a very few bright lines of rule because technology and innovation seem to move faster than the courts. Nonetheless, we've chosen a few important cases to illustrate key points and demonstrate some of the nuances to various forms of intellectual property and their governing laws. Some cases have set a precedent, while others push the envelope farther into the new millennium…and beg for more clarification.

Introduction: What Is Intellectual Property?

None of the material here will make you an expert on intellectual property law. However, we hope to take some of the mystery out of the rules governing intellectual property, so that you can make conscious decisions in your endeavors—creative, business or otherwise. Because there's no substitute for protecting the value of a good idea.

The Value of a Good Idea

PART ONE:
COPYRIGHTS

Chapter 1: What Is Copyrightable Material?

You're a stand-up comic who's slowly carving out a name for yourself with ribald poetry. You've spent months perfecting a dirty limerick—choosing the words carefully, mixing erudition with shock value, honing the metric structure so that it matches classic style precisely. Your plan is to add it to your act for a big benefit that's going to be televised. A week before the benefit, you post your filthy gem on your Web site for a few friends to gauge their reactions. They're shocked…and laugh hard. Things are looking up.

A few days before the big show, one of your friends calls. Your limerick has been posted—word for word—on a much better known comedian's Web site. Now, if you use it, people in the business may think you stole it. Is there anything you can do?

Although it sounds like a simple question, the matter of what material can be protected is central to many intellectual property disputes. This chapter looks at the mechanics of what can be copyrighted…and what copyrights mean.

What a Copyright Does

In its simplest terms, a copyright is the legal ownership you have once your creative work is **fixed in a tangible medium of expression**; that is, when you put it in a form where it can be witnessed by others—written

down, painted, sculpted, recorded, photographed, etc. According to the Copyright Act, a work is "fixed" when it becomes "sufficiently permanent or stable to permit it to be perceived, reproduced, or otherwise communicated for a period of more than transitory duration." An example: A story is "fixed" into a tangible—copyrightable—form when you write it down. A book is a tangible form. A photograph is a tangible form. While this may not seem a hurdle too high to clear, there are limitations. For example, a drawing made on an Etch-a-Sketch toy is probably too "transitory" to permit copyrighting—unless you take a photo of the image on the screen. The same holds true of live theater. Unless the performance is recorded, it is too impermanent to meet the copyright's fixation requirement.

> **When you own a copyright, you own the exclusive rights to reproduce the work in any medium—print, electronic, audio, video, etc.—and to develop derivative works, and to distribute copies or records of the copyrighted work.**

Any original literary work may be copyrighted. The necessary **degree of originality is low**, and the work need not have artistic merit to be copyrightable. Term papers by college sophomores are as much within the domain of copyright as Saul Bellow's latest novel. Non-literal aspects of copyrighted works—like structure, sequence and organization—may also be protected under copyright law.

Whether you can protect what you've created will depend upon: a) whether your work is *original*; and b) whether it has been *fixed*.

Originality exists if you came up with material yourself and did not copy it from someone else. Only minimal creativity is required to meet this standard. The creation need not be something novel or unique. For example, if you wanted to write a country song about a rusty pickup truck and the woman who broke your heart—as long as you don't use the same lyrics

or music as the hundreds (or maybe thousands) of other country songs with these themes, you're okay.

> **Copyright protection is afforded only to the original manner in which something is expressed; it does not extend to the idea or concept for the work, or to such ephemeral things as principles, procedures, processes, systems or methods of operation.**

The term *original* means that a work is "independently created by the author…[and] possess[es] at least some minimal level of creativity." However, the requisite level of creativity is extremely low; even a slight amount will suffice. A work can be original if it incorporates pre-existing material; an edition of a magazine is copyrightable even if it incorporates articles for which the individual authors hold the copyrights. As long as the authors gave their permission for the articles to be used in the magazine, the magazine will hold the copyright in the new material that it has added as well as that edition of the magazine as a whole.

The History of Copyrights

Modern copyright law dates back to an English law called the Statute of Anne, which Parliament passed in 1710. Prior to the law's passage, publishing in England was controled entirely by a group of London printers and booksellers called the Stationer's Company. Although the Statute of Anne originally was meant to maintain the Stationer's Company monopoly, it instead laid the groundwork for the consortium's demise by recognizing for the first time the rights of authors to the works they had created. In doing so, the **Statute of Anne** declared that this new development would benefit the public welfare by "encourag[ing] learned men to compose and write useful work." This concept was then included in the U.S. Constitu-

tion, which empowers Congress "[t]o promote the progress of science and the useful arts, by securing for limited times, to authors and inventors, the exclusive right to their respective writings and discoveries."

With the help and persistence of Noah Webster, George Washington signed the first U.S. copyright law in 1790. It was called the Copyright Act and it specified three protectable items: maps, books and charts. Rights were granted only to U.S. citizens, a policy that remained until 1891. Prior to U.S. copyright law, however, a precedence had already been set.

Successive updates to U.S. copyright law still seek to promote the creation of "useful works." At the same time, it must balance this goal against equally important public concerns like the **free flow of information** and promoting a **competitive marketplace**. U.S. copyright law walks a fine line between rewarding authors for their creativity (and encouraging them to create more) by giving them certain exclusive property rights in their creations, on the one hand, and enhancing the availability of these creations to the public, on the other. The balance is struck by giving protection only to the manner in which an idea, concept or fact is *expressed*, and leaves the inspirations for that expression in the public domain for all to use.

The current law that governs copyrights in the United States is the federal Copyright Act of 1976, which went into effect on January 1, 1978. Works created on or before December 31, 1977 continue to be governed by the Copyright Act of 1909. The biggest difference between these two versions: Under the Copyright Act of 1909, works published without an express copyright notice went into the **public domain** upon publication. (Refer to Appendix B for more information regarding the laws that govern copyrights—particularly the duration of copyrights and renewing copyrights.)

Modern Copyright

Copyright laws have changed with the times, as well as the value people place on copyrights. Back in Washington's day, the law permitted offend-

ers of copyrights to "forfeit and pay the sum of fifty cents for every sheet which shall be found in his or her possession... ." Today, people sue for millions over copyrights—or spend healthy sums protecting their works. Furthermore, technological advances have created more works to protect besides books, maps and charts. Things like musical works, computer programs and screenplays.

Generally, there are eight categories of protectable works under copyright law. They include:

1) **Literary works**. Examples include books, novels, poetry, newspaper or magazine articles, handbooks and manuals, computer software, catalogs, brochures, textual advertisements and even compilations like directories and the phonebook.

2) **Musical works**. Anything that can be represented in sheet music, including songs, instrumental music and advertising jingles.

3) **Dramatic works**. Anything that can be acted out on stage, such as scripts, treatments, skits, plays and operas.

4) **Pantomimes and choreographic works**. Anything that looks like dancing, including ballets, modern dance, jazz dance, cheerleader routines, and even that stuff that mimes do.

5) **Pictorial, graphic and sculptural works**. Visual images and physical pieces of art, including photographs, posters, paintings, drawings, cartoons and comics, stuffed animals, figurines, statues, maps and works of fine art. Unique designs for useful articles—such as shaping a Gucci® watch like a stylized "G"—can be protected under copyright law, but that protection extends only to the specific design used and not to watch designs in general.

6) **Motion pictures and other audiovisual works**. In addition to the obvious things like theatrical motion pictures and television shows, this category also covers documentaries, travelogues, training films and videos (sometimes called "industrials"), commercials, streaming video and any other com-

bination of moving images (with or without accompanying sound or sound effects).

7) **Sound recordings**. Anything that can be recorded—whether mechanically, magnetically or digitally—including musical instruments, singing, sounds or words.

8) **Architectural works**. Building designs, including the finished structures as well as the architect's plans and sketches.

Although Congress permits works of art, including sculptures, to be copyrighted, it does not extend the copyright to industrial design, which falls into the province of patent, trademark or trade dress law.[1] Sometimes what you may think falls under copyright falls under another type of law.

Art vs. Utility

When the maker of a lamp—or any other three-dimensional article that serves some utilitarian office purpose—seeks to obtain a copyright for the item as a sculpture, it becomes necessary to determine whether its artistic and utilitarian aspects are separable. If they are, the artistic elements of the design may be copyrighted; if they're not, the designer must look outside copyright law for protection.

Such an inquiry mixes two distinct issues: **originality and functionality**. A lamp may be entirely original, but if the novel elements are also functional (i.e. the elements are what make a lamp a lamp or the elements make this particular lamp more useful) then the lamp cannot be copyrighted. Copyrights cannot protect functions—like the way a bulb fits a socket and lights up—or the manner in which something commonly works. Imagine what the world would be like if the function of car engines (e.g., moving pistons and crankshafts) could be copyrighted and held by one individual for the entirety of his life and then by his heirs for another 70 years after that. There wouldn't be much competition among car makers. But this brings up another point: An original car engine could be patented.

[1] Industrial design refers to any original shape, pattern, configuration or ornamentation applied to a manufactured article, and made by hand, tool or machine. Examples: the shape of a table, an ergonomic chair or the decoration on a silver spoon.

So, the duration of a copyright (or patent) is key. (Refer to Appendix B at the end of this book for more about the different duration rights for different types of intellectual property.)

You Can't Copyright an Idea

One of the most complicated elements of copyright law is the fact that you can't copyright an idea—you can only copyright a particular **expression of an idea**. We've touched upon this before, but it's worth reiterating the words from the Copyright Act:

> Copyright protection for an original work of authorship does not extend to any idea, procedure, process, system, method of operation, concept, principle or discovery [that is] explained, illustrated or embodied in such work.

This point flummoxes many smart people. What, you ask, is the difference between an idea and the expression of that idea? Fortunately, the July 1999 New York federal court decision *Thomas Kerr v. The New Yorker Magazine* illustrates the point pretty clearly.

Thomas Kerr sued *The New Yorker* magazine and illustrator Anita Kunz for copyright infringement. Kerr, a freelance illustrator, alleged that the July 10, 1995 cover of *The New Yorker*—"Manhattan Mohawk" drawn by Kunz—was copied from his 1989 drawing, "New York Hairline." Both drawings depict a male with a mohawk haircut in the shape of the Manhattan skyline. Kunz and *The New Yorker* sought summary judgment, contending that Kunz had developed the idea for the drawing on her own and that she did not copy Kerr's drawing.

Kerr, who primarily worked in pen and ink, taught at the Art Institute of Boston. While his works had appeared in *The Washington Post*, *Fortune* and *The New York Times*, they had never appeared on a cover of a national magazine. *The New Yorker* had commissioned Kerr to execute three drawings for which he was paid; but they were never published.

Kunz, a well-known Canadian illustrator, generally worked in watercolor and gouache. Her works had appeared on the covers of magazines like

The Value of a Good Idea

Time, Newsweek, Rolling Stone, Sports Illustrated, and the *Sunday Magazine* of *The New York Times*, among others. She had won a number of prestigious illustration awards and had taught at various universities.

Both artists had previously created works, which either depicted the New York skyline in unusual ways or showed objects coming out of people's heads—including other depictions of mohawk haircuts.

The two drawings that became the subject of the lawsuit were equally striking. Kerr's "New York Skyline" is in pen-and-ink and depicts a male figure facing his viewer at a three-quarter view with a mohawk that forms the silhouette of the Manhattan skyline. Both eyes are visible and seem to watch the viewer. The figure has a long nose, a full bottom lip and a goatee in the shape of the Statute of Liberty. He wears a leather jacket and a T-shirt, and has shoulders in a realistic proportion to his head. The figure wears no jewelry, and the background is blank.

Kunz's "Mohawk Manhattan" is in color and depicts a clean-shaven male figure with dark olive skin in profile wearing four earrings and a chain running from a pierced nostril to a pierced earlobe. The figure's head is tilted slightly downward, and the one eye that is visible is looking downward. The figure has full lips, a smooth, rounded chin and a long, straight nose. The figure also has a Mohawk, which forms a silhouette of the Manhattan skyline with the buildings in a different order than in Kerr's image. It has a thick neck, with steeply sloped shoulders and no clothing. The background is a night sky in shades of blue and green, with faint images of clouds, a crescent moon and stars.

Kerr testified that he registered "New York Hairline" for copyright in January 1996. In September 1990, Kerr had orally licensed "New York Hairline" to his business partner Joel Cohen to create postcards in return for half of the total cards printed to use as promotional mailers. Cohen printed about 1,500 to 2,000 cards, of which a few were sold to local stores between 1991 and 1992. The card was also included in a catalog called *Unusual Quill* that was distributed by Cohen in 1992.

Kerr testified that he received space on Cohen's Web site, money for entertainment expenses and royalties as a result of the oral license. Kerr also claimed that between 1991 and early 1993 he sent out about 1,200 postcards, at least three of which were sent to *New Yorker* employees.

In 1993, Kerr gave one of his students oral permission to use the image on a T-shirt in return for a dozen of the T-shirts. In 1994 or 1995, Kerr also gave a copy of the postcard to an acquaintance of his, James Yang, an illustrator and friend of Kunz. Kerr claimed that Kunz saw the postcard when she visited Yang's studio (though Yang later testified that he didn't show the card to Kunz).

Kerr also contended that on November 10, 1994 he attended the opening of Kunz's exhibition at the Foreign Press Center while wearing a "New York Hairline" T-shirt under an open jacket. According to Kerr, he spoke briefly with Kunz, so she had the opportunity to view the image. Kunz and *The New Yorker* insisted that Kunz would not have focused on the image because she spoke to more than a hundred people that night and only spoke to Kerr for a few moments.

In 1993, Françoise Mouly, *The New Yorker* Art Director, asked Kunz to submit ideas for the cover of a special issue of *The New Yorker*.

Kunz submitted several ideas, but another artist was chosen to do the cover. Mouly then sent Kunz *The New Yorker*'s publication schedule and invited her to submit ideas for covers. In May 1995, Kunz faxed four sketches to Mouly, including a punk with a skyline Mohawk. Mouly was interested in the sketch—which appeared to her as a "hip" and "ethnic" visual pun—and *The New Yorker* editor approved it. A finished rendering in acrylic was published on the cover of the July 10, 1995 issue.

Still, Kerr argued that Kunz's work and his own were **substantially similar** and that Kunz had had access to his image on a number of different occasions.

According to the court, however, the similarities between the pictures were limited to the idea of a skyline as a haircut and other **uncopyrightable elements** and a figure in profile and certain buildings, which any expres-

sion of this idea might reasonably be expected to include. But the two figures had an entirely different "concept and feel." Kerr's pen and ink drawing had a sketchy, edgy feel to it; Kunz's cool colors and smooth lines gave a more serene and thoughtful impression. These different "feels," said the court, were sufficient to support a finding that the two images weren't substantially similar.

Even if Kunz did glimpse the image briefly and subconsciously took up the idea of a punk with a skyline haircut, there could be no copyright infringement if she did not copy Kerr's expression of that idea. Thus, the court held that Kunz's illustration of a male figure with a Mohawk haircut in the shape of New York City skyline was not "substantially similar" to Kerr's copyrighted work as a matter of law.

Derivative Works

What if you own the copyright to a business book's first edition and want to create a new work based on that work? Federal copyright law defines a *derivative work* as a work "consisting of editorial revisions, annotations, elaborations or other modifications," which, as a whole, represent an original work of authorship based on a pre-existing work. New versions of works can include translations, musical arrangements, dramatizations, fictionalizations, art reproductions and condensations. You must own or have a license to use the original work in order to legally create a derivative work.

The **copyright in a derivative work** extends only to the material contributed by the author of such work, as distinguished from the pre-existing material employed in the work. In other words, the copyright in a derivative work covers only the additions and changes; it does not extend the life of the copyrights to the pre-existing material. And, to be copyrightable, it must be different enough from the original to be regarded as a "new work" or must contain a substantial amount of new material. Making minor changes or additions of little substance to a pre-existing work do not qualify. Moreover, the new material must be original and copyrightable in itself.

Defined too broadly, derivative work would confer enormous power on the owners of copyrights on pre-existing works. The Bernstein-Sondheim musical *West Side Story* is based loosely on Shakespeare's *Romeo and Juliet*, which in turn is based loosely on Ovid's *Pyramus and Thisbe*. If derivative work were defined broadly enough (and copyright were perpetual) *West Side Story* would infringe *Pyramus and Thisbe* unless authorized by Ovid's heirs.

Typical examples of derivative works include a:

- publication that contain previously published material;

- TV show based on a novel;

- lithograph based on a painting;

- drawing based on a photograph;

- sculpture based on a drawing;

- book of maps that contain some public domain maps and some new ones; and

- musical arrangement based on a work by a classical composer.

An important point: You cannot protect your individual contributions to a derivative work unless you own the underlying work or are licensed to use it. The March 2000 Federal Appeals Court decision *Ferdinand Pickett v. Prince* demonstrates how you can lose any rights to what you've made because you failed to get the rights to use the materials from which you derived your inspiration.

Prince, a well-known musician whose name at birth was Prince Rogers Nelson, performed for many years under his first name. Beginning in 1992, he began referring to himself by a symbol, instead of by a name or something you could pronounce. This forced all who referred to him in speech to use the convoluted expression "the Artist formerly known as Prince."

The symbol, similar to the Egyptian hieroglyph *Ankh*, was his trademark but it was also a **copyrighted work of visual art** that licensees of Prince used in various forms, including jewelry, clothing and musical instruments.

The Value of a Good Idea

Ferdinand Pickett, a designer of guitars, made a guitar in the shape of the Prince symbol in 1993. According to Pickett, the guitar was a derivative work (from the visual art) within the meaning of U.S. copyright law. Pickett claimed to have shown the guitar to Prince; and, shortly afterwards, Prince appeared in public playing a guitar quite similar to Pickett's. As a result, Pickett filed suit for copyright infringement against Prince.

Prince, however, counterclaimed for infringement of the copyright on his symbol. In response to the counterclaim, Pickett argued that he could copyright a work derived from another person's copyrighted material without that person's permission and then sue for infringement of the new, but nonetheless derivative, work. In other words, Pickett argued that his guitar was a **derivative work of the copyrighted Prince symbol**…and that was okay; but Prince's guitar was derivative of Pickett's guitar…and that was not okay.

The Copyright Act grants the owner of a copyright the exclusive right to prepare derivative works based upon the copyrighted work. Although Pickett's guitar wasn't identical to the Prince symbol, the court reasoned that the difference in their appearance might have been due to nothing more than the functional difference between a two-dimensional symbol and a guitar in the shape of that symbol.

Pickett's claim was dismissed on the ground that he had no right to make a derivative work based on the Prince symbol—even if Pickett's guitar possessed a smidgen of originality—without Prince's consent, which Pickett never sought and which was never granted. According to the court, this narrow ruling was necessary because a derivative work is, by definition, bound to be similar to the original.

Pickett appealed his loss. But the appeals court affirmed most of the trial court's decision, offering this analogy:

> Consider two translations into English of a book originally published in French. The two translations are bound to be very similar and it will be difficult to establish whether they are very similar

because one is a copy of the other or because both are copies of the same foreign-language original.

The question of whether Prince's guitar was a copy of his copyrighted symbol or a copy of Pickett's guitar was likewise not a question that litigation could answer with confidence. In the words of the appeals court, "If anyone can make derivative works based on the Prince symbol, we could have hundreds of Picketts, each charging infringement by the others."

Technical Compilations in a Business

Not much of corporate intellectual property involves the kinds of material that ordinary people normally equate with artistic intellectual property such as that of Prince's guitar or Ovid's *Pyramus and Thisbe*. Few companies write books or make movies as a part of their business plan. But, even if your business is manufacturing or agriculture, you may develop customer lists, vendor directories and data archives that you organize in a particular—original—way and use as part of your business. In legal terms, these lists usually come under trade secret, or, if it's a business method, patent law. However, the May 1997 Federal Appeals Court decision *American Dental Association v. Delta Dental Plans Association* dealt with a dispute over a technical compilation. Specifically, the case considered whether a **taxonomy**—a set of categories and descriptive terms—is copyrightable.

The American Dental Association's *Code on Dental Procedures and Nomenclature* was first published in 1969. Since then, the *Code* has undergone frequent revisions in response to changes in dental knowledge and technology. The *Code* lists dental procedures by a number followed by a description.

The *Code* first appeared in the Journal of the American Dental Association, covered by a general copyright notice. The ADA submitted the subsequent 1991 and 1994 versions for copyright registration, which was granted by the Register of Copyrights.

The Value of a Good Idea

The dispute arose when Delta Dental Plans published its *Universal Coding and Nomenclature*, a reference work that includes much of the same numbering system and descriptions as the ADA's *Code*. Following publication, the ADA brought an action against Delta, alleging copyright infringement of its *Code*.

Delta argued that it was entitled to reprint modified versions of the *Code*, under an implied license, as a joint author (Delta had helped draft the original *Code*). Delta also argued that its use of the ADA material constituted fair use of copyrighted material.

Another Delta argument—with which the court agreed—was that the ADA *Code* did not represent copyrightable material in the first place. The *Code* was not copyrightable because it **cataloged a field of knowledge**. A comprehensive description of dental treatments, said the district court, cannot be selective in scope or arrangement, and therefore cannot be original either—taxonomies, by their very nature, are designed to be useful, not original.

The ADA appealed the ruling, and the case attracted the attention of many other suppliers of taxonomies, including the American Medical Association, the American National Standards Institute and Underwriters Laboratories, among others. In fact, the groups filed a brief as *amici curiae* to let the court know that they, too, produced catalogs of some field of knowledge and depended on the copyright laws to enable them to recover the costs of the endeavor.

The appeals court determined that there can be multiple, and equally original, biographies of the same person's life, and similarly, there can be multiple original taxonomies of a field of knowledge. The creativity required for copyright protection was inherent in the descriptions of the procedures in the ADA *Code*, said the judge, and the numbers assigned to each procedure are original works of authorship. The decision of how to word the description was not guided by the facts of dental procedures. The court determined that the numbers and the descriptions were copyrightable subject matter.

The court explained its finding in more detail:

> Note that we do not conclude that the *Code* is a compilation covered by [copyright law]. It could be a compilation only if its elements existed independently and the ADA merely put them in order. A taxonomy is a way of describing items in a body of knowledge or practice; it is not a collection or compilation of bits and pieces of "reality." The 1991 and 1994 versions of the *Code* may be recompilations of earlier editions, but the original *Code* is covered…as an "original work of authorship," and its amendments…as derivative works.

The ADA allowed anyone to devise and use forms into which the *Code*'s descriptions might be entered. In fact, the ADA encouraged this because, according to the organization, standardization of language promoted interchange among professionals. The ADA only objected to Delta's use of most of the *Code* while making its own modifications.

According to the court, Delta could send out forms inviting dentists to use the ADA's *Code* to submit bills to insurers; but it could not copy the *Code* itself or make and distribute a derivative work based on the *Code*.

In short, the ADA won. It got the decision that it sought from the courts—that the taxonomy could be copyrighted.

Compilations don't have to refer to lists and taxonomies; they can be **collections of works by different authors** who did not intend their works to be joined together. A magazine, for example, is a compilation of the works of the different authors who wrote the articles. Anthologies are compilations of writings by different authors. Each contributor to the compilations reserves certain rights afforded them by copyright—including, sometimes, the editor who compiles and organizes.

Telephone companies cannot copyright telephone listings, which are merely facts; but they can copyright the original arrangement of that data in a book. Rand McNally copyrights the fancy arrangement of its maps—not the maps themselves.

Computer Programs

Computers constitute a hard, specialized intellectual property subject area. Most people don't read, for pleasure, the source or object code of a word processing program or of an operating system that runs a computer. Yet computer **software is copyrightable**; it's art of a technical form. Bill Gates is a billionaire many times over because of his copyrighted programs. When the Copyright Act was amended in 1976 "to include computer programs in the definition of protectable literary works," it defined a *computer program* as "a set of statements or instructions to be used directly or indirectly in a computer in order to bring about a certain result."

Initially, courts faced the difficult issue of finding a practical way to analyze programs for the sake of copyright. Because the codes and internal mechanics of computers are artistic to some degree, but some parts are not, figuring out the difference is the key to program copyrights. Efforts to distinguish between the artistic and unprotected elements of programming eventually resulted in what is known as the **abstraction-filtration-comparison test**.

In 1992, the Federal Appeals Court for the Second Circuit decided *Computer Associates Int'l. v. Altai, Inc.*, updating the scope of software copyright protection from what was set forth by the Third Circuit's *Whelan Associates v. Jaslow Dental Laboratory, Inc.*, in 1986. In *Computer Associates*, the court developed this three-part test, which was later adopted by other courts.

When trying to compare two programs, courts are directed to first dissect the programs according to their varying levels of generality—called an abstraction test.

Second, courts are directed to examine each level of abstraction in order to "filter" out those elements of the program that are unprotectable. Theoretically, filtration eliminates the **unprotectable elements** like ideas, processes, facts, public domain information, merger material, etc.

Third, the courts must then compare the remaining protectable elements with the allegedly infringing program. In sum:

1) Abstraction Test: dissect each program into its essential elements or parts;

2) Filtration Test: filter out the parts of each program that by law cannot be protected; and

3) Comparison: compare what's left and see if one has infringed the other.

As in copyrighting other materials, the standard or functional parts of a computer generally are not copyrightable (remember the lamp, what makes a lamp a lamp cannot be copyrighted; what makes a computer a computer cannot be copyrighted). While this doctrine had already defined other types of work, the Tenth Circuit extended this idea to computers in its 1993 decision *Gates Rubber Co. v. Bando Chemical Industries, Ltd.* And, functional parts in the area of computers include:

- hardware and software standards;

- mechanical specifications;

- compatibility requirements;

- computer manufacturer design standards;

- target industry practices and demands; and

- computer industry programming practices.

Computer programs do not always come under copyrights. In fact, much of computer technology falls under patent law, and constitutes the most technically difficult intellectual property to police and protect. Computer hardware and software often evolve faster than the law's ability to keep up with current conditions. (In Chapter 10, How Patents Work, we'll look at a case that may have set—in 1998—the precedent for software patentability.)

Scènes à Faire

Scènes à faire is a term used to describe common elements or themes that appear in many stories. For example, Paramount Pictures was once

sued for copyright infringement when an archeologist-screenwriter claimed that his scenes in his *Black Rainbow* screenplay were identical to those in the iconic film *Raiders of the Lost Ark*. His case went nowhere: copyright can't protect details, characters, events or elements of a fictional story that are inherent to the conventional telling of that kind of tale. Similarly, anything dictated by the requirements of a setting or genre are not protectable. As the court wrote:

> [That] treasure might be hidden in a cave inhabited by snakes, that fire might be used to repel the snakes, that birds might frighten an intruder in the jungle, and that a wary traveler might seek solace in a tavern, all are indispensable elements to the treatment of the "Raiders" theme, and are…simply too general to be protectable.

Works that serve a functional purpose or that are dictated by external factors such as particular business practices, also come under the *scènes à faire* doctrine and cannot be copyrighted.

However, there are exceptions—which have to do with the amount of subjective content and the position it holds in the marketplace. Recall the ADA's case against Delta Dental. In that case, the ADA's classification taxonomy was declared an original work and worthy of copyright protection. Similarly, the American Medical Association's copyright in the Physician's Current Procedural Terminology, its catalog of medical procedures, has been sustained.

A good example of a *scènes à faire* exception was the centerpiece of the July 2000 United States Court of Appeals decision *Computer Management Assistance Company v. Robert F. deCastro, Inc., et al.*

Computer Management Assistance Company (CMAC) developed a computer program for the picture-framing industry called ACCESS. In 1983,

CMAC licensed ACCESS, to Robert F. deCastro, Inc., a major wholesale distributor of picture frames, and trained deCastro's information systems manager, Luis Escalona, to use ACCESS.

Under the license agreement, CMAC placed restrictions on deCastro's right to use ACCESS. The agreement also included a sublicense of an interpreter to run ACCESS on deCastro's computer. An interpreter translates instructions in a specific program language, in which a programmer has written a program (source code), into a specific numerical language (object code) on which the computer is built to run.

In 1992, Information Management Consultants (IMC), a reseller of FACTS, a comprehensive software package for wholesale distributors in general contacted deCastro. IMC, in its inaugural foray into the picture framing industry, presented a proposal to install and modify FACTS to fit deCastro's needs.

In August of 1993, deCastro decided to enter into a new contract with CMAC. CMAC agreed to attempt to modify ACCESS for direct order entry. To accomplish this purpose, CMAC obtained a FACTS demo package including that feature from IMC. In the end, CMAC was unable to modify ACCESS for direct order entry. DeCastro renewed discussions with IMC and eventually entered into a contract for FACTS. IMC modified the program by adding files to the generic FACTS and installed the modified program. DeCastro began using it in June of 1996.

In early 1997, CMAC filed suit against deCastro, Escalona and IMC, alleging copyright infringement, trade secret misappropriation, unfair and deceptive trade practices and breach of contract. After a two-week bench trial, the district court entered judgment against CMAC on all claims.

CMAC appealed, arguing that copyright protection applied to its literal lines of code and its non-literal elements of architecture, design and coding methodology. Although there was no literal similarity between the code lines of FACTS and ACCESS, CMAC argued that deCastro infringed on its copyright protection of the non-literal design and organizational elements.

The Value of a Good Idea

To analyze the problem, the appeals court used the abstraction-filtration method to determine where copyright protection applied. To filter out the unprotectable elements of the FACTS program, the court divided the program's segments into layers of abstraction.

CMAC had asserted that Appendix A of FACTS was evidence of a copyright violation because it contained numerous copyrightable design specifications, not just general business practices, which were copied from the ACCESS program. Specifically, Appendix A detailed the most significant modifications to generic FACTS—those necessary to accommodate deCastro's pricing matrices.

> **The appeals court agreed with the district court on the initial level of abstraction analysis. The ACCESS program contained several features that qualified as an "expression." The elements designed to meet the requirements of the framing industry qualified as well. Accordingly, the court proceeded to the next stage of the analysis: "filtration."**

The court filtered out noncopyrightable elements from each particular level of the program. The district court found that the modifications to generic FACTS performed by IMC were dictated by the business practices and demands of deCastro and, therefore, fell within the *scènes à faire* exception. In other words, Appendix A represented the specific needs of deCastro's business, as well as practices that were standard in the picture framing industry. These expressions, dictated by external factors, did not qualify for copyright protection and were eliminated from consideration in comparing the ACCESS and FACTS programs.

Next, the court examined whether deCastro copied any remaining protected aspects of ACCESS—i.e., the source code and file layouts for the

program, which were unrelated to the functional purposes excluded from protection. The court came to the conclusion that substantial differences existed between the modified FACTS program and ACCESS. For example, the two programs were written in different basic languages. IMC adapted FACTS to fit deCastro's needs by adding simple file maintenance programs, keys and data to the generic FACTS program. The appeals court affirmed the district court's finding that the logical way to modify generic FACTS was to add files to accommodate deCastro's particular business practices.

The appeals court concluded that generic FACTS and ACCESS were similar only in that they both served deCastro's needs when modified to reflect the particular practices of the framing industry and deCastro's business. The copied elements of CMAC's program were **unprotectable** *scènes à faire*.

Conclusion

The purpose of this chapter has been to establish some of the ground rules for what constitutes a copyrightable work or system. It's a complex area of law and constantly under review by the courts. In case you're still wondering: The easiest way to register a copyright is to visit the Library of Congress online at *www.loc.gov* and go directly to the **Office of Copyrights**. Or, simply go to *www.loc.gov/copyright/* where you can download forms and find lots of information. Refer to Appendix A for a complete list of useful Web sites and points of contact.

Like many topics covered in this book, the answers to questions may seem counter-intuitive at first. But the main thing to remember is that common notions of copyrights—putting a © on the bottom of the page of a book or software program—is only part of the total equation. And—to answer the question from the start of this chapter—you'll find it hard to sue the hack comedian for stealing your perfect dirty limerick since you merely spoke it and you didn't register it. You probably did write it down, but even so, the hack might claim *fair use*, which is another topic we'll discuss in Chapter 4, Fair Use of Copyrighted Material.

The Value of a Good Idea

CHAPTER 2:
AUTHORS AND
AUTHOR ISSUES

When it comes to creating copyrightable material, a lot of terms are thrown around: *author*, *artist*, *contractor*, *contributor*, *compilation*, *derivative work*, *joint work*, *work made for hire*, etc.

These terms all mean different things in different contexts.

This chapter considers everything from who is an author, according to copyright law…to what happens when more than one person or entity is an author…and what terms like "work made for hire" mean.

Who Is the Author?

To most people, an author is someone who—independently and creatively—makes written, audio or visual work. The law looks for a more precise definition. The June 1989 U.S. Supreme Court decision *Community for Creative Non-Violence, et al. v. James Earl Reid* further established ground rules used in disputes over the meanings of **author**, **freelance contributor** and **work made for hire**.

In the fall of 1985, the Community for Creative Non-Violence (CCNV), a Washington, D.C. organization dedicated to eliminating homelessness entered into an oral agreement with James Earl Reid to produce a statue dramatizing the plight of the homeless for display at a 1985 Christmas pageant in Washington.

The Value of a Good Idea

Mitch Snyder, the head of CCNV and other CCNV members conceived the main concept of the display: A sculpture of a modern Nativity scene in which, in lieu of the traditional Holy Family, two adult figures and an infant would appear as contemporary homeless people huddled on a streetside steam grate.

The people at CCNV had more specific ideas about what they wanted. The family was to be African American (most of the homeless in Washington at the time were black); the figures were to be life-sized; and the steam grate would be positioned atop a platform or base, within which special-effects equipment would be enclosed to emit simulated steam through the grid to swirl about the figures. CCNV had also chosen a title for the work—*Third World America*—and wanted a legend on the pedestal to read: "…and still there is no room at the inn."

Snyder made inquiries to locate an artist to produce the sculpture and was referred to Reid. In the course of two phone calls, Reid agreed to sculpt the three human figures. CCNV agreed to make the steam grate and pedestal for the statue. Reid proposed that the work be cast in bronze for roughly $100,000 and that it take six to eight months to complete.

Snyder rejected that proposal because CCNV didn't have enough money—and needed the project to be completed by December 12. Reid then suggested that the sculpture could be made of Design Cast, a synthetic substance that would meet CCNV's monetary and time constraints, could be tinted to resemble bronze, and could withstand the elements. The parties agreed that the sculpture would cost no more than $15,000, not including Reid's services (which he offered to donate). The parties did not sign a written agreement. Neither party mentioned copyright.

After Reid received an advance of $3,000, he made several sketches of figures in various poses. At Snyder's request, Reid sent CCNV a sketch of a proposed sculpture to use in raising funds for the sculpture. Snyder said that it was also for his approval.

Reid looked for a black family to serve as a model for the sculpture. At Snyder's suggestion, Reid visited a family living at CCNV's Washington shelter; but he decided that only their new born was a suitable model.

While Reid was in Washington, Snyder took him to see homeless people living on the streets. Snyder pointed out that they tended to recline on steam grates, rather than sit or stand, in order to warm their bodies. From that time on, Reid's sketches contained only reclining figures.

Throughout November and the first two weeks of December 1985, Reid worked exclusively on the statue—assisted at various times by a dozen different people who were paid in installments by CCNV. On a number of occasions, CCNV members visited Reid to check on his progress and to coordinate CCNV's construction of the base. CCNV rejected Reid's proposal to use suitcases or shopping bags to hold the family's personal belongings, insisting instead on a shopping cart. Again, neither party discussed copyright ownership.

On December 24, 1985—12 days after the agreed-upon date—Reid delivered the completed statue to Washington. There, it was joined to the steam grate and pedestal prepared by CCNV and placed on display near the site of the pageant. Snyder paid Reid the final installment of the $15,000. The statue remained on display for a month. In late January 1986, CCNV members returned it to Reid's studio in Baltimore for minor repairs.

Snyder began making plans to take the statue on a tour of several cities to raise money for the homeless. Reid objected, contending that the Design Cast 62 material was not strong enough to withstand the ambitious itinerary. He urged CCNV to cast the statue in bronze at a cost of $35,000, or to create a master mold at a cost of $5,000. Snyder declined to spend more of CCNV's money on the project.

In March 1986, Snyder asked Reid to return the sculpture to CCNV. Reid refused. He then filed a certificate of copyright registration for *Third World America* in his name and announced plans to take the sculpture on a more modest tour than the one CCNV had proposed. Snyder, acting in his capacity as CCNV's trustee, immediately filed a competing certificate of copyright registration.

Snyder and CCNV also filed a lawsuit against Reid, seeking return of the sculpture and a determination of copyright ownership. The federal court hearing the case granted a preliminary injunction, ordering Reid to return

the sculpture to CCNV. Then, it settled into the business of determining who had what rights in the sculpture.

In legal terms, the dispute centered on the question of whether the sculpture was a work made for hire—which is the copyright status that grants the maker of a work fewest rights, and employer or client most. To answer this question, courts determine whether the work was prepared by an employee or an independent contractor.

CCNV had contracted with Reid for a single project. It had no right to assign additional projects to him; it paid him in a manner in which independent contractors are often compensated—not paying payroll or Social Security taxes, not providing employee benefits and not contributing to unemployment insurance or workers' comp funds on Reid's behalf. These facts suggested Reid would retain copyright. But, after a two-day bench trial, the district court ruled for CCNV. It held that the statue was a work made for hire and therefore the exclusive property of CCNV.

Reid appealed the decision, and the court of appeals reversed the lower court's ruling. It ruled that the sculpture was not a work made for hire since it was not "prepared by an employee within the scope of his or her employment." Although CCNV members had directed enough of the work to ensure that the statue met their specifications, other circumstances weighed against finding an employment relationship. Reid engaged in a skilled occupation, supplied his own tools, worked in Baltimore without daily supervision from Washington, had freedom to decide when and how long to work in order to meet his deadline and had total discretion in hiring and paying assistants.

The appeals court admitted that CCNV might be considered a joint author of the sculpture and, thus, a **co-owner of the copyright**. But this could only happen if both sides agreed that they had prepared the work with the intent that their contributions would be "merged into inseparable or interdependent parts of a unitary whole."

CCNV appealed the appeal—which pushed the case up to the Supreme Court. According to the high court, the Copyright Act of 1976 held that

copyright ownership "vests initially in the author or authors of the work." As a general rule, the *author* is the party who actually creates the work; that is, the person who translates an idea into a fixed, tangible expression entitled to copyright protection.

The Act carves out an important exception, however, for works made for hire. Classifying a work as made for hire determines not only the original copyright owner, but also the copyright's duration and the owners' renewal rights, termination rights and right to import certain goods bearing the copyright. To determine whether *Third World America* represented a work for hire, several factors were important, namely:

- the hiring party's right to control the manner and means by which the product is accomplished;

- the duration of the relationship between the parties;

- the skills required to complete the assignment;

- the location of the work;

- whether the hiring party had the right to assign additional projects to the hired party;

- the extent of the hired party's discretion over when and how long to work;

- the method of payment;

- the hired party's role in hiring and paying assistants;

- the provision of employee benefits; and

- the tax treatment of the hired party.

The high court agreed with the appeals court that Reid was not an employee of CCNV; he was an independent contractor. Thus, CCNV was not the author of *Third World America* by virtue of the work for hire provisions of the Copyright Act.

The high court also agreed with the appeals court's suggestion that CCNV might be considered a joint author of the sculpture. But the Supreme Court

didn't have enough evidence before it to make that decision…and CCNV hadn't gotten around to proving that intention back in the lower court.

When Authors Are Confused

Sometimes problems follow from an author's assumption that he's always free to use material he has written. If he's assigned the copyrights, however, he may not be able to do so freely.

An example of this **erroneous assumption** comes in the October 2000 Federal Trial Court decision *CRC Press LLC v. Wolfram Research, Inc., et al.* The case clarified when an author controls content…and when he does not.

The CRC Concise Encyclopedia of Mathematics began its evolution in 1995. At that time, Eric Weisstein was a Staff Scientist in the Division of Geological and Planetary Sciences at the California Institute of Technology (Caltech). He had been collecting notes to develop a reference work for approximately 10 years. It was not until Weisstein took his position at Caltech, however, that he began to convert these notes into a Web-based reference work entitled *Eric's Treasure Trove of Mathematics*.

The site had some success on the Internet and developed into a dynamic work to which people accessing the site could add their own entries. After accepting a position at the University of Virginia in 1996, Weisstein decided to adapt *Treasure Trove* to book form with the hope of advancing his reputation in the academic community.

CRC was one of the publishers who received a manuscript from Weisstein. Timothy Pletscher was the first editor at CRC with whom Weisstein dealt. Weisstein sent an e-mail to Pletscher during negotiation, which stated:

> As I recall, there were a few outstanding issues left, including… how to format a CD-ROM version…[and] the possibility of maintaining my present WWW site…once the CD is out, not to mention contractual details.

Chapter 2: Authors and Author Issues

In March 1997, Robert Stern began editing mathematics titles for CRC, replacing Pletscher. A month later, Weisstein received a letter from Stern containing an Author Agreement. Weisstein took this to mean that:

> CRC had agreed in substance to the discussions [he] had with Pletscher and [his] discussion with Mr. Stern, including [his] desire to maintain a free and publicly accessible Web site.

After receiving the contract, Weisstein reviewed it and had a number of discussions with Stern. Weisstein negotiated a change to the royalty rate on derivative works. Stern agreed to increase the royalty on these works from five to 10 percent. Weisstein signed and returned the contract in April 1997. At this point, according to Weisstein, he believed that work as defined in the contract meant only that CRC had rights to the manuscript of the Encyclopedia rather than to the content of the Web site.

In May 1997, Stern and Weisstein discussed the possibility of creating a CD-ROM version of the book. As a result of these talks, Weisstein and CRC entered into a second contract in late 1998, which contained the same copyright assignment language as the initial Author Agreement.

In a later letter, Stern informed Weisstein that he should "leave the Web site alone until [his] book is almost published as it [sic] will provide lots of free advertising which can only bring...lots of sales." As a result of the letter and related discussions, Weisstein began limiting access to the Web site. He said that he did this out of "a spirit of voluntary cooperation to advance [CRC's and Weisstein's] shared interest" rather than out of any sense of contractual responsibility.

The encyclopedia was first published in December 1998. Sales of the first printing were strong, and it sold out in a matter of months. The book quickly became CRC's bestselling mathematics title.

In February 1999, Weisstein was invited to visit Wolfram Research, Inc. (WRI) at its Illinois headquarters to speak about his site. WRI publishes technical software and has a user base of over one million academics. About 90 percent of its revenues are generated by its *Mathematica* software, a sophisticated reference and training application.

The Value of a Good Idea

Many members of WRI's staff were aware of Weisstein's encyclopedia and recognized its value as a resource. As a result, WRI offered Weisstein a job—which he accepted in June 1999.

Throughout this time, WRI had been discussing the possibility of developing products with CRC. In an e-mail dated May 6, 1999, from Allan Wylde (a publishing consultant working for WRI) to CRC's Stern, Wylde described the encyclopedia as the "top priority" for a joint venture.

Weisstein continued to maintain his Web site in some form throughout these discussions. He did not believe he'd transferred his rights to the site in either of the Author Agreements he'd signed with CRC. He based this belief primarily on four points:

1) the CD-ROM version of the encyclopedia published by CRC contained a link to the "Encyclopedia of Mathematics Home Page," given as his site—treasure-troves.com/math;

2) the contact e-mail address given on every page of the CD-ROM was comments@treasure-troves.com;

3) the introduction page of the CD-ROM was titled "Concise Encyclopedia of Mathematics CD-ROM: A Treasure Trove of Mathematical Formulas, Facts, Figures and Fun" which suggested it was an adaptation of his *Treasure Troves* Web site; and

4) each of the thousands of pages of encyclopedic material on the CD-ROM published by CRC contained the copyright statement "1996-9 Eric W. Weisstein, 1999-05-26."

In June 1999, representatives of WRI and CRC met to discuss possible joint ventures based on six of CRC's existing publications. No agreements were reached at this meeting. A proposal was later sent by WRI to CRC regarding placement of Weisstein's encyclopedia on the WRI Web site. WRI proposed waiting three months before placing the encyclopedia on the Web site to accommodate CRC's concerns about lost sales.

In response to the proposal, CRC stated via e-mail that "[t]here is a great deal of concern here about allowing Wolfram to put the entire Weisstein

Encyclopedia on the Web without providing [CRC] with some hard compensation." Following this communication, negotiations ceased.

From June through November 1999, Weisstein worked with WRI on improving the graphic design of the Web site and adding a subject classification. The new design was completed in December 1999, and the name of the site was changed from *Treasure Trove* to *Eric Weisstein's World of Mathematics* (it was also called *MathWorld* in some places). The site was moved to a WRI-owned computer at mathworld.wolfram.com.

In February 2000, Stern learned about the *MathWorld* site from another CRC employee. Assessing the site, Stern found that the opening page contained the announcement: "Presenting MathWorld—Wolfram Research teams with Eric Weisstein to develop the Web's most extensive mathematical resource."

CRC then conducted research on the similarity between the *Encyclopedia* and *MathWorld*. It made the following conclusions:

- Out of 515 entries in the CRC book, 509 appeared on the MathWorld site.

- Of the 509 common entries, 335—or 65 percent—contained the same text and figures verbatim, with no alterations. Only 174 entries—or 33 percent—of the entries copied contained editing in the text or figures, in many cases of trivial degree.

- One of the useful features of the CRC book was that it gave bibliographic references to other sources for many of its entries. In almost all cases, references that appeared in the CRC book were carried over into the MathWorld site.

CRC wrote WRI, asking it to remove *MathWorld* from its servers. WRI refused. So, CRC filed a lawsuit alleging copyright infringement.

Weisstein had been an employee of WRI since June 1999. All that time, he clearly had access to the work he'd done for CRC. This met one of the key tests of an infringement case—but could an author really be held to have infringed on his own work?

The Value of a Good Idea

WRI argued that Weisstein had never transferred his rights in the Web site to CRC. It claimed that the CRC book and CD-ROM were merely derivative works of this senior work—and it was only the rights to these derivative works which Weisstein had granted to CRC.

On this point, federal copyright law states:

> The copyright in a compilation or derivative work extends only to the material contributed by the author of such work, as distinguished from the pre-existing material employed in the work, and does not imply any exclusive right in the pre-existing material. The copyright in such work is independent of, and does not affect or enlarge the scope, duration, ownership or subsistence of any copyright protection in the pre-existing material.

So, if Weisstein transferred only his rights in derivative works of *Treasure Trove*, CRC had no valid claim of copyright infringement related to the *MathWorld* site. But had Wesstein **waived his rights by contract**?

To determine precisely what had been transferred, the trial court reviewed the two Author Agreements. The contracts contained the following language with regard to the copyright of the encyclopedia:

> The Author hereby expressly grants, transfers and assigns to the Publisher full and exclusive rights to the Work, including, without limitation, the copyright in the Work, all revisions thereof and the right to prepare translations and other derivative works based upon the Work in all forms and languages for the full term of the copyright and/or renewals and extensions thereof, throughout the world.

This was a very broad grant of rights. And the details got even worse for the enterprising academic. The agreements defined *work* as follows:

> The Work shall consist of approximately 1,400 camera-ready manuscript pages and include approximately 1,200 camera-ready illustrations to yield a completed work of approximately 1,408 printed pages. In addition to the camera-ready copy, the Author

> will submit to the Publisher an electronic version of the text and a paper copy for Publisher's review.... .

But it didn't say anything about Weisstein's Web site.

The court admitted that the **Author Agreements** may have implied a connection to the Web site—but they offered no clear indication that CRC's rights were limited to the derivative *Encyclopedia* because there was no language concerning explicitly either CRC's or Weisstein's rights pertaining to the site.

Weisstein argued that he would not have signed the contract if it limited his ability to control the Web site in the future. Specifically, he said:

> I have worked innumerable 70-plus hour weeks in order to continue developing my Web site into the world's best mathematics resource. The site existed for years before CRC ever knew it— or I— existed. No one from CRC ever lifted a finger to help me develop the Web site… I never believed that CRC had any proprietary claim to my Web site, and CRC led me to believe that it had no intention of asserting any such claim. The Web site is, and always has been, mine and mine alone.

Weisstein and WRI noted that Weisstein had always been the person who determined to what degree the Web site would be available to users throughout the development of the CRC book. He determined which computers would host the site and what security measures would be employed to prevent copying of the *Treasure Trove/Math World* content.

They also argued that the very existence of the second Author Agreement (which covered the CD-ROM version of the CRC book) proved that the Web site was a separate product. The second contract would not have been necessary if Weisstein had transferred his rights to the Web site in the initial agreement.

Finally, Weisstein and WRI argued that Internet publishing practices demonstrated Weisstein's intent to exclude the Web site from the definition of work in the Author Agreement. Theodore Gray, a member of the Executive Committee at WRI, stated in an affidavit:

> CRC knew or should have known the difference between [Weisstein's] dynamic, collaborative, evolving Web site—which preceded the book, made it possible and has evolved further since its publication—and a Web site which merely reproduces [static images of] a traditionally created and published book.

But the court found all of these arguments unconvincing.

Weisstein's control over the security measures imposed on the Web site and his control over the computer which hosted the Web site was unpersuasive. The court ruled:

> Simply because CRC allowed Weisstein personally to block portions of the Web site does not negate the fact that Weisstein blocked these portions at the direction of CRC.

And the existence of the second contract related to the CD-ROM version of the CRC book didn't prove anything about Weisstein's rights. The court ruled that Weisstein was entitled to additional compensation for doing additional work for CRC in the development of the CD-ROM version. For example, "the CD-ROM required, and Weisstein was able to provide, links and cross-references between the various entries in the Encyclopedia." The second contract simply covered this additional work.

Finally, the statements made by WRI's employee Gray concerning his impressions about what CRC should have realized shed little light on what Weisstein and CRC intended.

In general, the court concluded that Weisstein's statements about his intent when entering into the contract did not align with the circumstances existing when the contract was signed. Most significant among those circumstances was proved by an e-mail Weisstein had sent to CRC, after the book had been published but before he was hired by WRI:

> I have been getting lots of requests from people who would like to access the full Web version of my encyclopedia, which currently has many portions blocked at CRC's request. Is there any mechanism for CRC to license the Web version (for a fee)?

This language clearly indicated that Weisstein was aware he no longer had control over his Web site. Further, Weisstein continued to keep portions of his site blocked at the request of CRC. And Weisstein had clearly reviewed the second contract upon receiving it, because he requested a greater percentage of royalties on derivative works. Weisstein could have easily requested an addendum to the contract which excluded the Web site when he negotiated a change in the amount of royalty. But he didn't.

The court issued a **preliminary injunction** for CRC Press, ordering Weisstein and WRI to remove the Web site. Weisstein has since relinquished his control over the content in his contracts with CRC. The outcome of this case clearly points to the need for authors to **negotiate well when signing contracts with publishers**. The widespread use of the Internet and other forms of communicating information, such as CD-ROMs, make the issue of content control all the more complicated.

Joint Authors and Compilations

The boom in "interactive" media during the 1990s and early 2000s raises some critical questions about joint authorship. How do you handle copyright disputes when two or more people were involved in creating a work? The so-called "Twelfth Street Rag" doctrine derives from the 1955 appeals court decision in *Shapiro, Bernstein & Co. v. Jerry Vogel Music Co.* This decision allowed the assignee of an ownership interest in a musical composition to add new elements to a pre-existing work and thereby create new ownership interests in the resulting "joint work."

If you think a rag is tough to play on the piano, wait until you try to sue somebody under the Twelfth Street Rag. This definition of *joint work* extinguished any other ownership interests in the pre-existing work. Congress overruled this doctrine in 1976 by adopting a new definition for **joint work**, which requires that each author intend the merger at the time the author prepares his or her contribution. Specifically:

> work prepared by two or more authors with the intention that their contributions be merged into inseparable or interdependent parts of a unitary whole.

The Value of a Good Idea

On the other hand, Section 103(b) of the Copyright Act provides that:

> The copyright in a compilation or derivative work extends only to the material contributed by the author of such work, as distinguished from the pre-existing material employed in the work, and does not imply any exclusive right to the pre-existing material.

The author of a compilation work may therefore receive copyright protection for the particular way in which he selected and arranged the works within the compilation. The protection will not, however, extend to the underlying works themselves.

The June 2001 U.S. Supreme Court decision *New York Times, et al., v. Jonathan Tasini, et al.* dealt with a dispute over compilations—and helped establish the terms of freelance, contract work in the Internet age.

Tasini represented a group of freelance authors who wrote articles for newspapers and magazines published by the New York Times Company, Newsday Inc. and Time Inc. (the print publishers).

The authors registered copyrights in each of the articles. The print publishers registered collective work copyrights in each periodical edition in which an article originally appeared.

The print publishers had engaged the authors as independent contractors (freelancers) under contracts that in no instance secured consent from an author to place an article in an electronic database. However, the print publishers licensed rights to copy and sell articles to LEXIS/NEXIS, owner and operator of NEXIS—a computerized database containing articles in text-only format from hundreds of periodicals spanning many years.

Pursuant to the licensing agreements, the print publishers regularly provided LEXIS/NEXIS with a batch of all the articles published in each periodical edition. Each print publisher coded each article to facilitate computerized retrieval, then transmitted it in a separate file. After further coding, LEXIS/NEXIS placed the article in the central discs of its database.

Subscribers access NEXIS through computers; search for articles using criteria such as author and subject; and view, print or download each

article yielded by the search. An article's display identifies its original print publication, date, section, initial page number, title and author—but each article appears in isolation, without a visible link to other stories originally published in the same periodical.

The Times Company also has **licensing agreements** with University Microfilms International (UMI), authorizing reproduction of *Times* materials on two CD-ROM products. One, the *New York Times* OnDisc (NYTO), is a text-only database containing *Times* articles presented in essentially the same way they appear in LEXIS/NEXIS. The other, General Periodicals OnDisc (GPO), is an image-based system that reproduces the *Times'* *Sunday Book Review* and *Magazine* exactly as they appeared on the printed pages, complete with photographs, captions, advertisements and other surrounding materials.

The two CD-ROM products are searchable in much the same way as LEXIS/NEXIS; in both, articles retrieved by users provide no links to other articles appearing in the original print publications.

In December 1993, the authors filed a lawsuit in the U.S. District Court for the Southern District of New York, alleging that their copyrights were infringed when—as permitted and facilitated by the print publishers— LEXIS/NEXIS and UMI (the electronic publishers) placed the articles in NEXIS, NYTO and GPO.

The authors sought declaratory and injunctive relief and money damages. In response, the print and electronic publishers raised the privilege afforded to collective work copyright owners by section 201(c) of the Copyright Act. That section, pivotal in this case, reads:

> Copyright in each separate contribution to a collective work is distinct from copyright in the collective work as a whole, and vests initially in the author of the contribution. In the absence of an express transfer of the copyright or of any rights under it, the owner of copyright in the collective work is presumed to have acquired only the privilege of reproducing and distributing the contribution as part of that particular collective work, any revision of that collective work, and any later collective work in the same series.

Both sides asked the trial court for summary judgment. The court granted the publishers' request, holding that the collective work privilege conferred by 201(c) was transferable and therefore could be conveyed from the original print publishers to the electronic publishers.

Section 201(c) applied, in the trial court's view, because:

> [T]he electronic technologies not only copy the publisher['s] complete original selection of articles, they tag those articles in such a way that the publisher defendants' original selection remains evident online.

The databases "highlight" the connection between the articles and the print periodicals, the court observed, by showing not only the author and periodical, but also the print publication's particular issue and page numbers.

The authors appealed. And the Second Circuit U.S. Court of Appeals reversed the trial court's decision, granting summary judgment for the authors on the ground that the databases were not among the collective works covered by 201(c), and specifically, were not "revisions" of the periodicals in which the articles first appeared.

In the appeals court's view, the databases effectively eliminated the collective context by providing multitudes of "individually retrievable" articles. The court concluded that the databases might fairly be described as containing "new antholog[ies] of innumerable" editions or publications—but that they did not qualify as "revisions" of particular editions of periodicals.

So, the publishers pressed the case up to the Supreme Court. The high court started by noting that, under the 1976 Copyright Act:

> Copyright protection subsists…in original works of authorship fixed in any tangible medium of expression…from which they can be perceived, reproduced or otherwise communicated.

Moving forward from this assumption, the high court noted that, when a freelance author has contributed an article to a "collective work" such as a newspaper or magazine, the statute recognizes two distinct copyrighted works: "Copyright in each separate contribution to a collective work is distinct from copyright in the collective work as a whole…."

Copyright in the separate contribution "vests initially in the author of the contribution" (in the *Times* case, the freelancer); copyright in the collective work vests in the collective author (the newspaper or magazine publisher) and extends only to the creative material contributed by that author, not to "the pre-existing material employed in the work."

The court pointed out that the 1976 **amendments to the Copyright Act** allowed this conclusion; prior to the 1976 revision, authors risked losing their rights when they placed an article in a collective work. In the 1976 revision, Congress acted to "clarify and improve [this] confused and frequently unfair legal situation with respect to rights in contributions." The amendments recast the copyright as a bundle of exclusive rights—specifically, the rights:

1) to reproduce the copyrighted work in copies or phonorecords;

2) to prepare derivative works based upon the copyrighted work;

3) to distribute copies or phonorecords of the copyrighted work to the public by sale or other transfer of ownership, or by rental, lease or lending;

4) to perform the copyrighted work publicly in the case of literary, musical, dramatic and choreographic works, pantomimes, and motion pictures and other audiovisual works;

5) to display the work publicly in the case of literary, musical, dramatic and choreographic works, pantomimes, and pictorial, graphic, or sculptural works, including the individual images of a motion picture or other audiovisual work; and

6) to perform the copyrighted work publicly by means of a digital audio transmission in the case of sound recordings.

Each of these individual rights "may be transferred...and owned separately."

The high court agreed that Congress' adjustment of the author/publisher balance was a permissible expression of the "economic philosophy behind the Copyright Clause," namely, "the conviction that encouragement

of individual effort [motivated] by personal gain is the best way to advance public welfare." It wrote that, in accord with this change:

> A publishing company could reprint a contribution from one issue in a later issue of its magazine, and could reprint an article from a 1980 edition of an encyclopedia in a 1990 revision of it; the publisher could not revise the contribution itself or include it in a new anthology or an entirely different magazine or other collective work.

Essentially, Section 201(c) adjusts a publisher's copyright in its collective work to accommodate a freelancer's copyright in his or her contribution. If there is demand for an article standing alone or in a new collection, the Act allows the freelancer to benefit from that demand; after authorizing initial publication, the freelancer may also sell the article to others.

The court concluded that, in the Internet age, print collections of reviews, commentaries and news reports prove less popular because of article databases. In fact, it noted that freelance authors had experienced significant economic loss due to a "digital revolution that has given publishers [new] opportunities to exploit authors' works."

One way around all of this would be to use only works made for hire—in which case, the employer or person for whom a work was prepared is the author. But the print publishers in the *Times* case never claimed that status; they didn't do either of the things a publisher must do in order to secure work-made-for-hire status, namely:

1) engage the authors to write the articles as employees; or

2) commission the articles through "a written instrument signed by both parties" indicating that the articles would be considered works made for hire.

Instead, the print publishers rested entirely on the revision and reproduction privileges described in Section 201(c).

On the revision issue, the high court noted that:

The Database no more constitutes a "revision" of each constituent edition than a 400-page novel quoting a sonnet in passing would represent a "revision" of that poem.

On the reproduction issues, the print publishers invoked the concept of "media neutrality" to argue that the "transfer of a work between media" does not alter the character of that work for copyright purposes.

The court agreed. But, unlike the conversion of newsprint to microfilm, the transfer of articles to the databases didn't represent a conversion of intact periodicals (or revisions of periodicals) from one medium to another. The databases offered individual articles, not intact periodicals. In this case, media neutrality seemed to protect the authors' rights in the individual articles to the extent those articles were presented individually, outside the collective work context, through new media.

For the purpose of determining whether the authors' copyrights had been infringed, the Supreme Court suggested that an **analogy to an imaginary library** might be instructive:

> Rather than maintaining intact editions of periodicals, the library would contain separate copies of each article. Perhaps these copies would exactly reproduce the periodical pages from which the articles derive (if the model is GPO); perhaps the copies would contain only typescript characters, but still indicate the original periodical's name and date, as well as the article's headline and page number (if the model is NEXIS or NYTO). The library would store the folders containing the articles in a file room, indexed based on diverse criteria, and containing articles from vast numbers of editions. In response to patron requests, an inhumanly speedy librarian would search the room and provide copies of the articles matching patron-specified criteria.

> Viewing this strange library, one could not, consistent with ordinary English usage, characterize the articles "as part of" a "revision" of the editions in which the articles first appeared. In substance, however, the Databases differ from the file room only to

the extent they aggregate articles in electronic packages (the LEXIS/NEXIS central discs or UMI CD-ROMs), while the file room stores articles in spatially separate files.

The crucial fact was that the databases, like the hypothetical library, stored and retrieved articles separately within a vast domain of diverse texts. Such a storage and retrieval system effectively infringed on the authors' **exclusive right to control the individual reproduction and distribution** of each article.

The print publishers also warned the Supreme Court that a ruling for the authors would have "devastating" consequences. A ruling for the authors would "punch gaping holes in the electronic record of history." They offered the testimony of experts like TV documentarian Ken Burns to support this argument. The court, however, dismissed this argument, noting that authors and publishers—or courts and Congress, if necessary—could negotiate a way to retain digital archives and make sure freelancers are paid fairly.

In general, the court ruled that the publishers' view that inclusion of the articles in the databases lay within the "privilege of reproducing and distributing the [articles] as part of…[a] revision of that collective work" was unacceptable. The databases did not reproduce and distribute articles "as part of" either the original edition or a "revision" of that edition. The articles could be viewed as parts of a new compendium—namely, all the works in the database.

Furthermore, the articles in the databases could be viewed "as part of" no larger work at all, but simply as articles presented individually. That each article bore marks of its origin in a particular periodical suggested only that the article had previously been part of that periodical—not that the article was currently reproduced or distributed in the periodical.

If the compendium issue was hazy, the individual article issue was clear: The reproduction and distribution of individual articles—simply as individual articles—would invade the core of the authors' exclusive rights.

So, the Supreme Court concluded:

> that 201(c) does not authorize the copying at issue here. The publishers are not sheltered by 201(c), we conclude, because the databases reproduce and distribute articles standing alone and not in context, not "as part of that particular collective work" to which the author contributed....

> The Electronic Publishers infringed the Authors' copyrights by reproducing and distributing the Articles in a manner not authorized by the Authors and not privileged by 201(c). We further conclude that the Print Publishers infringed the Authors' copyrights by authorizing the Electronic Publishers to place the Articles in the Databases and by aiding the Electronic Publishers in that endeavor.

It was a win for freelance writers...though not as big a win as some legal commentators trumpeted at the time. As the court itself noted, publishers were free to amend their standard agreements to cover reproduction in digital databases. Most publishers promptly did that.

Licenses

Reading this book might leave you with the impression that copyrighted material can never be used by anyone other than the person who creates it. Of course, the opposite is true. Copyrights are designed to be **assigned**, **licensed** or **transferred**—and to make sure the owners get paid.

The October 1990 federal district court decision *Broadcast Music, Inc., et al. v. Jeep Sales & Service Co. d/b/a Haynes Jeep, et al.* illustrates how standard popular music licenses work.

Broadcast Music, Inc. (known commonly as BMI) is the company which enforces music copyrights for most of America's largest record companies. BMI has the authority to license the public performance rights to nearly two million musical compositions.

The Value of a Good Idea

> BMI's main competition in the music rights enforcement business is the American Society of Composers, Authors and Publishers (ASCAP). The two firms take similar actions. The main difference between them is that BMI primarily represents record companies while ASCAP primarily represents artists.

Most consumers know that the music they hear in stores, malls and other retail outlets is chosen and organized carefully. In most cases, it's designed to make shoppers feel happy and to loosen their grip on their pocketbooks. Some retailers pay big money for carefully planned music packages; others simply play local radio stations through sound systems. In either case, they are supposed to pay a license fee to BMI—which then distributes the money among its member companies.

In order to make sure that companies pay when they use the music, BMI sends investigators out to listen to what companies play. In December 1989, BMI investigator Philip Neff visited Haynes Jeep. While inside the dealership, Neff listened to the broadcast of "oldies" radio station WVGO-FM piped in on at least four speakers in the ceiling. The station was also playing on at least four public address horns mounted on light poles outside on the lot.

Neff made a written report of the musical compositions he heard that included "I Get Around," "I Thank You," "It's the Same Old Song" and "Groovy Kind of Love."

BMI contacted Haynes Jeep in writing, reminding the dealership that the use of the music to entertain customers represented an unauthorized public performance of copyrighted material. BMI advised Haynes Jeep that a license was required to play the music; and it suggested one of several standard license agreements. Haynes Jeep did not respond to the letters or comply with BMI's request.

BMI—as the representative of several holders of copyrights to the songs heard at the dealership—sued Haynes Jeep in a Richmond, Virginia fed-

eral court for publicly performing musical compositions without the consent of the holders of the copyright.

Rather than just settling with BMI, Haynes Jeep made the dubious decision to attempt a bizarre, quasi-constitutional argument in court. It questioned whether BMI and its member companies actually held valid copyrights to the musical compositions in question. And it asked the court to dismiss BMI's suit.

The court refused.

Technically, BMI's lawsuit was a copyright infringement claim. In order to make its case, BMI had to establish five elements in regard to the songs in question:

1) the originality and authorship of the songs involved;

2) the company's compliance with the formalities of the Copyright Act;

3) its proprietary rights in the copyrighted works involved;

4) evidence of a public performance of the compositions involved; and

5) the lack of authorization for the public performance.

The first four elements were undisputed, so the court focused on the fifth issue—Haynes Jeep's alleged lack of authorization for the public performance of the songs.

According to the Copyright Act, the term *perform* is defined as "to recite, render, play, dance or act…either directly or by means of any device or process… ." So, an individual is considered performing whenever he or she plays a phonorecord embodying the performance or turns on a receiver that does the same.

The definition of *publicly* is more complicated, however. To qualify as public under the Act, a performance must:

1) take place at a place open to the public or at any place where a substantial number of persons outside of any normal circle of a family and its social acquaintance is gathered; or

2) be transmitted or communicated where specified by clause or to the public through any device or process.

Haynes Jeep clearly fell within these definitions.

Sensing rightly that it was losing the case, Haynes Jeep changed the focus of its argument to the Copyright Act's **exemption for small businesses** (sometimes called a "home system" exemption). The exemption applies to any communication of a transmission embodying a performance received on a single receiving apparatus of the type that is usually used in a private home.

This exemption traces back to the 1975 U.S. Supreme Court decision *Twentieth Century Music Corp. v. Aiken.* In that case, the Supreme Court determined that a small fast food restaurant did not violate the Copyright Act by playing a radio station to entertain its customers. The restaurant had only 620 square feet open to the public, and the broadcasting system consisted "of a home receiver with four ordinary loudspeakers grouped within a relatively narrow circumference from the set...."

While the *Twentieth Century* decision has been influential, courts have been unwilling to apply the exemption to situations where the public space is larger than in the *Twentieth Century* case, and where the receiving equipment used is of a commercial nature.

Within this framework, the actions of Haynes Jeep went beyond the limit of the exemption. It had infringed BMI's copyrights.

The court awarded BMI statutory damages of $500 for each of the 17 proven copyright infringements, stating specifically that Haynes Jeep's repeated failure to respond to BMI's warnings had influenced the amount of the award. The court also ordered Haynes Jeep to pay BMI's attorneys' fees.

In addition, the court issued an injunction barring Haynes Jeep from playing radio broadcasts over loudspeakers that might infringe upon BMI's copyrighted material.

Terminating a Transfer Agreement

Since most copyright licenses or assignments take place by contract (either express or implied), disputes sometimes involve the termination or assignment of those contracts. And, since contracts take place in the world of business rather than law school seminars, they're sometimes messy.

The March 1999 Seventh Circuit U.S. Court of Appeals decision *Paul L. Walthal, et al. v. Corey Rusk d/b/a Touch and Go Records, et al.* provides a good example of a rights transfer done on a handshake that ended up…messy.

Paul Walthal, Gibson Haynes and Jeffrey Coffey comprised the rock band the Butthole Surfers. In 1984, they entered into an agreement with Corey Rusk, who ran a company that eventually became Touch and Go Records. Under the agreement, Touch and Go was granted the nonexclusive right to manufacture and sell copies of the Butthole Surfers' musical performances in return for a 50 percent share of the net profits.

The band and Touch and Go never got around to writing up their deal. So, what existed between them was an **oral licensing agreement** between the parties that had no specified duration. It did not set out any circumstances under which the parties would have a right to terminate the oral contract.

The band provided Touch and Go with six recorded performances and one video performance to manufacture and sell.

In December 1995, the Butthole Surfers were riding an unexpected rise in popularity and demanded that the agreed 50/50 split be changed to a more favorable (for them) 80/20 split. And that the agreement terminate in three years. Touch and Go responded—this time, in writing—that it considered the parties bound by the original agreement. A few days later, the band sent a letter terminating the agreement effective immediately and demanding a return of inventory. Touch and Go ignored the notice and continued to copy and sell the performances. So, the Butthole Surfers called their lawyers.

The federal district court determined that the band's termination of the licensing agreement was effective and, accordingly, that Touch and Go was guilty of infringement.

Touch and Go appealed, making two arguments. First, it argued that the licensing agreement was irrevocable because it had paid the band the consideration that they were due—the 50 percent share of the profits. Second, it argued that termination of the agreement was prohibited by the Copyright Act. Specifically, Touch and Go argued that the law prohibits the termination of a copyright license—including one of unspecified duration arising out of an oral agreement—prior to 35 years from the date the license was granted.

The appeals court rejected Touch and Go's first argument...but agreed to consider its second in detail.

Section 203 of the federal Copyright Act provides that a "grant of a transfer or license of copyright or of any right under a copyright...is subject to termination" under certain conditions. The law states that such a grant may be terminated at any time during a period of five years beginning at the end of 35 years from the date the transfer became effective.

The appeals court itself admitted that this was confusing. The problem lay in the question of whether the law intended to establish 35 years as a minimum or maximum term of an open-ended transfer.

There wasn't much precedent on this issue; and what was available was controversial. Some courts had ruled that, unless a transfer states otherwise, it can't be terminated for 35 years. Legal experts deplored this conclusion, noting that such decisions turned protection for authors into a way to acquire rights for an unfairly long term.

According to the appeals court hearing the Butthole Surfers' case, the time had come to "take a fresh look at Section 203, putting the statute in context." The purpose of Section 203, wrote the court, was to give authors and their heirs a **second chance to market works** even after a transfer of rights had been made. This is particularly important because often it is not clear, when a work is new, how valuable it will prove to be.

For example, when Richard Berry, a small-time performer in the mid-1950s, sold the publication rights to his song "Louie, Louie" for $750, he had no idea that it would reemerge in the early 1960s as a monster hit. The Kingsmen recorded "Louie, Louie" and, despite (or maybe because of) its slurred lyrics, it soon became a raucous rock anthem. Hundreds of artists—from Bruce Springsteen to Otis Redding—have sung it and, all the while, the song earned untold millions of dollars for producers and performers other than Berry.

In drafting Section 203 of the Copyright Act, Congress intended to safeguard "authors against unremunerative transfers." This was necessary because authors are traditionally at an economic disadvantage when bargaining with a publishing company. So, the appeals court concluded, Section 203 meant that—if an author grants a license for the life of the copyright or for some long period of time—he can nevertheless terminate the license after 35 years and **look around for a better deal**.

The appeals court said that Section 203 was not intended to extend the duration of a transfer made for a period of less than 35 years. Hence, it made no sense that a 35-year period be considered a minimum under the statute. The court also disagreed with the conclusion that, if an agreement contains no termination date, it must continue for 35 years. When a contract is silent as to its length, it is implicit that either side can terminate it, the court ruled.

According to the appeals court, the Butthole Surfers' letter of December 1995 did what it set out to do: It rendered the license agreement *kaput*.

Authors and Their Spouses

The stereotype of an author is someone who lives an unconventional life; and enough writers, artists and performers make messes of their lives outside of their work that the stereotype seems to have some element of truth to it. On the business side of art, *la vie boheme* can create some problems in the courtroom. The October 1987 California Appeals Court decision *Susan M. Worth v. Frederick L. Worth* shows how convoluted

the transfer of a copyright can be…when it's related to the end of a marriage.

Susan and Frederick Worth were getting divorced. During their marriage, Frederick had written several published books, including two books on trivia: *The Complete Unabridged Super Trivia Encyclopedia* (1977) and *The Complete Super Trivia Encyclopedia, Volume II* (1981). The couple agreed to split the royalties from the books equally after their marriage was dissolved.

In 1984, Frederick decided to sue…no, not his ex-wife, but the producers of the board game "Trivial Pursuit." He alleged that the makers of the game had infringed on his copyright by plagiarizing certain questions used in the board game from his books.

When Susan heard the news, she sought an order from the superior court declaring that she would be entitled to half of any proceeds derived from the lawsuit, based on the **terms of the divorce**. The trial court granted Susan's request and ordered Frederick restrained from disbursing the proceeds of any verdict or settlement until Susan's claim was resolved.

Frederick appealed.

While the appeal was pending, the federal district court ruled that Trivial Pursuit had not infringed on Frederick's copyright, and the decision was affirmed on appeal. Frederick informed the court that he intended to pursue further appeals; the court agreed to consider whether the order giving Susan the right to half the proceeds should stand.

Frederick argued that the Copyright Act specifically "vests [copyright] initially in the author or authors of the work." Thus, he argued, the copyright belongs only to the author.

The court disagreed. It pointed out that all property acquired during marriage is **community property**. This applies to rights in any artistic work created during the marriage. The fact that Frederick alone authored the trivia books did not matter in this case, because the principles of community property law do not require joint or qualitatively equal efforts or contributions by both partners in acquiring the property.

Hence, said the court, if an artistic work is community property, then it must follow that the copyright itself enjoys the same status. Under copyright legislation, a copyright automatically belongs to the author when the expression of the work takes place. Still, since Frederick's copyrights and related tangible benefits were considered community property, the copyright was automatically transferred to both spouses by the California law of community property. The court concluded:

> The fact that a copyright is intangible property will not affect its community character or the community nature of any tangible benefits directly associated with the copyright.

Frederick argued that the divorce agreement intended to divide only the royalties from the books and not the copyrights. Without these rights, Susan would have no claim to share any proceeds arising from infringement of the statutory right to the exclusive use of the books to prepare derivative works.

However, said the court, Frederick's argument failed to take into account the **community nature of the copyrights**. Although the divorce agreement divided only the future book royalties, the intangible copyrights were property interests acquired during the marriage; so, Susan would be entitled to share in all of the proceeds, including any settlement or award of damages resulting from a copyright infringement.

Frederick suggested that under the patent and copyright clause of the Constitution, copyright protection couldn't be extended to anyone but the author. However, according to the court, the term author, within the constitutional text, may include the author's spouse under the principles of co-ownership or transferred ownership.

The court took care to point out that the intangible property of a copyright is different from other intangible things, such as a law school education which became the subject of a separate case. In that case, the court had reasoned that classification of a legal education—represented by a law degree—as a "community" asset would run counter to settled community property principles by requiring division of post-divorce earnings that, by definition, constitute the property of the acquiring spouse.

Copyright is fundamentally different, said the court, because a copyright has a present value based upon value of the underlying artistic work. Its value normally would not depend on the postmarital efforts of the authoring spouse. In short, the court concluded that a copyright on a literary work produced during the marriage is **as much a divisible community asset as the underlying artistic creation itself**.

In the end, the court concluded that the copyrights on the trivia books constituted divisible community assets. Frederick and Susan—while no longer bound together by their vows—remained joint owners of an undivided interest in the copyrights of the trivia books.

Conclusion

As this chapter has shown, there a several permutations to author issues and copyright law. Each case carries its own set of circumstances and evidence, which calls for courts to make decisions on a case-by-case basis. Foremost among the issues related to copyright is infringement. In this next chapter we'll uncover a variety of infringement situations and see how the courts have awarded—or not rewarded—damages to alleged copyright owners.

CHAPTER 3:
COPYRIGHT INFRINGEMENT

"Thou shalt not steal" has been an admonition followed since the dawn of civilization. Unfortunately, in the modern world of business, this admonition is not always followed. If the number of lawsuits filed every year is any indication, copyright infringement is one of most prevalent forms of theft in this **information-based economy**.

Companies or people accused of copyright infringement may argue that "stealing ideas" is rampant in business and, for that reason, their conduct is excusable…or, at least, justifiable. But the Seventh Commandment is a big part of copyright law. And stealing copyrighted material is illegal.

This chapter deals with the main violation of a copyright, namely, infringement. What does infringement mean? When does it happen? What happens after it occurs?

The Mother of All Infringement Disputes

There's probably no better copyright infringement case for the Internet economy than the dispute that made the news in early 2001. The March 2001 Federal Appeals Court decision *A&M Records, Inc. v. Napster, Inc.* summed up various issues neatly (well, as neatly as they can be summed up) in one lawsuit.

On March 5, 2001, the United States Court of Appeals for the Ninth Circuit ordered Napster to stop copying, downloading, uploading, trans-

mitting and distributing copyrighted sound recordings. This restriction was to remain in effect until a final ruling on the case was issued; it effectively put Napster out of business—at least in its original configuration. The injunction also ended a frenzied period during which some Internet enthusiasts had breathlessly predicted that the "Napster model" would change the nature of copyrights.

It didn't. But why did some people think it would?

Napster was an Internet service; through a process known as "peer-to-peer" file sharing, the service made trading songs stored in digital format easy. Specifically, Napster allowed users to:

1) make music files stored on individual computer hard drives available for copying by other Napster users;

2) search for those music files stored on other users' computers; and

3) transfer exact copies of the contents of other users' files from one computer to another via the Internet.

The service, similar in many ways to e-mail, relied on songs stored in the MPEG version 3 format—also called MP3 files.

The MP3 format had been around for a while. Its origins traced back to 1987, when the Moving Picture Experts Group set a standard file format for the storage of audio recordings in a digital format.

Napster didn't have anything to do with the development of the MP3 format. Its genius was in making MP3 files easy to use.

Napster's peer-to-peer software, called MusicShare, was available free of charge on Napster's Internet site. Once a user had installed Napster's software, he was asked to create a "user name" and password to gain access to the Napster system. A registered user could post a list of MP3 files stored in his computer's hard drive for others to access. If the files were in the correct MP3 format and stored in a recognizable directory, the names of the files (but not the files themselves) would be uploaded to the Napster servers every time the user logged on.

Once uploaded to the Napster servers, the MP3 file names were listed in a server-side library under the user's name and became part of a collective directory of files available for transfer. Then, a user could locate other users' MP3 files in two ways: 1) through Napster's search function; and 2) through its hotlist function.

Napster's servers maintained a real-time "search index" of the collective directory, which an individual user could access via a form in the MusicShare software. The user could enter either the name of a song or an artist. Napster's server would then compile a list of all file names pulled from the search index that included the search terms.

Again, the Napster server did not search the actual contents of an MP3 file; the search was limited to a text search of the file names indexed in a particular group. Those file names might contain typographical errors or otherwise inaccurate descriptions of the content of the files since they were designated by other users—and not Napster.

To use the hotlist function, a user would create a list of other users' names from whom he has obtained MP3 files in the past. When logged onto Napster, the system alerted the user if any hotlisted user was also logged onto the system. If so, the user could access an index of all MP3 file names in a particular hotlisted user's library.

To transfer a copy of an actual MP3 file, the Napster server software would obtain the Internet address of the requesting user and the Internet address of the user with the available files. The server would then communicate the host user's Internet address to the requesting user. The requesting user's computer uses this information to establish a connection with the host user and downloaded a copy of the contents of the MP3 file from one computer to the other over the Internet, "peer-to-peer."

A downloaded MP3 file could be played directly from the user's hard drive using Napster's MusicShare program or other software. The file could also be transferred back onto an audio CD if the user had access to equipment designed for that purpose.

The Value of a Good Idea

In less than two years of operation, Napster had become a major threat to established record companies. Its system meant free music was easy to find with a computer, a modem and half an hour to spend getting set up. Several record companies had taken legal shots at Napster, but it had insisted that the peer-to-peer nature of its music swapping kept it an arm's length from copyright infringement.

The case that stuck hardest was **A&M Records, Inc.'s copyright infringement complaint**. According to A&M, Napster users engaged in the wholesale reproduction and distribution of copyrighted works, all constituting direct infringement. The district court agreed, determining that "as much as 87 percent of the files available on Napster may be copyrighted...."

Following the standard rules of a copyright infringement case, the court instructed A&M that it had to provide to Napster detailed information related to the alleged infringement, including:

1) the title of the infringed work;

2) the name of the artist performing the work;

3) the name(s) of the files on Napster containing such work; and

4) a certification that A&M owns or controls the rights to the allegedly infringed music.

Arguably, the ruling imposed a heavy burden on A&M. The record company voiced some concerns about the difficulty involved in identifying the infringing files on the Napster site, given the transitory nature of its operation. The court agreed and ordered Napster to search the files available on its system against lists of A&M's copyrighted recordings.

In its defense, Napster argued that its users did not directly infringe A&M's copyrighted works because the users are engaged in **fair use** of the material. Napster identified three specific alleged fair uses:

1) sampling, where users make temporary copies of a work before purchasing;

2) space-shifting, where users access a sound recording through the Napster system that they already own in audio CD format; and

3) permissive distribution of recordings by both new and estab-lished artists.

The district court, however, noted that **sampling is a commercial use** even if some users eventually purchase the music. It noted that free pro-motional downloads are highly regulated by record companies and the companies collect royalties for song samples available on retail Internet sites. And, the so-called "free" downloads provided by the companies usually consisted of 30 to 60-second excerpts of songs. In comparison, Napster users downloaded a full, free and permanent copy of the recording.

Next, the district court conducted a general analysis of the Napster sys-tem and concluded that its users didn't engage in any other sort of fair use of the copyrighted materials. According to the court, users engaged in commercial use of the copyrighted materials largely because:

> Napster users get for free something they would ordinarily have to buy [and] a host user sending a file cannot be said to engage in a personal use when distributing that file to an anonymous re-quester.

Or thousands of anonymous requesters.

The district court concluded that:

> Without the support services [Napster] provides, users could not find and download the music they want with the ease of which [Napster] boasts. [T]he evidence establishes that a majority of Napster users use the service to download and upload copy-righted music.... And by doing that, the uses constitute direct infringement of [A&M's] musical compositions, recordings.

A&M proved that Napster users infringed at least two of the copyright holders' exclusive rights. Napster users who uploaded file names to the search index violated A&M's distribution rights; users who downloaded files containing copyrighted music violated A&M's reproduction rights. And Napster contributed to these abuses.

What's more, Napster had a direct financial interest in the infringing activ-ity. Its future revenue was directly dependent upon increases in user base.

The Value of a Good Idea

The district court held that a preliminary injunction against Napster's participation in copyright infringement was not only warranted but required. It ordered Napster to prevent the downloading, uploading, transmitting and distributing of the noticed copyrighted sound recordings.

Napster appealed, claiming that the trial court didn't properly recognize its fair use arguments. The appeals court wasn't sympathetic. It upheld the trial court's conclusions:

> We agree that if a computer system operator learns of specific infringing material available on his system and fails to purge such material from the system, the operator knows of and contributes to direct infringement.

Napster provided the "site and facilities" with which direct copyright infringement occurred. And Napster's conduct confirmed this conclusion.

There was a lot of circumstantial evidence that proved Napster knew it was enabling infringement; and there were at least two pieces of direct evidence. The direct evidence included:

- a document authored by Napster co-founder Sean Parker mentioned "the need to remain ignorant of users' real names and IP addresses 'since they are exchanging pirated music'"; and

- documents showing that the Recording Industry Association of America (RIAA) had informed Napster of more than 12,000 infringing files, some of which were still available on the system when the court wrote its decision.

Next, Napster argued that the trial court should have awarded damages or imposed a constructive royalty payment structure instead of an injunction. The appeals court rejected the argument sharply:

> Imposing a compulsory royalty payment schedule would give Napster an "easy out" of this case. If such royalties were imposed, Napster would avoid penalties for any future violation of an injunction, statutory copyright damages and any possible criminal penalties for continuing infringement. The royalty structure would

also grant Napster the luxury of either choosing to continue and pay royalties or shut down. On the other hand, the wronged parties would be forced to do business with a company that profits from the wrongful use of intellectual properties…[and those parties] could not make a business decision not to license their property to Napster.

After slamming Napster so strongly, the appeals court did make a couple of small concessions.

First, it ruled that the scope of the trial court's injunction needed modification. Specifically, it made any finding of contributory liability conditional on proof that Napster continued the forbidden behavior.

The appeals court also ruled that the trial court's injunction went overboard because it placed on Napster the entire burden of ensuring that no "copying, downloading, uploading, transmitting or distributing" of A&M's works occurred. Instead, the appeals court placed the burden on A&M to provide notice to Napster of copyrighted works available on Napster before Napster was required to disable access to the offending content.

Napster, however, also had to **police the system**. This was not as clearcut and simple as it sounded because the files were user named, and Napster's system was allowed to access users' MP3 files. It would have been tricky and difficult to police such an enormous, intricate system.

To date, both sides are still battling over the issue of how to police Napster before a federal appeals court. For all practical purposes, the case ended the Napster service that became so popular in 1999 and 2000. A fee-based membership service model may emerge from the company sometime in the future.

Licenses and Infringement

Because copyrights are transferred more often than other types of intellectual property, it's not always clear who owns what.

The Value of a Good Idea

These confusing issues often come together in a business context that may surprise some people: rap music. One of the most distinctive elements of rap music, which boomed during the 1990s, is that it relies heavily on "sampling"—copying snippets of classic songs to form new ones. In fact, the major record companies have even developed standard license agreements, which allow their rap acts to use old songs legally.

But not every rap act is affiliated with a major record label…so some problems occur. The December 1991 Federal Court decision *Grand Upright Music Ltd. v. Warner Brothers Records, Cold Chillin' Records, et al.* dealt with a case of infringing use. This case rendered all sampling suspect, and **scared record label companies**.

The Biz Markie album *I Need A Haircut* included the rap song "Alone Again," which used three words and a portion of the music from the song "Alone Again (Naturally)" composed and recorded by Gilbert O'Sullivan. Basically, Biz Markie used a digital sample of a short chorus from O'Sullivan's popular song.

Grand Upright Music brought action for preliminary injunction against Marcel Hall—Biz Markie's real name—and his record company, based on copyright infringement.

Biz Markie's lawyers claimed that the whole mess had started because it wasn't clear who owned the copyright to the original song. The original copyright was owned by NAM Music, Inc.; but that company had long been dissolved. The lawyers claimed they weren't able to locate the successor owner. And, in a limited sense, they were right: The transfer of copyright ownership from NAM Music to Grand Upright hadn't been filed formally with the PTO.

However, various documents offered into evidence showed that Grand Upright had assumed ownership of the copyrights. And Gilbert O'Sullivan—the composer, lyricist and first performer of the song—testified that Grand Upright Music was the owner.

Biz Markie's camp should have known this. Prior to the release of the album, they'd apparently discussed among themselves the need to obtain

a license. They decided to contact O'Sullivan and wrote to his agent, enclosing a copy of the tape. The letter stated:

> This firm represents a recording artist professionally known as Biz Markie, who has recorded a composition for Cold Chillin' Records entitled "Alone Again" which incorporates portions of the composition entitled "Alone Again Naturally" originally recorded by Gilbert O'Sullivan (the "Original Composition"). Biz Markie would like to obtain your consent to the use of the "Original Composition."

In writing this letter, Biz Markie's crew knew that it was necessary to obtain a license—sometimes called a "clearance"—from the holder of a valid copyright before using the copyrighted work in another piece. In fact, Warner Brothers Records had a department set up specifically to obtain such clearances.

Biz Markie's attorneys also knew of this obligation. In fact, they had sent a letter to counsel for Cold Chillin' Records, that read in part:

> In light of the fact that Cold Chillin' knew that other sample clearance requests were pending at that time, it follows that Cold Chillin' should have known that similar denials of permission by rightsholders of other samples used on the album might be forthcoming, for which similar action would have been appropriate.

Nevertheless, Cold Chillin' elected to release the album and single (through Warner Records), perhaps with the thought that Biz Markie would personally have to resolve any **problems related to sampling**.

Biz Markie's lawyers insisted otherwise. They argued that any legal action connected to the sampling did not arise from the fact that Biz Markie used the samples—but from the fact that Cold Chillin' released the record prior to the appropriate clearances being secured.

But the court wasn't up for the finger-pointing. It was inclined to find all of them at fault:

The defendants knew that they were violating Grand Upright Music's rights as well as the rights of others. This callous disregard for the law and for the rights of others requires not only the preliminary injunction, but also sterner measures.... The argument suggested by the defendants that they should be excused because others in the "rap music" business are also engaged in illegal activity is totally specious. The mere statement of the argument is its own refutation.

According to the district court, Grand Upright Music owned a valid copyright that was infringed by Biz Markie's partial incorporation of the copyrighted piece. The application for the preliminary injunction was granted. Biz Markie—and his record label—were barred from selling the album and the single. The case was also referred to the U.S. Attorney General's office for possible criminal prosecution. And Biz Markie had to cough up $250,000 to make amends with the angry court.

Direct vs. Secondary Infringement

The owner of a copyright must satisfy two requirements to present a *prima facie* case of direct infringement:

1) he must show ownership of the allegedly infringed material; and

2) he must demonstrate that the alleged infringers violate at least one exclusive right granted to a copyright holder.

Beyond that, there is **secondary infringement**, in which someone—with knowledge of the infringing activity—"induces, causes or materially contributes to the infringing conduct" of another. Put differently, secondary liability exists if someone engages in "personal conduct that encourages or assists the infringement." That *someone* may be held liable as a contributory or secondary infringer.

A caveat: Secondary liability for copyright infringement only exists when direct infringement by a third party can be proven.

The 1995 Federal Court decision *Religious Technology Center v. Netcom Online Communication Services* suggested that, in an online context, evidence of actual knowledge of specific acts of infringement is required to hold a computer system operator **liable for contributory copyright infringement**.

Netcom considered the potential contributory copyright liability of a computer bulletin board operator whose system supported the posting of infringing material. The court, in denying Netcom's motion for summary judgment of noninfringement, found that a disputed issue of fact existed as to whether the operator had sufficient knowledge of infringing activity.

The court determined that for the operator to have sufficient knowledge, the copyright holder must "provide the necessary documentation to show there is likely infringement." If such documentation was provided, the court reasoned that Netcom would be liable for contributory infringement because its failure to remove the material "and thereby stop an infringing copy from being distributed worldwide constitutes substantial participation" in distribution of copyrighted material.

Infringement Damages

An award of damages in a copyright infringement case serves two purposes. It compensates the owner for the infringement of its copyrights while, at the same time, serving as a deterrent by punishing the infringer for its unlawful conduct. When determining the appropriate level of damages, a court will consider a number of factors, including the expenses saved and the profits earned by the infringer, the revenues lost by the owner and the infringer's state of mind. It's often the blameworthiness of the infringer that weighs heaviest in the court's analysis.

An injunction or injunctive relief—that is, a court **order prohibiting unlawful behavior**—can accomplish even more. Owners in copyright infringement suits often ask courts to issue injunctions to stop disputed business while a lawsuit grinds on. Courts are cautious about doing this.

The Value of a Good Idea

Federal law requires owners to post a bond for damages incurred by the enjoined party in the event that the injunction turns out to have been wrongfully issued. This causes a lot of problems—both the alleged infringer and the copyright owner often complain about the amount of the bond required by the court.

An award of **reasonable attorneys' fees and costs** tends to be the rule rather than the exception in actions for copyright infringement.

The March 1994 Federal Appeals Court decision *Wildlife Express Corp. v. Carol Wright Sales, Inc.* laid out the basic terms of how damages and legal fees are assessed in a copyright infringement case.

Indiana-based Wildlife Express made and sold children's duffel bags adorned with soft sculptured animal heads and tails; the bags were made to resemble bears, pandas, ducks and elephants. Wildlife obtained registered copyrights for the soft sculptures on the bags, which were called "Critters in a Carrier."

Delaware-based Carol Wright, a mail-order retailer that purchases products from suppliers and offers them for sale through catalogs, marketed four similar duffel bags with plush heads and tails. These bags came in the forms of a bear, panda, duck and elephant, and were marketed under the name "Precious Pet Duffel Bags."

The bags were enough alike that someone was bound to call a lawyer.

The story started in 1986. That year, Wildlife Express exhibited its bags at the American International Toy Fair in New York City. Jackson Lin, who owned a toy manufacturer based in Taiwan, stopped by Wildlife Express's booth and carefully examined the bags. In fact, Lin spent so much time looking at the bags that Wildlife Express employees noticed—and were concerned.

Wildlife Express President Stephen Janney introduced himself to Lin, who promptly offered to manufacture the bags cheaply. Janney declined the offer and escorted Lin away from the booth.

Months later, Carol Wright CEO Robert Ginsberg visited Lin's showroom in Taiwan to discuss production of various toys that Carol Wright would sell in the U.S. Following the visit, Carol Wright's senior buyer made arrangements to market the Precious Pet Duffels, which were made by one of Lin's companies. Carol Wright offered the Precious Pet Duffels for sale in 1987.

In May 1987, Wildlife Express employees saw the duffels advertised in Carol Wright's catalog. After his experience at the New York trade show, Wildlife Express President Janney had a strong suspicion of where the duffels were made. Instead of confronting Carol Wright directly, he approached the U.S. Customs authorities.

In October 1988, Carol Wright received a notice from the U.S. Customs Service that its panda duffel bags infringed a copyright owned by Wildlife Express. The next month, however, the Customs Service canceled the notice because Wildlife Express failed to post the bond that was required to contest Carol Wright's shipment as violative of its copyright.

But Wildlife Express still intended to do something. In February 1989, it sent Carol Wright a letter requesting damages for copyright infringement of the duffel bags. Carol Wright denied the claim but said it would discontinue the bags when it sold through its existing inventory. This wasn't a good enough deal for Wildlife Express, which proceeded with a lawsuit.

The federal trial court acknowledged that Wildlife Express owned valid copyright registrations for the duffel bags. After examining the disassembled pattern pieces of both the Critters and Precious Pets, the court determined that Carol Wright's bags were substantially similar to Wildlife Express's bags. It determined that an "**ordinary observer**" comparing the duffel bags would regard their aesthetic appeal as identical. This allowed the conclusion that Carol Wright unlawfully appropriated Wildlife Express's work and infringed on its copyrights.

According to the court, Carol Wright's failure to conduct a check on copyrights amounted to reckless disregard. And the company's continued sales after Wildlife Express's letter and subsequent suit claiming infringement

constituted willful infringement. The court set damages at $50,000 for each of the three copyright infringements.

Carol Wright challenged the district court's findings. The company asserted that the copyright protection over generic animal heads and tails, with very little originality of expression, was too narrow.

After side-by-side comparisons of the bears, ducks and elephants, the appeals court agreed with the district court. It noted that the Copyright Act does not require identical copying, only substantial similarity. Carol Wright's main defense was that it didn't even know that Wildlife Express existed—and that, if there was any infringement, Jackson Lin was responsible. Although Lin indicated that he was "amazed" that there was a copyright problem, he did not offer proof that his design was of independent origin.

The appeals court didn't buy any of this. It concluded that, after Carol Wright was aware of Wildlife Express's claim to a copyright covering the Precious Pet Duffel Panda, the catalog company **failed to inquire** about the Wildlife Express copyrights. According to the court, this amounted to reckless indifference. It also ruled that Carol Wright's continued sales after Wildlife Express's letter and lawsuit were clear instances of willful infringement. The willfulness was a critical point, because it meant that Carol Wright would have to pay Wildlife Express's legal fees.

According to the testimony of its CEO, Carol Wright did not conduct patent and copyright searches but was willing to risk possible infringement and subsequent payment for infringement as a "cost of doing business."

Specifically, that cost would be three times $50,000 plus legal expenses.

Willful Infringement

When determining an appropriate amount to award in a case involving willful infringement, the court considers **compensation and deterrence**. In particular, when there appears to be significant merit to the copyright

owner's case, the court focuses its analysis on whether the alleged infringer was acting intentionally, willfully or in bad faith.

The Copyright Act permits an increased statutory damage award of up to $50,000 for willful infringement. The Act does not define "willful"; its determination is left up to the courts.

Case law establishes that a finding of willfulness is justified "if the infringer knows that its conduct is an infringement or if the infringer has acted in reckless disregard of the copyright owner's right."

Therefore, in determining whether the violation was willful, a court may consider evidence that the defendant ignored the plaintiff's notices about copyright protection (as in the last case), did not seek advice of an attorney and passed the matter off as a nuisance.

A **letter informing a person or company of possible infringement** clearly provides notice. When questions concerning the quality of the notice of infringement arise, the court must determine the weight that ought to be accorded to the notice in deciding whether the violation was willful.

The July 2000 Federal Court decision *Harry Palmer v. John Slaughter* dealt with the details of how copyright infringement damages work.

Harry Palmer was an educational psychologist who'd created a program known as AVATAR—a nine-day course that "teaches individuals how to effect positive changes in their lives through the management of their beliefs." He filed copyrights and registered trademarks protecting the AVATAR course.

So-called "masters," who led participants through a series of self-awareness exercises, taught the AVATAR course. The exercises—which were themselves copyrighted—were only disseminated to the masters, who signed agreements to keep the materials confidential. Some of the exercises were also disseminated to participants; these individuals also signed confidentiality agreements and agreed to return their course materials after the seminar ended.

The Value of a Good Idea

In May 1999, John Slaughter—who had, apparently, taken the AVATAR course—posted an advertisement on the Internet offering AVATAR course materials for $100.

Palmer contacted Slaughter and asked him to stop his activities. Although Slaughter promised to do so, he kept selling the materials through an anonymous e-mail address and continued to post ads on at least two different Web sites.

In November of 1999, Palmer learned of these new activities and again asked Slaughter to **cease and desist**. Slaughter responded with an e-mail, admitting that "posting the course materials…was wrong." However, he refused to remove the ads; in fact, he made them available for free download from the Internet.

In December 1999, Palmer sued Slaughter for copyright and trademark infringement. Palmer sought monetary and injunctive relief in addition to reasonable attorneys' fees and costs.

Palmer contacted the operators of the Web sites containing Slaughter's posts and requested that the materials be removed. The sites complied. Nevertheless, for approximately one month, anyone could download the AVATAR works for free.

In his suit, Palmer alleged copyright and trademark infringement as well as unfair competition. Primarily, he sought an injunction to prohibit the further dissemination of his materials. Although Slaughter was served with a summons and a copy of the complaint, he failed to respond.

Palmer requested the maximum amount of statutory damages for the infringement of his copyrighted materials—$150,000 per each of two works—in addition to monetary damages for the eight instances of alleged trademark infringement. He also sought to recover reasonable attorneys' fees and costs.

At a hearing in May 2000, the court determined that Palmer was entitled to an injunction prohibiting Slaughter from possessing or using anything related to AVATAR and the following **money damages**:

1) statutory damages in the amount of $20,000 for the infringement of Palmer's copyrights;

2) damages in the amount of $12,000 under the Lanham Act; and

3) attorneys' fees and costs in the amount of $8,000 and $352.72.

How did the court arrive at these amounts?

Under the Copyright Act, Palmer was entitled to:

> recover, instead of actual damages and profits, an award for infringements in the action, with respect to any one work, for which any one infringer is liable individually…in a sum not less than $750 or more than $30,000 as the court considers just.

However, when infringement is committed willfully, the court may increase the award of statutory damages to a maximum of $150,000. According to the D.C. Circuit, "statutory damages are to be calculated according to the number of works infringed, not the number of infringements."

There was no doubt that Slaughter had **willfully infringed** on Palmer's copyrights. As a result of his efforts, at least two copies of the work were sold. However, the court determined that an award of $150,000 per infringed work (for a total statutory damages award of $300,000) was excessive for three reasons:

1) Although Slaughter offered the AVATAR works over the Internet during a seven-month period, his asking price was only $100. Thus, he did not profit greatly from these sales;

2) Palmer could not show that attendance at his seminars had declined by any noticeable extent because of Slaughter's activities. Consequently, Palmer did not lose a large amount of revenue as a result of Slaughter's conduct; and

3) the injunctive relief that Palmer obtained would probably work to recapture control over the copyrighted materials.

Since this high degree of control was largely responsible for the success of the AVATAR program, a statutory damage award in the hundreds of thousands of dollars was inappropriate.

Nevertheless, the court recognized the need to compensate Palmer and to deter Slaughter and others from violating copyright laws in the future and awarded statutory damages in the amount of $10,000 per work (for a total of $20,000).

Because Slaughter's conduct was found willful, the court found a tripling of this loss appropriate. Hence, the court awarded Palmer an additional $12,000 for the violation of his other rights.

Adding the legal fees to the equations, Slaughter had to pay more than $40,000 for a measly $200 in illegal sales. Definitely not worth it—which was the point.

Conclusion

Damages awarded in any copyright infringement suit must reflect profit losses to the rightful owner and profit gains to the infringer. However, often adding to the complexity of copyright infringement cases is the notion of *fair use*, or the legal right to use someone else's material without permission. The next chapter looks at this topic in detail.

Chapter 4:

Fair Use of
Copyrighted Material

You've developed a Web site dedicated to the actress Sarah Jessica Parker—famous of late for her role on the television show *Sex and the City*. You post pictures of her, excerpt articles you've read, invite people to post comments…and include some of your own thoughts about her. It's the kind of thing that makes up a big part of the Internet.

You run the site for a year without any problems. Because you're diligent about posting the best pictures of Parker and adding your own witty asides, you attract a loyal following of the actress' enthusiasts.

Then, out of the blue one day, you get a letter from a law firm. It says that it's representing a movie magazine you've never heard of (and you've heard of most of them). The letter goes on to say that one of the pictures of Parker on your site—a smirky shot of her slinking around in her underwear—belongs to the magazine and that, unless you remove the picture, they're going to pursue legal action.

Could this be right? You didn't take the pictures from a copyrighted site. There aren't any copyright marks on the pictures themselves. And you don't make any money from your Web site.

Your cousin the lawyer was talking about "fair use" at last Thanksgiving's family gathering. Can't you post the pictures under fair use?

This chapter explores one of the central issues involving copyrights in the Internet era—fair use. The theory is that, under certain conditions, you

can use copyrighted materials without getting the owner's permission. This applies, for example, to book reviews: You can quote a book at length in the course of reviewing it. It also applies to news—copyrighted works that make news can be quoted. However, in the modern day, some people try to make this theory fit just *every* use of copyrighted material.

History of Fair Use

From the infancy of copyright law, some opportunity for fair use of copyrighted materials has been thought necessary to fulfill a copyright's very purpose—to promote the progress of science and useful arts. In copyright cases brought under the Statute of Anne, English courts held that in some instances "fair abridgements" would not infringe an author's rights.

Fair use was traditionally defined as "a privilege in others than the owner of the copyright to use the copyrighted material in a reasonable manner without his consent."

The First U.S. Congress enacted an initial copyright statute, the Copyright Act of 1790, without any explicit reference to "fair use." But, even at that time, the doctrine of fair use was recognized by the American courts. And the subject of fair use has always been **a subjective judgment call** for courts. The specific circumstances of each case differ. In the 1841 case of *Folsom v. Marsh*, Justice Joseph Story explained what a judge must do when considering a fair use claim:

> [L]ook to the nature and objects of the selections made, the quantity and value of the materials used, and the degree in which the use may prejudice the sale, or diminish the profits, or supersede the objects, of the original work.

According to Section 107 of the Copyright Act, there are four factors that determine whether or not previously copyrighted material qualifies as fair use:

1) the purpose and character of the use, including whether such use is of a commercial nature or is for nonprofit educational purposes;

2) the nature of the copyrighted work;

3) the amount and substantiality of the portion used in relation to the copyrighted work as a whole; and

4) the effect of the use upon the potential market for or value of the copyrighted work.

All of the factors are important; but the third is often where courts focus in a legal dispute. This is because the amount of work used is the easiest factor to establish, objectively. The third factor is also important when determining how much material questioned relates to the copyrighted work.

The task of making fair use decisions can't be simplified with bright-line rules. Even when the courts consider all of the above four factors, no single factor is and of itself sufficient to prove fair use. The law, like the doctrine it recognizes, calls for **case-by-case analysis**. The text employs the terms "including" and "such as" to indicate the illustrative and not limitative function of the examples used, which provide only general guidance about the types of copying that courts and Congress most commonly view as fair use.

Also in the Act: "The fact that a work is unpublished shall not itself bar a finding of fair use if such finding is made upon consideration of all the above factors."

The four statutory factors can't be treated in isolation, one from another. All are to be explored, and the results weighed together, in light of the purposes of copyright.

All of this leads some people to believe that fair use can be interpreted broadly—to include just about any use of any work. But that's not true, either.

The four-part standard reflects the spirit of the fair use theory. U.S. copyright law states plainly that fair use is designed to allow: "news reporting, comment, criticism, teaching, scholarship and research." It is even intended to allow lampoon or parody, as long as these riffs have "transformative value."

The Value of a Good Idea

But what exactly does **transformative value** mean? According to Supreme Court Justice David Souter, transformative value is value that "adds something new, with a further purpose of different character, altering the first with new expression, meaning, or message."[1] This transformative value comes up frequently in cases of fair use. In a case we'll look at later, Souter uses his definition to make a decision on fair use by a work that parodies another. Cases involving parodies can be difficult to resolve. If you transform an original work into something else, you are still bound by certain laws.

The Basic Parameters

Fair use, when properly applied, is limited to copying that does not materially impair the marketability of the copied work. The Copyright Act confers a bundle of exclusive rights to the owner of the copyright. Under the Copyright Act, these rights—to publish, copy and distribute the author's work—vest in the author of an original work from the time of its creation. In practice, the author commonly sells his rights to publishers who offer **royalties in exchange for their services** in producing and marketing the author's work.

> Fair use is an issue decided and defined by courts. And, as the four-part standard defined by the U.S. Code and executed by the courts suggests, every individual instance of fair use can be judged differently than others—depending on the facts at hand in a specific case.

The best approach that people dealing with fair use issues can take is to get some knowledge of how courts are likely to react to their situations…and proceed accordingly.

[1] He wrote this in *Campbell v. Acuff-Rose*, a decision we'll consider in detail a little later in this chapter.

Chapter 4: Fair Use of Copyrighted Material

To that end, it's a good idea to start with a look at the most often cited fair use dispute of modern times: The U.S. Supreme Court's 1985 decision *Harper & Row Publishers v. Nation Enterprises*.

In 1977, former President Gerald Ford contracted with Harper & Row to publish his as yet unwritten memoirs. The agreement gave Harper & Row various rights to the work—including the exclusive first serial right to license prepublication excerpts to magazines or newspapers. This licensing is a common practice in publishing; it serves as both a way to generate publicity for a book and earn back some of its development cost.

As Ford's memoirs neared completion, Harper & Row negotiated a prepublication licensing agreement with *Time* magazine. Time agreed to pay $25,000—$12,500 in advance and an additional $12,500 at publication—for the right to excerpt 7,500 words from Ford's account of the Watergate crisis and his pardon of former President Richard Nixon.

Shortly before the release of *Time*'s excerpt—one week before the book was shipped—an unauthorized source provided *The Nation* magazine with a **copy of the unpublished manuscript**. Working directly from this manuscript, an editor at *The Nation* produced an article, which included lengthy verbatim quotes from the book. *The Nation* scheduled the article to "scoop" the *Time* excerpt. As a result, *Time* canceled its excerpt and refused to pay Harper & Row the second half of its licensing fee.

Harper & Row sued Nation Enterprises, the publisher of *The Nation*, alleging violations of the Copyright Act. The trial court ruled that the memoirs were protected by copyright and that *The Nation*'s use of the copyrighted material constituted an infringement.

According to the trial court, though billed as "hot news," the article in *The Nation* contained no new facts. The magazine had "published its article for profit," taking "the heart" of "a soon-to-be-published" work. This unauthorized use "caused the *Time* agreement to be aborted and thus diminished the value of the copyright."

Although certain elements of the Ford memoirs, such as historical facts and memoranda, were not copyrightable, the trial court held that it was

the totality of these facts and memoranda collected together with Ford's reflections that made them of value to *The Nation*, [and] this…totality…is protected by the copyright laws.

The court awarded actual damages of $12,500—the same amount that *Time* owed but did not pay Harper & Row. Nation Enterprises appealed.

Although the majority recognized that Ford's verbatim "reflections" were original "expression" protected by copyright, the Court of Appeals reversed the trial court's decision, holding that *The Nation*'s publication of the 300 to 400 (copyrighted) words could be considered a fair use under Section 107 of the Copyright Act.

The majority also held that the trial court had erred in assuming that the combination of Ford's reflections and the uncopyrightable facts represented a copyrightable "totality."

According to the appeals court, the purpose of *The Nation*'s article was **news reporting**. The original work was essentially factual in nature, and the 300 words appropriated were insubstantial in relation to the 2,250-word article or the 30,000 word manuscript.

Finally, the majority also found that the impact on the market for the original manuscript was minimal and that the evidence did not support the conclusion that *Time* decided not to publish the article because of the excerpts that had been appropriated.

This time, Harper & Row appealed…and the case made its way to the Supreme Court. The Supreme Court turned the decision back in favor of Harper & Row.

According to the high court, *The Nation* admitted lifting verbatim quotes of the manuscript to lend authenticity to its account of the forthcoming memoirs. As a result, *The Nation* effectively usurped the right of first publication, "an important marketable subsidiary right." This use, even if only applied to the short verbatim quotes, was not a fair use within the meaning of the Copyright Act.

In addition, the high court threw out *The Nation*'s argument that the First Amendment implies that the scope of fair use should be considered greater

when the information in question relates to "matters of high public concern." According to the court, this theory would have expanded fair use to destroy any expectation of copyright protection in the work of a public figure. Specifically, the court wrote:

> Absent such protection, there would be little incentive to create or profit in financing such memoirs, and the public would be denied an important source of historical information. The promise of copyright would be an empty one if it could be avoided merely by dubbing the infringement a fair use "news report" of the book.

The Nation had every right to attempt to publish the news about the memoir's upcoming release first. However, it **went beyond simply reporting** information to exploiting the headline value of its infringement, making a news event out of its unauthorized first publication of a noted figure's copyrighted expression. And it didn't matter whether *The Nation*'s motive of the use was commercial, not nonprofit, said the high court; what mattered was whether it "intended to profit from exploitation of the copyrighted material without paying the customary price."

The Nation's purpose was to scoop the forthcoming memoirs and the *Time* excerpts. This included the intended purpose of usurping the copyright holder's commercially valuable right of first publication. *The Nation*'s use clearly infringed the copyright holder's interests—an action that was difficult to characterize as "fair."

The direct quotes from the unpublished manuscript constituted only about 13 percent of the infringing article. However, the article was structured around the quoted excerpts, which served as its dramatic focal points. In light of this, the high court disagreed with the appeals court's statement that the "magazine took a meager...amount of Ford's original language." The use was an **infringement**. And *Time* magazine's cancelation of its projected serialization and its refusal to pay the second $12,500 were direct results of the infringement.

In its decision, the Supreme Court confirmed that *fair use* is not a term that can be applied indiscriminately to any taking of copyrighted material.

It must meet strictly the four-part test from Section 107 of the Copyright Act to work. And that standard is a tough one to meet strictly.

The Internet and Fair Use

The spirit of the Supreme Court's *Harper & Row* decision is a long way from the spirit of today's decisions involving the Internet.

Since the mid-1990s, when the Internet became a booming social and commercial force in advanced economies, there's been a lot of talk about the **ethics of the Internet community**. While this notion of "ethics" might not survive a university philosophy seminar, it does express recurring characteristics of early Internet users. They tended to be intelligent, aggressive in their style of communication and opposed to any form of regulation that would put up stop signs to the information passed over the Web. In short, Internet surfers didn't want any restrictions put on the Information Highway. They were ever eager for ways to get things—long distance phone service, music, photographs and pictures—for free. Think of those MP3 files, software upgrades, screensavers, pornography and e-mail accounts. Even greeting cards and recipes, or transcripts from television shows.

It's no surprise that these people preferred some loose definitions of fair use. Many Internet pioneers considered any piece of digital intellectual property that they could hack, copy or otherwise access to be covered by fair use.

This ethic is a problem for the people who own the intellectual property...usually secured through copyrights. A big part of Internet-related copyright disputes involves aggressive users and **fuzzy notions of fair use**. The February 2001 United States Court of Appeals decision *Peter Veeck, d/b/a RegionalWeb v. Southern Building Code Congress International Inc.*, for example, dealt with one such case.

Southern Building Code Congress International, Inc. (SBCCI) is a non-profit organization that develops, promotes and promulgates model building codes, such as the Standard Plumbing Code, the Standard Gas Code, the Standard Fire Prevention Code and the Standard Mechanical Code.

Chapter 4: Fair Use of Copyrighted Material

The organization encourages local governments to enact its codes into law by reference, without cost to the governmental entity.

In each of its codes, SBCCI asserts a copyright under which it claims the exclusive right to publish these codes or license their reproduction and publication. Although SBCCI is a nonprofit organization, it uses revenue from sales of its codes to fund its continuing activities.

Once a local government enacts an SBCCI code into law, the public may obtain copies of the codes from city offices or local libraries or may purchase copies directly from SBCCI or at a limited number of bookstores.

Peter Veeck's nonprofit Web site, RegionalWeb, posted information about North Texas, including text from local building codes. A dispute arose when several towns in north Texas—including Veeck's hometown of Denison—adopted SBCCI codes. Veeck unsuccessfully attempted to obtain a copy of Denison's building code at local bookstores and libraries. He then ordered copies of the codes in electronic format from SBCCI.

According to Veeck, he later visited more than a dozen towns in North Texas in an effort to obtain copies of their local building codes. He was unable to buy complete copies of the respective codes at any of the cities he visited, but he apparently never attempted to view or copy the codes in a city clerk's or other municipal office.

Upon receiving the 1994 codes from SBCCI, Veeck realized that Denison had adopted the 1988 version of the codes. Nevertheless, he **posted the 1994 codes on his Web site**, identifying them as the building codes of the cities of Anna and Savoy, Texas. Anyone logging on to his site could download these codes.

After learning about Veeck's site, SBCCI sent him a cease and desist letter. It accused Veeck of infringing its copyrights and demanded that he remove the infringing content from his site. Veeck filed a response in court, arguing that he had not violated federal copyright law and that his posting qualified as fair use. SBCCI counterclaimed with five counts of copyright infringement, as well as unfair competition and breach of contract.

The Value of a Good Idea

The district court granted summary judgment in favor of SBCCI, ruling that SBCCI held valid, enforceable copyrights to the codes. The court rejected Veeck's defenses of fair use and other theories. Veeck appealed.

According to Veeck, when SBCCI's model codes became public law, they lost any copyright protection under principles of due process, freedom of speech and various affirmative defenses including fair use.

Veeck's main argument was that the public's due process interest in **free access to the building codes** extinguished SBCCI's copyright because the codes entered the public domain when they were enacted into law.

This was an argument that many producers of Web sites made—either in court or among themselves—through the late 1990s. But the appeals court hearing Veeck's case didn't buy the argument. In order to support his claim, Veeck had to prove—among other things—that the codes weren't available to people through public channels. In legal terms, this lack of availability is called *denial of access* and it's critical to claims like Veeck's.

Veeck's denial of access claims centered on the cities of Anna and Savoy, Texas. The appeals court concluded that he was basing some very broad conclusions on experiences in "two extremely small communities with fewer than 1,000 residents each."

Veeck had visited Savoy's city hall and been told that the codes were at the public works department. He did not go there to obtain the codes. Similarly, when the city clerk of Anna was absent twice, Veeck made no further effort to view the codes. In his affidavit, Veeck admitted that the codes may have been publicly available in both towns; but claimed that "the codes are only available at the Anna and Savoy city halls during those times when city officials are available."

This may have been inconvenient, but the appeals court concluded that it wasn't the same as being "actually prevented or substantially hindered from viewing the public law."

With the specific claim resolved, the appeals court considered the general question of whether a private entity—in this case, SBCCI—that develops a code may maintain copyright in it once that code is adopted into law.

The court wrote:

> Due process requires that the public have notice of what the law is so that they may comply with its mandates. Thus, the question is whether, once adopted into law, [SBCCI's] codes fall outside its exclusive domain and into the public domain because of the due process requirements.

Things like court decisions, statutes and government-promulgated standards are not copyrightable and are—by law—available for public use. But the SBCCI codes were different. They started out as the copyrighted intellectual property owned by a private-sector non-profit organization. Veeck's argument was that their adoption by some cities changed them into public domain information.

This is what lawyers call a *merger argument*—that, when a copyrightable expression merges with an uncopyrightable idea, the idea prevails and the result is uncopyrightable. Veeck contended that SBCCI's building codes, once enacted into law, became fact that could be expressed in only one way and were therefore not copyrightable. In other words, the adoption of SBCCI's code into law represented a **transformative event**—changing the essence of the original, copyrighted code. This event stripped the code of its copyright.

The appeals court didn't agree with Veeck's line of thinking, and said the merger argument wouldn't work in his case. SBCCI's codes were "infused with the opinions of their authors, from the requirements chosen in the codes to their arrangement, level of detail, and grammatical style." The court declined to rule that the codes fell into the public domain once enacted into law.

The appeals court pointed out that the purpose behind the concept of the merger of expression with idea is to ensure that copyright protection does not extend to ideas. The doctrine applies only when there are few or no other ways of expressing a particular idea. As articulated in *Kepner-Trequo, Inc. v. Leadership Software, Inc.* (Fifth Circuit, 1994):

> [W]hen an idea can be expressed in very few ways, copyright law does not protect that expression, because doing so would

confer a de facto monopoly over the idea. In such cases idea and expression are said to be merged.

In Veeck's case, there were at least two other sets of building codes that competed with SBCCI's—namely, the National Codes published by Building Officials and Code Administrators International and the Uniform Codes published by the International Conference of Building Officials. So, the existence of SBCCI's copyright had not stifled independent creative expression by groups that wanted to develop coding systems, improve current codes and lobby governments to adopt them.

The appeals court noted that, if Veeck had been a contractor who needed to use building codes, he could have quoted applicable provisions or incorporated them by reference in preparing bids or setting project specifications. But this was not the case—he posted the entire code on his Web site as an information service.

Veeck made a number of other arguments, as well. He tried a first amendment argument—that his use of the codes was protected free speech. He also argued that SBCCI had misused its copyright to discourage development of alternative code systems. None of his arguments—or counterclaims—persuaded the court. As the court reiterated:

> Today, the trend toward adoption of privately promulgated codes is widespread, and the social benefit from it is great. Our balancing of the countervailing policy concerns presented in this case ultimately leads us to conclude on these facts that copyright protection of privately authored model codes does not simply [disappear] when the codes are adopted by local governments; rather, they remain enforceable, even as to non-commercial copying, as long as the citizenry has reasonable access to such publications cum law....

Fair Use and Waiver of Copyright

Veeck then argued that SBCCI had effectively waived its copyright by encouraging municipalities to adopt its codes by reference. And he said

he had proof: SBCCI had given the North Carolina Building Inspectors Association permission to post on its Web site that state's building codes, which were modeled on the SBCCI codes. This, Veeck argued, waived the copyright.

This argument deserved a little more attention than Veeck's other arguments.

By law, a copyright may be **waived by inaction** or as the result of a particular act, even if waiver was not the intended result.

> **An example of inaction: You own a copyright to a work and find out that people are reproducing that work for broad use—but you don't tell them to stop. A court may later determine that you gave up your copyright by not acting when you knew people were using your material illegally.**

This is why cease and desist letters are such a big part of intellectual property protection. Letting the infringer know that he has violated your copyright is an important first step. At the start of SBCCI's battle, it had sent Veeck a cease and desist letter accusing him of copyright infringement. In essence, cease and desist letters maintain copyrights.

An example of a particular act: You own a famous painting by Thomas Eakins. Your cousin Morrie asks if he can make a digital copy of the painting and put it on his personal Web site. You say okay. Morrie then asks if he can share the digital copies with a few friends. Again, you say okay. Later, you're shocked to see the Eakins painting on a Web site dedicated to liberalizing laws banning public nudity. It's probably too late for you to claim your copyright. And, to make matter worse, the Eakins society in Oxford, England, comes after you for having defamed the Eakins name and reputation. The society claims *droit moral*, or the painter's

"moral right" to protect his reputation regardless of the sale of his rights to the work. You had no idea.

Having concluded that SBCCI's codes were not in the public domain and that due process did not require suppression of SBCCI's copyright, the appeals court determined that SBCCI had done nothing—active or inactive—to waive copyright protection. On the contrary, SBCCI expressly reserved its copyright in the codes.

The appeals court ruled that the North Carolina Building Inspectors Association deal hadn't amounted to a waiver. It agreed with the trial court's assertion that "[c]ountless entities provide free access to materials on the Internet and still retain enforcement of their copyrights."

Finally, Veeck argued that his actions constituted a fair use of the copyrighted codes. However, this argument failed as well.

Veeck admitted that he did nothing more than copy SBCCI's model codes verbatim; he did not transform them, through parody or otherwise. Hence, Veeck could not support the argument that the adoption by reference of SBCCI's codes was a "transformative" event. He didn't transform—change—anything. He **copied verbatim and posted**.

Even though Veeck's use of SBCCI's codes was noncommercial, he did not copy the codes for personal use—thus, the court determined that his actions could have severely undermined the market for those codes if such use were to become widespread.

On all counts, the appeals court sided with SBCCI. Limiting its copyright would be counter to the law's purpose of encouraging creativity, given the fact that a growing number of federal, state and local governments were adopting model codes into law. The appeals court wrote:

> [I]f code writing groups like SBCCI lose their incentives to craft and update model codes and thus cease to publish, the foreseeable outcome is that state and local governments would have to fill the void directly, resulting in increased governmental costs as well as loss of the consistency and quality to which standard codes aspire.

As we mentioned before, Veeck's arguments—even though they failed—are central to understanding copyright and Internet publishing. The appeals court here ruled for **limiting pubic access to the law**. But, in its conclusion, the court also emphasized that its decision was restricted to "the narrow set of facts and circumstances in this case" and that even slightly different facts or circumstances might produce a different result.

In a dissenting opinion, one judge hit upon the issues raised by the publication on the Internet. Judge Little disagreed with the majority view that the benefits generated from model codes require the court to rule in favor of the creators of the model code who wish to continue to enforce their copyright, even after such a code has been adopted into law. According to Little, once a model code is adopted into law by the government, a private entity, such as SBCCI, should not be permitted to obstruct publication and transmission of the law. Specifically, he wrote:

> Adoption of the model code as law serves to place the law in the public domain and it should, therefore, be readily available for access by all citizens. [When a law is enacted,] its contents transform into "ideas," which are no longer distinguishable from their expression.

So, at least one judge supported the merger theory. And Webmasters and Internet publishers doing business in the U.S. may cling desperately to the spirit of that dissent.

Unpublished Works

One of the problems with fair use and the Internet revolves around what it means for a work to be "published" or "unpublished."

The scope of fair use is narrower with respect to unpublished works. While even substantial quotations might qualify as fair use in a review of a published work or a news account of a speech that had been delivered to the public or disseminated to the press, the author's right to control the **first public appearance of his expression** weighs against such use of the work before its release.

The right of first publication encompasses not only the choice of whether to publish at all, but also the choices of when, where and in what form to first publish a work. Theoretically, the benefit to author and public alike of assuring authors the leisure to develop their ideas free from fear of expropriation outweighs any short-term "news value" to be gained from premature publication of the author's expression.

The author's control of first public distribution affects not only his personal interest in creative control but his **property interest in exploitation of prepublication rights**, which are valuable in themselves and serve as a valuable adjunct to publicity and marketing.

Under ordinary circumstances, the author's right to control the first public appearance of his undisseminated expression outweighs a claim of fair use. That's what allowed Harper & Row to win in the end. Ford (and, in turn, the publishers of his memoirs) had a right to control access to the work prior to its release.

When Congress amended federal copyright law in 1966, it had this to say about fair use:

> The applicability of the fair use doctrine to unpublished works is narrowly limited since, although the work is unavailable, this is the result of a deliberate choice on the part of the copyright owner. Under ordinary circumstances, the copyright owner's "right of first publication" would outweigh any needs of reproduction for [educational] purposes.

So, does posting material on an Internet Web site constitute a first publication? Usually, yes. But, we'll get into the Digital Millennium Copyright Act (DMCA) in the next chapter.

Parody

It's best to think of fair use as a series of narrow exceptions rather than a blanket of comfortable theft. One of the strongest examples of these exceptions is when a fair use is for parody. Legally, the theory is that parody

creates transformative value by making fun of an original work. But while this governs legal rulings in disputes over fair use, every case gets scrutinized separately. So, claiming a parodic defense to copyright infringement may not always hold.

The common suggestion that any parodic use is fair has no more justification than the claim that any use for news reporting should be presumed fair…or any use by a not-for-profit group should be presumed fair.

> The threshold question when fair use is raised in defense of parody is whether a parodic character may reasonably be perceived. Going beyond that, whether parody is in good taste or bad does not and should not matter to fair use.

This is not, of course, to say that anyone who calls himself a parodist can skim the cream and get away scot free. In parody, as in news reporting, context is everything—and the question of fairness asks what else the parodist did besides draw from the heart of the original.

If a parody whose wide dissemination in the market runs the risk of serving as a substitute for the original or licensed derivatives, it is more incumbent on one claiming fair use to establish the extent of transformation and the parody's critical relationship to the original. By contrast, when there is little or no risk of market substitution, taking parodic aim at an original is a less critical factor. This could happen if the work largely was transformed from the earlier work, was minimally distributed in the market or borrowed little from the original. In this case, looser forms of parody may be found to be fair use, as may satire with lesser justification for the borrowing than would otherwise be required.

Among the most-cited rulings that has defined the terms of parody and fair use is the March 1994 U.S. Supreme Court decision *Luther R. Campbell (aka Luke Skyywalker), et al., v. Acuff-Rose Music, Inc.*

The Value of a Good Idea

In 1964, Roy Orbison and William Dees wrote the rock-and-roll song "Oh, Pretty Woman." Orbison and Dees assigned their rights to the song to Acuff-Rose, a music publishing company that registered the song for copyright protection. The song became a hit for Orbison. Over the years, a number of well-known rock bands recorded their own versions of the song, paying Acuff-Rose for the rights to do so.

In 1989, Luther Campbell—a member of the rap music group 2 Live Crew—wrote a song called "Pretty Woman." According to Campbell, his song intended, "through comical lyrics, to satirize the original work...."

In July 1989, 2 Live Crew's manager informed Acuff-Rose that the group had written a parody of "Oh, Pretty Woman" and that the group would give all credit for ownership and authorship of the original song to Acuff-Rose, Dees and Orbison. The manager also indicated that the group was willing to pay a fee for the use of the original song. Enclosed with the letter were the lyrics and a recording of 2 Live Crew's song.

Acuff-Rose refused permission. Despite this refusal, 2 Live Crew released "Pretty Woman" in a collection of songs entitled *As Clean As They Wanna Be*. The printed credits accompanying the record identified the authors of "Pretty Woman" as Orbison and Dees and its publisher as Acuff-Rose.

Almost a year later, after nearly a quarter of a million copies of *As Clean As They Wanna Be* had been sold, Acuff-Rose sued 2 Live Crew and its record company, Luke Skyywalker Records, claiming that 2 Live Crew's song infringed on Acuff-Rose's copyright in Roy Orbison's "Oh, Pretty Woman."

The district court granted summary judgment for 2 Live Crew, ruling that its **song was a parody** that made fair use of the original. The court cited the reasons for granting summary judgment as follows:

- the commercial purpose of 2 Live Crew's song did not conflict with the fair use doctrine;

- 2 Live Crew's version was a parody, which "quickly degenerates into a play on words, substituting predictable lyrics with shocking ones" to show "how bland and banal the Orbison song" is;

- the rap group had taken no more than was necessary to "conjure up" the original in order to parody it; and

- it was very unlikely that 2 Live Crew's song would negatively affect the market for the original.

Acuff-Rose appealed.

In 1992, a federal appeals court reversed the district court's decision. Although 2 Live Crew's song was a parody of the Orbison original, the appeals court ruled that the lower court had put too little emphasis on the U.S. Supreme Court's earlier ruling that "every commercial use…is presumptively…unfair."[2]

The appeals court also ruled that "the admittedly commercial nature" of 2 Live Crew's parody failed to meet the four-part standard for fair use.

In addition, the appeals court wrote that 2 Live Crew had taken the "heart of the original" to make it "the heart of a new work" without stating plainly or labeling the result as parody. By doing so, 2 Live Crew had qualitatively taken too much of the original.

Campbell and his bandmates appealed that decision to the U.S. Supreme Court.

The High Court determined that Orbison's original creation, which was made for public dissemination, was a very good example of the copyright's protective purposes. However, it also held that this determination had less impact in this case because parodies "almost invariably copy publicly known expressive works."

As courts often do, the Supreme Court started by asking whether 2 Live Crew had taken too much of Orbison's song. What followed was a detailed description of the rap song:

> [2 Live Crew's] song copied the first line of the original, but thereafter departed markedly from the Orbison lyrics. [2 Live Crew] also copied the bass riff and repeated it, but also included other

[2]In the 1984 decision *Sony Corp. of America v. Universal City Studios*, the Supreme Court wrote: "[E]very commercial use of copyrighted material is presumptively an unfair exploitation of the monopoly privilege that belongs to the owner of the copyright."

distinctive sounds, including interposing "scraper" noise, overlaying the music with solos in different keys and altering the drum beat.

Despite all this, said the high court, "a substantial portion" of the parody itself was not composed of a "verbatim" copy of the original. What's more, said the Supreme Court, 2 Live Crew's "Pretty Woman" clearly contained parody—the song commented on and criticized Orbison's original song. The rap group should not have been penalized by having to explain that its song was a parody. The high court wrote:

> Parody serves its goals whether labeled or not, and there is no reason to require parody to state the obvious (or even the reasonably perceived).

In addition, the Supreme Court wrote that the appeals court had put too much weight on the commercial nature of the parody. Many courts—and many people—focus too much on the first of the four factors described in Section 107 of the Copyright Act: "the purpose and character of the use, including whether such use is of a commercial nature or is for nonprofit educational purposes." Taking this point to an extreme, groups like *The Nation* magazine argue that, because its corporate parent is a not-for-profit organization, it is free to use others' copyrights as it likes.

The Supreme Court has never agreed. Instead, it has repeatedly ruled that the law "clearly states that the commercial or nonprofit educational purpose of a work is only one element of the first factor inquiry into its purpose and character."

And, in an even harsher rebuke, the Supreme Court wrote that the appeals court had misinterpreted its statement "every commercial use of copyrighted material is presumptively...unfair." The Supreme Court clarified its meaning on this point:

> And, while...a publication's commercial nature tends to weigh against a finding of fair use, this tendency may vary with the context. For example, the use of a copyrighted work to advertise a product, even in a parody, would more likely not be considered

fair use under the first factor than the sale of a parody for its own sake.

So, a parody can be a for-profit venture and still be legal under the fair use theory. The Supreme Court reversed the appeals court's decision and ruled in favor of Campbell and 2 Live Crew.

Droit Moral

While U.S. Copyright law is designed to protect the economic rights of authors, i.e., we let them control access to their work in order to ensure they get paid for use of their creations, in other countries—notably France and Germany—copyright law recognizes an author's *droit moral* or moral right to protect his or her reputation by preventing others from misusing or misrepresenting the work even after the author has given away all other rights in the work.

In 1990, Congress enacted the **Visual Artists' Rights Act** to extend a limited version of *droit moral* only to works of visual art. Because copyright law gets complicated when it comes to things like paintings and fine art, this Act sharpens the courts' view on a hazy matter. These rights are based on what the court said in *Carter v. Helmsley-Spear, Inc.*:

> A belief that an artist in the process of creation injects his spirit into the work and that the artist's personality as well as the integrity of the work, should therefore be protected and preserved.

In other words, the Act provides a **right of integrity**, allowing the artist to prevent any intentional distortion, mutilation or other modification of his work prejudicial to his honor or reputation. When Annie Liebowitz sells a photograph, for example, she maintains certain moral rights to that photograph, which could prevent the buyer of that photograph from making mass copies and sell them for profit. Visual arts encompass a variety of works: sculptures, paintings, mobiles, photographs, murals, prints, etc.

But, rights to visual arts are not absolute. The Supreme Court has ruled that the Act does not prevent the removal and destruction of works. The Act applies to a restricted category of visual artworks, extends only lim-

ited rights and is prone to loopholes, exclusions and waiver provisions that erode its powers.

One example of a case that upheld the rights afforded artists in the Act was *Gilliam v. ABC*. In *Gilliam*, a federal appeals court considered a claim by the group of performers known as Monty Python seeking a preliminary injunction to prevent the American Broadcasting Company (ABC) from broadcasting edited versions of three of their programs.

The court stopped the broadcasts, concluding that the group had shown a likelihood of succeeding on the merits of their claims that the **editing exceeded the scope of ABC's license**.

The court further determined that the group would likely succeed on its claim that, "regardless of the right ABC had to broadcast an edited program, the cuts made constituted an actionable mutilation of Monty Python's work," and that such a cause of action:

> finds its roots in the continental concept of *droit moral*, or moral right, which may generally be summarized as including the right of the artist to have his work attributed to him in the form in which he created it.

Conclusion

Fair use is a mixed question of law and fact. And it defies easy description. According to the 1990 Supreme Court decision *Stewart v. Abend*, the fair use doctrine:

> permits [and requires] courts to avoid rigid application of the copyright statute when, on occasion, it would stifle the very creativity which that law is designed to foster.

Congress resisted attempts to narrow the definition of *fair use*…and it urged courts to preserve the breadth of their view of the universe of relevant evidence. The result: Courts must consider the four factors defining *fair use* in a sort of multi-variable equation.

Chapter 4: Fair Use of Copyrighted Material

The mere fact that a use is educational and not for profit does not insulate it from a finding of infringement, any more than a commercial use bars a finding of fairness. If commerciality barred a finding of fairness, the presumption would swallow nearly all of the illustrative uses listed in Section 107—including news reporting, comment, criticism, teaching, scholarship and research, since courts have repeatedly noted that these activities are generally conducted for profit.

If the use has no critical bearing on the substance or style of the original composition, which the alleged infringer merely uses to get attention or to avoid the drudgery in working up something fresh, the claim to fairness in borrowing diminishes and other factors, like the extent of its commerciality, loom larger.

The fourth fair use factor—the effect of the use upon the potential market for or value of the copyrighted work—requires courts to consider not only the **extent of market harm** caused by the particular actions of the alleged infringer but also whether "unrestricted and widespread conduct of the sort engaged in by the defendant" would result in a **substantially adverse impact on the potential market for the original**.

And then there's transformative value. Although transformative use is not absolutely necessary for a finding of fair use, the goal of copyright—to promote science and the arts—is generally furthered by the creation of transformative works. Such works thus lie at the heart of the fair use doctrine's guarantee of breathing space within the confines of copyright.

The more transformative the new work, the less the significance of other factors, like commercialism, that may weigh against a finding of fair use.

So, finally, is your use of Ms. Parker's sultry images on your Web site fair? Since you don't make any money from the site, the commercial use factor works for you. Since you add comments about the pictures, you may be able to make the case that you've added transformative value.

And there are always commercial solutions: You might be able to negotiate a deal whereby you refer people to the magazine's site to see more—if they let you keep the pictures you've got up on the site.

The Value of a Good Idea

CHAPTER 5: THE DIGITAL MILLENNIUM COPYRIGHT ACT

As we've seen throughout this section, the digital era has changed a lot of the practical realities of copyright protection. What about this "digital era" makes copyrights so complicated? Primarily, it's the fact that information and creative works no longer rely on physical media like pen and paper to be transmitted from maker to user. Images, words and sounds can be conveyed electronically—from workstation to workstation...or from database to disk or CD.

This freedom from physical limitations makes **delivering intellectual property easier** and less expensive both for makers and users. It also makes unapproved use and infringement easier, be it intentional or not. Traditional notions of copyrights were based heavily on the idea that intellectual property had to take some physical form—think book or canvas—in order to be used. TV and radio changed that slightly, though the ability to broadcast through those media was fairly well controled.

Personal computers, hand-held devices and the Internet have exploded the traditional paradigm of intellectual property control.

In the late 1990s, the U.S. Congress tried to put some restraints on this explosion with a group of refinements to American copyright law called the Digital Millennium Copyright Act (DMCA).

History and Mechanics of the DMCA

In December 1996, the World Intellectual Property Organization (WIPO) adopted the WIPO Copyright Treaty Article 11. The measure provides, in part, that contracting states:

> shall provide adequate legal protection and effective legal remedies against the circumvention of effective technological measures that authors use to exercise their rights under this Treaty or the Berne Convention.[1]

In other words, Article 11 calls for countries to give authors the means to restrict uses of their work that the concerned authors have not authorized and that are not permitted by law.

The adoption of the WIPO Copyright Treaty spurred continued congressional attention to the adaptation of copyright law to the digital age. Lengthy hearings involving a broad range of interested parties both preceded and succeeded the adoption of the treaty. A critical focus of congressional consideration of the legislation was the conflict between those who opposed anticircumvention measures and those who supported them.

Proponents of strong restrictions on **circumvention of access control measures** argued that the measures are essential if copyright holders make their works available in digital form because digital publishing without restriction permits easy pirating. Opponents, however, contended that strong anticircumvention measures would only extend the copyright monopoly inappropriately and prevent many fair uses of copyrighted material.

Congress's solution? A compromise. In October 1998, lawmakers enacted the DMCA. DMCA provisions cover everything from the circumvention of copyright protection systems and fair use in a digital environment to online service provider liability—including details on safe harbors, damages and "notice and takedown" practices. Specifically, the DMCA

[1] The Berne Convention established international copyright law for literary and artistic works in 1886. All participating countries—or contracting states—were recognized as part of a Union. Parts to the Convention have been revised and amended since 1886 and as recently as 1979. The Convention is often cited in conjunction with the International Copyright Act of 1886.

makes it a crime to circumvent antipiracy measures built into most commercial software.

The DMCA forbids trafficking in technology that decrypts or avoids an access control measure without the copyright holder consenting to the decryption or avoidance. Specifically, the Act's anti-trafficking provision bans "offering or providing technology that may be used to circumvent technological access controls to copyrighted works."

It also outlaws the manufacture, sale or distribution of code-cracking devices used to illegally copy software. Whether this compromise proves ideal, remains to be seen and depends, in part, on how technology and commerce develop.

The DMCA also includes a couple of attorney-related rules that make it a good tool for people or firms that have been wronged. It not only provides that "[a]ny person injured by a violation…may bring a civil action in an appropriate United States court for such violation," but it permits awards of costs and attorneys' fees to the prevailing party. As far as attorneys' fees are concerned, this is an exception to the so-called "American rule" pursuant to which each side in a litigation customarily bears its own attorneys' fees.

Mechanically, the **focus of the DMCA is anticircumvention**—that is, preventing people from using technology to get around copyright protections. This is a more specific purpose than the general Copyright Act.

The DMCA contains two principal anticircumvention provisions:

> Section 1201(a)(1) governs "[t]he act of circumventing a technological protection measure put in place by a copyright owner to control access to a copyrighted work"; and

> Section 1201(a)(2), known as the anti-trafficking provision, states that "No person shall…offer to the public, provide or otherwise traffic in any technology…that:

>> A) is primarily designed or produced for the purpose of circumventing a technological measure that effectively controls access to a work protected under [the Copyright Act];

B) has only limited commercially significant purpose or use other than to circumvent a technological measure that effectively controls access to a work protected under [the Copyright Act]; or

C) is marketed by that person or another acting in concert with that person with that person's knowledge for use in circumventing a technological measure that effectively controls access to a work protected under [the Copyright Act]."

Exceptions Within the DMCA

Congress was aware during the consideration of the DMCA of the traditional role of the fair use defense in accommodating the exclusive rights of copyright owners with legitimate interests of noninfringing users of portions of copyrighted works. It recognized the contention, voiced by a range of constituencies concerned with the legislation, that technological controls on access to copyrighted works might erode fair use by preventing access even for uses that would be deemed "fair" if only access might be gained. And it tried to strike a balance among the competing interests.

So, there have been fair use issues plaguing the enforcement of the DMCA from its beginning. For this reason, Congress delayed the effective date of the sharpest circumvention prohibitions for two years after the rest of the law, pending further investigation about how best to reconcile those prohibitions with fair use concerns.

Following that investigation, the prohibition will not apply to users of particular classes of copyrighted works who demonstrate that their ability to make noninfringing uses of those classes of works would be affected adversely by the DMCA.

Also, the DMCA created a series of **exceptions to the prohibition** for certain uses that Congress thought fair, including:

- reverse engineering;
- security testing;

- good faith encryption research; and

- certain uses by nonprofit libraries and educational institutions.

Of these, **good faith encryption research** seems the most unusual, but it's done to advance encryption technology. And in determining whether one is engaged in good faith encryption research, most courts consider whether the results of the putative encryption research are disseminated in a manner designed to advance the state of knowledge of encryption technology versus facilitation of copyright infringement, whether the person in question is engaged in legitimate study of or work in encryption and whether the results of the research are communicated in a timely fashion to the copyright owner.

Free Speech

Aside from fair use, another problem with the DMCA is its potential clash with the U.S. Constitution's First Amendment. This clash—as described by the hacker community and libertarian commentators—resides in the restrictions that the DMCA places on free speech in cyberspace.

The key question here: What is *free speech* in cyberspace?

A second key question: Does the U.S. Constitution and its First Amendment have jurisdiction in cyberspace?

We'll deal with the second question first. Most courts assume that the U.S. Constitution and U.S. laws apply to activities that take place on U.S. soil. So, even if cyberspace is a different legal jurisdiction, the use of content on computers or digital devices located within the U.S. is covered by the DMCA and the First Amendment. So, the courts don't care about free speech in cyberspace. They only are concerned about free speech as it applies to computers, PDAs and other appliances located in the U.S.

So, we pose the refined question: Does the DMCA place illegal restrictions on free speech on computers, etc., in the U.S.?

Broadly speaking, restrictions on expression fall into two categories. Some are restrictions on the voicing of particular ideas, which typically are re-

ferred to as **content-based restrictions**. Others have nothing to do with the content of the expression—they are content neutral—but they have the incidental effect of limiting expression.

Content-based restrictions on speech are permissible only if they serve compelling state interests by the least restrictive means available. This is the classic First Amendment arena. You can't, for example, get a vanity plate that contains four-letter curse words; ABC can't broadcast pornography at 6 p.m. when kids are most likely to be watching TV. It is the content that is restricted here. And it serves a compelling—albeit obvious—interest.

On the other hand, **content-neutral** restrictions are measured against a less exacting standard. Because restrictions of this type are not motivated by a desire to limit the message, they are permissible if they serve a substantial governmental interest and restrict First Amendment freedoms "no more than necessary." An example: Your town wants to ban displays on the green in front of the town hall. This means that the annual Nativity scene can't be displayed either, and you think it violates your constitutional rights on of free speech and religion. However, you might later find that your argument doesn't hold in court. This is because the restriction aims to prevent the proliferation of signs and displays, so it has less to do with content and more to do with limiting unattended displays.

The DMCA's restrictions on circumvention are also content neutral, so courts are inclined to give them the benefit of the doubt in constitutional challenges.

The Hackers vs. the Feds

The first major legal precedent involving circumvention and the DMCA was the August 2000 New York Federal Court decision *Universal City Studios, Inc., et al., v. Shawn C. Reimerdes, et al*. The case involved the early use of **digital versatile disks**—more commonly known as DVDs.

DVDs offer drastically improved audio and visual clarity over video tape cassettes for playing movies on televisions or computer screens. They

also hold significantly more audio and visual material than tapes; this allows long films or additional content (interviews with actors or directors, etc.) to be recorded on a single disc. DVDs are popular with consumers and are a lucrative business for the major motion picture studios.

But when DVDs first hit the market, as a kind of flip-side to their various advantages, they posed a significant problem: They were relatively easy to copy and reproduce—and, pirate. Movies on DVDs are stored as digital files. This format caters to pirates because copying of these files from generation to generation does not cause degradation as does repeated copying on videotapes.

The studios addressed this problem by commissioning the development of an encryption system called CSS, or **Content Scramble System**. CSS was essentially a software program that prevented the easy copying of DVDs. CSS-protected files can only be viewed on DVD players and computer drives equipped with licensed technology. These special DVD players can decrypt and play the CD content—but they do not allow copying of the films.

To ensure that the decryption technology did not become generally available and to guarantee that compliant devices could not be used to copy as well as play CSS-protected movies, the technology was licensed to consumer electronics manufacturers, subject to strict security requirements. These licenses restricted manufacturers from making equipment that would supply digital output that could be used in copying protected DVDs.

In 1999, however, a group of computer hackers—including a 15-year-old Norwegian named Jon Johansen and two individuals he "met" under pseudonyms on the Internet—devised a computer **program called DeCSS that circumvents the CSS protection system** and allows CSS-protected content to be copied and played on devices that lack the licensed decryption technology.

Johansen posted the executable code for the program on his personal Web site and informed others that he had done so. Neither Johansen nor his collaborators obtained a license from the DVD Copy Control Asso-

ciation—the entity created by the motion picture industry to administer CSS licenses.

In the months following its posting on Johansen's site, DeCSS became widely available on the Internet. Soon, hundreds of Web sites offered the software for download. And many variations of CSS-decryption software popped up.

After learning of DeCSS and its availability on the Internet, the studios sent out a number of cease and desist letters to Web site operators who'd posted the program. Some of these operators removed DeCSS from their sites; others didn't.

Eric Corley was one of those who didn't. Corley was a rare high-profile person in the hacker community; he also owned the company that published the magazine *2600: The Hacker Quarterly*, something of a bible in that world.

Corley posted the DeCSS program on his 2600.com Web site, making it readily **available to the public**. In January 2000, several studios sued Corley under the DMCA to prohibit him from posting DeCSS and to prevent them from electronically linking their sites to others posting DeCSS.

According to the studios, Corley violated the DMCA. He didn't create DeCSS; but posting the program on his site and providing links to other sites offering DeCSS "negatively affected" the studios as described by the DMCA.

A trial court in New York issued a preliminary injunction ordering Corley to remove DeCSS from his site until the case had been decided. Corley did…but, in what he termed an act of "electronic civil disobedience," he continued to support links to other sites offering DeCSS for download.

In court, the studios demonstrated how simple and quick DeCSS made piracy of a DVD. A studio expert decrypted a store-bought DVD of the movie *Sleepless in Seattle* in about 30 minutes and created an unencrypted file that could be copied and shared like any other digital file.

Based on this exhibit, the trial court likened the effect of DeCSS to the publication of a bank vault combination in a national newspaper. It wrote:

> Even if no one uses the combination to open the vault, its mere publication defeats the bank's security system, forcing the bank to reprogram the lock.

Moreover, the fact that DeCSS gave the public the ability to **copy and distribute movies freely**, both on CD-ROM and via the Internet, threatened to reduce the studios' revenue from the sale and rental of DVDs, the court acknowledged. It also threatened to impede new, potentially lucrative initiatives for the distribution of movies in digital form, such as video-on-demand via the Internet.

These were major issues that the DMCA was designed to address. The court pointed to the anti-trafficking provision of the DMCA that makes it illegal to offer or provide technology that may be used to circumvent technological access controls to copyrighted works.

CSS was precisely such a technology. Corley and 2600 offered and provided DeCSS by posting it on the 2600.com Web site. Doing so, said the court, was prohibited—irrespective of why the program was written or why Corley posted the program on his site.

Corley represented a sizeable subculture of Internet users who believed strongly in the free exchange of content on the Internet. These were the people who opposed the DMCA when it was being developed in Congress. They'd lost that battle but were looking for a victory in this first big trial.

Corley made a couple of interesting broad arguments against the DMCA claims. First, he argued that his actions didn't violate the DMCA because the act focused on direct acts of copying specific files and didn't address software that might be used to decypher files generally in the future. This argument was relatively weak; the DMCA clearly addressed software piracy tools. The court tossed out this argument.

Second, he argued that DMCA limitations, as applied to computer programs or code, violated the First Amendment. This was a slightly stronger

claim; legal experts had worried from the beginning that the DMCA cut too close into First Amendment speech rights.

The court agreed to consider this point.

Aside from these broad arguments, Corley also made a couple of technical arguments—that his behavior was allowed under the exceptions contained in the DMCA. The court rejected this claim. Neither Corley nor his company performed reverse engineering. They weren't involved in good faith encryption research. And they had nothing to do with testing computers, computer systems or computer networks.

Finally, Corley argued that the DMCA did not apply because the Act, as a technological access control measure, prevented the fair use of copyrighted works as well as the foul. In other words, he made a fair use claim.

CSS encryption prevented exact copying of either the video or the audio portion of all or any part of a film. Hence, Corley argued, certain uses that might qualify as fair for purposes of copyright infringement—for example, the preparation of a single CD-ROM containing clips from different movies in order to illustrate a point in a lecture on cinematography—would be impossible without circumvention of the CSS encryption.

Corley argued that the DMCA did not apply to his activities, which were simply a means to enable users of DeCSS to make fair use of certain movies. However, the court made a trenchant observation here. Fair use is a defense against allegations of copyright infringement; but Corley and his company weren't being sued for copyright infringement. They were being sued for offering and providing "technology designed to circumvent technological measures that control access to copyrighted works." This was a violation of the DMCA—a separate body of law from the anti-infringement language of the Copyright Act.

Does the DMCA Violate the First Amendment?

Corley was left with his First Amendment argument, which rested on two propositions:

1) that computer code, regardless of its function, is "speech" entitled to maximum constitutional protection; and

2) that computer code therefore should be exempt from government oversight.

The court noted that the **anti-trafficking provision** of the DMCA does not aim to suppress the ideas of computer programmers. Rather, the DMCA is a functional law concerned with preventing people from circumventing technological access control. The court likened this situation to laws prohibiting the possession of certain burglar's tools; the laws are designed to prevent burglaries and have nothing to do with preventing people from expressing themselves by accumulating attractive devices.

According to the court, any impact of the DMCA on the dissemination of programmers' ideas is purely incidental. Besides, copyright protection (whether provided by the DMCA or the traditional Copyright Act) can't be construed to curb free speech. The Supreme Court has stated repeatedly that copyright protection is "the engine of free expression"; this purpose supersedes any incidental restraints on protected expression.

The court admitted that not everyone who obtains DeCSS or any other decryption program engages in copyright infringement—just as not everyone who is exposed to a contagious disease contracts it. But, again, this wasn't simply an infringement case. The DMCA goes farther; it deals with the means of infringement or privacy.

> What mattered more to the court was the manner in which the DeCSS program was spread and the lack of any control of the resulting infringement, when it occurred later. In other words, the DMCA forced the court to focus on the link between computer program dissemination (including Internet links) and the illicit use of programs.

The Value of a Good Idea

Through this process, the court developed a deeper respect for the work Congress had done in drafting the DMCA. The court wrote:

> Congress correctly used its authority when curbing posting of computer code designed to circumvent access control measures with the anti-trafficking provisions of the DMCA. The DMCA does not unduly restrict free expression but is a content neutral regulation designed to further important governmental interests.

Among the court's specific reasons for this ruling were the following facts:

1) The studios had established by clear and convincing evidence that Corley linked to sites posting DeCSS, knowing that it was a circumvention device. Indeed, Corley and his company initially touted the program as a way to get free movies.

2) Later, Corley and his company maintained the links to promote the dissemination of the program in an effort to defeat effective judicial relief.

3) The trial definitely made Corley and his company aware of the fact that dissemination of DeCSS violates the DMCA.

The court took care to emphasize that its ruling was very narrow and only applied to programs that circumvent access controls to copyrighted works in digital form when:

1) there is no other practical way of preventing infringement through use of the programs; and

2) the regulation is designed to prevent the programs from performing their illicit function and not to restrict any particular message they might convey.

The court predicted that the ruling would not chill the activities of other Web site operators dealing with different materials. Such operators may be held liable "only on a compelling showing of deliberate evasion" of the law, the court noted.

Corley and his company were part of **a movement that believes that information is free to anyone clever enough to access it**—regardless of how he accesses it. As a result of the stance, they raised a legiti-

mate concern about the possible impact on traditional fair use of access control measures in the digital era. But the court concluded that the DMCA's focus on **prohibiting the tools of piracy** didn't endanger legitimate fair use, and the studios won all of their points. The New York court concluded:

- posting decryption software violates DMCA provisions prohibiting "trafficking in technology" that circumvents measures controling access to copyrighted works;

- posting hyperlinks to other Web sites offering decryption software violates related DMCA provisions;

- the DMCA anti-trafficking provisions are content-neutral, as applied to computer programs;

- the DMCA, as applied to decryption software and hypertext links to such software, does not violate the First Amendment; and

- Corley failed to establish that the DMCA was overly broad and prevented noninfringing fair use (though different circumstances might support that claim).

The court in *Universal City Studios* made one observation—as a kind of throw-away aside—that may be quoted a lot in the coming years. In its discussion of the possible fair use problems raised by the CSS encryption, it noted that the anti-trafficking provision of the DMCA may prevent technologically unsophisticated persons who wish to copy portions of DVD movies for fair use from obtaining the means of doing so. That led to an even more important discussion:

> The same point might be made with respect to copying of works upon which copyright has expired. Once the statutory protection lapses, the works pass into the public domain. The encryption on a DVD copy of such a work, however, will persist. Moreover, the combination of such a work with a new preface or introduction might result in a claim to copyright in the entire combination. If the combination then were released on DVD and encrypted, the encryption would preclude access not only to the copyrighted new material, but to the public domain work.

This could be a major issue, indeed. The fact that CSS encryption will outlast statutory copyright protection means that DVDs—as they exist today—will serve as a tool for extending studios' proprietary claims to movies beyond their legal limits. That's not likely to stand up to continued legal scrutiny.

The "Everyone Else Is Doing It" Defense

In the midst of all the back-and-forth related to the *Universal City Studios* case, Corley and his codefendants made the lame "everyone else is doing it" argument that many people—not just those in DMCA cases—make.

Corley and the others argued that an injunction barring them from posting links to DeCSS sites would be futile because DeCSS was already all over the Internet. They said that an injunction would be comparable to locking the barn door after the horse is gone.

The court admitted that might be possible; but the countervailing arguments overcame its concern. It wrote:

> To begin with, any such conclusion effectively would create all the wrong incentives by allowing [infringers] to continue violating the DMCA simply because others…are doing so as well. Were that the law, [infringers] confronted with the possibility of injunctive relief would be well advised to ensure that others engage in the same unlawful conduct in order to set up the argument that an injunction against the [infringers] would be futile because everyone else is doing the same thing.

In legal terms, injunctions barring someone from doing something are called *equity relief.* They are different than—and sometimes preferable to—*monetary relief.* But they raise issues of their own; for one thing, they are not supposed to be ordered when a controversy has become moot. However, courts look skeptically at claims that defendants "already have done all the harm that might be done" before an injunction is issued.

In *Universal City Studios*, the court noted that, in the context of DMCA disputes, most courts are "not persuaded that modern technology has withered the strong right arm of equity." It went on to write:

> The likelihood is that this decision will serve notice on others that "the strong right arm of equity" may be brought to bear against them absent a change in their conduct and thus contribute to a climate of appropriate respect for intellectual property rights in an age in which the excitement of ready access to untold quantities of information has blurred in some minds the fact that taking what is not yours and not freely offered to you is stealing.

This bias toward awarding equity relief was based primarily on the fact that the court was "troubled by the notion that any Internet user...can destroy valuable intellectual property rights by posting them over the Internet."

This is really what the DMCA is about—refining the existing Copyright Act to offer legal protections designed for Internet applications.

The DMCA Gives a Break to ISPs

One big question that has surfaced in various Internet-related lawsuits: Can companies that provide access to the Internet be held responsible for things their customers do online?

The DMCA created several so-called "safe harbor provisions" designed to clear up the confusion. These provisions state pretty clearly that Internet service providers (ISPs) aren't responsible.

The DMCA was enacted both to preserve copyright enforcement on the Internet and to provide immunity to service providers from copyright infringement liability for "passive" or "automatic" actions in which a service provider's system engages through a technological process initiated by another **without the knowledge of the service provider**. This immunity, however, is not presumptive, but granted only to "innocent" service providers who can prove they do not have actual or constructive knowledge of the infringement.

The Value of a Good Idea

Title II of the DMCA, the Online Copyright Infringement Limitation Act, defines limitations of liability for copyright infringement to which ISPs might otherwise be exposed. The DMCA broadly defines an ISP as any provider of online services or network access, or the operator of facilities, including any entity providing "digital online communications, between or among points specified by user, of material of the user's choosing, without modification to the content of the material as sent or received."

Specifically, the DMCA provides:

A service provider shall not be liable for monetary relief, or, except as provided in subsection (j), for injunctive or other equitable relief, for infringement of copyright by reason of the storage at the direction of a user of material that resides on a system or network controled or operated by or for the service provider, if the service provider:

A) does not have actual knowledge that the material or an activity using the material on the system or network is infringing; in the absence of such actual knowledge, is not aware of facts or circumstances from which infringing activity is apparent; or upon obtaining such knowledge or awareness, acts expeditiously to remove, or disable access to, the material;

B) does not receive a financial benefit directly attributable to the infringing activity, in a case in which the service provider has the right and ability to control such activity; and

C) upon notification of claimed infringement...responds expeditiously to remove, or disable access to, the material that is claimed to be infringing or to be the subject of infringing activity.

To qualify for the exception, an ISP must show that it has **met all three of these requirements**. In addition, when demonstrating its lack of actual or constructive knowledge of the infringement, the ISP must prove that this condition existed prior to—and separate from—the second and third requirement.

The DMCA's protection of an innocent service provider disappears at the moment the service provider loses its innocence, i.e., at the moment it becomes aware that a third party is using its system to infringe. At that point, the Act shifts responsibility to the service provider to disable the infringing matter.

In the spirit of achieving a balance between the responsibilities of the service provider and the copyright owner, the DMCA requires that a copyright owner put the service provider on notice in a detailed manner.

> **Notification requirements are relaxed to the extent that, with respect to multiple works, not all must be identified—only a representative list. And with respect to location information, the copyright holder must provide information that is reasonably sufficient to permit the service provider to locate this material.**

The subsection in the DMCA that specifies the requirement of notification does not seek to burden copyright holders with the responsibility of identifying every infringing work—or even most of them—when multiple copyrights are involved. It's meant to simplify the complaint process.

Safe Harbor Provisions

Despite the DMCA's exceptions, there have been a number of lawsuits filed against ISPs for the misdeeds of their customers. The February 2001 Federal Appeals Court decision *ALS Scan, Inc. v. RemarQ Communities, Inc.* considered whether an ISP enjoys a safe harbor from copyright infringement liability when it is put on notice of infringement activity on its system by an imperfect notice.

Maryland-based ALS Scan created and marketed "adult" photographs, which it displayed on the Internet to paying subscribers. ALS also offered

the pictures in CD-ROM and video formats. The company owned the copyrights for all of these photographs.

Delaware-based RemarQ Communities was an ISP that provided access to approximately 24,000 members. It provided access to over 30,000 newsgroups, organized by topic, enabling subscribers to participate in discussions on virtually any topic. RemarQ claimed that its users posted over one million articles per day in these newsgroups, which RemarQ removed after eight to 10 days because of limited server capacity.

RemarQ did not monitor, regulate or censor the content of articles posted in the newsgroup by subscribing members. It did, however, filter information contained in the newsgroups and screen its members from logging onto certain newsgroups, such as those containing pornographic material.

RemarQ provided access to two newsgroups containing ALS's name in the titles: "alt.als" and "alt.binaries.pictures.erotica.als." These newsgroups contained hundreds of postings that infringed ALS's copyrights—all placed in the newsgroups by various RemarQ subscribers.

In August 1999, after discovering that RemarQ's groups contained pictures and other material that infringed its copyrights, ALS sent a letter to RemarQ that stated:

> Both of these newsgroups were created for the sole purpose of violating our Federally filed Copyrights and Tradename. These newsgroups contain virtually all Federally Copyrighted images.... Your servers provide access to these illegally posted images and enable the illegal transmission of these images across state lines. This is a cease and desist letter. You are hereby ordered to cease carrying these newsgroups within twenty-four (24) hours upon receipt of this correspondence... . America Online, Erol's, Mindspring, and others have all complied with our cease and desist order and no longer carry these newsgroups.

RemarQ refused to cancel the ALS-related newsgroups. The company did, however, advise ALS that it would eliminate individual infringing

items—the pictures posted by the subscribers—from these newsgroups if ALS identified them "with sufficient specificity."

ALS was not satisfied with RemarQ's response. According to ALS, over 10,000 of its copyrighted images were included in the newsgroups over several months. RemarQ's subscribers created the newsgroups for the sole purpose of illegally posting, transferring and disseminating ALS's copyrighted photographs.

ALS filed suit, alleging that RemarQ had violated the Copyright Act and Title II of the DMCA. ALS also alleged unfair competition—because RemarQ knew that the newsgroups contained infringing material but "steadfastly refused to remove or block access to the material."

ALS stated that RemarQ was informed by ALS of the infringing material and asked for an injunction against RemarQ, in addition to actual and statutory damages and attorneys' fees.

RemarQ asked the court to dismiss the suit immediately or enter summary judgment because it was prepared to remove the copyrighted material from its newsgroups if the material was specifically identified.

RemarQ argued that ALS had failed to comply with the DMCA compliant notice. For that reason, and because it was **merely a provider of access to newsgroups**, RemarQ contended that it was not guilty of infringement. RemarQ also claimed that ALS had failed to comply with two of the six requirements of a notification: 1) it never provided RemarQ with a "representative list" of the infringing photographs; and 2) it did not identify those photographs with sufficient detail to enable RemarQ to locate and disable them.

The trial court sided with RemarQ and dismissed the suit. More specifically, it held that:

1) RemarQ could not be held liable for direct copyright infringement because it merely provided access to a newsgroup containing infringing material; and

2) RemarQ could not be held liable for contributory infringement because ALS failed to comply with the notice requirements contained in the DMCA.

ALS appealed, arguing that it had "substantially complied" with the DMCA compliant notification requirements. It also argued that the trial court's application of the DMCA was overly strict and that Congress did not intend to permit Internet providers to avoid copyright infringement liability "merely because a cease and desist notice failed to technically comply with the DMCA."

RemarQ countered that it had no "knowledge of the infringing activity as a matter of law," and that it was protected under the DMCA because "ALS Scan failed to identify the infringing works in compliance with the Act, and RemarQ falls within the 'safe harbor' provisions of the Act."

According to the appeals court, if the trial court had evaluated ALS's complaint correctly, it would have had to accept ALS's allegation for purposes of testing the adequacy of the complaint. Also, the trial court had failed to consider ALS's allegation that RemarQ knew of the infringing nature of the two newsgroups even before being contacted by ALS.

Even more damning, the appeals court noted: The pictures could be identified as ALS's material because they included ALS Scan's "name and/or copyright symbol."

All of this led to the conclusion that ALS had substantially **complied with the notification requirement** of providing a representative list of infringing material as well as information reasonably sufficient to enable RemarQ to locate the infringing material. The appeals court held that RemarQ was provided with a notice of infringing activity that substantially complied with the DMCA; it **couldn't hide behind the safe harbor provisions**.

The appeals court reversed the trial court's ruling and sent the case back to trial with some new guidelines that would give ALS more fuel.

Liability of Hypertext Links

The anti-trafficking provisions of the DMCA have caused courts—in several cases, including the *Universal City Studios* decision we considered earlier—to look at the role that hypertext links play in communication on the Internet in general. As the court in *Universal City Studios* noted:

The possible chilling effect of a rule permitting liability for or injunctions against Internet hyperlinks is a genuine concern. But it is not unique to the issue of linking. The constitutional law of defamation provides a highly relevant analogy. The threat of defamation suits creates the same risk of self-censorship, the same chilling effect, for the traditional press as a prohibition of linking to sites containing circumvention technology poses for Web site operators.

Just as the potential chilling effect of defamation suits has not completely immunized the traditional press from all actions for defamation, however, the **potential chilling effect of DMCA liability** cannot utterly immunize Web site operators from all actions for disseminating circumvention technology. And the solution to the problem is the same: the adoption of a standard of culpability sufficiently high to immunize the activity, whether it is publishing a newspaper or linking, except in cases in which the conduct in question has little or no redeeming constitutional value.

In the defamation area, this has been accomplished by a two-tiered constitutional standard. There may be no liability under the First Amendment for defamation of a public official or a public figure unless the plaintiff proves, by clear and convincing evidence, that the defendant published the offending statement with knowledge of its falsity or with serious doubt as to its truth.

The other concern—that a liability based on a link to another site simply because the other site happened to contain some circumvention technology in the midst of other perfectly appropriate content could be overkill—also is readily dealt with.

The offense under the DMCA is offering, providing or otherwise trafficking in circumvention technology. An essential ingredient is a desire to bring about the dissemination. Hence, a strong requirement of that forbidden purpose is an essential prerequisite to any liability for linking.

Accordingly, there may be no injunction against, nor liability for, linking to a site containing circumvention technology, the offering of which is unlaw-

ful under the DMCA, absent clear and convincing evidence that those responsible for the link:

1) know at the relevant time that the offending material is on the linked-to site;

2) know that it is circumvention technology that may not lawfully be offered; and

3) create or maintain the link for the purpose of disseminating that technology.

Such a standard should **limit the fear of liability** on the part of Web site operators. And it will not subject Web site operators to liability for linking to a site containing proscribed technology where the link exists for purposes other than dissemination of that technology.

Conclusion

The mechanics of copyright law in the emerging digital age will certainly change and meet greater challenges. Perpetually evolving, the copyright industry always keeps up with technology and better methods of delivering media to people around the world. As we've seen in this chapter, that evolution is often triggered by novel lawsuits that shift the current model to a new paradigm.

This same evolutionary process is not special to copyrights, though. It extends to other types of intellectual property, as we'll see in the upcoming sections on trademarks, patents and publicity and privacy. As companies reinvent themselves and find innovative ways to do business and promote themselves, intellectual property issues across the board emerge. And in most cases, no new statute can supply a simple answer.

PART TWO: TRADEMARKS

CHAPTER 6:
THE MECHANICS OF TRADEMARKS

Trademarks are measured and defined by less objective standards than copyrights or patents.

When a fruit merchant sells *apples* or *blackberries*, he shouldn't be able to exclude competitors from using the actual words *apple* or *blackberry* to sell their fruit. But if the common word *apple* or *blackberry* is used by a computer merchant in selling computers, the usage—though not the word—is so uncommon and therefore distinctive that the computer merchant should be entitled to exclude other competitors from using *Apple* or *BlackBerry* in the sale of computers.

While this example demonstrates the principle of trademark law, the practice often is difficult. Because our dynamic economy—with its creativity and inventiveness—produces new products and services for which no words of description have previously existed, entrepreneurs and the public are engaged in a **continual tug of war** over naming these new products and services. Entrepreneurs want to gain some exclusive rights to the names of their inventions; the public wants merely to have a convenient term by which to refer to the new product or service to **facilitate communication**.

The task of distinguishing phrases that can function as trademarks from phrases that can't is almost metaphysical. It begins with an understanding of the common meaning of words and their common usage and proceeds to a determination of where the would-be trademark falls on a spectrum of meaning. That spectrum ranges from the basic words (e.g. *cat, spoon*

and *bottle*) that every infant first learns to new words (e.g. *Olestra*, *Viagra* and *Accenture*) created by high-rent marketing geniuses for the purpose of branding goods or services.

The farther a would-be mark moves away from basic words, the more "distinctive" it becomes. At one level, the difference is a question of law; at another, it's a factual question as to what the relevant public perceives.

> When a word or phrase does not fall within the most basic words but is close, its distinctiveness is strengthened by the entrepreneur's use. So, words that are not directly descriptive of a company, product or service but *suggest* the company, product or service can become trademarks.

Similarly, well-recognized slogans used without any direct context can, through use, become marks. A slogan can be used generally—suggestively—rather than in the context of it's common meaning. Nike's famous "Just do it!" is a good example.

The law of trademarks intends to protect the goodwill represented by marks and the valid property interests of entrepreneurs, against those who would appropriate marks for their own use. But the law likewise protects for public use those commonly used words and phrases that the public has adopted, denying to any one competitor a right to corner those words and phrases by expropriating them from the public linguistic commons.

Enforcing these conflicting policies creates problems that are not always easily solved.

Who Grants Trademarks...and How?

Getting a trademark takes **time and money**. It's wise to first search the trademark database for pending and existing trademarks so you don't file

for someone else's trademark. This can easily be done by going to *http://tess.uspto.gov*, by visiting the Trademark Public Search Library in Virginia or by visiting other such libraries throughout the country that house these databases (refer to Appendix A for help). Private search firms will also conduct a search for a fee. Then, you must fill out the application and pay a filing fee, which generally is $325 per class of goods or services. (Again, refer to Appendix A for information and contacts regarding the trademark application process.) It can take months before you get your federally registered mark, or "notice of allowance," and you might encounter a few bumps in the road that call for a trademark trial and appeal board. The **U.S. Patent and Trademark Office** (*www.uspto.gov*) does not decide whether you have the right to use a given mark, however, so even without a registration you can still use any adopted mark to identify the source of your goods and services. Once you obtain a federally registered mark, it's up to you to enforce your rights in the mark.

In the U.S., the Commissioner of Patents and Trademarks grants trademarks. When the Commissioner's office is considering an application for a trademark, it lists the mark on its Principal Register and issues a certificate of registration. This certificate provides the registrant with *prima facie* evidence of:

* the validity of the mark and its registration;

* the registrant's ownership; and

* the registrant's "exclusive right" to use the mark on or in connection with the goods and services specified in the certificate of registration.

The Commissioner does not register a mark unless it meets the requirements established by statute. With a certificate of registration, therefore, the registrant obtains evidence that its mark is not generic in the eyes of the relevant public and that its mark is not merely descriptive, but at a minimum is descriptive and has secondary meaning.

Through the certificate of registration, the Commissioner introduces his opinion that the application of the registrant was sufficient to demonstrate a valid mark. The Commissioner need not require evidence of secondary

meaning if the applied-for mark is "inherently distinctive by being suggestive, arbitrary or fanciful."

However, the Commissioner and the Patent and Trademark Office (PTO) are not the final arbiters of what can be trademarked. Federal law vests ultimate adjudication of trademark disputes in the federal courts. (So, trademark holders who allege infringement may sue infringers in federal court and obtain monetary damages, equitable relief or both.)

More revealing, Congress expressly vested in federal courts the power to "determine the right to registration, order the cancelation of registrations, in whole or in part, restore canceled registrations and otherwise rectify the register with respect to the registrations of any party to the action."

When a **certificate of registration** is entered into evidence, it serves only as *"prima facie* evidence of the validity of the registered mark."

The Lanham Act

Although it's become a staple of intellectual property disputes involving trademarks, the Lanham Act was not intended to be used as it is today. It was originally designed as a more general law to prohibit a wide range of unfair business practices.

But trademark law is a body of court decisions looking for statutory support. Without the clear conceptual definitions that shape copyrights and patents (lawyers call this clear origin "black letter law"), trademark disputes grab on to various parts of various laws that will add some definition—and the Lanham Act is a big part of this grabbing.

When it comes to intellectual property issues, three sections of the Lanham Act cited most often are:

- Section 32(1), which prohibits trademark and service mark infringement;

- Section 43(a), which prohibits false designation of origin and false description of products and services; and

- Section 43(c), which prohibits trademark dilution.

The first and third sections have an obvious connection to issues involving registered trademarks. Section 43(a) applies in a less explicit way. And, maybe because of that, it's cited even more often than the other two.

Section 43(a) of the Lanham Act states, in part:

> Any person who, on or in connection with any goods or services, or any container for goods, uses in commerce any word, term, name, symbol or device, or any combination thereof, or any false designation of origin, false or misleading description of fact, or false or misleading representation of fact—which (A) is likely to cause confusion, or to cause mistake, or to deceive as to the affiliation, connection or association of such person with another person, or as to the origin, sponsorship or approval of his or her goods, services or commercial activities by another person; or (B) in commercial advertising or promotion, misrepresents the nature, characteristics, qualities or geographic origin of his or her or another person's goods, services or commercial activities, shall be liable in a civil action by any person who believes that he or she is or is likely to be damaged by such act.

This section covers a lot of ground. What it means, in practical effect, is that a lot of words and phrases that aren't—strictly speaking—registered trademarks can be treated as if they were.

Since the process for registering a trademark is so much more subjective than prosecuting a patent or filing a copyright, the looser language of Section 43(a) makes a big difference. And that language creates as much controversy for courts as it resolves.

Why Trademark Cases Are So Complex

Because trademarks are valuable—and because the black letter law that supports them is something of a patchwork—owners often fight hard when they think their trademarks have been violated or used improperly.

The Value of a Good Idea

Another complicating factor has nothing to do with court decisions or black letter law. Since the 1990s and early 2000s, **branding** has become a central tenet of business management. Companies want their product to resonate with customers and potential customers. When you think of something as basic as tuna, do you see a can of plain tuna or do you see the Starkist label…or maybe even Charlie the Starkist tuna character? If Charlie came to mind, then the makers of Starkist tuna have done a good job branding.

But what—mechanically—constitutes a brand? Tough to say. Surely, a brand is a combination of many things…part consumer awareness, part implied meaning and part marketplace good will. It begins to sound like our discussions of trademarks.

In the intellectual property arena, **trademarks are the closest thing to brands**. If a company is trying to develop or protect its brands, its attorneys will turn their attention to its trademarks. Investors or strategic partners may do the same.

So, while the consumer may have a hazy notion of who owns a particular trademark, lawyers and executives are keenly and intricately aware.

To begin our discussion of how trademarks have played out in the courts, we'll first look at the heated trademark dispute that occurred between the Hard Rock Café restaurant chain and the Hard Rock Hotel & Casino in Las Vegas. Most people probably think the two are one in the same— that the Vegas casino is simply part of the restaurant chain. The truth is a lot more complicated, as the September 1999 federal court decision *Hard Rock Café International (USA), Inc. v. Peter A. Morton and Hard Rock Hotel, Inc.* demonstrates.

First, some back story. Peter Morton and Isaac Tigrett founded the Hard Rock Café in London in the summer of 1971. They were two music-loving Americans who created an instant classic with a blend of casual American fare and a flamboyant rock'n'roll setting. Their company was the first of the wave of "theme restaurants" that would dominate the industry in the 1980s and 1990s. But it wasn't easy for these two enterprising personalities to run even a thriving business together and, by 1985,

they had divided the Hard Rock world into two halves. Morton took the United States and Tigrett took the rest of the world.

In early 1996, Morton sold the U.S. Hard Rock restaurants, including his interest in the Hard Rock trademark, to the U.K.-based Rank Organisation. Rank had already acquired Tigrett's restaurants through several prior transactions—now, it was reassembling the global operation under a single corporate banner. Sort of.

Morton retained considerable rights under his deal with Rank. When the sale was completed, Morton had $410 million in cash, the Hard Rock Hotel in Las Vegas and the right to develop other Hard Rock hotels in several agreed-upon locations. He also had a license agreement that gave him the **right to use the Hard Rock trademark** for his hotels and for certain merchandising purposes.

At the time, Rank was happy with the arrangement. The Las Vegas hotel and casino had been doing pretty well since it opened in March 1995, but Rank management thought it was at odds with the family-oriented focus it had planned for the Hard Rock chain. Letting Morton keep the casino as a kind of franchise seemed like a good solution.

When Morton and Rank had been negotiating the sale, the two sides discussed jointly developing a Web site that would allow users to access information about the Hard Rock Cafés and the Las Vegas Hard Rock casino.

Morton, whose company was the more Web savvy of the two, registered the URL hardrock.com and began developing the site with occasional input from Rank. (Rank did not hire its own Web developer until 1998.)

Morton's main man for the job was Warwick Stone, an employee in various capacities since the early 1980s and—as of 1995—Morton's Creative Director. The Web site began operation in June 1996, complete with Hard Rock logos and a link to a separate Hard Rock Hotel site.

Rank didn't like this. It fired the first legal salvo within a year of acquiring Morton's restaurants. In the suit, Rank alleged many things, including breach

of contract, trademark and service mark infringement under the Lanham Act and trademark dilution.

More specifically, Rank claimed that Morton had breached the sale agreements by using the hardrock.com domain name, selling merchandise not granted by the license agreement and selling records on the site (through a link to another vendor unrelated to any of the Hard Rock enterprises). Rank wanted $100 million in damages.

Morton argued that Rank had been lazy and inattentive about business on the Internet. Several of its licensees and franchisees used unauthorized versions of Hard Rock Café trademarks on the Web. And a number of unrelated companies and individuals used logos and variations of "Hard Rock" in domain names on Web sites—without any license or permission from Rank. In all, **Rank hadn't enforced its trademarks on the Internet** until Morton had developed his site.

The court found that Rank had sued Morton's Web designer as an individual in a separate suit, without ever sending him a cease and desist letter. The court also noted that Rank had sent mixed signals by telling Morton—after suing his developer—that it would continue to support a link between the two parties' Web sites.

Rank's Lanham Act claims were also shaky. In order to bring the Lanham Act into the lawsuit, Rank claimed that Morton's use of the Web site infringed upon its trademarks. But, under questioning from Morton's attorneys, Rank managers admitted that any display of information about the Hard Rock Cafés on the Hard Rock Hotel site benefited the Hard Rock Café marks. Likewise, "any gains to the goodwill of the Hard Rock Hotel mark also benefit[ed] the Hard Rock Café mark."

The court noted, coolly:

> Obviously, [Rank] knew of and encouraged the public's view that Hard Rock Hotel was linked with the Hard Rock Cafés and it never tried to disassociate the two brands in the eye of the public. The two entities shared several cross-promotions…and shared the goodwill.

These facts made it hard for Rank to sustain on any of its claims. The court sided with Morton and his hotel, concluding:

> [Rank] presented no evidence at trial of any monetary or other pecuniary damages it has suffered, other than costs it has incurred in its effort to gain control of the "hardrock.com" domain name. [There is] no conceivable basis upon which damages of anywhere near this magnitude [$100 million] could have been recovered....

Several things pushed the ruling in Morton's favor.

First, he was quick to act at the first signs of litigation. When Rank first voiced concerns about the Web site—how Morton advertised his hotel and how he sold merchandise online—Morton stopped all of the challenged activity. Before the trial started, Morton moved all of his Web content to his hardrockhotel.com site and handed Rank the hardrock.com domain name. These responsive measures allowed Morton to avoid damages under the Lanham Act.

Second, Rank's slow move to the Internet and its failure to enforce its trademarks generally were both big mistakes. In this context, Rank had a **hard time establishing Lanham Act damages**. And Morton's use of the hardrockhotel.com domain name—when he had a license that allowed him to run the hotel and was silent on matters of Internet use—seemed reasonable.

Rank's demands for actual damages, an accounting of Morton's profits, attorneys' fees and punitive damages were denied. The court emphasized its reasonings:

> [Rank]'s delay in bringing any complaint about the content of the Web site, defendants' good faith efforts at arbitration and voluntary corrective action following the failure of mediation in which they participated, and the branding of defendants' Web site, [indicates] there [was] insufficient basis for a finding of bad faith infringement or willful intent to deceive consumers.

This case illustrates several aspects of trademark law, most of which we'll discuss in detail as we go along. Because the purpose of the Lanham Act

is to allow those who place their goods and services into the marketplace to **distinguish such goods and services from those of their competitors**, it's easy to see how these two disparate entities of Hard Rock came head to head over various trademark issues.

Four Classes of Trademark Terms

To simplify the area of trademarks, it's important to note how the courts break marks down into types, from which they can pass judgments and settle disputes between parties.

Federal case law and sections of trademark statute identify **four different classes of terms** or phrases which can be protected by U.S. trademark law. Ranked in an ascending order of their eligibility to trademark status and the degree of protection accorded, these classes are:

- generic;

- descriptive;

- suggestive; and

- arbitrary or fanciful.

The lines of demarcation among these classes of terms are not always clear. A term may shift from one category to another in light of differences in usage through time; a term may have one meaning to one group of users and a different one to others; and a term may be used differently with respect to a single product.

Nevertheless, these four classes are worth some attention. Why? Because they are commonly used in trademark law.

A *generic term* is one that refers, or has come to be understood as referring, to the genus of which the particular product is a species. Examples include words like *aspirin*, *escalator*, *linoleum*, *zipper* and *yo-yo*. Even combinations of generic terms remain generic: honey brown ale; super glue; and shredded wheat. Under common law, neither generic nor merely descriptive terms could become valid trademarks. The 19th Century Fed-

eral Court decision *Delaware & Hudson Canal Co. v. Clark* put this point plainly:

> Nor can a generic name, or a name merely descriptive of an article or its qualities, ingredients or characteristics, be employed as a trademark and the exclusive use of it be entitled to legal protection.

Throughout the 20th Century, federal trademark law softened this position. It allowed an important exception with respect to descriptive terms; the Trademark Act of 1920 permitted registration of certain descriptive marks that had **acquired secondary meaning**. That is, if it conveyed some sense of a specific product or service.

The Lanham Act took this exception even farther by defining secondary meaning in language that was good for trademark applicants:

> [N]othing in this [section] shall prevent the registration of a mark used by the applicant which has become distinctive of the applicant's goods in commerce [and federal regulators] may accept, as *prima facie* evidence that the mark has become distinctive, proof of substantially exclusive and continuous use of the mark applied to the applicant's goods for five years preceding the application.

So, five years of commercial use would give a descriptive term the presumption of a secondary meaning. Examples include *After Tan* (for after sunbathing lotion), *Home Savings* (for banking services) and *Bufferin* for buffered aspirin.

But the law still treats generic terms harshly; it's almost impossible to make a trademark out of a generic term or phrase. In fact, federal trademark law provides for the cancelation of a registered mark if at any time it "becomes the common descriptive name of an article or substance."

This means that even proof of secondary meaning, by virtue of which some "merely descriptive" marks may be registered, cannot transform a generic term into a subject for trademark.

> The standard for generic terms remains tough because granting trademarks to these terms would, in effect, confer a monopoly not only of the mark but of the product—rendering a competitor effectively unable to name what it was endeavoring to sell.

A classic example:

> A manufacturer makes and sells a "Deep Bowl Spoon." It seeks to trademark that phrase. "Deep Bowl" identifies a significant characteristic of the product. It is merely descriptive of the goods, because it informs you that you are deep in the bowl. It is not, however, the common descriptive name of the article since the product is not a deep bowl. It is a spoon. "Spoon" is not merely descriptive of the product; it identifies the product and, therefore, the term is generic.

The solution? The manufacturer would have to develop some version of the phrase that doesn't include the word *spoon*. And then since the phrase is descriptive, it would need to **show continuous commercial** use for at least five years.

Continuous Commercial Use

This issue of continuous commercial use causes a lot of problems. Some manufacturers or marketers argue that the need to show commercial use for at least five years means that they have to invest money in promoting brands or taglines during this time—before receiving the mark. And, a mark may end up in the public domain anyhow, making all that marketing and advertising money pointless.

The words *Internet*, *pixel*, *chip*, *software*, *byte* or *e-mail* might well have become marks distinguishing one entrepreneur's product or service from other electronic networks, screen density aspects, transistorized com-

ponents, sets of computer commands, groups of digital information or electronic communications.

However, pervasive use of these terms have made them generic. And even when created words for new products have become strong marks, the public's pervasive use of these marks sometimes creates a real **risk that their distinctiveness will disappear**, a process that has occurred with earlier trademarks such as *thermos*, *aspirin* and *escalator*.

But federal courts have remained staunch in their position. For example, according to one court:

> No matter how much money and effort the user of a generic term has poured into promoting the sale of its merchandise and what success it has achieved in securing public identification, it cannot deprive competing manufacturers of the product of the right to call an article by its name.... The pervasiveness of the principle is illustrated by a series of well known cases holding that when a suggestive or fanciful term has become generic as a result of a manufacturer's own advertising efforts, trademark protection will be denied save for those markets where the term still has not become generic and a secondary meaning has been shown to continue.[1]

Thus, a chastened company might conclude, the best strategy is to avoid phrases that are made up of generic terms. Otherwise, the only workable option is to argue that the phrase may thus be generic in one market but descriptive, or suggestive or fanciful in another. And that's tough.

Descriptive in One Sense, Generic in Another

Designing and marketing clothing is a competitive business and has been for quite a while. Today, Abercrombie & Fitch is a trendy clothing retailer; however, the company's trademarks on its merchandise date back to the early part of the 20th Century when the company touted itself as "The

[1] See *Abercrombie & Fitch Co. v. Hunting World, Inc.* (1975); and *CES Publishing Corp v. St. Regis Publications, Inc.* (1976).

The Value of a Good Idea

Greatest Sporting Goods Store in the World." Back then, A&F's claim to fame was its high-quality hunting, camping and fishing gear for professionals, not trendy men's and women's clothing. Started in 1892, A&F was an outfitter of sorts, but eventually grew to make and sell sporting clothes for both the outdoorsman and woman. (A&F was among the first to sell sporting clothing to women in the Big Apple.)

A&F's trademark Safari Mills was registered in 1919 and referred to its cotton goods. Then, beginning in 1936, A&F used the **safari mark** on a variety of men's and women's outer garments. It also spent a considerable amount of money in advertising and promoting its products under this label. Decades later, however, a competitor began to use the same word on its apparel, and a long battle ensued.

The 1976 Federal Appeals Court decision *Abercrombie & Fitch Company v. Hunting World, Inc.* began in New York in 1970. At the time, A&F had stores at Madison Avenue and 45th in New York City and in seven other places in other states. The company had hit its high point, and unfortunately, the lawsuit represented the beginning of the end of its financial soundness. The courts ran amok over the myriad existing principles related to trademarks. At the core of the problem was the alleged legal right to trademarks for common words like *safari*. By the time the case reached the U.S. Court of Appeals, it was 1975—five years after A&F first filed its complaint.

A&F's beef was with a New York competitor, Hunting World, located on East 53rd Street. The store specialized in sporting apparel, including hats and shoes that were identified by use of the word safari alone or by expressions such as *minisafari* and *safariland*. A&F believed that these words confused and deceived the public, impairing "the distinct and unique quality of [A&F's] trademark."

So, A&F filed a lawsuit, in the hopes of preventing Hunting from using its mark. A&F also hoped to receive a monetary reward for damages and lost profits. (Whether the company was motivated by its impending money troubles is a question for another discussion.)

Hunting argued that safari was an ordinary, common, descriptive, geographic and generic word commonly used and understood by the public to mean and refer to a journey or expedition. So, the word could not be trademarked. Hunting sought cancelation of all of A&F's trademark registrations that used the word safari on the ground that A&F had fraudulently failed to disclose the true nature of the term to the Patent and Trademark Office.

In the first round, the trial court sided with Hunting—for the most part, holding that the word was indeed generic but that A&F could have created a secondary meaning in its use of the word. The court concluded that A&F had no right to prevent Hunting from using the word to describe its business (that is, organizing safaris to Africa). The court also held that Hunting did not infringe A&F's registered mark using the word safari under its brand name on a classical safari hat or in advertising the hat as "The Hat for Safari." Such use was purely descriptive, said the court.

Furthermore, the court said that Hunting had not infringed by using the term minisafari as a name for its narrower brimmed safari hats, and that it was entitled to use the word safariland as the description of an area within its shop. Use of safariland wasn't new; the term was also used as the name of a corporation engaged in the wholesale distribution of products imported from East Africa by an affiliate and in the "Safariland News," a newsletter.

With respect to naming shoes, the court concluded that both parties had used the word safari in a fanciful rather than a descriptive sense. Keeping the door open for A&F, the court ruled that if the company could prove that it had established a secondary meaning via the use of the word safari, then it could argue an infringement claim.

A&F appealed. And the appeals court reversed the trial court's ruling on technical grounds. The appeals court didn't make any broad decisions; it just sent the case back for another trial.

In the second round, the court ruled more broadly in Hunting's favor—again finding that there was **already frequent use of the word safari in connection with apparel** and that A&F's policing efforts had been un-

successful. In addition, the court pointed out that A&F had itself used the term in a descriptive sense not covered by its registration when it had urged customers to make a "Christmas Gift Safari" to the A&F store.

This level of analysis may seem trivial. But the mechanics of trademark use turn on trivial points.

The court concluded that trademark law may, in certain instances, protect common terms, such as the word safari. However, this protection only applies if the term comes to identify the company that is merchandising the product, and not the product itself. A&F had failed to establish this with respect to the word safari because it hadn't proved that the word safari immediately led people to think of the company and its products.

The court then entered a judgment that not only canceled the four registered trademarks that were the focus of the lawsuit but also all of A&F's other registered safari trademarks. Not surprisingly, A&F appealed again.

The appeals court started by analyzing the various uses of the word safari in relation to the disputed clothes. The case took on the **tone of a college linguistics seminar**.

First, the appeals court determined the scope of protection to which A&F was entitled. It concluded:

1) The word "safari" is a generic term when it refers to specific types of clothing; thus, "minisafari" could be used to describe variations on these specific types (for example, a smaller brim version of the traditional safari hat).

2) The word "safari" is not, however, a generic term for boots or shoes; it is either "suggestive" or "merely descriptive" and is a valid trademark.

3) A&F stood on stronger ground with respect to Hunting's use of "Camel Safari," "Hippo Safari" and "Chukka Safari" as names for boots imported from Africa because no evidence suggested that "safari" was a generic term for boots.

But the appeals court also made a decision more important than the hats-versus-boots distinction. It didn't agree with the lower court's broad in-

validation of A&F's trademarks and ruled that the court had to decide specifically which items A&F could rightfully claim as its mark.

Prior case law established that **a word could be generic in one sense but not in others**. An example often used by the courts is the word "ivory"; it's generic when used to describe a product made from the tusks of elephants…but arbitrary when applied to soap. In this case, the appeals court decided that the word safari was generic when applied to hats, jackets, and "expedition[s] into the African wilderness" but fanciful when applied to shorts, scarves, portable grills and other items.

This was a big win for A&F, whose stores in those days were full of gear with the word safari stitched in the label.

Hunting argued that A&F had registered trademarks on these other items fraudulently by deceiving the Patent Office into registering them without proof of secondary meaning. However, the appeals court ruled that terms like safari luggage and safari swimtrunks were suggestive rather than "merely descriptive." The word safari does not describe things like ice chests, axes, tents and smoking tobacco. "Rather it is a way of conveying to affluent patrons of A&F a romantic notion of high style, coupled with an attractive foreign allusion," the court noted. As such, A&F could claim a mark to suggest A&F quality.

In all, the appeals court's decision was a mixed bag. It allowed the cancelation of A&F's marks over generic uses of the term but reversed the cancelation of marks that A&F had proven conveyed secondary meanings.

A&F's problems didn't end with this lawsuit though. The **company declared bankruptcy** a year after the case closed. Business didn't improve much after Oshman's Sporting Goods bought the company. And, by the time The Limited snatched it up in 1988, the company needed a major facelift. A&F survived through a new look and a focus on trend-setting clothes rather than on boats, tents and icepicks. Today, you won't even find items marked with the term safari at an A&F store.

The case set a new tone in trademark law, though, by stressing that—while generic marks cannot receive trademark protection—a mark can be generic in one sense but distinctive in another. And, unfortunately, proving that distinction is usually left to the courts.

Suggestive and Fanciful Terms

The class of suggestive marks was spawned by the need to accord protection to marks that were neither exactly descriptive on the one hand nor truly fanciful on the other—a need that was particularly acute because of the bar in the Trademark Act of 1905 on the registration of "merely descriptive" marks regardless of proof of secondary meaning.

Having created the class of suggestive terms, the courts have had a very hard time defining it. Judge Learned Hand—usually a beacon of clarity—made this not-so-helpful statement:

> It is quite impossible to get any rule out of the cases beyond this: That the validity of the mark ends where suggestion ends and description begins.

Another court observed, somewhat more usefully, that:

> A term is *suggestive* if it requires imagination, thought and perception to reach a conclusion as to the nature of goods. A term is *descriptive* if it forthwith conveys an immediate idea of the ingredients, qualities or characteristics of the goods.

Examples of suggestive marks include Coppertone, Playboy and Q-Tips. In the unlikely chance that you've never heard of these products, their marks require some thought and perception to determine the nature of the goods or services. Descriptive terms that we've mentioned (i.e. Home Savings, After Tan) and others like Open MRI, World Book (for encyclopedias) and Spex (for optician services) don't need you to go that extra mile when wondering what these mean with regard to the good or service.

The Second Circuit U.S. Court of Appeals also cleared the matter up a bit in its 1958 decision *Aluminum Fabricating Co. of Pittsburgh v. Season-All Window Corp.* Here, the court wrote that the reason for restricting the protection accorded descriptive terms, namely the undesirability of preventing an entrant from using a descriptive term for his product, is much less forceful when the trademark is a suggestive word since:

> The English language has a wealth of synonyms and related words with which to describe the qualities which manufacturers may wish to claim for their products and the ingenuity of the public relations profession supplies new words and slogans as they are needed. If a term is suggestive, it is entitled to registration without proof of secondary meaning.

The distinctions between suggestive terms and fanciful or arbitrary terms may seem artificial. A common word may be used in a fanciful sense; indeed you could argue that only a common word can be used fancifully, since a coined word can't be put to a bizarre use.

Nevertheless, the term fanciful, as a classifying concept, is usually applied to **words invented solely for their use as trademarks**. Examples include Exxon, Kodak and Xerox. When the same legal consequences attach to a common word, i.e., when it is applied in an unfamiliar way, the use is called arbitrary. Examples include Apple (for a computer), Jaguar (for a car), Camel (for cigarettes) and Beefeater (for gin).

Fanciful or arbitrary terms make the best trademarks because they enjoy all the rights accorded to suggestive terms as marks—without the need of debating whether the term is merely descriptive and with ease of establishing infringement.

Arbitrary Doesn't Need Secondary Meaning

Essentially, any phrase—other than the most fanciful or arbitrary—must be supported by secondary meaning. Sure, five years of continuous commercial use can create the presumption that secondary meaning exists; but presumptions are rebuttable. And disputes over descriptive or generic marks and secondary meaning can get complex.

In the February 2001 Federal Appeals Court decision *America Online, Inc. v. AT&T Corp.*, two corporate giants faced off in court over three trademarks relating to the Internet service features Buddy List, You've Got Mail and IM. The case would ultimately turn on the **importance of secondary meaning** with regard to descriptive or generic terms used in a disputed trademark.

Founded in 1985, AOL is the world's largest Internet service provider, claiming millions of members. Most people are familiar with AOL's services, which, include e-mail, chat rooms and a set of services called "instant messaging."

AOL's Buddy List enables subscribers to create a list of identified screen names with whom the subscriber wishes to communicate. The feature then displays which of the pre-selected users is currently using the AOL service. If a Buddy is identified as online, the subscriber may then click a button labeled IM, short for "instant messaging," and initiate a real-time exchange of messages.

AOL began using the terms Buddy List and IM in 1997. Because it promoted these features extensively, AOL believed that it had a proprietary interest in them. The company obtained a certificate of registration for the Buddy List mark in June 1998, indicating that it had used the mark since August 1995.

Another famous AOL feature is the cheerful voice that announces to the user You've Got Mail, accompanied by an icon of a traditional mailbox with a raised red flag. The company did not use the phrase as a trademark, but it asserted its proprietary interest in the term. AOL indicated that it had used the box and voice since 1992.

A dispute arose when AT&T, a competing ISP began using similar phrases, including Buddy List, You Have Mail and I M Here. In December 1998, AOL sued AT&T, alleging that AT&T had violated the trademark dilution provisions of federal law and had infringed on AOL's marks. AOL wanted monetary reward for lost profits, damages, punitive damages, attorneys' fees and costs.

AT&T, on the other hand, said that the words were "common, generic terms" for those services. And it denied that the terms had developed any secondary meaning that people equated with AOL. AT&T filed a counterclaim seeking a declaratory judgment that AOL's marks were not valid trademarks and requested that the trademark registration for Buddy List be canceled.

The trial court ruled in AT&T's favor, saying that all three marks were incapable of functioning as trademarks—that they were **generic terms that hadn't developed secondary meaning**. The court also ordered cancelation of the Buddy List registration, basing its decision on evidence from third-party sources, including Internet dictionaries, published users' guides to both the Internet and to AOL services, uses of the alleged marks by competitors and even use by AOL in a manner pointing to their generic character.

AOL appealed, arguing two critical points:

- that the district court should not have called the term Buddy List generic because the Patent office, which had registered the mark, was the expert agency in that regard; and

- that the district court had failed to apply the "primary significance" test correctly when ruling the marks generic. (This was because the court had focused on the use of the mark in published sources rather than on the perceptions of consumers.)

The appeals court focused on the most well-known of the disputed marks—the prompt You've Got Mail. To start with, You've Got Mail was never registered as a trademark, so AOL had to prove that it had valid trademark rights…and that AT&T had infringed on these valid marks

by creating confusion or deceiving the public. AOL, however, did not meet this burden. Specifically, the court wrote:

> "You Have Mail" has been used to inform computer users since the 1970s, a decade before AOL came into existence, that they have electronic mail in their electronic "mailboxes." ...[I]n the context of computer-based electronic communication across networked computers, the phrase "You Have Mail" has been used for the common, ordinary purpose of informing users of the arrival of electronic mail.... .

Books describing how a computer user is informed that he has e-mail similarly revealed the functional nature of the phrase. Other companies (e.g. Prodigy, Netcom, Qualcomm) used the phrase to notify subscribers.

All of this added up to a textbook case of the sort of generic term that can't be appropriated as a trademark.

AOL kept pressing, though. It made the only argument it had left: That, even though it was generic, the term You've Got Mail had developed a secondary meaning that people associated with AOL. It offered the court the results of a survey it had conducted which supposedly showed that people readily associated You've Got Mail with AOL.

But the appeals court wasn't convinced. The fact that the term had been used long before AOL existed was simply too strong to overcome. Although a portion of the public did seem to associate You've Got Mail with AOL, the court could not find this to be a distinctive aspect. The term You've Got Mail was **functional because it means what it says**. And weakly-established secondary meanings did not entitle AOL to exclude others (some who were there first) from a functional use of the word.

"We agree with the district court that when words are used in a context that suggests only their common meaning, they are generic and may not be appropriated as exclusive property," the appeals court concluded.

AOL would have to share its generic terms with the rest of the cyberworld. It couldn't appropriate the wheel and then trademark it.

Later in this section, we'll take a closer look at secondary meaning and how it affects trademark decisions. Establishing secondary meaning can mean the difference between winning a verdict and losing a trademark.

Senior Marks and Reverse Confusion

Because they involve legal standards and guidelines that can be quite subjective, trademark cases often churn through various hearings, appeals and retrials. In a classic example of this phenomenon, two companies eventually had to live and conduct business with **nearly identical marks**. The case culminated in the October 1998 Federal Court decision *Alta Vista Corporation (AVC), Ltd. v. Digital Equipment Corp.* And it paved a path for future trademark litigation.

Most readers of this book have probably heard of AltaVista, an Internet search engine launched by computer giant Digital in 1995. The site attracts millions of users monthly and, through most of the late 1990s, was ranked consistently among the 10 most popular sites on the Internet.

But Digital was not the first entity using the term "Alta Vista" on the Web. Alta Vista Corporation (AVC), a small, London-based company, was a specialized literary services agency that provided labor-intensive representation and management to its clients, mostly writers seeking to publish books or to produce films or television shows. AVC had begun using the service mark Alta Vista in New York City and Los Angeles in 1993, but it did not seek to have a more general presence in the United States until 1997. In January of that year, it took out its first ad in an American publication. In April it created a Web page to give Americans an easy way to find out about its services; and in September of that year its trademark on Alta Vista was issued.

When Digital launched its search engine in 1995, it was not aware of AVC or its use of the name Alta Vista. It had chosen the name in a brainstorming session because of its meaning in Spanish: "high view." It then went on to use the term for over two and a half years.

The Value of a Good Idea

After launching the search engine, Digital introduced an array of Internet-related computer software, starting in May 1996. It marketed its software under numerous AltaVista names, including AltaVista Directory, AltaVista Mail, AltaVista Forum and AltaVista Firewall and later entered into agreements with other large corporations, including Amazon.com and OneZero Media. Digital's Alta Vista continued to break into new markets and provide more services for Internet users.

With all these deals making news, AVC sued Digital, arguing that, **by making the high-profile agreements** with Amazon.com and others, Digital "expanded its AltaVista business into a full-fledged media company" and, in doing that, **it competed with AVC's mark** in New York City and Los Angeles.

Specifically, AVC claimed that it suffered *reverse confusion*, in which a less well-known senior user's goodwill and identity are overwhelmed by a more well-known junior user's use of a confusingly similar mark.

Digital responded by saying there was no substantial likelihood of confusion between the two marks. It acknowledged that the marks were similar, but claimed that they made different impressions in their respective commercial contexts. More importantly, Digital claimed that it was not "a full fledged media company," and that it had not expanded into "media development, publicity and promotion services." In addition, said Digital, the cost of changing the name of Digital's AltaVista search engine would be very high, significantly higher than even the proportional cost to the much smaller AVC of clarifying any confusion that would arise from the similar marks.

To succeed under federal trademark law, AVC had to show:

- that it used, and thereby owned a mark;

- that Digital was using that same or a similar mark; and

- that Digital's use was likely to confuse the public, thereby harming AVC.

Digital did not contest that AVC owned, used and was the senior user of the Alta Vista mark in New York City and Los Angeles. In addition, there

was no doubt that the two marks had a strong resemblance, at least out of context. The more difficult question was **whether the resemblance led to confusion**. And, in order to determine that answer, the court delved into a variety of subjective issues, including:

- the similarity of the marks;
- the similarity of the goods the marks represent;
- Digital's intent in adopting its mark;
- the strength of AVC's mark.
- the relationship between the parties' channels of trade;
- the relationship between the parties' advertising;
- the classes of prospective purchasers; and
- evidence of actual confusion.

In a move that invariably seems to make more sense for attorneys, AVC asked the court to support its claims in a summary judgment before the case went to trial. This turned out to be an unwise tactic; the standard for winning such a preemptive ruling is very strict. And, on these terms, the court ended up ruling largely for Digital.

First, it noted that, when viewed out of context, the marks seemed highly similar. But, in their respective contexts (in other words, knowing that one was an Internet search engine and the other was a high-tech literary agency), they were hard to confuse. On a related point, the court ruled that AVC and Digital's services were fundamentally dissimilar and noncompetitive.

Second, the court observed that AVC's clientele came from a small, very **sophisticated segment of the information economy**. The sophistication of those clients was sufficiently high so that they could be expected to know the difference between a search engine and a literary agent.

Third, the court ruled that there was little evidence to demonstrate that actual confusion had taken place.

Fourth, the court concluded that AVC had not proved that Digital showed any bad faith in adopting the AltaVista mark. Digital's employees swore that they weren't even aware of AVC when they came up with the name for their search engine—and the court believed them.

Last, the court looked at the respective hardships imposed on each party. It ruled that the harm AVC would suffer was the minimal cost of setting the record straight for those people who were curious if there was any connection between AVC and Digital. By contrast, it concluded that the cost to Digital of changing the name of its search engine subsidiary would be quite substantial.

It may seem unequitable somehow that the court ruled so certainly for a corporate giant against a plucky upstart. But AVC made the same mistake that many companies dealing with trademarks do—it expected the courts to enforce its trademark like a patent or copyright. In fact, a trademark is the **most subjectively enforced** of all three types of intellectual property protection.

The outcome of a trademark dispute is always tough to predict…and, for all the reasons we've seen, it's much more difficult to predict than a patent or copyright dispute.

Can You Trademark a Domain Name?

Legal fights over domain names are common in the Internet Age. When the domain name involves an ugly twist of words and meaning, however, interesting situations can arise. Take, for example, the June 2000 Federal District Court decision *PETA v. Michael T. Doughney*. This case arose after a man bought the domain name peta.org and used it to run a site featuring materials on eating meat and hunting. (For him, "peta" stood for People Eating Tasty Animals.)

Of course, the prominent animal rights group wasn't too happy.

PETA (People for the Ethical Treatment of Animals), although not embraced by everyone, is a very public and global organization, which was established as a nonprofit corporation in 1980. The active and vocal group

led the backlash against fur coats that made news in the late 1980s and early 1990s. Throughout its history, the group has focused its marketing efforts on recruiting the support of celebrities from film and television—and has raised its profile effectively with this support.

The organization obtained a registered trademark to its name, PETA, in 1992; but it was using the trade name continuously since at least 1980.

In September 1995, Michael Doughney registered several domain names—including peta.org for a nonprofit organization—with the Internet clearinghouse Network Solutions. Doughney registered numerous domain names that included or were based on the names or acronyms of well-known organizations. He seems to be a member of the group of Internet enthusiasts who saw the value in domain names before mainstream America did.

When Doughney registered the name, PETA had no Web sites of its own. Normally, PETA positions itself as a grass-roots organization battling plodding corporate giants; it was about to experience those tables being turned.

Doughney's use of the four-letter abbreviation referred to "People Eating Tasty Animals"—a cause diametrically opposed to that of PETA. When registering the site, Doughney indicated that peta.org did not interfere with or infringe upon the rights of any third party.

Doughney's Web site contained the obvious: information and materials antithetical to PETA's purpose. It was "[a] resource for those who enjoy eating meat, wearing fur and leather, hunting, and the fruits of scientific research." Over 30 links on the site led visitors to commercial sites promoting, among other things, the sale of leather goods and meats.

In January 1996, PETA sent Doughney a letter requesting that he relinquish his registration of the domain name because it infringed upon the longstanding registered service mark of its organization. When PETA then complained to Network Solutions in May 1996, peta.org was put on hold—as allowed by federal anticybersquatting law. Doughney reacted to this by transferring the contents of his Web site to another site.

The Value of a Good Idea

PETA filed a lawsuit alleging claims for **service mark infringement**, unfair competition, service mark **dilution** and **cybersquatting**. Doughney claimed there was no infringement because his Web site was a parody. PETA dropped its claim for damages and sought, instead, to merely stop him from using the site and to turn it over to PETA.

This case didn't go past the district court. It ended quickly and without an appeal. The facts of the case met the requirements of several different federal laws covering this sort of dispute.

First, the court acknowledged that PETA owned the PETA mark and that Doughney didn't have a defense to its validity and incontestability. The PETA mark was thus presumed to be distinctive as a matter of law.

Second, Doughney used the identical PETA mark to register a domain name and post a Web site.

Third, Doughney admitted that his use of the mark was "in commerce," and the court agreed. It found that Doughney used the mark in connection with the sale, distribution and advertising of goods and services in commerce, albeit mostly having to do with the dissemination of information. And, under the law, it **only takes one link to another commercial site** to suffice the commercial use requirement of the Lanham Act.

Finally, Doughney's **use of the mark caused confusion**. Users who wanted to reach the real organization's site would have found Doughney's site, and would not have known that it had nothing to do with PETA or that PETA, in fact, didn't have its own site at the time.

The court also ruled that Doughney's Web site diluted PETA's mark. Doughney was found guilty of blurring the PETA mark because: 1) he used the identical mark to associate peta.org to PETA; and 2) such use caused actual economic harm to the PETA mark by lessening its selling power as an advertising agent for PETA's goods and services.

What made this case simple and brief was that PETA was entitled to

summary judgment under the Anticybersquatting Consumer Protection Act (ACPA). PETA successfully showed that Doughney acted in bad faith with the intent to profit from using peta.org; and that the peta.org domain name was identical or confusingly similar to, or dilutive of, the distinctive and famous PETA mark.

Doughney's defense argued that his expression was protected since his site was a parody. He also tried to claim that he was simply exercising his First Amendment rights. But in all, PETA did not seek to censor what Doughney had to say. The organization wanted him to stop using its mark and hand it over. When Doughney moved his material to another site, PETA did not complain; Doughney was able to continue to practice his First Amendment rights. PETA ultimately proved its case…and Doughney had to go elsewhere to rant and rave on the other side of PETA's cause.[2]

Lots of cases related to domain names and trademarks have emerged since the dawn of the Internet. In Chapter 9, we'll delve into more tricky situations that range from cybersquatting to using someone else's trademark on your Web site to promote your products. Note that in every domain name, the ".com" portion has no trademark significance. It's essentially the generic locator for all names in that top level domain.

Confusion Over Trademarks

Perhaps the most damning part of the judgment against Michael Doughney in the PETA case was the court's ruling that he had created confusion among potential PETA members about what his parody site meant.

As we've noted from the beginning of this chapter, the public policy rationale for trademark law is that it's important to **give consumers a clear, unconfused method for recognizing specific brands of goods and services**. So, the mechanics of what causes consumer confusion are a key part of understanding how trademarks work.

[2]In a rich irony, PETA later went on to reserve Internet names of organizations it opposed, including ringlingbrothers.com to use in the same manner that Doughney had.

The Value of a Good Idea

Federal courts have established an eight-part test for determining whether trademark confusion exists and, if so, how damaging it is. Specifically, the eight parts are:

1) Similarity of the marks;

2) Similarity of the goods and services;

3) Channels of trade;

4) Forms of advertising;

5) Classes of prospective purchasers;

6) Evidence of actual confusion;

7) Intent in adopting the mark; and

8) Strength of the marks.

Surprisingly, there is no consistent measure of what constitutes the strength of a mark, but five factors can be gleaned from recent case law:

- being registered;

- being in use a long time;

- being widely promoted;

- being renown in the relevant field of business; and

- being distinctive or having strong secondary meaning.

Confusion is a meaty topic in trademark law. This eight-part test is explained in detail in Chapter 8 along with several cases, which will consider how confusion fits into the mechanics of the law. For now, it's back to basics and, specifically, what the Lanham Act can do.

Damages Under the Lanham Act

The fact that Rank, in the *Hard Rock Café* case we discussed at the beginning of this chapter, had to soak up court fees raises the important question of who pays damages and under what circumstances damages are awarded in Lanham disputes. In legal terms, this is the matter of dam-

ages. The Lanham Act provides that someone who wins a lawsuit shall be entitled, subject to the principles of equity, to recover:

1) defendant's profits;

2) any damages sustained by plaintiff; and

3) costs of the action.

To recover an infringer's profits, the party making the suit must prove that the infringer acted in bad faith or with willful deception.

A showing of bad faith or willful infringement, though necessary to support an award of the infringer's profits, may not be sufficient—courts often look for additional factors, to the extent that they are relevant.

To receive an award of damages, a plaintiff must prove:

> either actual consumer confusion or deception resulting from the violation, or that the defendant's actions were intentionally deceptive, thus giving rise to a rebuttable presumption of consumer confusion.

In the case of damages based on intentional deception, "a powerful inference may be drawn that the defendant has succeeded in confusing the public," which places the **burden on the defendant** to demonstrate the absence of consumer confusion.

An award of the infringer's profits or the plaintiff's damages may be enhanced, where appropriate, to compensate a plaintiff for its actual injuries. Additionally, **punitive damages** may be awarded under state law—though such an award may require gross or wanton conduct, willful fraud or other morally culpable behavior.

> Awards of attorneys' fees under the Lanham Act are not made as a matter of course, but rather as a matter of the court's discretion.

The Value of a Good Idea

Under the Lanham Act, a prevailing defendant may recover attorneys' fees in an exceptional case, necessitating a showing of "something less than bad faith." Relevant factors include:

- economic coercion;

- groundless arguments; and

- failure to cite controling law.

Federal trial courts, when exercising this discretion, usually consider:

1) the motivation of the parties;

2) the objective reasonableness of the legal and factual positions advanced;

3) the need in particular circumstances to advance considerations of compensation and deterrence; and

4) any other relevant factor presented.

Aside from stating in detail who has to pay whom, what and when, the Lanham Act also allows courts to make certain **nonmonetary awards**.

What could be important...but nonmonetary? The trademarks themselves. The Lanham Act provides authority for courts to cancel trademarks or service marks—even if they've already been registered.

A court usually cancels a trademark only if one of two things has happened: First, if the trademarked words or phrases have changed from descriptive or fanciful to generic; second, if something about the original registration of the trademark was inaccurate or misleading.

Cancelation also may be decreed at any time if the registered mark has become "the common descriptive name of an article or substance."

Such partial cancelation accords with the rationale by which a court is authorized to cancel a registration to rectify the register by conforming it to court judgments that often must be framed in something less than an all-or-nothing way.

The Lanham Act says you can challenge a mark, which does not have a secondary meaning on the basis of a **fraudulent filing**. Normally, it's hard to challenge any mark—even a descriptive one—on the basis of bogus filing. But, the fact remains, that the Act gives the courts the right to reach back and correct—and even cancel—weak trademarks.

This is something that a trademark owner should consider before filing Lanham Act charges. The legal process may open all disputed marks to scrutiny by the court. And, if there's something that has changed the mark's status, the court may cancel an existing registration.

Trademarks and Metatags

The September 2000 New York Federal Court decision *Marianne Bihari and Bihari Interiors v. Craig Gross and Yolanda Truglio* shows how broadly some people try to use the Lanham Act.

This case involved a disputed **use of metatags**—which are lines of HTML code that allow Web designers to build links between different pages. The metatags themselves are invisible to ordinary users...but they sometimes include trademarked phrases or names (product names, company names, etc.). The question: When the metatags include trademarked phrases or names, can the owner of the trademarked phrase or name invoke the Lanham Act or other federal trademark law against unauthorized users?

The story starts with Marianne Bihari, an interior designer who established her reputation in the early 1980s by catering to wealthy clients in New York, Connecticut, California, Florida and Italy. She didn't need to rely on paid advertising to promote her services; she relied on referrals from clients and other design-industry professionals.

The Value of a Good Idea

In the late 1980s, Bihari started using the commercial name Bihari Interiors. Following the legal guidelines set by the Lanham Act and other federal law, Bihari Interiors met the basic requirements of a trademark by the mid-1990s.

Craig Gross and his girlfriend, Yolanda Truglio, were Bihari clients who decided to raise hell after an unhappy experience with the designer in the late 1990s. Gross had retained Bihari to design his condominium on East 76th Street in Manhattan. The project went badly, and, in June 1999, Gross sued Bihari—alleging **fraud** and **breach of contract**. Some legal gymnastics followed, including settlement negotiations between Bihari and Gross. But talking didn't seem to work.

In August 1999, Gross registered the domain names bihari.com and bihariinteriors.com. A few weeks later, Bihari received an anonymous fax alerting her to the Web sites. Their content was critical of Bihari, occasionally sarcastic and sometimes vicious. But they included this apologia:

> Our goal is to protect you from experiencing the overwhelming grief and aggravation in dealing with someone that allegedly only has intentions to defraud.

Gross later amended the sites to exclude this statement. Still, anyone with an Internet browser could read sections called "The Initial Meeting," "The Contract," "The Scam" and "The Law Suit." And the sites were clearly designed to solicit posts from people who'd had similar bad experiences with Bihari.

Disturbed by this use of her name and her business name in the domain name, Bihari contacted her attorney. Before the end of August, Bihari's attorney sent a letter to Gross demanding that he terminate the Web sites.

Rather than complying with the demand, Gross delivered pens to Bihari's residence that read "www.bihariinteriors.com." Bihari alleged that she started receiving prank phone calls and other forms of harassment. Finally, in late November, Bihari filed a criminal complaint alleging **aggravated harassment** against Gross and Truglio.

Gross and Truglio denied making the harassing phone calls. Bihari said her caller ID proved the source. It was her word against theirs. The District Attorney's office declined to prosecute. But the drama continued.

Bihari held on to three sofas that had been purchased by Gross but never delivered to him. When Gross found out about this, he **filed a criminal complaint** against Bihari for theft. She was arrested, held for six hours, and charged with criminal possession of stolen property. But the District Attorney declined to prosecute this matter, too.

In early 2000, Bihari filed a lawsuit against Gross that actually had some potential value. She cited the Lanham Act, federal anticybersquatting laws and other federal laws to demand that Gross stop using her trademarked company name in the domain names and metatags of his Web sites.

Gross received a copy of Bihari's complaint in early March 2000 and quickly offered to take down the bihariinteriors.com site pending a preliminary hearing. He later relinquished the bihari.com and bihariinteriors.com sites, essentially replacing them with designscam.com and manhattaninteriordesign.com. Whatever the domain name, all of these sites used the phrase "Bihari Interiors" in metatags embedded within their HTML code.

Bihari had other complaints. She pointed to so-called "guestbook entries" on the sites. These postings—supposedly made by people visiting the sites—included disparaging remarks about Bihari and her company. (She argued that Gross and Truglio had penned these entries themselves.)

The trial court hearing the case agreed with Bihari that Gross's **intent was to cause her commercial harm through the Web sites**. His sites intended to warn potential customers of Bihari's alleged ill intentions and to protect them from experiencing the "overwhelming grief and aggravation" that he had experienced. But, the court ruled, Gross's actions constituted fair use of Bihari's trademarks. He'd based his content on honest criticism and a review of facts that—despite different interpretations—had occurred. And he hadn't exhibited bad faith in his use.

The Value of a Good Idea

As we've noted before, proving bad faith is difficult. In this case, Gross had not profited from using Bihari's marks. He had every right to catalog the contents of his Web sites; the metatags were key to this cataloging. So, even though Internet users looking for Bihari Interiors could come across Gross's disparaging site because search engines use those metatags to locate sites, this didn't help Bihari's argument. Plus, Gross's sites included the disclaimer "this site reflects only the [viewpoints] and experiences of one Manhattan couple."

Because Gross had voluntarily abandoned the Bihari domain names early on, the issue of injunctive relief under federal anticybersquatting law was moot. The metatag problem was different; but the court held that **cybersquatting law only applies to the registration, trafficking or use of a domain names**—and not to a Web site's internal mechanics.

Nor was his use of the metatags likely to cause confusion, according to the court. Gross's sites provided a forum for complaints directed at Bihari; no reasonable Internet user would believe that Bihari endorsed the disparaging comments. Because Bihari didn't have a Web site, she couldn't claim that Gross diverted traffic to his sites instead of her own. And his sites did not try to confuse people who were looking for Bihari; instead, they tried to offer and exchange information about Bihari.

This last point might be considered a "no such thing as bad publicity" defense against trademark abuse charges.

From these broad conclusions, the court drilled down into more specific details and mechanics of the case—and the results weren't any better for Bihari.

The court started by noting that Bihari Interiors was not a registered trademark. Marianne Bihari argued that she was entitled to a common law service mark; but the court had some doubts, writing:

Service marks are essentially trademarks used in the sale of services, instead of goods. Both service marks and trademarks are governed by identical standards.... Generally, personal names used as trademarks are regarded as descriptive terms, protected only if they have acquired distinctive and secondary meaning.

Bihari argued that Bihari Interiors was suggestive rather than descriptive because it only suggested the nature of her services. The court acknowledged that, as a suggestive mark, Bihari Interiors would be deemed inherently distinctive and entitled to protection—although not in a way that prevented Gross from using it in the metatags of his Web site.

Instead, the court concluded, Gross had not used the terms in the metatags as marks but, rather, to **identify the content of his sites**. In short, Gross used the marks in their descriptive sense only—and that was fair.

The court also accepted Gross's argument that he had to use Bihari's marks in the metatags of his sites in order to get his message to the public. The court wrote:

A broad rule prohibiting use of "Bihari Interiors" in the metatags of Web sites not sponsored by Bihari would effectively foreclose all discourse and comment about Bihari Interiors, including fair comment. Courts must be particularly cautious of overextending the reach of the Lanham Act and intruding on First Amendment values.

What's more, even the Lanham Act's own definition of fair use supported Gross's use of Bihari's marks in his metatags. The New York court quoted the relevant sections of the Lanham Act:

Fair use is established when the challenged term is a use, [other than a mark,]...of a term or device which is descriptive of and used fairly and in good faith only to describe the goods or services of such party....

In other words, the Lanham Act permits people to use a protected mark to **discuss aspects of the goods or services those marks represent**. Even if the discussion includes mean-spirited or vindictive comments.

Gross's Web sites and their metatags concerned the business practices and alleged fraud of a well-known interior designer. Such speech was "arguably within the sphere of legitimate public concern" and, therefore, carried a heavy presumption of constitutional protection.

The decision's key point: The intent to cause commercial harm (covered by the Lanham Act) doesn't justify a prior restraint of constitutionally protected speech (covered by the First Amendment). The court did not order Gross to shut down his sites.

Other Metatag Decisions Aren't so Clear

The 1998 Massachusetts Federal Court decision *Niton Corp. v. Radiation Monitoring Devices, Inc.* provides a good example of the use of metatags to divert a competitor's customers. Radiation Monitoring Devices (RMD) and Niton Corporation were direct competitors in the market for producing analytical instrumentation (for testing things like radon and lead in the environment). RMD did not simply use Niton's trademark in its metatag; it **directly copied Niton's metatags and HTML code**.

As a result, an Internet search using the phrase "home page of Niton Corporation" revealed three matches for Niton's Web site and five for RMD's Web site. RMD obviously was taking advantage of Niton's good will to divert customers to the RMD Web site.

Similarly, in the 1998 Virginia Federal Court decision *Playboy Enterprises v. Asiafocus International*, the court enjoined use of the marks Playboy and Playmate in the domain name and metatags of Asiafocus's Web site. Asiafocus provided adult nude photos on Web pages located at asianplaymates.com and playmates-asian.com. The Playboy and Playmate trademarks were embedded in the metatags such that a search for Play-

boy Enterprises Inc.'s Web site would produce a list that included asian-playmates.com.

The court forced Asiafocus to stop using Playboy's metatags. It did this, as the law demanded, to prevent confusion among consumers.

It may seem trivial to talk about something as technical as a metatag, which are things computer users don't see. But metatags are important to the **overall mechanics of marketing** a good or service on the Web. Another equally important tool when it comes to Web design and product promotion—and trademark—is Web page framing. Looking back at *Hard Rock*, the only contractual breaches the court found related to Morton's use of his hotel Web site was in selling CDs through a third-party vendor. His license agreement didn't allow him to do this, since the third party—and not the Hard Rock Hotel—was technically the one selling the CDs.

This point is worth considering in some detail. It's a common problem with trademarks on the Internet.

Web Page Framing and Trademarks

When users on the Hard Rock Hotel Web site chose to buy a CD, they didn't remain on the hotel site. They were transferred to the third-party vendor's site—though most consumers wouldn't realize this.

The transfer raised issues of "framing," which, in cyberspeak, refers to the technical connection between two independent sources of material. Simply said, framing allows two or more sites to combine in a single visual presentation.

In *Hard Rock Café*, the third party's material appeared as a window within the original linking page, so it wasn't clear to the computer user that he had left the Hard Rock Hotel Web site. The domain name appearing at the top of the computer screen, which indicates the location of the user in the World Wide Web, continued to indicate the domain name of the Hard Rock Hotel, not that of the CD seller.

The Value of a Good Idea

The court, however, sided with Rank's claim that Morton's deal with the CD seller improperly used the Hard Rock trademark for business with a company that wasn't part of Morton's deal. The court acknowledged that a certain level of confusion existed with regard to the marks between the two sites. It noted:

> When a licensee [Hard Rock Hotel] makes both permissible and impermissible use of a trademark in selling merchandise on the Internet, the likelihood of confusion is strong. This conclusion does not enhance the scope of [Rank's] relief. [T]here [was] insufficient evidence of bad faith or willful deception on defendants' part to justify any monetary relief.

The court ordered Morton to stop framing the CD seller's site. But he did not have to pay any damages. Though Morton breached the agreement with Rank on some level, it did not constitute trademark dilution.

Morton had not used any of Rank's trademarks in connection with inferior or unwholesome goods or services, such as sexual activity, obscenity or illegal activity.

Nor did he **dilute Rank's marks by blurring**, which involves the "whittling away of an established trademark's selling power" (though, arguably, the framing issue came close to this). Rank had been aware that Morton's casino and the Hard Rock Cafés were linked together in the public's mind—and did nothing to distinguish Morton's Hard Rock Hotel from its restaurants. In light of these facts, Rank could not claim that Morton had blurred its trademarks.

In the end, Morton walked away with a minor infraction, having to reconfigure his CD selling site and other sales of unlicensed products. Rank had to soak up the court fees and find another tune to play.

This case is significant for businesses with Web sits because it is among the first to deal with trademark rights in an Internet domain name and the **interplay between territorial restrictions** and Web sites.

Transferring Trademarks

One party can't just hand over a trademark to another party. In most situations, courts have held that a trademark sale, assignment or transfer is only meaningful if it is part of a larger deal. Specifically, a trademark usually has to be **transferred along with goodwill** and other intangible assets.

Courts analyze whether or not good will accompanied a trademark assignment by determining whether the assignee is producing a substantially similar product.

The 1984 Federal Appeals Court decision *Marshak v. Green* ruled that:

> Courts have upheld such assignments if they find that the assignee is producing a service substantially similar to that of the assignor and that the customers would not be deceived or harmed.

This was the case with *Sugar Busters! Cut Sugar to Trim Fat*, written by H. Leighton Steward and various contributors. The book sold more than one million copies and hit the New York *Times* bestseller list more than once. Lots of people—including people involved in the creation of the original books—wanted to copy its success. But the question over how the Sugar Busters! trademark could be transferred (or had been transferred in the first place) had a big effect.

One of the contributors to the first edition, Ellen Brennan, published her own version of a cookbook, titled *Sugar Bust for Life!*...and soon heard from her former collaborators. The resulting May 1999 Federal Appeals Court decision *Sugar Busters, LLC. v. Ellen C. Brennan, et al.*, explored how a trademark can be transferred or shared.

In the first *Sugar Busters!* book, the authors outlined a diet based on the role of insulin in obesity and cardiovascular disease. In short, the book set forth a low-carbohydrate (low sugar) diet—and it sold like hotcakes.

Ellen Brennan was an independent consultant employed by the authors to assist with the sales, publishing and marketing of the first edition of the book. In it, she wrote the forward and endorsed a diet plan. Later, her

hopes for writing a cookbook based on the diet were encouraged by H. Leighton Steward, the main author of the first book. He said to her: "[You can] snuggle up next to our book, because you can rightly claim you were a consultant to *Sugar Busters!*"

So, Ellen Brennan and her husband then wrote *Sugar Bust For Life!*, which was published in May 1998 by their own company, Shamrock Publishing. Brennen and her husband were well-known restaurant owners in New Orleans, where the first book had gotten its start. They were optimistic for their new project.

Sugar Bust For Life! stated on its cover that it was a "cookbook and companion guide by the famous family of good food," and that Brennan was "Consultant, Editor, Publisher [and] Sales and Marketing Director for the original, best-selling *Sugar Busters! Cut Sugar to Trim Fat.*"

In the six months after its release, Brennen's book sold over 100,000 copies. And its success stirred up trouble. In May 1998, Brennen's former collaborators filed a suit in Louisiana federal court for trademark infringement, dilution, unfair competition and trade dress infringement—among other claims. They wanted to stop her from selling the book and to recover damages and any profits derived from the book.

One notable point: The term "sugarbusters" had a history. It was originally registered in 1992 by a retail store in Indianapolis that provided products and information for diabetics. This mark was then sold a couple of times until it was eventually acquired by the original *Sugar Busters!* authors.

At trial, the authors argued that the recipes in Brennan's book did not comport with the *Sugar Busters!* lifestyle and that consumers were being misled into believing that her cookbook was affiliated with—or approved by—them.

Brennan, on the other hand, said their mark was invalid because:

1) it was purchased "in gross" (as it had originally been registered and not part of a larger transaction);

2) the term "sugarbusters" had become generic through third-party use; and

3) the authors had abandoned the mark by licensing it back to the owner of the Indiana store without any supervision or control of the store.

In September 1998, the trial court issued an injunction against Brennan for engaging in the sale and distribution of her cookbook. The court said that the sugarbusters mark was valid and that Brennan's cookbook would have created a likelihood of confusion on the minds of customers. Because a "substantial threat of irreparable injury" to the original authors existed, the court ordered Brennen not to sell any more cookbooks.

Brennan appealed, arguing that the Lanham Act doesn't protect a single book title and that the court should have considered her use fair use. And, even if the Act protected the title, Brennan argued that the district court didn't determine whether it had acquired secondary meaning for purposes of protection.

The appeals court ruled for Brennen and overturned the district court's ruling. It did this for two reasons.

First, it found that the authors didn't have a valid trademark. Originally, the mark had been classified "for retail store services featuring products and supplies for diabetic people;" when it had been transferred, **it never became a mark** for "information, literature and books."

Second, the appeals court sent the authors' unfair competition claim back to the district court so it could determine whether the book's title had obtained secondary meaning in May 1998 and—if so—whether Brennan's title was so likely to confuse consumers that it outweighed any First Amendment interests. The appeals court ultimately threw out the preliminary injunction and allowed Brennan to continue selling her book.

Even after the first decision had been reversed, the lawsuit continued for quite some time. (All parties had the financial means to pay lots of legal fees.) A later judge ruled that Brennen could keep the title and publish a second edition of her cookbook—but that it had to indicate on the cover that the diet's creators didn't endorse the book.

The final outcome of this case—in terms of money—was never disclosed. Attorneys for both sides kept a tight lip. And meanwhile, the Brennans entangled themselves in another lawsuit, this time suing a book-selling chain for unpaid orders. Seems the book buyers reduced the orders when they learned that Brennan's cookbook wasn't a joint project with the original *Sugar Busters!* book.

Conclusion

We've looked at a lot of cases in this chapter, each a little different from the next. But in all, trademarks are used to distinguish a producer's goods and services from those of his competitors. Trademarks—and service marks—**identify the source of the good or services**. They answer the two questions:

1) Who are you?; and

2) Where do you come from?

When you spy a three-pointed star in a circle, you know you're looking at something made or serviced by Mercedes-Benz. And with that recognition comes a sense of value and quality inherent to that particular brand. Trademarks are vital to companies because they often come to represent what companies stand for and how they choose to conduct business.

Within trademark law lies other tangents that add more meaning to the body of trademark law. Chief among these tangents is trade dress, and it constitutes our next chapter.

Chapter 7: Trade Dress

In the movie *Office Space* there is a recurring joke about how Jennifer Aniston's character—a waitress in a middlebrow chain restaurant—is constantly pressured by her boss to wear more *flair*: buttons and decals on her uniform. It's company policy that employees dress in an upbeat manner. And *upbeat* means lots of buttons.

This plot device shows how silly and trivial work rules can be. But it's also a decent way to think about the **slippery concept of trade dress**.

The Supreme Court has defined *trade dress* as the "total image and overall appearance" of a good, further specifying that it "may include features such as size, shape, color or color combinations, texture, graphics or even particular sales techniques."

Imagine that a trademark goes beyond an image or phrase used in advertisements and extends to the physical size and shape of the product sold…or the store in which it's sold. Retail chains are the most notable users of trade dress defenses. Trade dress applies to design elements like the Golden Arches of the McDonald's fast food restaurants…or to the design and layout of stores like The Gap or The Limited.

The public policy rationale for trade dress protection has been explained by the Supreme Court as follows:

> Protection of trade dress, no less than of trademarks, serves the [trademark law]'s purpose to "secure to the owner of the mark

the goodwill of his business and to protect the ability of consumers to distinguish among competing producers. National protection of trademarks is desirable, Congress concluded, because trademarks foster competition and the maintenance of quality by securing to the producer the benefits of good reputation.

Trade dress includes subjects as **concrete** as decorative tiles and as **abstract** as restaurant service. It can include a selling image or method, the way a business chooses to function, attract customers, build a reputation and maintain that reputation. Complicating this concept is the combination of concrete and not-so-concrete subjects. Searching for a legal platform upon which to rule in this area, courts are having to face new challenges.

In this chapter, we'll consider how the trade dress of various companies is challenged—and, occasionally, how it's defended.

Trade Dress Can't Be Generic

Trade dress issues follow standard trademark issues in many ways. Chief among these: Generic designs or configurations don't support trade dress claims. The test for determining whether trade dress is protected is the same for determining a trademark. A court must determine whether it is:

1) generic or functional;

2) descriptive;

3) suggestive; or

4) arbitrary or fanciful.

Generic dress refers to the genus or class of which a particular product is a member—and such dress can't be protected. According to the Supreme Court, trade dress should be considered generic if it is well-known, common, a mere refinement of a commonly-adopted and well-known form of ornamentation or a common basic shape or design, even if it has "not before been refined in precisely the same way."

According to the 1995 U.S. Supreme Court decision *Qualitex Co. v. Jacobson Prods. Co.*, a feature of a trade dress is functional when it is:

essential to the use or purpose of the article or if it affects the cost or quality of the article, that is, if the exclusive use of the feature would put competitors at a significant non-reputation-related disadvantage.

On the other hand, trade dress is not generic if it is "unique or unusual in the particular field at issue."

In the March 2000 Federal Appeals Court decision *Ale House Management, Inc. v. Raleigh Ale House, Inc.*, two unrelated restaurateurs went to court over the use of the words "ale house" and the designs of each other's restaurants. The key question: **Were these terms generic**?

Ale House Management, Inc. (AHM) was the first to establish itself. It opened its first restaurant selling food and beer in Florida in 1988. The place was a hit; by the mid-1990s, AHM had opened 21 restaurants throughout Florida. Each restaurant was named after its geographical location plus the words "ale house" (e.g., Orlando Ale House, Tampa Ale House, etc.).

The general layouts of these Ale Houses were similar—a mix of both a dining room and a sports bar in a specially configured manner. The image of "a wood-and-brass decorated pub or pub-style restaurant" was conveyed at every facility. There was a central rectangular bar; booth seating was at one side of the bar; stool seating was located on the other side. Numerous televisions and video games decorated the room, as well as pool tables. Although the interiors of AHM's restaurants were similar, they weren't identical in every degree. For example, they varied in the amount, configuration and the number of pool tables, placement of seating and the precise bar space. (The restaurants were about as similar to one another as most chain restaurants or bars. Think Houstons, Hooters, Applebees, Chili's and the like.)

The exterior appearance of AHM's facilities was also somewhat similar, but not nearly as much as the interiors. Each was a rectangular building with a simulated tower, or two, on its roof and a sign on the side designating the facility's name in red block letters. The buildings, however, did not share a common color scheme, size or shape. The roofs reflected differ-

ent architectural styles and were constructed of various materials. Awnings, window sizes and window shapes also varied among the facilities.

AHM had plans to expand its chain northward into Georgia, South Carolina, North Carolina and Virginia. When investigating these areas in 1998, AHM encountered Raleigh Ale House...and thought it was looking in a mirror. The rectangular building had gray-colored siding and a tower on which "Raleigh Ale House" was painted in red block letters.

At the time, Raleigh Ale House wasn't open yet to the public. The architect's plan showed a rectangular island bar, with booth seating on one side, stool seating on the other, and tables and chairs at one end. The plans showed five television monitors, two pool tables and a jukebox. It seemed clear that Raleigh Ale House had been influenced by AHM's concept (and it was later shown that the owner of the Raleigh Ale House had visited several of AHM's restaurants in Florida).

AHM took prompt action, warning Raleigh Ale House in writing of its trademark rights to the term "ale house" and its protectable trade dress rights to the design of these restaurants. But AHM hadn't registered ale house as a valid mark. Raleigh Ale House didn't pay much attention to the warning and refused to change its name or the design. So AHM sued, alleging—among other things—**false designation of origin** of trade name and trade dress, trade name infringement and trade dress infringement.

Raleigh Ale House asked the court to dismiss AHM's claims as unsupported by existing trademark law. The court agreed, shooting down AHM's claims. It also awarded Raleigh Ale House attorneys' fees and other costs.

AHM appealed, focusing its argument on its assertion that Raleigh Ale House had appropriated its trade name and trade dress by deliberately copying them. But the evidence of this deliberate intent was pretty thin.

The appeals court first addressed AHM's claim to exclusive use of the words ale house. Although the company never registered ale house, it still could seek broad protection under federal trademark law. In this case, however, AHM failed to prove that ale house was anything more than a generic term.

To prove this generic status, the court did something most people would do—it surfed the Web. On the Internet, a search for ale house revealed over 100 facilities with the term in their names. Internet restaurant reviews referred to the term as meaning "eatery and bar" and a "neighborhood alehouse" that serves food and drinks.

AHM presented **no evidence suggesting that ale house was anything other than a generic term** that could refer to institutions serving both food and alcohol. So, the court concluded that AHM had no protectable interest in the words ale house because they were generic words for a facility that serves beer and ale, with or without food, just as are other similar terms such as bar, lounge, pub, saloon and tavern. All serve alcohol alone or both food and alcohol.

Although AHM devoted less attention to its trade dress argument, this looked like a more promising point. AHM maintained that Raleigh Ale House violated AHM's rights in its trade dress, both as to the exterior and interior appearance of its facilities.

At oral argument, however, AHM abandoned the trade dress claim with respect to the exterior and pressed only its claim to a proprietary interest in the appearance of the interior of its facilities, including its service.

AHM didn't get very far on its claim to the interior design. Despite the photos and floor plans, there was no evidence that AHM's centrally located rectangular bar with two types of seating on either side and television monitors, arcades and pool tables, decorated generally in wood and brass, was unique or unusual. This was particularly so when AHM's own configurations differed from facility to facility, denying it a single model from which to distinguish the numerous similar configurations used by other food-and-beer establishments.

The court then held that AHM did not present enough evidence to support its **claim to a proprietary interest in its appearance and service**. The court acknowledged an "imitation of an idea or a concept, but not a copying of the plans themselves"—which would have been requisite to a successful trade dress claim.

The Value of a Good Idea

Raleigh Ale House's floor plans were not in the same dimensions or proportions as any of those presented by AHM. For example, on some of AHM's drawings, the central bar was a peninsula extending from the kitchen area and transecting the rectangular facility across the short dimension. On other drawings, it was an island. On yet others, the central bar ran with the long dimension of the rectangular facility. On each of AHM's drawings, there were variations in the location of the various seating areas and the pool tables.

So, AHM appeared to be claiming that Raleigh had copied the concept of using an island or peninsula-shaped bar to bisect a seating area that has booths on one side and stool seating on the other. But AHM's design was **nothing more than a concept**. The appeals court affirmed all of the district court's rulings—including attorneys' fees to Raleigh Ale House.

Clearing Up Consumer Confusion

As we've seen, the so-called Polaroid test for determining trademark or trade dress confusion among consumers includes eight factors:

1) strength of the suing company's trade dress;
2) similarity between the two trade dresses;
3) proximity of the products in the marketplace;
4) likelihood that the prior owner will bridge the gap between the products;
5) evidence of actual confusion;
6) infringer's bad faith;
7) quality of infringer's product; and
8) sophistication of the relevant consumer group.

The **strength of a trade dress** or trademark is measured in terms of its distinctiveness, "or more precisely, [by] its tendency to identify the goods sold…as emanating from a particular…source."

Arbitrary dress is by its very nature distinctive and strong. However, this strength may be diminished by the existence of similar dresses used in connection with similar products. Dresses that lack distinctiveness and fall on the lower end of the scale are classified as weak and are entitled to limited scope of protection.

The **degree of similarity** factor looks to whether it is probable that the similarity of the dresses will cause confusion among numerous customers who are ordinarily prudent.

According to the 1992 Federal Appeals Court decision *Bristol-Myers Squibb Co. v. McNeil-P.P.C. Inc.*:

> The presence and prominence of markings tending to dispel confusion as to the origin, sponsorship or approval of the goods in question is highly relevant to an inquiry concerning the similarity of the two dresses. When prominently displayed it can go far towards...countering any suggestion of consumer confusion arising from any of the other Polaroid factors.

The proximity of the products inquiry concerns whether and to what extent the two products compete with each other. A court must consider the nature of the products themselves and the structure of the relevant market, including the class of customers to whom the goods are sold, the manner in which the products are advertised and the channels through which the goods are sold.

The next factor applies when the first user sells its products in one field and the second user sells its products in a closely related field, into which the first user might expand, thereby **bridging the gap**.

Usually, a company will use a survey or other type of systematic research to establish **confusion among consumers**. Even these reports can be based on comments that are anecdotal. However, it is black letter law (i.e. a basic principle of law) that actual confusion need not be shown, since actual confusion is very difficult to prove and federal law requires only a likelihood of confusion as to the source.

The **bad faith** factor looks to whether the infringer adopted its dress with the intention of capitalizing on someone's reputation and goodwill and any confusion between his and the senior user's product.

The **quality of defendant's products** factor considers whether the company alleged to have infringed or appropriated a disputed trade dress is selling products of a clearly inferior quality. The worse the product, the more likely a court will rule for the company making the allegations.

According to the 1993 Federal Appeals Court decision *W.W.W. Pharmaceutical Company v. Gillette Company*, the **consumer sophistication** factor requires consideration of:

> [t]he general impression of the ordinary purchaser, buying under the normally prevalent conditions of the market and giving the attention such purchasers usually give in buying that class of goods... .

A Detailed Primer on Trade Dress

Since the 1980s, the retail industry has become more specialized with a technical focus. Think about Starbucks's effort to educate consumers on the minutia of coffee or Jamba Juice's intricate take on, well, juice.

These companies—and dozens more like them—have drilled down into the details of a particular market…and developed arrays of well-planned and superbly executed methods. Some would argue that these companies were built upon "secret" models that employed innovative techniques— all of which constitute trade dress.

This technique-as-trade dress theory was tested in the March 2000 New York Federal Court decision *Best Cellars, Inc. v. Grape Finds at Dupont, Inc.* In this case, two enterprising enophiles fought over one good idea.

The wine business is as complex for the wine experts as it is for the casual wine drinker and the occasional buyer. But it's even more complex for the retailers who have to find ways of attracting new customers, as well as connoisseurs. Partners Joshua Wesson, Michael Green and Richard Marmet made their idea for retailing wine a reality by founding Best Cellars; they believed they had a winner…and so, as it turned out, did someone else.

Joshua Wesson was a familiar name in New York wine circles prior to launching the first Best Cellars store in Manhattan. He had been an internationally-recognized expert since the late 1970s and had worked for top New York and Boston restaurants, putting together their wine lists. In 1986, he started a wine consulting business; throughout this period, he also wrote numerous articles on wine. In 1989, he co-authored a well-known book entitled *Red Wine With Fish*, which discussed the concept of "wine by style"—that is, categorizing wine by taste and weight, rather than by the traditional systems of grape type or place of origin.

Wesson continued to promote the **wine by style concept** through additional writings and frequent speaking engagements. In the early 1990s, he began to think about developing a new kind of retail wine store that would appeal to people who knew nothing about wine as well as connoisseurs. It would also implement the wine by style concept. The name "Best Cellars" came to him in 1993.

In 1994, Wesson began to include Green, who was working at an upscale New York retail wine store, in the discussions for the new store. In 1995, Wesson met Marmet, a practicing attorney who had also written extensively about wine.

Wesson, Green and Marmet set out to make the Best Cellars concept a reality. They spent considerable time before and during the design phase of the first Best Cellars store refining the wine by style concept. Wesson

eventually reduced the store's scope to **eight taste categories**. For each category, he selected a single word to serve as a "primary descriptor." The eight primary descriptors were:

- fizzy (sparkling wine);

- fresh (light-bodied white);

- soft (medium-bodied white);

- luscious (full-bodied white);

- juicy (light-bodied red);

- smooth (medium-bodied red);

- big (full-bodied red); and

- sweet (dessert wine).

This conceptual reduction was the heart of the Best Cellars wine by style system. It was the nucleus of the good idea.

A principal reason Wesson reduced the world of wine to eight taste categories was to demystify wine for casual, non-connoisseur purchasers who might be intimidated purchasing wine in a traditional wine store, where wines are customarily organized by grape type and place of origin. Wesson also decided to limit the number of wines for sale at Best Cellars to approximately 100, and to price those wines at about $10 a bottle. (But he also decided to offer 15 or 20 more expensive wines for special occasions.)

The cofounders consulted an intellectual property attorney for advice on how to protect what they were developing. They also looked for an architect, settling in April 1996, on Samuel Houston Trimble from the Rockwell Group, known for its designs of prominent restaurants. To help in the efforts of creating an "anti-wine store," the partners also brought in a graphic designer, Hornall Anderson.

Everyone involved in the project received copies of Best Cellars' marketing and business plans—and everyone who received the plans signed a **confidentiality agreement**.

Best Cellars opened its first doors on the Upper East Side of Manhattan in 1996. It received instant acclaim and press coverage, and was highlighted in local and national television programs. An article in *Wine Business Monthly* stated that "Best Cellars is unlike any wine store that ever existed on Main Street, in cyberspace or anywhere else."

Rockwell won numerous awards for its architectural design of the store, including one for Best Retail Environment of the Year. Hornall Anderson won numerous awards as well, for the graphic designs of the informational materials in the store. Wesson won the Golden Grape Award, for retail innovator of the year, from the wine industry.

It was an instant success. Later, the store expanded to locations in other states—including Brookline, Massachusetts and Seattle, Washington.

So, what was the big deal about Best Cellars? The whole store was designed in the wine by style concept. The eight taste categories influenced the selection, organization and display of wine in the store. Among Best Cellars' selling tools:

- computer-manipulated drawings and photographs that appeared thematically throughout the store;

- color and graphic codes (e.g. the "fizzy" category for sparkling wine was represented by an ice-blue color and an icon suggesting bubbles rising…the "fizzy" category for light-bodied white wines was represented by a lime-green color and an icon suggesting a slice of citrus fruit);

- a simple, elegant and striking architectural design;

- inventive bottle displays, racks and "shelf-talkers" that provide information on the wine; and

- a specific and unique racking system unlike any other wine retailer's.

The **racking system**, which created the impression that the bottles were stored in cubbyholes in the walls of the stores, was so specific and uniquely designed that the partners **patented the concept**.

The Value of a Good Idea

The overall effect was of rows and rows of backlit, glowing bottles in the walls of the store. The categories of wine were arranged in the following order as one moved clockwise around the store from the doorway: fizzy, fresh, soft, luscious, juicy, smooth, big and sweet (corresponding to sparkling, light-, medium-, and full-bodied white, light-, medium- and full-bodied red and dessert wine, respectively).

In addition, the checkout or "cash wrap" area was recessed into the back wall, and to the right was a large placard on the wall explaining the Best Cellars system.

And, while certain aspects of the Seattle and Brookline stores differed from the New York store, the general concept and idea of Best Cellars prevailed.

No other store had a uniform display of "shelf-talkers" at eye level, and no other store arranged wine by taste category along the perimeter, backlit in vertical arrays, with storage cabinets underneath. Although the concept of categorizing wine by taste and style was not unknown to writers on wine (Serena Sutcliffe's *The Wine Handbook*, for example, uses its own 14 categories) the concept employed for retailing wine was new.

Trouble started when Best Cellars began looking toward expanding in the Washington, D.C. area. It spent two years looking, and eventually was notified that a "knock-off" store was moving into a space in the trendy Dupont Circle neighborhood. Grape Finds opened in December of 1999.

The Grape Finds story begins with John Mazur, who attended Columbia Business School in New York from 1996 through May 1998, when he received an M.B.A. Mazur wanted to run his own business, and he had an interest in wine. While at Columbia, he discovered the Best Cellars New York store, and spent considerable time researching its trade dress. He began to draft a business plan, **cutting and pasting descriptions** of the Best Cellars **concept and design from articles** downloaded from a legal database. He simply substituted "Grape Finds" for "Best Cellars."

After graduation, Mazur moved to the Washington, D.C. area and began to implement a plan to open a Grape Finds retail wine store using a con-

ceptual model very much like Best Cellars'. In March 1999, Mazur executed a contract to purchase a liquor store in the Dupont Circle area. He hired an architect, who was paid to go to New York and visit the Best Cellars store, among others.

In all, Mazur and Grape Finds made little effort to hide the fact that they **wanted to appropriate the look and feel** of Best Cellars' stores. In fact, Mazur eventually hired Michael Green—one of Best Cellars' founders—as a wine buyer and Hornall Anderson—Best Cellars' original graphic designer—to design material for Grape Finds.

Green, who'd signed a confidentiality agreement with Best Cellars, left his job in February 1997, shortly after the store opened. He still held shares in Best Cellars, despite Wesson and Marmet's efforts to buy him out.

Best Cellars had terminated Anderson, the graphic designer in late 1998, due to disagreement over how to improve Best Cellars' trade dress.

The most obvious similarity to Best Cellars at Grape Finds was the interior's system of organization: CRISPfinds, MELLOWfinds, RICHfinds, FRUITYfinds, SMOOTHfinds, BOLDfinds, BUBBLYfinds and SWEETfinds, corresponding to the eight categories in the Best Cellars classification system. These categories also appeared throughout Grape Finds' promotional materials, on its Web site and in its business plan.

Many of the Grape Finds category descriptors were based on ones used by Best Cellars, albeit rearranged slightly. As with Best Cellars, Grape Finds assigned to each taste category a corresponding color and icon-identifier, designed by Hornall Anderson. The categories were arranged in the store in systematic, Best Cellars'-like order. There were approximately 100 value-priced wines displayed around the perimeter of the store.

The stores' visual elements also mirrored each other. There were some differences between the two stores but, overall, any reasonable observer could see that Grape Finds had appropriated Best Cellars' look and feel.

Best Cellars sued Grape Finds, alleging a **conspiracy** among Grape Finds' owners, contractors and employees. Among other things, Best Cellars

sought injunctive relief for: trade dress infringement; trade dress dilution; unfair competition; and breach of confidentiality.

The trial court believed Best Cellars' claims, writing:

> There is sufficient circumstantial evidence to support a finding of a conspiracy between [Grape Finds and its members]…with respect to the causes of action for trade dress infringement, trade dress dilution, unfair competition and copyright infringement. [T]here was a meeting of the minds…to replicate the look and feel of the Best Cellars stores.

Best Cellars had met its burden, establishing the inherent distinctiveness of its trade dress. The court easily concluded that Best Cellars' trade dress was **arbitrary**, consisting of the total visual image that customers encountered when entering the store. This **unique design**—both the architectural component and the graphical component—had been acknowledged in numerous awards. Because Best Cellars achieved its goal of designing an "anti-wine store," the trade dress was not suggestive of the product being sold, let alone merely descriptive or generic.

In its defense, Grape Finds argued that Best Cellars' trade dress was not inherently distinctive. This argument didn't work.

Grape Finds also alleged that Best Cellars had not consistently applied its trade dress to all of its stores. In theory, this is a good legal tactic; trade dress is harder to establish when it's applied erratically.

But this argument didn't work, either. The court ruled that the designs were consistent enough to conclude that all Best Cellars stores shared the same trade dress.

In all, the court concluded there was a substantial likelihood that "an ordinarily prudent consumer would, when standing in the Grape Finds store, think he was standing in a Best Cellars store."

To add more fuel to Best Cellars' fire, the company proved that its dress **had acquired secondary meaning** (which happens more naturally when the trade dress is fanciful or arbitrary). There was an abundance of unso-

licited media coverage of Best Cellars, demonstrated sales success and its dress had been exclusively used by Best Cellars since the fall of 1996.

The court concluded that Grape Finds sold the same products in the same field—by utilizing the same formula and model. And it went farther, finding that Grape Finds had exhibited bad faith in using Best Cellars' trade dress. It wrote:

> Given the overwhelming evidence of copying by Mazur of so many aspects of the Best Cellars business, it strains credulity to think that the reproduction of the trade dress—in particular, the "wall of wine"—in the Grape Finds store was not meant to capitalize on the reputation, goodwill and any confusion between Grape Finds and Best Cellars.

This case illustrates that a good idea can be the basis for a business…and for real damages, if another party steals that good idea. As the ruling judge wrote:

> [This case] presents the tension between the protection of certain intellectual property and free and open competition. Under the particular facts of this case, the balance tips in favor of protection.

Trade Dress Dilution

One of Best Cellars' claims was trade dress dilution. While most lawsuits involving trade dress claims focus on the infringement…or illegal appropriation…of designs or appearances, smart companies will sometimes do better claiming **dilution**.

The Federal Trademark Dilution Act (FDTA) reads in part:

> The owner of a famous mark shall be entitled, subject to the principles of equity and upon such terms as the court deems reasonable, to an injunction against another person's commercial use in commerce of a mark or trade name, if such use begins after the mark has become famous and causes dilution of the distinctive quality of the mark.

The Value of a Good Idea

Dilution is defined by the statute as:

> [T]he lessening of the capacity of a famous mark to identify and distinguish goods or services, regardless of the presence or absence of 1) competition between the owner of the famous mark and other parties; or 2) likelihood of confusion, mistake or deception.

Federal courts generally agree that, in order to establish a trademark or trade dress dilution claim under the FDTA, a person or company must establish the following elements:

1) the senior mark is famous;

2) the senior mark is distinctive;

3) the junior use is a commercial use in commerce;

4) the junior use begins after the senior mark has become famous; and

5) the junior use causes dilution of the distinctive quality of the senior mark.

Unlike infringement cases, where a major consideration is the probability of future competition in the same geographic area, dilution cases consider already-established fame. Courts settling dilution claims don't consider "prospective" fame like they do with infringement claims.

The FDTA sets forth **eight nonexclusive factors** to consider in determining whether a mark or dress is famous:

1) the degree of inherent or acquired distinctiveness of the mark;

2) the duration and extent of use of the mark in connection with the goods;

3) the duration and extent of advertising and publicity of the mark;

4) the geographical extent of the trading area in which the mark is used;

5) the channels of trade for the goods or services with which the mark is used;

6) the degree of recognition of the mark in trading areas and channels of trade used by the mark's owner and the person against whom the injunction is sought;

7) the nature and extent of the use of same or similar marks by third parties; and

8) whether the mark was registered under the Act of March 3, 1881, or the Act of February 20, 1905, or on the Principal Register.

Why Trade Dress Rules Are So Difficult

One of the difficult things about trade marks and dress is that they are **based on more subjective factors** than copyrights or patents.

Unlike copyrights or patents, trademarks and trade dress are used commercially first—and established legally later.

Although most lawsuits dealing with trade dress focus on what it's not, trade dress often has a broad meaning. This makes a lot people—even a lot of lawyers—confused about what kind of claims can work under the trade dress theory.

For example, the Supreme Court upheld a federal district court's finding that a Mexican restaurant was entitled to protection for a trade dress consisting of:

> a festive eating atmosphere having interior dining and patio areas decorated with artifacts, bright colors, paintings and murals. The patio includes interior and exterior areas with the interior patio capable of being sealed off from the outside patio by overhead garage doors. The stepped exterior of the building is a festive and

vivid color scheme using top border paint and neon stripes. Bright awnings and umbrellas continue the theme.

That's pretty broad.

In short, trade dress is confusing because it encompasses a diverse set of intellectual properties—more ranging than standard trademark law. It's not mentioned specifically very much in U.S. intellectual property statutes; but it's a big part of English common law and has quite a bit of background in U.S. case law. There are many legal matters that share a common law origin…the main problem they share is a **conceptual fuzziness** that gives courts wide discretion in ruling on any particular case.

To establish a claim of trade dress infringement, a person or company must demonstrate that:

1) its trade dress is either inherently distinctive or that it has acquired distinctiveness through a secondary meaning;

2) there is a likelihood of confusion between defendant's trade dress and plaintiff's; and

3) where the dress has not been registered, that the design is nonfunctional.

A *nonfunctional design* means that it is not essential to the product's use or it does not affect the cost or quality of the product. Sometimes, elements of trade dress can encompass both functional and nonfunctional parts. However, if the collection of trade dress elements is not essential to the product's use or does not affect the cost or quality of the product, that dress is considered nonfunctional.

Because there is a virtually **unlimited number of ways to combine elements** to make up the total visual image that constitutes a trade dress, courts typically view trade dress as arbitrary or fanciful, which meets the inherently distinctive requirement for legal protection.

Fear of a slippery slope whereby every alleged trade dress gets protection, however, is alleviated by the difficulty of meeting the **likelihood of confusion prong**.

On the other hand, as the *Best Cellars* court said, "an idea, a concept or a generalized type of appearance" cannot be protected under trade dress law, although "the concrete expression of an idea in a trade dress has received protection."

This can be a difficult distinction to draw, and in doing so "a helpful consideration will be the purpose of trade dress law: to protect an owner of a dress in informing the public of the source of its products, without permitting the owner to exclude competition from functionally similar products," according to the *Best Cellars* court.

The courts have struggled to articulate a standard for when a trade dress is sufficiently distinctive to be entitled to the *prima facie* protection of federal law. But **efforts to define intuitive concepts** such as "distinctiveness" are often both futile and unnecessary. People use with perfect clarity many words that we can't define, such as time, number, beauty and law.

Everyone can recognize when a product has a distinctive appearance, without having been tutored in the meaning of "distinctiveness." But beyond stating the principles to be applied there is little to be said except to compare the impression made by two trade dresses.

So there cannot be an objection in principle to the concept of **aesthetic functionality** as a limitation on the legal protection of trade dress. But people who argue that in application the concept is mischievously vague certainly have a point, though not one necessary to labor further here.

Formally, *distinctiveness* and *functionality* are separate issues. While the burden of proving distinctiveness is of course on the plaintiff, some courts, including our own, hold that functionality is an affirmative defense and so the burden of proof rests on the defendant.

Federal trademark law was amended in 1999 to shift the burden of demonstrating nonfunctionality for an unregistered trade dress onto the party seeking relief. Previously, it had been an affirmative defense. This change was designed to clear up—on a tactical level—some of the confusion over how trade dress works. Its results have been mixed.

Conclusion

Trade dress is an important element to most successful businesses. Courts have had to define and redefine what constitutes trade dress and where it falls in the body of intellectual property—particularly trademark law.

Back when André Agassi pitched Canon products in advertisements, the catch phrase "image is everything" led the campaign. In some sense, that statement is true. A business's overall image (or maybe your image on a tennis court) can mean the difference between a winning business and an insolvent one—or a winner and a loser.

The subject of trade dress carves an **interesting niche out of trademark law**. But the framework of trademark law gets a lot tougher than what we've seen in this chapter. And it can go way beyond an image or a style. Although we've touched upon some of the aspects that complicate the topic—confusion, dilution and secondary meaning—the next chapter focuses on these trademark concepts.

CHAPTER 8: CONFUSION, DILUTION & SECONDARY MEANING

The Supreme Court has stated that, because trademarks promote competition and the maintenance of product quality, "a sound public policy requires that trademarks should receive nationally the greatest protection they can be given."

Still, the law behind trademarks remains more vague than the law behind other kinds of intellectual property. Given the previous chapters, you should be familiar with the basic elements of trademarks, but they do get more complex and trickier to understand.

Under the umbrella of trademark infringement lies a variety of claims that often accompany general infringement lawsuits. Among these are *confusion*, *dilution* and *unfair competition*. Because trademark law governs a manufacturer's or merchant's way of identifying its goods or services (through a mark) and to distinguish those from others, when another person uses a mark so as to cause confusion as to the source or sponsorship of the goods or services involved, courts must ultimately determine the **integrity of a challenged mark**. In many trademark cases, as we will see, secondary meaning becomes a more important issue.

We'll also find in this chapter how each case brought before a court is comprised of a different set of allegations and follows a different course of action depending upon the particular facts and circumstances in the case, in addition to the ruling state and presiding judge. The cases set forth here as examples, however, clearly point to some basic tenets of trademark

law and its role in maintaining this balance between offering the "greatest protection" and allowing for free-market competition.

How Trademark Infringement Works

When most people hear the term "infringement," they think of copyright infringement—if anything. But *trademark infringement*, the unauthorized, damaging use of trademarks or similar elements of a product or corporate identity, is also a major issue.

In order to prevail in a trademark infringement claim, a trademark owner must establish the following: 1) a protectable trademark's existence; and 2) a likelihood of confusion as to the origin of the infringing product.

This is the origin of the "better than negligible chance" standard that courts apply to requests for injunctions. A court will analyze not whether the trademark owner will or will not prevail on the merits, but rather whether the owner has demonstrated a better than negligible chance of establishing the a trademark and **likelihood of confusion**.

In determining whether there is a likelihood of confusion, the federal courts (specifically, the Seventh Circuit Court of Appeals in its 1977 decision *Helene Curtis Industries v. Church and Dwight Co.*) have established that several factors are important.

None of these factors by itself is dispositive or controling—and different factors will weigh more heavily from case-to-case depending on the particular facts involved. The courts first announced a variation of these factors in the precedent-setting *Polaroid Corp. v. Polared Electronics Corp.*

case in 1961. Later courts honed and defined those factors in myriad situations. As the Seventh Circuit stated in its 1989 decision *Schwinn Bicycle v. Ross Bicycles*:

> The weight and totality of the most important factors in each case will ultimately be determinative of the likelihood of confusion, not whether the majority of the factors tilt the scale in favor of one side or the other.

Each of these factors, however, is worth a brief discussion.

Similarity of the Marks. In determining whether two marks are similar, courts turn to **what occurs in the marketplace**. And, if one word or feature of a composite trademark is the prominent portion of the mark, it may be given greater weight than the surrounding elements. The 1987 Federal Appeals Court decision *Calvin Klein Cosmetics Corporation v. Lenox Laboratories* shed some light on this. Here, the court held:

> A realistic evaluation of consumer confusion must attempt to recreate the conditions in which buying decisions are made, and the court should try to determine not what it would do, but what a reasonable purchaser in market conditions would do.

In other words, courts must put themselves in the position of the purchaser in the marketplace to properly compare two marks.

Similarity of the Products. In analyzing the similarity of products, the question is whether the products are the kind the public attributes to a single source. The items must have a comparable effect on a comparable group. In its 1996 decision *Mejia and Associates v. IBM Corp.*, the judges in the Southern District of New York explained why **common sense** is required when determining the similarity of products:

> By increasing the level of generality, any products can be made to appear to fall in the same class. Aspirin and easy chairs could be characterized as "comfort products." Jet planes and roller blades could be characterized as transportation products. Such semantic exercises simply are not helpful in assessing likelihood of confusion.

The Value of a Good Idea

Aspirin and easy chairs are usually not made by the same people—so their sources are different. The public won't have a hard time recognizing that fact.

Area and Manner of Concurrent Use. The concurrent use factor focuses on the overlap of promotion, distribution and sales of both parties' goods. In determining whether the area and manner of concurrent use between two marks is likely to cause confusion, cases often focus on:

- the geographical area of distribution;

- whether there is evidence of direct competition between the relevant products;

- whether the products are sold in the same stores;

- whether the products are sold in the same section of a given store; and

- whether the products are sold through the same marketing channels.

For example, if the two marks relate to cosmetics, surely they would share similar distribution markets and ad campaigns. Conversely, a video game called Death by Design and a perfume by the same name would not share similar channels of trade.

Consumers' Degree of Care. The degree of care factor seeks to distinguish how likely the relevant group of consumers is to distinguish between different products. As a general rule, where the cost of the trademarked product is high, the courts assume that purchasers are likely to be more discriminating than they might otherwise be. (You're not going to mistake a BMW for a Jaguar.) Moreover, where the product involved was a low value item, the **risk of confusion** is greater. (You might have a hard time telling the difference between two Swiss Army Knives, one claiming to be the "original" and another a copy.

Strength of the Mark. The strength of a particular mark measures the likelihood that a consumer will view a mark as source-identifying. Surprisingly, there is no consistent measure of what constitutes the strength of a mark, but **five factors** can be gleaned from recent case law:

- the mark is registered;

- the mark has been in use a long time;

- the mark is widely promoted;

- the mark is renown in the relevant field of business; and

- the mark is distinctive or has strong "secondary meaning."

A good example: a Coke can versus a Pepsi can. Both have equally strong marks and meet these five factors. In fact, their marks are so strong that most would not have a hard time distinguishing a wordless Coke can from a wordless Pepsi can.

Actual Confusion. While proof of actual confusion is not required to prove likelihood of confusion, courts often view evidence of actual confusion as the best evidence of likelihood of confusion. This factor is overemphasized in many disputes. One or two confused customers may suffice to show some confusion—but that's not enough to make a case by itself.

Intent to Palm Off Plaintiff's Goods. In order to find trademark infringement, it is not necessary to find proof of the infringer's fraudulent intent. However, such proof helps establish a likelihood of confusion. If you try to copy someone else's trademark, you are probably trying to confuse consumers into thinking that your product (or service) is like the competing—superior—product. You are effectively **ripping off a legitimate trademark for your own good**.

So long as two goods or services are sufficiently different, they can employ the same or similar mark. Although some argue that geographically isolated marks, which are identical, do not compete and thus, can be protected separately, federally registered trademarks have a nationwide geographic scope in the U.S.

A Trademark Infringement Primer

Before delving into the dynamics of dilution and confusion, a sample case will help introduce some of the elements involved in trademark infringement claims.

The Value of a Good Idea

Barbie Dolls…Cabbage Patch Kids…Beanie Babies. Children's toys have become coveted things in the world of collectibles; they can be valuable—and important possessions for adults. The toy market has become as competitive as any other business; and when one company manipulates another's success, even the toy world can get litigious. In the June 2000 Federal Court decision *Ty, Inc. v. The Jones Group, Inc.*, the makers of Beanie Babies claimed the word Beanie as a trademark and charged infringement on the part of the makers of so-called Beanie Racers.

The dispute focused on something we've seen before in this book—Web site metatags. But it also involved bean bags.

Ty had begun selling its bean bag toys in the U.S. in 1993 under the trademarks "Beanie Babies" and "The Beanie Babies Collection," among others. The toys became a consumer craze in the mid-1990s, spawning press coverage and enthusiast Web sites, books and magazines—all devoted to Beanie Babies. A sure sign of their popularity: McDonald's used the toys (via licenses) for promotions in 1997, 1998 and 1999.

The Jones Group—a marketing company that worked with the NASCAR auto racing organization—decided to capitalize on the popularity of plush toys. Together with NASCAR, its corporate sponsors and several individual NASCAR drivers, the Jones Group manufactured and sold what it called Beanie Racers. Although they were shaped like racing cars, these toys weren't much different than Beanie Babies. They were **made of similar material and were of similar size**.

Ty sued, arguing that the Beanie Racers infringed on and diluted its trademark.

The Jones Group responded quickly by pointing out that it had registered the trademark "Beanie Racer." But Ty had several theories for why it thought that trademark shouldn't hold up.

The dispute centered on the term Beanie. Even though—technically—Ty only had legal trademark rights to the term Beanie Babies, it claimed common law trademark right to the word when it encountered Beanie Racers, alleging that the term Beanie had been a nickname for Beanie Babies since

May of 1995. It didn't think any other toy company had the right to invade the plush toy market with a similarly-made product bearing a similar name.

Ty also made some other arguments to bolster its case. These other points included allegations that:

- the Jones Group's strategy for marketing Beanie Racers was designed to confuse consumers, further diluting Ty's trademark;

- the Jones Group had promoted Beanie Racers by making overt references to Beanie Babies in advertisements stating that "[e]ach Beanie Racer is constructed from a plush material (like Beanie Babies)"; and

- a number of retailers **advertised** the Beanie Racers **on the Internet using Ty's registered trademark** Beanie Babies in the metatags of pages in their Internet sites.

As we've seen before, **metatags are HTML code used by search engines** in determining which sites correspond to key words offered by Internet users. The legal status of metatag use remains murky—though most courts dealing with these matters shy away from big claims. (We'll explore more details of metatags in the next chapter.)

Ty asked the court for an injunction prohibiting the Jones Group from selling its Beanie Racers.

The Jones Group, however, argued that Ty didn't have a real legal claim—that it was tossing various weak claims against the judicial wall, hoping that something would stick. The Jones Group asked the court to throw the whole case out.

The court had several different issues to resolve.

First, it had to determine what kind of protection—if any—Ty had over the unregistered, single-word trademark Beanie. The court researched the marketplace to find out whether Beanie was a generic term, consulting various sources, including dictionaries, the media, people in the toy trade, consumer surveys and the Internet for help.

The Value of a Good Idea

The Internet showed a great deal of evidence in Ty's favor. To the Jones Group's dismay, 80 percent of the products for sale on Yahoo!'s auction sites and 92 percent of the products for sale on eBay's auction sites that used the one-word term Beanie referred to Ty products.

Having done this research, the court concluded:

> In view of the fact that [Ty] has prevented other competitors from using the "Beanie" mark by rigorously policing its use, the fact that [Ty] has not used the mark "Beanie" generically itself, the dictionary definition of the word "Beanie" and the media's use of the term "Beanie," this court concludes that [Ty] has a better than negligible chance of proving that the "Beanie" mark is not generic.

With the generic issue answered, the court next had to consider whether Beanie had developed a secondary meaning. Again, it leaned in Ty's direction on this matter:

> [Ty's] use of "Beanie," combined with the widespread publicity, high sales volume and the result of [Ty]'s consumer survey, clearly render the chances of establishing that the "Beanie" name has acquired secondary meaning better than negligible.

So, the first issue was a win for Ty.

Second, the court had to determine whether there was a likelihood of confusion between the toys. This was a relatively easy decision.

The way in which the Jones group used the Beanie mark on similarly-constructed stuffed toys made confusion likely. Also, the fact that both toys were featured in the same or similar magazines added to the likely confusion.

Finding a likelihood of confusion did not, however, lead the court to find for actual confusion. To the Jones Group's benefit, the court concluded that **people wouldn't readily confuse Beanie Babies for Beanie Racers**. The objects were different; and people crazy for Beanie Babies wouldn't mistakenly buy a Beanie Racer on a whim. "Beanie Babies have become collectibles...[and] consumers will exercise more care than in the ordinary case of an inexpensive product," the court said.

This conclusion makes an important point: It's **difficult to prove that confusion is intentionally designed**.

Ty failed to prove that the Jones Group made the Beanie Racers with the intent to take advantage of Ty's goodwill or to mislead consumers into believing that its products were affiliated with Ty. The Jones Group had trademark counsel and had conducted surveys that suggested the marketplace would not be confused.

Thus, the second issue was a split: likelihood of confusion for Ty; actual confusion for the Jones Group.

Third, the court had to consider whether the Jones Group could be liable for the dilution created by retailers' use of the term Beanie on the metatags of their Web sites.

A fatal flaw emerged in this part of Ty's argument. Ty might have been able to make the metatag dilution claim against the Jones Group—if Jones' Web site had included the offending term. But there was no evidence of this; instead, Ty hammered the fact that retailers who sold the Beanie Racers used the term.

This was too much of a stretch. The Jones Group didn't own or control the retailers. The court found it hard to believe that the Jones Group would have had any control over its retailers' Web site codes.

So, the third issue was a win for the Jones Group.

Issue by issue, the court ruling would seem to be a draw between Ty and the Jones Group. But the court put more weight on the first issue than the other two—so the ruling tilted in Ty's favor. Because Ty had a better than negligible chance of showing likelihood of confusion, the court granted the preliminary injunction that prohibited the Jones Group from making or selling any more Beanie Racers.

These two cases are typical of modern trademark disputes. Courts are forced to hash out **minute details of subjective things**, such as the popularity of a board game or a stuffed animal—and the public's perception of those items. If some of the terms and jargon within these cases makes

your head spin, a closer look at the actual laws that comprise the body of trademark law will untangle some of the mess.

Federal Trademark Dilution Act of 1995

To expand the scope of rights granted to famous and distinctive marks under the Lanham Act, Congress passed the Federal Trademark Dilution Act (FTDA) in 1995. It establishes a **federal cause of action** against persons who trade on the goodwill of famous marks to dilute their distinctiveness. Unlike normal trademark infringement, the FTDA protects famous marks and famous trade dress "from subsequent uses that blur the distinctiveness of the mark or tarnish or disparage it, even in the absence of a likelihood of confusion."

The Act created a federal cause of action to protect trademarks from unauthorized users who "attempt to trade upon the goodwill and established renown of such marks." Congress sought to discourage forum-shopping and give authority to federal courts to issue nationwide injunctions based upon trademark dilution.

The language of the FTDA requires that a mark be truly distinctive and famous, a higher standard than that required for ordinary Lanham Act protection. Examples that meet this requirement include marks such as Kodak, Xerox and Unix.

The statute provides a **nonexclusive list of eight factors** that courts must consider when determining whether a mark is distinctive and famous, including:

The Degree of Inherent or Acquired Distinctiveness of the Mark. Congress indicated that courts should be discriminating in categorizing a mark as "famous." The "distinctiveness" of the mark, as the term is used in this context, is essentially synonymous with fame and art. Therefore, it is necessary for a mark to be more than merely inherently distinctive (or to have acquired distinctiveness through secondary meaning). The threshold finding of distinctiveness discussed above is a necessary, but not sufficient,

element of fame. This factor requires consideration of the strength and fame of the mark.

The Duration and Extent of Use of the Mark in Connection with the Goods. The relevant criteria used to assess this factor are similar to those criteria used to show that a mark is strong or has acquired secondary meaning in the context of finding distinctiveness.

The Duration and Extent of Advertising and Publicity of the Mark.

The Geographical Extent of the Trading Area in which the Mark Is Used. The geographic fame of a mark must extend throughout the U.S., or at least through a substantial portion of the country.

The Channels of Trade for the Goods or Services with which the Mark Is Used.

The Degree of Recognition of the Mark in the Trading Areas and Channels of Trade Used by the Mark's Owner and the Person Against Whom the Injunction Is Sought.

The Nature and Extent of the Use of the Same or Similar Marks by Third Parties. If a mark "is merely one in a crowd of similar marks, [it] will not usually be famous."

Whether the Mark Was Registered Under the Act as of March 3, 1881, or the Act of February 20, 1905, or on the Principal Register.

The FTDA is silent as to how similar the conflicting marks must be to create the requisite dilution. While some state anti-dilution statutes state that in the absence of "[substantial]...similarity...there can be no viable claim of dilution," every case receives individual attention.

> **A finding of substantial similarity between two marks is a prerequisite to any finding of dilution. And, the greater the similarity between the marks, the more likely that blurring will occur.**

It's important to reiterate that under the Act, **famous marks are protected** against the dilution of the distinctive nature of the mark. There is no need to prove a likelihood of confusion or show competition between the goods or services. This is why it's possible to claim dilution against a user of the same mark even when another's goods or services bear no relation to the goods or services of the famous mark.

How Trademark Dilution Works

Dilution legislation flowed from a desire to prevent "hypothetical anomalies" such as "Dupont shoes, Buick aspirin tablets, Schlitz varnish, Kodak pianos, Bulova gowns, and so forth."[1] In its often-quoted 1963 decision *Polaroid Corp. v. Polaraid, Inc.*, the Seventh Circuit U.S. Court of Appeals wrote:

> The gravamen of a dilution complaint is that the continuous use of a mark similar to plaintiff's works an inexorably adverse effect upon the distinctiveness of the plaintiff's mark, and that, if he is powerless to prevent such use, his mark will lose its distinctiveness entirely.... [D]ilution is an infection which, if allowed to spread, will inevitably destroy the advertising value of the mark.

By the time the FTDA was passed, 25 states had already enacted trademark dilution statutes. Because the federal Act states that federally registered marks may no longer be the subject of state law dilution claims, it effectively **preempts the existing state dilution acts** for most famous marks.

Looking back at the critical portion of the Lanham Act, Section 43(c) states in pertinent part:

> The owner of a famous mark shall be entitled, subject to the principles of equity and upon such terms as the court deems reasonable, to an injunction against another person's commercial use in commerce of a mark or trade name, if such use begins after the mark has become famous and causes dilution of the distinctive quality of the mark....

[1] See *Mead Data Central, Inc. v. Toyota Motor Sales, U.S.A., Inc.* (1989).

Dilution, as defined later by the Act of 1995, is:

> the lessening of the capacity of a famous mark to identify and distinguish goods or services, regardless of the presence or absence of competition between the owner of the famous mark and other parties or likelihood of confusion, mistake or deception.

Dilution is usually established by a showing of either tarnishment or blurring. **Tarnishment**, which is easier to explain…but is used less often, is, simply, the association of a trademark with a product or activity that suggests impropriety, illegality or untrustworthiness. This association erodes the goodwill and value that consumers assign toward the marks. **Blurring** involves an injury to the mark's selling power, and occurs when there is a possibility that the mark will lose its ability to serve as a unique identifier of an owner's products, due to another party's use. But, like so many aspects of trademark law, blurring is a subjective thing; blurring sufficient to constitute dilution requires a case-by-case factual inquiry.

Disagreement Over Legal Standards

Federal courts have articulated—and some have confirmed—a six-step analysis for considering the likelihood of dilution by blurring. The six steps in this process include an analysis of the following:

1) similarity of the marks;

2) similarity of the products covered by the marks;

3) sophistication of consumers;

4) predatory intent;

5) renown of the senior mark; and

6) renown of the junior mark.

These factors are balanced to determine whether a likelihood of dilution by blurring exists.

Competition is an important factor in determining dilution. Some courts have ruled that a competing mark should have a dilutive effect only in rare

cases—this allows competing products to compare themselves in advertising or promotions. One example of the kind of rare case that might be deemed dilutive: Volkswagen placing a copy of a 1950s Cadillac tail fin on its Beetles. While no consumers would be confused into thinking that the Beetle was a Cadillac, Volkswagen's use of the mark might dilute the strength of the tail fin as Cadillac's trademark.

If consumers are sophisticated, there is a reduced likelihood that a junior mark will blur the senior mark's selling power. Purchasers of relatively inexpensive goods such as ordinary grocery store foods are held to a lesser standard of purchasing care.

Predatory intent in this context means that the junior user adopted its mark hoping to benefit commercially from association with the senior mark.

Blurring is more likely if the junior user has a strong, independent image and reputation for its mark. But not every court agrees with these factors. Some courts and commentators have criticized these factors for introducing considerations that "are the offspring of classical likelihood of confusion analysis and are not particularly relevant or helpful in resolving the issues of dilution by blurring."

For example, one federal appeals court rejected the six-step process in a dilution analysis and instead proposed an inquiry into "whether target customers will perceive the products as essentially the same." This isn't any more objective, though.

Mechanically, the standard for establishing dilution is similar to the one for establishing infringement. More specifically, the 1999 Federal Appeals Court decision *Syndicate Sales v. Hampshire Paper* ruled that, to succeed on a trademark dilution claim, a party must provide sufficient evidence that:

1) the mark is famous;

2) the alleged infringer adopted the mark after the mark became famous;

3) the infringer diluted the mark; and

4) the defendant's use is commercial and in commerce.

Why does the mark have to be "famous"? Mostly, because the law says so. Claims for protection against dilution and infringement both require that the marks be:

1) used in commerce;

2) nonfunctional; and

3) distinctive.

If a mark isn't famous, incontestable will usually do. As we've seen before, a trademark becomes incontestable through five years of use after federal registration and compliance with statutory formalities. Once a mark has **achieved incontestable status**, "it is conclusively presumed either that the mark is non-descriptive, or if descriptive, has acquired a secondary meaning."

If the configuration mark is incontestable under federal law, it is presumed to have met the threshold distinctiveness requirement for a trademark infringement or dilution claim.

Why Dilution Is So Tough to Prove

From a business perspective, the biggest risk that the owner of a trademark faces is dilution. When you've done all the work that is required to register and establish a trademark, you don't want someone else's casual use of or reference to your mark to erode its value.

But, from a legal perspective, dilution is not such an essential part of trademark use. In fact, dilution claims are not easy to win—even if a full registered and established trademark is in question.

The Value of a Good Idea

Why is trademark dilution—which seems the most intuitive claim to make—so tough to prove? Because it relies on subjective standards like **marketplace reaction and appearances**.

Perhaps the best way to show how and why a trademark dilution claim is difficult is to look at a case in which one such claim worked. In the February 1999 Federal Court decision *Nabisco, Inc., et al. v. PF Brands, Inc.*, Pepperidge Farms won a dilution claim on behalf of its Goldfish crackers. But it had to do a lot of work to win.

Most people are familiar with Pepperidge Farm's Goldfish cheese flavored crackers—and even their distinctive foil-bag packaging. The company first obtained trademarks for Goldfish in the 1960s, when it registered "Goldfish" as a trademark name. By 1998, the company owned various marks—including ones for the product design of the Goldfish cracker, the product design of the foil-bag package and the designs and containers for various derivative snack foods (the smiley Goldfish, the Goldfish pretzel, the Goldfish with sunglasses, etc.). Pepperidge Farm invested a lot in building the Goldfish brand in the highly-competitive snack food market. It wanted to protect its fish against any imitators.

Pepperidge Farm and Nabisco are active competitors in the snack food market. In fact, they are competitors in the smaller cheese flavored cracker niche; Nabisco's Cheese Nips—small, square cheese crackers—rank right behind Pepperidge Farm's Goldfish in annual sales.

In late 1998, Pepperidge Farm learned that Nabisco intended to launch a new product in early 1999 based upon the Nickelodeon Television Network's popular cartoon program *CatDog*. Nabisco's new product, called CatDog but also keeping the Cheese Nips trademark, was a cheese cracker that came in three shapes: the CatDog and its two favorite foods, bones and…fish.

Pepperidge Farm didn't hesitate to take action; it sent Nabisco a cease and desist letter in mid-December, warning of its possible claims for dilution, tarnishment and infringement.

Chapter 8: Confusion, Dilution & Secondary Meaning

Instead of abiding by the letter, Nabisco sued Pepperidge Farm—apparently in the hope that a court would declare Nabisco wasn't diluting, tarnishing or infringing on the Goldfish trademark.

In January 1999, Pepperidge Farm answered Nabisco's complaint, claiming that the CatDog product:

1) threatened to dilute Pepperidge Farm's configuration trademark for use of the goldfish shape for a snack cracker;

2) infringed that trademark; and

3) injured Pepperidge Farm's business reputation as defined under New York General Business Law and common law theories.

Can you really trademark something like the shape of a goldfish? That was what the court set out to establish in this case. The dispute centered around how children—the target consumers of Nabisco's product and approximately half the consumers of Pepperidge Farm's product—perceived the new fish-shaped cheese cracker. Pepperidge Farm argued that Nabisco's cracker would allow Nabisco to "unfairly trade upon the good will and renown of the Pepperidge Farm Goldfish."

This is a good legal definition of dilution.

In addition, Pepperidge Farm asserted that CatDog infringed Pepperidge Farm's trademark because it would **cause consumer confusion** between the two products. It pointed out that, because adults and children frequently eat Goldfish from small plastic bags or from bowls or plates, the presence of a goldfish-shaped cheese cracker in the CatDog mix would confuse consumers into believing that the product originated with Pepperidge Farm.

And, less plausibly, Pepperidge Farm argued that the crude humor used in the *CatDog* TV show would **tarnish the Goldfish's wholesome image**.

Nabisco, on the other hand, asserted that it acted in good faith, modeling its new product after a character and symbols used in the cartoon.

The Value of a Good Idea

Less than a month before Nabisco's new product was set to launch, the court sided with Pepperidge Farm and granted the motion for a preliminary injunction. Nabisco couldn't launch its new cheese cracker with the goldfish design. It agreed to delay the product launch until the lawsuit was resolved.

Demonstrating the fame of Pepperidge Farm Goldfish was easy. When measured in sales dollars, Goldfish were the number one ranking cheese snack cracker. The first television advertisement for Pepperidge Farm Goldfish aired in 1974; after which the company launched an aggressive marketing and advertising campaign. Between August 1997 and August 1998, Goldfish reached over $234 million in total sales.

The Goldfish design had received substantial unsolicited media coverage, including segments on NBC's *Today* Show, a cameo appearance on the *Friends* TV sitcom, and numerous articles in the popular and trade press. Short of being live fish, Goldfish were arguably the most famous fish in the market. This extended duration and high volume of use made, in the eye of the court, the **Goldfish mark distinct and famous**.

That was only the first part of the issue, though. Pepperidge Farm had also claimed dilution and tarnishment—and the court looked for evidence of these abuses.

The tarnishment claim was weak. Pepperidge Farm claimed that it had to protect its wholesome, "family-oriented" product and image from tarnishment by association with the "coarse and/or unsavory elements" of the *CatDog* TV show. This didn't sway the court, though—the show was a children's cartoon airing on an award-winning cable network. The court dismissed the tarnishment claim.

The dilution claim seemed to have more weight, though.

The court had to consider both the distinctiveness of Goldfish as a configuration trademark and as trade dress. According to the court, the "product design of the Goldfish may be considered distinctive if it is 'likely to serve primarily as a designator of origin of the product.'"

Chapter 8: Confusion, Dilution & Secondary Meaning

In other words, did the design of the Goldfish point to Pepperidge Farm? The court relied on the subjective considerations of Pepperidge Farm's intent, an objective view of the Goldfish and the similarity of the Goldfish to other products in the market. Ultimately, the court found that the **Goldfish pointed to Pepperidge Farm**. It said the Goldfish's uncomplicated design was what allowed consumers to identify and associate the company readily with its snack cracker products.

The next question: Had Nabisco tried to blur that association? Blurring, as we've mentioned, is a key element to any dilution claim.

The court ruled that it had. Nabisco knew of the Goldfish fame; it could have picked another shape, developed a successful snack product tie-in without having to use the fish shape or changed the color if its crackers. Yet it failed to take any of these precautions. And all of these failures suggested a **lack of good faith**.

Moreover, the court wrote:

> An inference may be drawn that Nabisco intentionally kept its competitor in the dark as to its plans to use a goldfish cracker, so as to eliminate Pepperidge Farm's opportunity to mount an effective challenge to such use.

Before closing this case, the most interesting thing offered by the court came toward the end. It wrote:

> In essence, Pepperidge Farm has taken a unique and fanciful idea—creating a cheese cracker in the shape of a goldfish—and turned this idea into its signature. Nabisco's inclusion of this signature element as part of the CatDog product strikes at the heart of what dilution law is intended to prevent: the "gradual diminution or whittling away of the value of the famous mark by blurring uses by others." Over time, the presence of Nabisco's goldfish-shaped cracker within the CatDog mix is likely to weaken the focus of consumers on the true source of the Goldfish.

That's about as good a definition of dilution as any court has offered.

The court order Nabisco to:

1) recall all CatDog brand products; and

2) cease using the Goldfish mark (i.e. a gold goldfish) in connection with the manufacture, distribution, sale, advertisement or promotion of any of its products.

Nabsico could—and did—keep the CatDog crackers. But it had to stop making the fish crackers.

Acting Quickly

It's important to act quickly when you suspect someone is doing something that dilutes your trademark.

Although many intellectual property lawyers make a big deal about how important it is to act quickly and decisively when there is the slightest hint of trademark dilution, the mania for threatening every alleged dilution can go too far in some cases. According to the 1982 Federal Appeals Court decision *Playboy Enterprises v. Chuckleberry Publishing*:

> The owner of a mark is not required to police every conceivably related use thereby needlessly reducing non-competing commercial activity and encouraging litigation in order to protect a definable area of primary importance.

And there is such a thing as fair use—even for trademarks. The **fair use doctrine** permits use of a protected mark by others to describe certain aspects of the user's own goods.

Fair use analysis also requires a finding that the protected mark was used in good faith. The **good faith requirement** has not been litigated frequently.

Courts and commentators who've considered the question equate a lack of good faith with the subsequent user's intent to trade on the good will of the trademark holder by creating confusion as to source or sponsorship of said trademark.

In the 1997 Federal Appeals Court decision *Fun-Damental Too v. Gemmy Industries*, the court wrote:

If there is additional evidence that supports the inference that the defendant sought to confuse consumers as to the source of the product, we think the inference of bad faith may fairly be drawn.

On the other hand, an inference of a lack of good faith may arise from a defendant's use of a plaintiff's mark with the **intent to trade upon the good will** represented by that mark.

Competition and Confusion

So much of intellectual property issues is counter-intuitive that it's good to find something that makes common sense. One of these simple, clear points is that confusion is more likely to occur between companies or products that compete directly.

The fashion industry, for example, is a competitive business that's full of colorful trademark disputes. In the March 2001 Federal Court decision *Chum Limited v. Adam Lisowski, et al.*, a Canadian entertainment company went after a French production company in the U.S. over the rights to the term "fashion television."

You might wonder how these two foreign companies wound up in American courts. Given the extensive business bridges that exist these days among networks, television channels and production companies, many corporations hold rights to programs and have a major presence in countries other than their own. In this case, Chum—one of Canada's leading media companies and content providers—produces, broadcasts and distributes television and radio programming not only in Canada, but in Europe, South America and the U.S. One of its productions, *Fashion Television*, is a magazine format fashion program, which features a host, interviews with photographers, designers and models and edited clips of fashion footage. The program is also referred to as *FT Fashion Television*; *Fashion TV* and *FTV*. The slogan "The Original. The Best" often accompanies the program. The company adopted the FashionTelevision mark in 1985, which has been in use in the U.S. since 1992 when it first aired on VH-1. After seven years on VH-1, FashionTelevision moved to E! Entertainment Television in 1999.

The Value of a Good Idea

At the other end of the table in the case was Adam Lisowski and his entourage of people that produce a competing program—*Fashion TV* in their "Fashion TV Paris" production company. This company produces a 24-hour television channel featuring non-stop music and clips of fashion models on a catwalk. The program is broadcast in many countries, including the U.S. (in Miami and New York). The channel is known as *fl'original* and sometimes *fl'original Fashion TV*, *FTV*, *FTV The Original*, *Fashion TV The Original*, *Fashion TV* and *Fashion TV Paris*.

The trial took place in federal court in New York.

Lisowski managed to register three variations of *Fashion Television* in France, but failed to do so in the U.S. When he tried in 1998, the Patent and Trademark Office **rejected his application** on grounds that the term was not protectable and that he'd have to disclaim exclusive rights to the use of the term in order for its mark to be registered.

Among Chum's complaints were the obvious: trademark infringement and dilution, unfair competition and unfair business practices.

It should be noted that the two companies had previously negotiated business deals. They had met at an industry meeting in Cannes in 1997 and talked about the sale of certain programs. Their discussions, however, came to a halt once legal actions began over the use of the Fashion Television mark. In a trial first held in France, under French law, a preliminary injunction was granted to Chum, then taken away by an appeals court.

Back in the U.S., Judge Kimba Wood of a New York district court rejected Fashion TV Paris's motion to dismiss, but ordered only the unfair competition claim to go to trial. The judge also dismissed any and all claims countered by Fashion TV Paris.

Because Chum did not own valid trademarks in the U.S., and the company could not demonstrate that it had a "valid trademark entitled to protection," the court threw out the trademark infringement and dilution claims. Faced with the defense's evidence that "fashion television" was a generic term, Chum **failed to prove that the mark was anything but generic**.

On the unfair competition claim, however, the court found more. It ruled that a trial was necessary to determine the likelihood of confusion, bad faith and the other claims related to unfair competition.

The outcome of this case is yet to be determined. The defense's motions to dismiss, as well as its counterclaims, were denied. Chum has a chance to protect its investment and aggressively pursue the competition.

Trademarks and Antitrust

The Fashion Television case was also interesting because it involved several claims of antitrust violations.

What does an intellectual property dispute have to do with antitrust claims? More than you might guess. Antitrust is a new but growing aspect of trademark law. In short, the arguments usually allege that unfair use of a trademark or commercial name **creates a monopoly** in a disputed market.

In the FTV lawsuit, Lisowski made a counter-argument claiming that Chum's market share, in the specific context of the market for fashion programming, suggested a dangerous probability of a monopoly in the market.

On this matter, the court ruled:

> The undisputed evidence is that [Chum] possesses less than a [25] percent share of the United States market for fashion programming, and that [it] competes with several other producers of fashion programming—including CNN, MTV, E! and defendants—within this market.

Lisowski offered no evidence that there existed barriers to entry or other factors to suggest that Chum's market power was not adequately reflected by its current market share. So, the court ruled that Lisowski hadn't provided sufficient evidence to support **antitrust claim**.

The court also rejected Lisowski's contention that Chum's application for a license to produce a 24-hour fashion channel in Canada was likely to

result in Chum's domination of the United States market. The court noted that, in determining whether to apply U.S. antitrust law to a foreign act:

> the inquiry should be directed primarily toward whether the challenged restraint has, or is intended to have, any anticompetitive effect upon United States commerce, either commerce within the United States or export commerce from the United States.

Here, again, the court concluded that Lisowski had failed to produce competent evidence that Chum's application for a Canadian broadcasting license, even if successful, will have an anticompetitive effect upon U.S. commerce, or that Chum intended such an effect.

Even though Lisowski failed to make an antitrust claim that stuck, the idea has growing importance. In a world—or, more accurately, in a business market—that puts a lot of value in brand names, **trademarks can be barriers to entry**. And, if a trademark is used intentionally to keep competitors out of a market niche, it could be grounds for an antitrust claim.

"Michael Jordan" and Secondary Meaning

As we discussed earlier, *secondary meaning* can get a little fuzzy, but it can make or break a trademark infringement suit. Take, for example, the March 2001 U.S. District Court decision *Chattanoga Manufacturing v. Nike, Inc.*, which dealt with the **secondary meaning of the world's most famous basketball player**.

In 1979, Morris Moinian and Jimmy Soufian founded Chattanoga and its Jordan Blouse Division. Chattanoga sold only women's apparel. Moinian and Soufian claimed that they had used the term "Jordan" to identify the products of its Jordan Blouse Division since the start of their business.

In 1984, Chattanoga's net sales were almost $3.6 million. By 1998, net sales had grown to almost $16 million. Chattanoga sells directly to wholesalers and retailers, who, in turn, market it's products to consumers. Chattanoga's intended consumer market has, to date, principally been middle class women in the 25 to 50-year-old age group, and its products are sold at moderate prices.

Chapter 8: Confusion, Dilution & Secondary Meaning

Michael Jordan is a man of extraordinary fame throughout the world. In 1984, Jordan joined the NBA's Chicago Bulls and became the NBA Rookie of the Year, an All Star and the Slam Dunk Champion. In all, Jordan played 12 full seasons with the Bulls, leading the league in scoring 10 times and achieving the highest career scoring average of any player in NBA history. Jordan led the Bulls to six NBA championships, winning the regular season MVP award five times and the finals MVP award six times.

Since 1984, Jordan has endorsed and given valuable input into the design of Nike's athletic apparel products; and Nike has promoted Jordan in its marketing campaigns.

Jordan's first contract with Nike, effective September 1, 1984, was a Pro Basketball Consultant Contract, which had a term of five years. At the expiration of the first contract, Jordan and Nike entered into a second five-year agreement, effective September 1, 1989, also denoted Pro Basketball Consultant Contract.

Nike and Jordan's next deal expanded significantly. Technically, it was a Personal Services and Endorsement Contract, effective September 1, 1994, which had a term of 29 years. Under the contract, Nike, in exchange for its agreement to pay compensation to Jordan, had the right to use Jordan's name and image in connection with a variety of Nike products. Furthermore, under the contract, Jordan had rights of approval, which he could not unreasonably withhold, for proposed trademarks or marketing materials that use an element of "the Jordan endorsement."

The contract stated that Nike is the "sole and absolute owner" of the Jordan-related marks.

Since it has been manufacturing and distributing Michael Jordan-endorsed products, Nike has sold many millions of dollars of footwear, apparel and accessories, all bearing the name or image of Michael Jordan. With the exception of women's athletic shoes sold in 1999, all of the Michael Jordan-endorsed Nike apparel has been designed for men, boys and small children. Nike's target customer for its Michael Jordan-endorsed products generally is an urban male between the ages of 18 and 25. Most Michael Jordan-endorsed apparel is either intended for exercise or de-

signed to have an athletic feel. According to Nike, this apparel is priced in a premium price range relative to the competition and product type.

In 1997, Chattanoga retained trademark counsel and applied for trademark registration for "Jordan" for use on "women's wearing apparel, namely blouses, sweaters, tee shirts[,] jackets, vests, pants, trousers, skirts, suits, dresses, jumpers, jump suits, jogging suits, exercise wear and women's underwear."

When it applied for registration of the Jordan mark in 1997, Chattanoga did not submit evidence that the mark had become distinctive of the Chattanoga goods in commerce and its first trademark application was rejected by the PTO. By 1998, however, the company had succeeded in obtaining the mark, and the Certificate of Registration was issued in October of that year.

In October 1999, Chattanoga **filed a trademark infringement and dilution lawsuit against Nike and Michael Jordan**. The lawsuit was assigned to the Federal Court for the Eastern District of Illinois.

Chattanoga had bitten off quite a bit in its lawsuit. It had to show evidence of secondary meaning in court, but its first step in this process was to point out that the PTO had registered its trademark.

This argument works, in some situations. In the 1999 decision *Lane Capital Mgmt. v. Lane Capital Mgmt.*, the Second Circuit Federal Appeals Court wrote that registration of the mark "without proof of secondary meaning creates the presumption that the mark is more than merely descriptive, and, thus, that the mark is inherently distinctive."

That's only a presumption, though. Courts can either rebut the presumption or demand more evidence. In this case, the Illinois Federal Court wrote:

> Even if we could say that, as a matter of law, Chattanoga's Jordan mark required proof of secondary meaning, there would remain a question of fact as to whether [it] has met its burden in proving secondary meaning. Courts consider a variety of factors in determining whether a mark has achieved secondary meaning.... A

party seeking to establish secondary meaning may rely on direct evidence of consumer recognition or indirect evidence consisting of sales volume, advertising expenses and other indicia of recognition and promotion of the product in commerce.

So, with a question of fact before it, the court looked for evidence of secondary meaning. Because it had found a question of fact as to whether Chattanoga's mark was protectable, the court moved on to consider whether there was a likelihood of confusion resulting from Nike's use of the Jordan mark. At this point, the court wrote:

> In determining whether there is similarity in the two marks, we must consider the marks "in light of what happens in the marketplace." Chattanoga's Jordan and Nike's Jordan marks are nearly identical, with the exception that Chattanoga's mark has an elongated "J." Nike asserts that its use of…other identifying marks such as Michael Jordan's picture and the number 23, used in conjunction with its Jordan mark, distinguish its mark from Chattanoga's mark. In addition, Nike argues that Chattanoga's use of a flower image on its hang tags also serves to make clear the difference between the two marks.

But the marks themselves were **nearly identical**. The court could not say that, as a matter of law, the other markings successfully mitigated the similarity. So, it had to move on to the question of whether consumers were likely to **mistakenly believe that there was an association or sponsorship connection** between Chattanoga and Nike.

The parties agreed that Nike's Jordan mark was strong; neither side disputed that the media and the public had come to identify the name Jordan with Nike's Michael Jordan-endorsed products. All this was true, even though Nike had started using its Jordan mark after Chattanoga had started using its. Following trademark law simply, the strength of Nike's newer (or "junior" in legal terms) Jordan mark would weigh in favor of Chattanoga.

But Nike urged the court to look beyond simple comparisons because, to do otherwise, would work "a perverse result." In other words, "less imagi-

native marks (i.e. "Jordan") would be more likely to win reverse confusion claims than arbitrary or fanciful marks (e.g. Kodak)."

To address this anomalous result, other federal courts had considered both a **mark's commercial and conceptual strength**. Specifically, a plaintiff with a commercially weak mark is more likely to prevail on a reverse confusion claim than one with a stronger mark; on the other hand, a conceptually strong mark weighs in the plaintiff's favor. So, the two prongs—commercial strength and conceptual strength—complement each other.

On this point, the court noted:

> We believe that this two-prong approach to the strength of mark determination would adequately address Nike's concern of "perverse results" and, in fact, mirrors [Nike's] own proposal to consider the strength of the junior user's mark in considering advertising and promotion but to measure the conceptual strength of the senior user.

Clearly, "Michael Jordan" had secondary meaning. But even the two-prong approach left questions open. The Chattanoga mark was conceptually weak but Nike's mark is commercially strong—so the two elements canceled each other out. In the end, the court turned to the issue of timelines.

For more than 15 years, Nike had spent millions of dollars each year to promote its Michael Jordan-endorsed products and to pay royalties to Jordan. Nike invested big money in promoting its products as Jordan products; doing so, it had acquired a position as a market leader. All that time, **Chattanoga had sat silently and watched** Nike's Jordan marks develop their secondary meaning—and bring in millions of dollars in business. The court wrote:

> Had Chattanoga brought this action in a more timely manner, [Nike] might well have chosen some alternative position which it believed to best promote its chosen image. Instead, the undisputed facts establish that Chattanoga did virtually nothing in the face of the growing popularity of the Michael Jordan-endorsed Nike products.... Indeed, Chattanoga's first effort to protect its

mark against [Nike's] very public use of the mark on its own products was to belatedly file an application for trademark registration in 1997. Even after taking this step, Chattanoga did not attempt to contact [Nike or Jordan] to make them aware of its claimed superior rights until just before it filed this lawsuit.

The court concluded that forcing Nike to abandon its name, after 15 years of unchallenged promotion and expansion, would result in extreme prejudice to Nike and Michael Jordan. The court concluded:

Due to Chattanoga's long delay and the extreme prejudice to Defendants, we must deny both damages and injunctive relief to Chattanoga. To do otherwise would be to work an extreme injustice to [Nike] and to reward Chattanoga for sleeping on its rights.

It granted summary judgment for Nike and Michael Jordan—and dismissed Chattanoga's claims.

Abandonment As a Defense

Often, when a dispute over the use of a trademarked word, phrase or image comes up, the party making the alleged improper use will argue that the trademark owner has abandoned the mark.

Can you **abandon a trademark** and then seek relief from an infringer later on? That was a key issue in the March 2001 Federal Court decision *Emachines, Inc. v. Ready Access Memory, Inc.*

EMachines, a company that makes, sells and markets low cost computers, sued Ready Access Memory (RAM), a company that sells, repairs and services computer components, for using its registered "e-Machines" trademark.

EMachines first filed its suit in July 1999, alleging trademark infringement, false designation of origin, false representation and unfair competition, unlawful business practices, common law trademark infringement and common law unfair competition.

The Value of a Good Idea

The case was complicated by the fact that EMachines didn't own its mark during all of the 1990s. Through various rights assignments and other deals, the e-Machines mark had passed through a series of owners that included Supermac, Radius and Korean Data Systems America, Inc. (KDS).

According to RAM, by 1994 Supermac and its successor Radius had abandoned the mark. This became the bone of contention—if and when the trademark had been abandoned.

The federal trial court hearing the case turned its attention first to the issue of abandonment. Under the Lanham Act, a federally-registered trademark is deemed *abandoned* "when its use has been discontinued with intent not to resume such use" or when the owner of the mark takes actions to render it generic.

The court noted that, following the language of the Lanham Act, federal case law had held that **three years' consecutive nonuse** constitutes *prima facie* evidence of abandonment. However, "this showing can be rebutted with 'valid reasons for nonuse or by proving lack of intent to abandon.'"

Since RAM had focused its claim of abandonment on a period starting in 1994, EMachines offered evidence that then-owner Supermac had built 100,000 and sold 50,000 videoboards using the e-Machines mark between 1993 and 1994.

EMachines and RAM bickered over what constituted sales with and without the mark—but the evidence did support EMachines' contention that its mark had not been abandoned. Even if certain sales were discontinued or very low in volume, the owners never intended to abandon the mark. And, as the court acknowledged, this intention is key to the rules controling trademark abandonment.

RAM could not offer evidence of three years of nonuse. To the contrary, the evidence it offered proved that Supermac and Radius sold computer products under the e-Machine mark between 1994 and 1998; and, even in the periods when there were no sales, the owners continued to service e-Machines products.

Even if the e-Machines product line "was thought to be obsolete" at various times during the 1990s, "evidence of intent not to resume use, without evidence of nonuse, is insufficient." So, EMachines's rights to the e-Machines trademark was still valid.

Conclusion

Hopefully, this chapter's focus on some of the thornier aspects to trademark law didn't leave you befuddled. Because so many of these issues—confusion, dilution and secondary meaning—come together in different ways in any single case, it's hard to absorb the entire scope of trademark law by looking at a small handful of cases. And we haven't been able to address every question that emerges; for example: Do trademarks not connected to any good or service have any value? One last case here can answer that.

The 1975 Federal Court decision *Boston Pro. Hockey Assoc., Inc. v. Dallas Cap & Emblem Mfg., Inc.* dealt with a company selling National Hockey League logos—the logos themselves, unattached to any product (such as a hat or sweatshirt). The court stated:

> The difficulty with this case stems from the fact that a reproduction of the trademark itself is being sold, unattached to any other goods or services.

The court concluded that trademark law should protect the trademark itself:

> Although our decision here may slightly tilt the trademark laws from the purpose of protecting the public to the protection of the business interests of plaintiffs, we think that the two become... intermeshed.... Whereas traditional trademark law sought primarily to protect consumers, dilution laws place more emphasis on protecting the investment of the trademark owners.

And, indeed, that has been the drift of trademark law for more than 20 years.

The Value of a Good Idea

We've seen how the digital age has affected the copyright industry, resulting in the DMCA. The digital age, specifically the Internet, has also directly impacted trademark law. The **Consumer Protection Anticybersquatting Act** is just one example of how courts have responded to new challenges posed by the Internet and its method of delivering content and material to people in an instant. Although more issues exist that can fit in a book on this topic, we've dedicated the next chapter to some of the more critical issues as they relate to trademarks.

Chapter 9:
Internet Issues

The Internet is a vast marketplace. In a legal and commercial sense, the Internet has been compared to the Old West—a place where **growth is booming and business is loosely regulated**. In this environment, legal nuances of trademark and marketing details like branding can get crushed under the boot of exploding growth.

Of course, there are courts, regulators and business groups trying to apply some order to the chaos. In this chapter, we'll consider some of the effects of these efforts.

A good place to start would be with a look at what U.S. courts make of the Internet. In its 1999 decision *Brookfield Communications, Inc. v. West Coast Entertainment Corp.*, the Ninth Circuit U.S. Court of Appeals gave a useful description of the Internet and domain names, as follows:

> The Internet is a global network of interconnected computers which allow users around the world to communicate and share information. The Web, a collection of information resources contained in documents located on individual computers around the world, is the most widely used and fastest-growing part of the Internet, except perhaps for electronic mail (e-mail).
>
> With the Web becoming an important mechanism for commerce, companies are racing to stake out their place in cyberspace. Prevalent on the Web are multimedia "Web pages" [or Web sites]—

computer data files written in Hypertext Markup Language (HTML)—which contain information such as text, pictures, sounds, audio and video recordings, and links to other Web pages. Each Web page has a corresponding domain address, which is an identifier somewhat analogous to a telephone number or street address.

Oftentimes, an Internet user will begin by hazarding a guess at the domain name, especially if there is an obvious domain name to try. Web users often assume, as a rule of thumb, that the domain name of a particular company will be the company name followed by ".com."

A Web surfer's second option when he does not know the domain name is to utilize an Internet search engine, such as Yahoo, Altavista, or Lycos. When a keyword is entered, the search engine processes it through a self-created index of Web sites to generate a (sometimes long) list relating to the entered keyword.

So, that's how a court describes the Internet. What does that mean when you bring an Internet-related intellectual property dispute to a court? Various things.

An Early Internet Decision

The April 1998 Federal Appeals Court decision *Panavision International, L.P. v. Toeppen* is often cited by federal and state courts as the Rosetta Stone of Internet trademark disputes.

Coming before the ACPA, or the Anticybersquatting Consumer Protection Act, this decision set an **early standard for litigating cyberspace cases** across different jurisdictions. It also forced the courts to interpret the Federal Trademark Dilution Act as it applies to the Internet.

The case was like other cases involving cybersquatters that would follow later in various state and federal courts. In 1994, Illinois resident Dennis Toeppen established a Web site devoted to displaying an aerial view of

Pana, Illinois. His site was registered as panavision.com, calling to mind the well-known photographic equipment company Panavision that owned the trademarks and trade names to Panavision and Panaflex.

When Panavision tried to establish a Web presence in late 1995, it found that Toeppen had already taken the name. And, when the company notified Toeppen of its intent to use panavision.com for its Internet address, he asked for $13,000 to release the name. When Panavision refused to meet his demand, he registered "panaflex.com" as well.

Panavision accused Toeppen of being a "cyberpirate" who established domain names on the Internet using well-known trademarks with the intent of **selling the domain names** later to the trademark owners. It noted that Toeppen had obtained trademark-based domain names to countless other popular companies—including Delta Airlines, Neiman Marcus, Eddie Bauer, Lufthansa and Air Canada. He'd offered to sell these domain names for as much as $15,000.

Toeppen thought he was safe because he was in Illinois; California-based Panavision wouldn't be able to touch him legally. But the courts quickly shot down that theory, ruling that under the "effects doctrine" Toeppen was subject to personal jurisdiction in California.[1]

The court sided with Panavision, concluding that Toeppen's conduct violated the Federal Trademark Dilution Act and the California law.

Toeppen appealed, arguing several points. Chief among these: That his use of Panavision's trademarks on the Internet was not a commercial use and did not dilute those marks. The appeals court determined that Toeppen did considerably more than simply register Panavision's trademarks as domain names. He registered those names as part of a scheme to obtain money from Panavision. His acts were aimed at Panavision in California and caused it to suffer injury there. As a result, Panavision was entitled to summary judgment under the **federal and state dilution statutes**.

[1] The mechanism of the "effects doctrine" relates to how jurisdiction attaches over a nonresident tortfeasor who commits an act outside the forum state, directed at the forum state and causes harm to a resident of the forum state.

The appeals court ruled that the California court's involvement was in comport with "fair play and substantial justice." It went on to note, in terms that would shape Internet trademark law to come:

> Toeppen traded on the value of Panavision's marks. So long as he held the Internet registrations, he curtailed Panavision's exploitation of the value of its trademarks on the Internet, a value which Toeppen then used when he attempted to sell the [p]anavision.com domain name to Panavision.

So, the court concluded, a domain name is more than an address where a Web page is located. It is an integral part of the value of a trademark. As the court in *MTV Networks, Inc. v. Curry* had already articulated in 1994, "[A] domain name mirroring a corporate name may be a valuable corporate asset, as it facilitates communication with a customer base."

Toeppen was ordered to hand the domain names over to Panavision. This court loss was only one of several that Toeppen suffered. Through the 1990s and early 2000s, dedicated cybersquatters became repeat defendants in courts all around the United States.

The Anticybersquatting Protection Act

Cases like *Panavision v. Toeppen* called out for the refinement of existing law—and drafting of new law—to deal with Internet issues.

On November 29, 1999, Congress passed the federal Anticybersquatting Consumer Protection Act (ACPA). The purpose of the new law was:

> to protect consumers and American businesses, to promote the growth of online commerce, and to provide clarity in the law for trademark owners by prohibiting the bad-faith and abusive registration of distinctive marks as Internet domain names with the intent to profit from the goodwill associated with such marks—a practice commonly referred to as "cybersquatting."

Cybersquatting involves registering domain names of well-known trademarks by non-trademark holders who then try to sell the names back to

the trademark owners. Since domain name registrars do not check to see whether a domain name request is related to existing trademarks, it has been simple and inexpensive for any person to register as domain names the marks of established companies. This prevents use of the domain name by the mark owners, who not infrequently have been willing to pay a ransom in order to get their names back.

The ACPA further provides:

> A person shall be liable in a civil action by the owner of a mark, including a personal name which is protected as a mark under this section, if, without regard to the goods or services of the parties, that person has a bad faith intent to profit from that mark, including a personal name which is protected as a mark under this section; and registers, traffics in or uses a domain name that:

1) in the case of a mark that is distinctive at the time of registration of the domain name, is identical or confusingly similar to that mark;

2) in the case of a famous mark that is famous at the time of registration of the domain name, is identical or confusingly similar to or dilutive of that mark; or

3) is a trademark, word or name that is protected.

The ACPA lists **nine factors** to consider when determining whether a domain name was registered in bad faith:

1) the trademark or other intellectual property rights of the person, if any, in the domain name;

2) the extent to which the domain name consists of the legal name of the person or a name that is otherwise commonly used to identify that person;

3) the person's prior use, if any, of the domain name in connection with the bona fide offering of any goods or services;

4) the person's bona fide noncommercial or fair use of the mark in a site accessible under the domain name;

5) the person's intent to divert consumers from the mark owner's online location to a site accessible under the domain name that could harm the goodwill represented by the mark, either for commercial gain or with the intent to tarnish or disparage the mark, by creating a likelihood of confusion as to the source, sponsorship, affiliation or endorsement of the site;

6) the person's offer to transfer, sell or otherwise assign the domain name to the mark owner or any third party for financial gain without having used, or having an intent to use, the domain name in the bona fide offering of any goods or services or the person's prior conduct indicating a pattern of such conduct;

7) the person's provision of material and misleading false contact information when applying for the registration of the domain name, the person's intentional failure to maintain accurate contact information or the person's prior conduct indicating a pattern of such conduct;

8) the person's registration or acquisition of multiple domain names which the person knows are identical or confusingly similar to marks of others that are distinctive at the time of registration of such domain names, or dilutive of famous marks of others that are famous at the time of registration of such domain names, without regard to the goods or services of the parties; and

9) the extent to which the mark incorporated in the person's domain name registration is or is not distinctive and famous.

Courts, however, are not limited to considering just the listed factors when determining whether the statutory criterion has been met. The factors are, instead, expressly **described as indicia** that "may" be considered with the other facts. The statute further provides that:

> Bad faith intent…shall not be found in any case in which the court determines that the person believed and had reasonable grounds to believe that the use of the domain name was a fair use or otherwise lawful.

Obviously, one of the most important remedies to cybersquatting is to return the domain name to the rightful trademark owner. Under the ACPA:

> In any civil action involving the registration, trafficking or use of a domain name under this paragraph, a court may order the forfeiture or cancelation of the domain name or the transfer of the domain name to the owner of the mark.

Cybersquatters and the Laws Against Them

The value of an Internet domain name to anyone with a business reputation to uphold is substantial—and even greater when cybersquatters enter the arena to frustrate established trademark and service mark owners. When the rush of registering domain names began, so did the opportunity to **take advantage of another's reputation**. As we mentioned earlier, encouraged to register infringing domain names, cybersquatters hoped to beat legitimate trade and service mark owners, then turn around and sell those domains for a few extra bucks. The courts eventually had to step in and set new standards with new laws.

Another good example of a cybersquatting case is the January 2001 Texas federal court decision *E. & J. Gallo Winery v. Spider Webs Ltd., et al.*

Spider Webs was formed during the gold rush of domain registration for the names of various large U.S. companies. It reserved "ernestandjuliogallo.com" among 2,000 other names of well-known companies, cities and buildings. Spider Webs planned to hold on to the famous domain names until corporate America discovered the Internet—and then sell them for profit to those companies.

When Gallo found out that "ernestandjuliogallo.com" had been reserved by a cybersquatter, they hit Spider Webs with a lawsuit.

Gallo, a California wine industry powerhouse, makes and sells mid-level wines and related products. The secretive and litigious Gallo family operates a network of related companies. Between 1953 and 1999, Gallo registered 12 trademarks, including Gallo, Ernest & Julio Gallo and Gallo/Sonoma.

The Value of a Good Idea

Gallo also controled several Internet domain names at the time of its dispute with Spider Webs.

Between the late 1950s and late 1990s, Gallo sold more than $4 billion bottles of wine bearing the Gallo family of trademarks and spent more than $500 million promoting the brand—an investment the company wanted to protect.

According to Gallo, Spider Webs had violated the ACPA and diluted Gallo's marks in violation of both the federal and state statutes.

Six months after the lawsuit had been filed, Spider Webs started a Web site at ernestandjuliogallo.com that discussed the pending litigation as well as the risks associated with alcohol use. In all, the site contained a number of articles critical of alcohol consumption and of any company in the business of selling alcoholic beverages.

The site included a disclaimer saying that it wasn't affiliated with the actual winery. The site eventually was removed from the Internet.

In August 2001, Gallo requested a partial summary judgment on its claims. The court held that Gallo was a distinctive mark, which clearly had developed secondary meaning within the U.S. and that the public associated it with wine. The court also ruled that, by registering the domain name ernestandjuliogallo.com, Spider Webs had **diluted the domain name** by preventing Gallo from controling it or posting such a Web site to promote its products. Specifically, the court wrote:

> The value of a trademark is diluted when the domain name does not belong to the company sharing that name because potential customers will be discouraged if they cannot find its Web page by typing plaintiff's name.com, but instead are forced to wade through hundreds of Web sites.... Spider Webs' ownership of the domain name E[rnestandjuliogallo.com] gives Spider Webs exclusive control over the use of Gallo's trademark "E[rnest & Julio Gallo]" on the Internet, effectively preventing Gallo from ensuring the ability of its mark to serve as a unique identifier for its goods and services.

236

This discussion reflects the ideas behind the ACPA.

It didn't take much effort on Gallo's part to prove that Spider Webs had violated the ACPA. Although the ACPA was enacted after Spider Webs registered the domain name, the Act applies "to all domain names registered before, on or after the date of [its] enactment... ."

As it turned out, Spider Webs was counting on the ACPA being declared unconstitutional, after which it would be able to sell the domain name. No such thing happened.

It was all about money for Spider Webs…with no intent to sell a valuable good or service. The company didn't even have an intellectual property interest in the name, given that the company itself was called Spider Webs. Pleading the First Amendment and fair use didn't help, either.

The crude formatting and misspellings on the Web site furthered Gallo's argument for having suffered imminent and irreparable harm. And, combined with the disparaging remarks found on the site, Gallo's request for a permanent injunction held substantial merit.

Also, Spider Webs had registered hundreds of domain names that contained either company names or famous trademarks, including the names firestonetires.com, bridgestonetires.com and oreocookies.com. The ACPA singles out this type of behavior as **indicative of bad faith**.

As a result, Spider Webs was permanently enjoined from using the Internet domain name ernestandjuliogallo.com and from registering any domain name that contained the word *gallo* or the words *ernest* and *julio* in combination. The court also ordered Spider Webs to transfer the domain name to Gallo.

Finally, the court awarded Gallo $25,000 in statutory damages under the ACPA. Although Gallo had originally asked for more money, the court determined that $25,000 was the appropriate amount—balancing the fact that Spider Webs never offered products for sale bearing the Gallo name, and that Gallo failed to present **evidence of actual harm** against the fact

that Spider Webs could have placed Gallo at risk of losing business and of having its reputation tarnished.

In all, this case confirmed the constitutionality of the ACPA.

Infringement and Dilution Claims

While the ACPA is a good tool for protecting companies on the Internet, trademark claims can also apply to disputes involving domain names and other Internet matters—although they apply somewhat differently than they do in traditional non-Internet related disputes.

In Chapter 8, for example, we mentioned that in trademark dilution cases, a finding of a likelihood of confusion is not a necessary element for a claim of trademark dilution. Rather, the harm is "the inability of the victim to control the nature and quality of the defendant's goods." In the context of domain names, it has been held that the use of another's trademark in a domain names dilutes the trademark by placing the trademark owner at the mercy of the Web site operator. The Web site operator is able to decide what messages, goods or services are associated with the Web site and by extension, with the trademark.

Another example, according to Internet law expert Peter Brown:[2]

> The domain name serves a dual purpose. It marks the location of the site within cyberspace, much like a postal address in the real world, but it may also indicate to users some information as to the content of the site, and, in instances of well-known trade names or trademarks, may provide information as to the origin of the contents of the site.

Instant secondary meaning!

For these reasons, most courts tend to **favor trademark owners in Internet disputes**. In the April 1998 decision *Playboy Enterprises, Inc. v. Asiafocus International, Inc.*, for example, a federal trial court in Vir-

[2]Peter Brown, *New Issues in Internet Litigation*, 17th Annual Institute on Computer Law: The Evolving Law of the Internet—Commerce, Free Speech, Security, Obscenity and Entertainment, 471 Prac. L. Inst. 151 (1997).

ginia ruled that the domain names playmates-asian.com and asian-playmates.com infringed upon and diluted the Playmate trademark.

That court wrote:

> Although the defendants' use of the term "playmate" as the main component of the domain names…did not exactly duplicate [plaintiff's] mark, minor differences between the registered mark and the unauthorized use of the mark do not preclude liability under the Lanham Act.

This thinking works very well for trademark owners—and doesn't work so well for the Old West image of Internet business.

The August 2000 Michigan Federal Court decision *Paccar, Inc. v. Telescan Technologies* dealt with a domain name that came under fire for trademark infringement and dilution. The case provides a great discussion of the roles that Web sites have in a trademark dilution dispute, and the use of marks on Internet pages.

Paccar makes heavy trucks and truck parts sold under the federally registered trademarks Peterbilt and Kenworth. You've probably seen these names when you look through your rear-view mirror at a truck—they are among the best-selling heavy trucks on American roads.

Paccar also operates a used-truck locator service, which helps people find used Peterbilts and Kenworths for sale throughout North America.

On the other side of this case stood Telescan, a company that runs a number of Web sites: peterbiltnewtrucks; peterbiltusedtrucks; kenworthdealers; and kenworthtruckdealers. At some of these sites, Telescan provides information concerning new and used Peterbilt and Kenworth trucks.

Obviously, Telescan used Paccar's marks in the Web site's titles, metatags and backgrounds to drive traffic to the sites. It maintained its own truckscan.com and telescanequiptment.com sites that held links to other sites maintained by Telescan—but not affiliated with the manufacturers themselves. It did, however, **post a disclaimer** that read: This Web site

provides a listing service for name brand products and has no affiliation with any manufacturer whose branded products are listed here.

So, Telescan wasn't a cybersquatter. It was providing a real service to the trucking and transportation markets. Paccar's claims involved trademark infringement and trademark dilution under the Lanham Act.

Paccar initially asked for a preliminary injunction prohibiting Telescan from using Paccar's registered marks. And the federal court that was hearing the case agreed: It ordered Telescan to stop using Paccar's marks in the domain names, metatags, titles and wallpapering on its sites. At least while the two sides made their cases in court.

At trial, there was little dispute as to the distinctiveness of the Peterbilt and Kenworth names. They had been used in North America for decades. There was also little dispute as to the similarity between Paccar's marks and the ones Telescan used on its sites.

Both Paccar and Telescan offered used-truck locator services through the Internet—so, the similar marks were likely to cause confusion among users. The court acknowledged the fact that consumers could mistakenly believe that Paccar sponsored the Web sites maintained by Telescan, or that they were related companies.

According to the court:

> A disclaimer that purports to disavow association with the trademark owner after the consumer has reached the site comes too late; the customer has already been misdirected. This problem, denoted as "initial interest confusion," and recognized by at least one case in this district is a form of confusion protected by the Lanham Act.

Telescan argued that it did not adopt Paccar's trademarks intentionally to cause confusion; rather, it pointed out that it used the marks Peterbilt and Kenworth in a purely descriptive sense—the domain names simply describe what was on their respective Web sites (e.g. the peterbiltusedtrucks.com site contains a listing of used Peterbilt trucks for sale).

Telescan also made a fair use argument, stating that other courts had held that use of a trademark in advertising constituted a fair use.

The court didn't agree with any of Telescan's arguments, writing:

> Due to the nature of the Internet, and the way in which Internet surfers search for information on the Web, a domain name is significantly different than a classified advertisement. The use of the name of a truck in a classified advertisement communicates information as to the source of the truck, not information as to the seller of the truck. Words in domain names, however, do communicate information as to the nature of the entity sponsoring the Web site. Using the name Peterbilt or Kenworth in a domain name sends a message to Internet users that the Web site is associated with, or sponsored by the company owning the trademarks Peterbilt and Kenworth.

The court concluded that, even if TeleScan had not adopted the domain names with the intent to deceive the public, it certainly **intended to derive a benefit from the reputation** of the Peterbilt and Kenworth marks. Because Peterbilt and Kenworth are so closely associated with trucks, peterbilttrucks.com was not appreciably different from peterbilt.com.

The dilution claim came down to control over the content of the site. Because a consumer could mistakenly associate Telescan's Web site with Paccar's trademark, and Paccar had no power to influence or control what appeared on Telescan's sites, it was effectively "at the mercy" of Telescan. This, in the court's eye, constituted trademark dilution.

Finally, the court ordered Telescan to function without the contested domain names and corresponding Web sites. It could use its telescan.com site and maintain the same list of Peterbilt dealers without using the terms Peterbilt or Kenworth in the domain name itself. That said, the court went on to say that "some authority suggests that the use of trademarks in the post-domain path of a URL is acceptable." In other words, Telescan could get away with telescan.com/peterbilt.

The court ordered Telescan to transfer its Web sites with URLs that included the words Peterbilt and Kenworth to Paccar. It also ordered Telescan to avoid using the marks on its Web pages in any way that would confuse customers, including the use of the marks as titles and wallpaper background.

When Domain Names Cross Borders

Clearly, as the Internet became a major commercial marketing channel in the late 1990s, cybersquatters became a major legal problem. Most Internet experts predicted that they were a nuisance of transition; once the Internet matured into a mainstream media, trademark owners would be more savvy about domain names—and not let computer geeks grab key names.

In the meantime, though, courts around the world faced hundreds—or thousands—of cybersquatter lawsuits.

As a result, judges and legislators were happy to delegate some responsibility for resolving domain name disputes to the **World Intellectual Property Organization** (WIPO) and the **Internet Corporation for Assigned Names and Numbers** (ICANN).

Operated by WIPO,[3] the WIPO Arbitration and Mediation Center mediates and arbitrates cases involving Internet domain name disputes that cross national boundaries. These proceedings generally follow guidelines established by ICANN.

ICANN was established by Internet service providers and related companies around the world to serve as a kind of international referee mechanism for legal and political disputes related to the Internet.

While the full legal reach of WIPO and ICANN remains somewhat fuzzy, they have accomplished something by establishing the **Uniform Domain Name Dispute Resolution Policy** (UDRP), which serves as a useful mediation mechanism. Disputes are supposed to go through UDRP review before heading to court.

[3]For more information on the WIPO, see its Web site at www.wipo.org. For more on ICANN, see www.icann.org.

ICANN, a nonprofit California corporation, governs the assignment of Internet domain names, the allocation of Internet Protocol (IP) address space, and management of the Domain Name System (DNS) and Internet "root" server under the auspices of the Department of Commerce.

ICANN accredits institutions and corporations to serve as domain name "registrars." Network Solutions, Inc. is a principal registrar of the second-level domain names (i.e., the "silverlakepub" part of silverlakepub.com) within the popular ".com" top-level domain name.

Although ICANN exerts quasi-governmental sway over the administration of the Internet, the UDRP is enforced through contract rather than regulation. Every domain name registrar accredited by ICANN must incorporate the UDRP into each domain name registration agreement.

In effect, the UDRP binds registrants by virtue of their contracts with registrars, such as Network Solutions, Inc., to submit to mandatory administrative proceedings initiated by third-party complainants.

The scope of such UDRP proceedings is limited to claims of abusive registrations of Internet domain names. The UDRP covers no other disputes. Complainants in UDRP proceedings must prove that the disputed "domain name is identical or confusingly similar to a trademark or service mark in which the complainant has rights," that the registrant has "no rights or legitimate interests in respect of the domain name" and that the domain name "has been registered and is being used in bad faith."

The UDRP identifies bad faith and grounds for demonstrating a registrant's rights and legitimate interests in a domain name.

The UDRP prescribes detailed procedures for appointing either a solo arbitrator or a three-member panel to conduct the inquiry. The UDRP is

fashioned as an online procedure administered via the Internet. Although a panel may opt in exceptional cases to hold live or telephonic hearings, it is expected to base its decision on the statements and documents submitted in accordance with the UDRP, the UDRP rules and any "rules and principles of law that it deems applicable." In the absence of exceptional circumstances, a panel is expected to **issue its decision within 14 days** of its appointment.

If the panel rules in the complainant's favor, the only available remedy is for the registrar to cancel the domain name registration or transfer it to the complainant. A registrar may automatically implement a UDRP panel decision after 10 days unless the aggrieved registrant notifies the registrar within this 10-day-period that it has "commenced a lawsuit against the complainant in a jurisdiction to which the complainant has submitted" as required by the UDRP rules.

Upon such notification, the registrar waits until it receives satisfactory evidence of the resolution of the dispute, the dismissal or withdrawal of the lawsuit, or a court order that the registrant does not have the right to continue using the domain name.

This may sound unwieldy, but it has been effective. By May 2001, roughly 3,622 separate proceedings concerning 6,410 different domain names had been initiated under the UDRP. So, it was serving a useful purpose—at least weeding out the weakest claims. Still, many Internet experts complain that the UDRP has no mechanism for enforcing its decisions—no legal teeth.

A good example of how the UDRP works—or doesn't—comes in the May 2001 Federal Court decision *Dan Parisi v. Netlearning, Inc.* The two parties were fighting over the rights of the domain name netlearning.com.

In April 1996, Parisi filed a trademark application for the "netlearning" mark. A few days later, he registered netlearning.com with Network Solutions, Inc.

The Patent and Trademark Office denied the trademark application on grounds of descriptiveness and likelihood of confusion with an existing mark (owned by a company not involved in the eventual lawsuit). Parisi abandoned the application in October 1997 but continued to use the domain name to operate a Web site with links to university Web sites. He claimed to be developing netlearning.com as a component of his Megasearch.com search engine.

Meanwhile, Netlearning began using the mark "net learning the ultimate learning system" in June 1997. It registered and began operating the net-learning.com site in May of that year and filed a trademark application for "net learning the ultimate learning system" in April 2000.

Parisi claimed that Netlearning offered to purchase his netlearning.com domain name for as much as $22,500 in early 2000—but he refused to transfer the registration.

Netlearning subsequently **initiated UDRP administrative proceedings** challenging Parisi's registration and use of the netlearning.com domain name. Network Solutions—which cooperates with ICANN—prepared the domain name for reassignment, pending the outcome of the mediation.

In October 2000, a three-member UDRP administrative panel issued a decision in Netlearning's favor, with one panelist dissenting. The panel ruled that each party was entitled to use the domain name it had; it directed Network Solutions to allow Parisi to keep the registration for netlearning.com. Netlearning, Inc. could keep using net-learning.com.

With that ruling in hand, Parisi took several legal steps to solidify his domain name. He sought a declaration of lawful use in federal court under the ACPA and the Federal Declaratory Judgment Act, as well as a declaration of non-infringement under the Lanham Act. He also sought an order directing the PTO to refuse Netlearning's pending application for the "netlearning the ultimate learning system" trademark, an award of fees and costs and further "just and proper" relief.

Parisi filed his complaint in late 2000; but the paperwork wasn't served to Netlearning until February 2001.

The Value of a Good Idea

Netlearning then filed a motion to dismiss Parisi's action because, under federal arbitration law, it constituted an improper motion to vacate an arbitration award. Netlearning argued that Parisi had failed to assert any reasons for setting aside an arbitration award and that, in any event, his action was time-barred.

Parisi countered that existing federal arbitration law didn't apply to the UDRP and that his complaint raised issues far beyond the scope of the UDRP panel ruling.

The court started by analyzing the UDRP. It wrote:

> Clearly, the UDRP creates a contract-based scheme for addressing disputes between domain name registrants and third parties challenging the registration and use of their domain names. However, in our view, the UDRP's unique contractual arrangement renders [the federal arbitration law]'s provisions for judicial review of arbitration awards inapplicable.

The court pointed out that the **UDRP has some serious legal weaknesses**.

First, nothing in the UDRP restrains either party from filing suit before, after or during the administrative proceedings. If litigation starts during the proceeding, the panel has "the discretion to decide whether to suspend or terminate the administrative proceeding, or to proceed to a decision."

Second, it wouldn't be appropriate to compel participation in UDRP proceedings because UDRP complainants are not parties under the registration agreement and are under no obligation to avail themselves of the UDRP.

Third, because the remedies available through the UDRP are so specific, the court found no basis for confirming and enforcing a panel decision.

Under the UDRP, an aggrieved registrant can effectively suspend the panel's decision by filing a lawsuit in the specified jurisdiction and notifying the registrar in accordance with the UDRP. From these provisions, it was clear that ICANN intended to provide "parity of appeal," ensuring a clear mechanism for "seeking judicial review of a decision of an administrative panel canceling or transferring the domain name."

The court concluded that the Federal Arbitration Act's limitations on judicial review of arbitration awards do not apply to civil actions seeking review of UDRP panel decisions concerning domain names.

So, Parisi could go forward with his actions to shore up his domain name.

As it turns out, Parisi is one of the most prolific cybersquatters on the Internet. This has meant a lot of time in depositions and court rooms for the New Jersey-based entrepreneur. But he's won the lawsuits—or at least fought to a draw—more often than most people in his line of work.

One of Parisi's biggest trouble-making activities is registering so-called yourcompanysucks.com domain names. He maintains more than 700 sites with the word *sucks* in them; and courts have confirmed his right to operate Lockheedsucks.com and Lockheedmartinsucks.com (under free speech protection—the sites provide message and complaint boards) and michaelbloombergsucks.com.

An interesting note: Michael Bloomberg—the billionaire media mogul and, as of 2002, mayor of New York—has thwarted online enemies by buying negative domain names. Bloomberg himself owns more than a dozen domains with names like NoBloomberg.org, IhateBloomberg.com, and BloombergSucks.com, according to Network Solutions. According to one Bloomberg spokesperson, "It's brand protection."

Defamation and Bad Faith

Cybersquatters often argue that their intentions in registering famous trademarks as domain names are not malicious or deceitful. This argument isn't terribly relevant to a legal interpretation of their actions—as we've seen, the test for bad faith doesn't exactly require establishing intentionality.

However, it's not true to state generally that cybersquatters are innocents who are merely running a kind of arbitrage for honest profit.

In some cases—and some people argue many cases—the cybersquatter does intend to do the trademark owner harm. Even if this malice is draped in a **cloak of supposed parody or satire**.

The Value of a Good Idea

The April 2000 Federal District Court decision *Morrison & Foerster, LLP v. Brian Wick and American Distribution Systems, Inc.* dealt with the question of malice.

Founded in 1883, Morrison & Foerster employs about 700 attorneys in 17 offices worldwide. It's one of the largest law firms based in the U.S.; it owns the mark bearing its name and is the registered owner of the domain name mofo.com.

In October 1999, Brian Wick registered the following domain names:

* morrisonfoerster.com;
* morrisonandfoerster.com;
* morrisonforester.com; and
* morrisonandforester.com.

(Evidently, Wick had bad feelings about lawyers in general; this wasn't the first—or last—time he'd gotten into trouble for maintaining an insulting site that matched that of a prominent law firm.)

Later that month, the firm attempted to register the domain names morrisonfoerster.com and morrisonandfoerster.com. That's when it discovered Wick.

At that point, no one at Morrison & Foerster knew who Wick was. But, from the messages crudely posted on the Web pages, it was clear he wasn't a supporter. The sites contained the following phrases:

* "We're your paid friends!";
* "Best friends money can buy";
* "Greed is good!";
* "We bend over for you…because you bend over for us!";
* "Parasites No Soul…No Conscience…No Spine…NO PROBLEM."

The firm sent Wick a letter, which stated that his use was an infringement of its mark. Wick posted the letter on the sites—alongside links to other offensive Web sites.

So, Morrison & Foerster did what it does best. It sued Wick in Colorado federal court, making the following claims:

1) cybersquatting in violation of the ACPA;

2) unfair competition and false designation of origin;

3) trademark infringement;

4) trademark dilution;

5) trademark infringement and unfair competition;

6) intentional interference with current and prospective economic advantage;

7) defamation; and

8) business disparagement.

The last two claims were what set the case apart from the run-of-the-mill trademark disputes.

The basic issues were all pretty clear. Morrison & Foerster owned the trademark Morrison & Foerster; and the mark was distinctive. In an initial hearing, the trial court concluded that the firm was entitled to the ACPA's protection.

As if to antagonize the law firm further, Wick amended one of several corporations that he used to include "Morri, Son & Foerster eBusiness, Inc." as an assumed name. But he did this after he'd registered the domain names, so it didn't help him legally.

The court ruled that Wick's four domain names were **identical or confusingly similar** to Morrison & Foerster's mark. It didn't matter that the ampersands were replaced with words, or that two of the domain names contained misspellings.

The court also concluded that Wick **intended to profit** from the marks—and had shown bad faith in doing so. On this point, the court noted the roundabout way Wick had obtained the domain names, using false identities or incomplete contact information. This was clear evidence of his bad faith.

Wick lamely played the parody card, arguing that he was making fun of Morrison & Foerster and the practice of law in general non-commercially. The court ruled otherwise. Wick's sites contained links to Anti-Semitic, racist and otherwise offensive sites. The sites didn't constitute a parody; they merely confused the public and disparaged the firm.

In deposition, Wick had testified that he began registering "parody" domain names to "get even" with a company that had allegedly reneged on a contract with him. When that company had paid him to hand over a domain name, Wick moved on to corporate America in general. At one point, he had registered domain names related somehow to nearly one in 10 Fortune 500 companies. From there, he moved on to big law firms.

Of his cybersquatting, Wick told the court, "I mean to be candid with you. I mean to see these people squirming around over 70 bucks. That's enjoyable." But it's not legal.

The court ordered Wick to transfer all the domains bearing identical marks over to the firm and to cancel the misspelled marks. It **permanently enjoined** him from taking any action to prevent and/or hinder Morrison & Foerster from obtaining the domain names. And it ordered him to pay some of Morrison & Foerster's legal costs related to the trial.

Most people would agree that it was an embarrassing rebuke, fueled by Wick's arrogant behavior. But the decision didn't faze Wick. Shortly afterward, he was involved in another fight with one of Boston's oldest and most well-respected law firms—Ropes & Gray. He lost that one, too.

In all, through early 2001, Brian Wick lost four disputes—two in federal courts and two by ICANN—for his improper use of trademarks in domain names. But he seemed content to continue with the legal battles.

Trespass as an Internet Trademark Issue

We've seen plenty of cases related to the Internet, particularly with regard to domain names and trademark infringement. But trademark disputes can involve more than just infringement; and the Internet remains a devel-

oping area for the law. The result: Internet trademark disputes can turn on some **unusual legal theories**.

A good example of these unusual theories came in the legal scuffle between Internet auction giant eBay and a much smaller company called Bidder's Edge. The July 2000 federal court decision focused on an unexpected legal theory: **trespassing**.

eBay is an online trading site that provides a forum in which individuals can sell just about any kind of personal property—anything from vintage baseball cards and vacuums to exotic cars and rare books. Over 400,000 new items are listed every day; every minute, around 600 bids are made on listed products.

Bidder's Edge, a much less well-known company, described itself as an auction aggregation site "designed to offer online auction buyers the ability to search for items across numerous online auctions without having to search each host site individually."

In the jargon of the time, Bidder's Edge designed and marketed software programs called "shopping bots." These bots (short for "robots") operate throughout the Internet—searching, copying and retrieving functions from other Web sites. The idea is that someone who wants to buy a widget uses the bot, which surfs hundreds of Web sites and brings back information on prices and availability. The user can then make a well-informed buying decision.

The main problem with shopping bots is that they usually consume some of the processing and storage resources of target Web sites and other systems, making them temporarily unavailable to the system operator or visitor. The result? Overload of a Web site that may malfunction or crash.

eBay's site employed "robot exclusion headers," which are messages—sent to computers programmed to detect and respond—that say eBay does not permit unauthorized robotic activity. Programmers who wish to comply with eBay's Robot Exclusion Standard design their robots to read a data file called "robots.txt" and follow the rules.

The Value of a Good Idea

Bidder's Edge, however, didn't comply with eBay's robot exclusion standard.

Still, things started cordially. In April 1999, eBay verbally approved Bidder's Edge accessing the eBay Web site for a period of 90 days. Both sides expected that, during this period, they would reach some kind of formal licensing agreement. But they were unable to do so.

The main hang-up was over the method Bidder's Edge used to search the eBay database. eBay wanted Bidder's Edge to search the eBay system only when queried by a Bidder's Edge user. Bidder's Edge wanted more—to access the eBay system continually and to compile its own auction database. This was a lot to expect without paying eBay in some manner for its information.

In the fall of 1999, eBay requested that Bidders' Edge cease posting eBay auction listings on its site. Bidder's Edge complied; but, when it learned soon afterward that other auction aggregation sites were still including information from eBay auctions, it went back to including the listings on its service.

At this point, eBay stepped up the tone and volume of its correspondence with Bidder's Edge. It reasserted that Bidder's Edge's use of its listings was unauthorized; and it alleged that this use constituted a "civil trespass" of its Web site.

Next, eBay attempted to block Bidder's Edge from accessing the eBay site. This didn't work very well. The main architecture of eBay's site was designed to encourage people to access its listings. The blocks worked something like filters—denying access to queries from Bidder's Edge sites; they were easy to get around. Bidder's Edge simply made its shopping bot queries through third-party sites. So, eBay had to call in its lawyers.

In its lawsuit against Bidder's Edge, eBay alleged **nine causes of action**: trespass, false advertising, federal and state trademark dilution, computer fraud and abuse, unfair competition, misappropriation, **interference with prospective economic advantage** and **unjust enrichment**.

The court was most interested in the first argument.

eBay argued that if Bidder's Edge were allowed to continue unchecked, it would encourage other auction aggregators to engage in similar searching of the eBay system—and that would result in irreparable harm from reduced system performance, system unavailability or data losses.

The court agreed, ruling that eBay had established:

> a strong likelihood of success on the merits of the trespass claim, and [was] therefore entitled to preliminary injunctive relief because it [had] established the possibility of irreparable harm.

Bidder's Edge tried to claim that eBay was a public site and, thus, public domain. The court didn't buy this argument. And, even if Bidder's Edge were allowed to make individual queries of eBay's system, its shopping bots "exceeded the scope of any such consent when they began acting like robots by making repeated queries."

The trespass claim was creative. But it caused some problems for the court. Specifically, trespass claims work when:

> the conduct complained of does not amount to a substantial interference with possession or the right thereto, but consists of intermeddling with or use of or damages to the personal property.

And, in these cases, the owner can recover only the actual damages suffered by reason of the **impairment of the property** or the **loss of its use**.

The difficulty with eBay's claim was that a wrongdoer trespassing on a computer system was more akin to the traditional notion of a trespass to real property than the traditional notion of a trespass to chattels (a legal term for "things"). Trespass to chattels usually caused quicker reaction from courts because it poses a bigger risk of "conversion"—or taking possession of—things.

So, what did the court in this case do? First, it noted that other courts had warned that applying traditional legal principles to the Internet can be troublesome, but it finally concluded that the circumstances in its case supported action. It wrote that:

> [Bidder's Edge]'s violation of eBay's fundamental property right to exclude others from its computer system potentially causes sufficient irreparable harm to support a preliminary injunction.

The court found that eBay had a fundamental "possessory interest" in its Web site and a property right to exclude others from its servers.

From the eBay case, many legal experts suggest that, in order to prevail on a claim for trespass based on accessing a computer system, the plaintiff must establish that:

1) the defendant intentionally and without authorization interfered with the plaintiff's possessory interest in the computer system; and

2) the defendant's unauthorized use proximately resulted in damage to the plaintiff.

In other words, a trespasser is liable when the trespass **diminishes the condition, quality or value of personal property**—even when that property is not physically damaged by a defendant's conduct.

Balance of Harms Analysis

When an aggrieved party asks a court to issue an injunction ordering another party to stop using a trademark, the court has to consider several issues before acting—or deciding not to act. The results can be frustrating to one party, or both.

Of course, the court's job is to be an impartial judge of what has happened…and how to repair any damage that has occurred. One of the main mechanisms for performing these tasks is the balance of harms analysis. In short, this is a legal procedure by which **a court determines how much various solutions would hurt each of the parties** in a dispute.

The worst kind of harm that can occur is *irreparable harm*—and that's what most trademark owners who initiate legal action claim they've suffered…or will suffer soon.

> Harm resulting from lost profits and lost customer good-
> will is irreparable because it is neither easily calcu-
> lable, nor easily compensable and is therefore an ap-
> propriate basis for injunctive relief.

In the dispute between eBay and Bidder's Edge, eBay argued that it would suffer four types of irreparable harm if the court didn't order Bidder's Edge to stop using eBay's site. Specifically, these harms were:

1) lost capacity of its computer systems resulting from to Bidder's Edge's use of automated agents;

2) damage to eBay's reputation and goodwill caused by Bidder's Edge's misleading postings;

3) dilution of the eBay mark; and

4) Bidder's Edge's unjust enrichment.

These harms could also be categorized into two types. The first was harm that eBay alleged it would suffer as a result of Bidder's Edge's automated query programs burdening eBay's computer system (*system harm*). The second was harm that eBay alleged it would suffer as a result of Bidder's Edge's misrepresentations regarding the information that it obtains through the use of these automated query programs (*reputational harm*).

But Bidder's Edge claimed that the problems with eBay's site had more to do with hardware problems within eBay's servers than the thousands of queries from Bidder's Edge's shopping bots. And Bidder's Edge claimed it could provide evidence that its bots weren't the only problem.

eBay then asked the court for another injunction—barring Bidder's Edge from providing any such evidence.

The court didn't think that it could do anything specifically designed to fix the harms eBay claimed—however they were categorized. Instead, it noted:

eBay's motion appears to be, in part, a tactical effort to increase the strength of its license negotiating position and not just a genuine effort to prevent irreparable harm.

So, the court concluded that eBay was not entitled to a conclusive presumption of harm "at this juncture in the proceedings," and eBay's motion to strike all evidence submitted by Bidder's Edge relating to a lack of harm was denied.

But trespass is a tricky claim. Most intellectual property disputes start with infringement.

In an infringement case, once a plaintiff has established a strong likelihood of success on the merits, any harm to the defendant that results from the defendant being preliminarily enjoined from continuing to infringe is legally irrelevant.

Most federal courts have held it to be reversible error for a district court to even consider "the fact that an injunction would be devastating to [defendant's] business" once the plaintiff has made a strong showing of likely success on the merits of a copyright infringement claim.

The reasoning here is that a defendant who builds a business model based upon a clear violation of the property rights of another party cannot then claim that the business will be harmed if the defendant is forced to respect those property rights.

The Federal Circuit Appeals Court has suggested a similar rule with respect to patent infringement:

One who elects to build a business on a product found to infringe cannot be heard to complain if an injunction against continuing infringement destroys the business so elected.

These rules can be applied in similar fashion to trademark infringement disputes.

Conclusion

The Internet will continue to raise new issues for trademark law and intellectual property law in general. The pace of technology is alarmingly fast, and as it further **facilitates the exchange of ideas and information**—and intellectual property—new methods of better protecting property might emerge. As evidenced by the cases discussed up to this point, the courts remain the main forum for defending and enforcing those rights.

This section presented some complex issues, from confusion and secondary meaning to the management of domain names over the Web. But none of these issues comes close to the complexity of the next section's topic: patents. Patents are the hardest type of intellectual property to understand, and they confuse even the experts sitting on the Supreme Court of the U.S.

The Value of a Good Idea

PART THREE:
PATENTS

CHAPTER 10:
HOW PATENTS WORK

Legally, patents are the most complex form of intellectual property protection in the United States and most developed economies. Simply said, a patent is a form of monopoly that the government allows for a limited period of time in order to reward and encourage the development of new devices, products and technologies.

Again, the key concept here is **restriction**. A patent is designed to allow a patent holder to restrict the use of his or her product or process.

Of course, patent law has supported a blossoming technology-based economy and competitive markets full of entrepreneurial business. The law works well in maintaining a balance of economic power among inventors, investors, competitors and—ultimately, consumers.

A discussion of patents can take many forms. Most information published on patents is related to the complicated and involved process of applying for one. That's not our focus here; there are plenty of hefty patent books around already. For the forms, you can go directly to the Patent Office and get most of the paperwork you need.[1]

Instead, we will consider—as we have throughout this book—how patents can be used to protect the value of an idea or invention that a person or company develops.

[1] For more information about patents in general or how to file an application, visit the Patent and Trademark Office at *www.uspto.gov*. Or, refer to Appendix A.

Patents are substantively different than copyrights or trademarks. For one thing, the patent application process is long and complex; it's neither as quick or as easy as filing a copyright or trademark. For another, the law doesn't rule so completely in patent issues; lawyers and judges have to rely on nonlegal experts in most patent disputes.

Patents usually deal with sophisticated technology, requiring an in-depth understanding of complex technology that often exceeds the average patent attorney's technical savvy.

Imagine having to write the description of an insanely recondite technology from the sharpest technical minds at MIT or CalTech. One that could be used in a court of law to defend its meaning? It can't simply describe one thing in a direct or literal sense—it will have to combine technological accuracy with legal validity. Welcome to the world of patents.

Types of Patents

When you file a patent, you must explain your invention in detail, declare that you are the original and first inventor of the subject matter and pay a fee. Completing this application isn't simply a process of filling in the blanks; to the contrary, *claims drafting*, or writing about your invention in a manner that makes a patent enforceable, is an acquired skill. The application must explain how the invention differs from *prior art*, or existing technology, and it must describe how the invention can be used. The one who decides whether to grant or deny a patent is called the *examiner*, and he bases his decision on the *claims*, or the parts that define the invention. There are three types of patents that patent law protects. They are:

1) **Utility patents**: Any new process, method, machine, manufacture or composition of matter, or any new and useful improvement thereof;

2) **Design patents**: New, original and ornamentation design for an article of manufacture, including the article's appearance; and

3) **Plant patents**: Distinct and new varieties of plants that have been invented or discovered and asexually reproduced.

Throughout this and the next chapter, we'll see how these different types of patents get challenged in different courts of law…and how the scope of patent protection changes—narrows or widens—depending upon the specific elements of a particular case.

Prosecuting a Patent

The **process of applying for a patent** is called a **prosecution**. If you believe you've designed a better mousetrap, you file your plans with the Patent Office and begin the prosecution.

The Patent Office reviews your drawings, models and descriptions…and makes its decision based on many factors. One of the most important is whether or not your new design looks or acts too much like anything that exists. If so, the Patent Office will allow you to modify your application.

> This process of submitting designs can go on for a long time. You may have to modify and refine a design substantially before it is finally accepted. The important thing to remember here is that the Patent Office keeps records of the whole history of the application. And, if a dispute comes along later, the Patent Office can use the refinements made to an application to help reach a conclusion.

Speaking generally, a protracted patent prosecution carves away at the power of the patent that's finally issued. A patent holder can't later construe its patent in a way that resurrects "subject matter previously surrendered during prosecution." This is especially relevant to so-called "doctrine of equivalents" claims—in which the patent holder argues that someone else didn't directly rip off a patent but made something so similar as to be the same. The April 2000 Massachusetts Federal Court decision *Bose Corporation v. JBL, Inc.* gives a good example of this.

The Value of a Good Idea

Audiophiles will be familiar with both parties in the dispute; Bose and JBL both design and manufacture audio equipment—and, particularly, speakers for both car and home stereo systems.

Bose, which is based in the Boston area, has developed a reputation for being a cutting-edge designer and maker of audio equipment. It started the lawsuit, claiming that JBL had infringed its patent for the design of a loudspeaker port tube.

What's a port tube? Here's Bose's description:

> Loudspeaker port tubes radiate acoustic energy from a region inside the enclosure to a region outside the enclosure at high sound levels without audible "port noise." A port tube's design is critical to eliminating this audible "port noise."

A key feature of Bose's patent, the shape of the boundary surrounding the port tube, was at issue in this case. Bose's patent contained a claim limitation, which defined the shape of the boundary as "an ellipse having a major diameter."

JBL argued that Bose's patent was invalid because its speakers contained boundaries defined by curves that were not exact mathematical ellipses; and, since the curves were not ellipses, there was no literal infringement.

JBL also argued that Bose couldn't assert infringement because amendments and cancelations Bose made during its prosecution of the patent application had limited what the patent really covered.

Both sides asked the court to dismiss the other's charges. The trial court looked at the history of Bose's patent.

In December 1990, Bose had filed a patent application, seeking protection for a speaker enclosure with "multiple subchambers and passive radiators." Among many claims in the application, three would become central to the JBL dispute.

The first claim read as follows:

> A loudspeaker enclosure having an inside volume, and at least one port characterized by predetermined acoustic mass

intercoupling said inside volume and the region outside said enclosure having a smoothly flared input end within said inside volume and a smoothly flared output end adjacent to the region outside said inside volume.

The second claim, which was dependent upon the first, added the limitation, "wherein said port defines a boundary between the acoustic mass therein and said inside volume, said boundary being defined by an ellipse."

The third claim, which was dependent upon the second, added the limitation, "wherein the length of said port corresponds to the major diameter of said ellipse."

The Patent and Trademark Office Examiner rejected the first claim because it was too close to two prior patents. The examiner noted, though, that the additional claims relating to an elliptical port would be allowable if they were rewritten in independent form to include all of the limitations of the base claim and any intervening claims.

In short, Bose had to limit its claim to a port that was mathematically elliptical in shape.

Bose amended the first claim several times; and, at least in response to its last three amendments, the examiner rejected proposed designs that would have been mostly elliptical but allowed for some variation. Bose offered alternative dictionary definitions of the term *ellipse* as meaning an oval or elongated circle, as well as the affidavit of an electroacoustical engineer who asserted that ellipse was understood by those skilled in speaker design to mean:

> an elongated circle or symmetrical oval, a portion of which corresponds to a section along the length of the continuously curved inside surface of the port that is of tapered cross section.…

But the Patent Office held firm. Bose's application was ultimately issued in March 1992—though it had to use a strict definition of ellipse related to the shape of its port.

JBL argued that Bose's multiple amendments of the original claim, and its eventual abandonment of broader descriptions, barred it from recapturing patent protection for port tube boundaries other than those defined by "an ellipse having a major diameter."

Bose argued, somewhat weakly, that its amendments to the first claim did not surrender the basic design that JBL had used in its curved port tubes. Bose claimed that it had amended the claim to distinguish its port boundary from a more flattened cylindrical boundary in the prior art of another patent.

The trial court noted that:

> Bose's arguments to the Examiner show that Bose was trying to develop claim language to avoid the flattened, cylindrical quality of already existing patents for port tubes. However, its arguments were always directed at another patent's longer, cylindrical tube while still trying to obtain patent coverage of a port tube that had a shorter, flattened center portion. But the arguments lacked a "clear and unmistakable surrender" of subject matter encompassing JBL's port tubes.

JBL's port tubes did not have a flattened, cylindrical portion; they were, like Bose's port tubes, continuously curved, with a progressively decreasing cross-sectional area. Therefore, the court ruled:

> While the prosecution history would preclude Bose from claiming any range of equivalents that contain the flattened section, neither the prior art nor Bose's arguments during prosecution dictate that Bose be limited to the literal scope of claim 2, and Bose is still entitled to some range of equivalents of an ellipse.

As a result, the court made a compromise ruling. It dismissed the charges of direct infringement, because JBL speaker models that were not mathematical ellipses did not literally infringe Bose's patent. The court held that "ellipse having a major diameter" unambiguously connotes the geometric definition of ellipse. The inclusion of the phrase "having a major diameter" invoked the very "mathematically precise" meaning that Bose wished to disavow.

The Parts of a Patent

Interpreting a patent dispute, the court will look first to the **intrinsic evidence of record**: the patent itself, including the claims, the specification and prosecution history.

First, the court looks to the words of the patent claims to define the scope of the invention. The words are generally given their ordinary and customary meaning, but an applicant may choose to use terms in a manner other than their ordinary meaning, as long as the special definitions are clearly stated in the application.

Second, the court will review the patent specification to determine whether any terms are used in a manner inconsistent with their ordinary meaning. The specification contains a written description of the invention that must be clear and thorough enough to enable those of ordinary skill in the art to make and use it. Specification is relevant to claim construction analysis; it acts as a dictionary for terms used in the claims or defined by implication.

Third, the court may also consider the **prosecution history of the patent**. This history contains the complete record of all the proceedings before the Patent and Trademark Office including any express representations made by the applicant regarding the scope of the claims. The prosecution history limits the interpretation of claim terms so as to exclude any interpretation that was disclaimed during prosecution. As such, the record before the PTO is often of critical significance in determining the meaning of the claims.

In most situations, an analysis of the intrinsic evidence—documents related to the application itself—will resolve any ambiguity in a disputed claim term. In such circumstances, it is improper to rely on extrinsic evidence, such as facts presented by other groups.

The Value of a Good Idea

In those cases where the public record unambiguously describes the scope of the patented invention, reliance on any extrinsic evidence is improper.

Of course, intrinsic and extrinsic evidence can be interrelated. Words in a claim are generally given their **ordinary and customary meaning**; if a patentee wishes to use a special definition of a term, that special definition must be clearly stated in the patent specification or prosecution history.

The September 1991 Pennsylvania Federal Court decision *Herbert Markman and Positek, Inc. v. Westview Instruments and Althon Enterprises* set several precedents about how the various parts of a patent work in contemporary lawsuits. For this reason—even though the facts of the case are fairly ordinary—*Markman* is a frequently cited patent decision.

Markman and Positek held a patent on an inventory control device used by laundries and dry cleaners. They sued Westview for infringing on that patent.

Westview sold an invoice printer, like a cash register, that produced a receipt; one copy of which was handed to the customer while the other copy was attached to batches of clothing. Markman and Positek claimed that this printer infringed on their device, which had computer memory for storing descriptions of the clothing.

Westview argued that the language of the patent and other evidence presented at trial required an interpretation by the court of the patent claims themselves. This was a kind of "best defense is a good offense" approach, moving the focus of the dispute onto the legitimacy of the original patents.

During the course of the trial, Markman and Positek's expert attempted to redefine several common words in unusual ways, which the court later interpreted as an attempt to give novel meaning to the terms *inventory*, *report* and *attached to* in order to sustain the claims of infringement.

So, the court agreed with Westview and took a hard look at Markman's patent. That patent read, in pertinent part, as follows:

> The inventory control and reporting system, comprising; a data input device for manual operation by an attendant...; data pro-

cessor having means to associate sequential transactions with unique sequential indicia and to generate at least one report of said transactions…; a dot matrix printer operable under control of the data processor to generate a written record of the indicia associated with sequential transactions…and at least part of the written record bearing a portion to be attached to said articles; and, at least one optical scanner connected to the data processor and operable on all articles passing a predetermined station [to] detect spurious additions to inventory….

According to Markman, these claims applied to Westview's system because: report meant invoice; "attached to said articles" meant "attached to a plastic bag that covers a batch of the articles"; and inventory meant cash or invoices, not "articles of clothing."

You knew that, right?

Well, neither did the court. It noted that Markman's definitions were "contrary to the ordinary and customary meaning of these terms." And these shifty definitions couldn't stand. An inventor can't change the meaning of his words to fit the particular circumstances of a trial. Specifically, the court noted:

> [Markman's patent] defined a system that includes a data processor, or computer, with sufficient memory to record information about sequential transactions, including the identity and descriptions of the articles of clothing involved…. A system, like Westview's, which does not have memory operable to record and store and later use information about clothing articles did not infringe the patent-in-suit. Westview's system lacked both the memory and the means to maintain an inventory total…. Inventory meant articles of clothing, not just dollars.

To read the word inventory otherwise, said the court, would lead to "semantic antics." In conclusion, the court wrote that:

> Tracking invoices is different from tracking articles of clothing…. Westview's device had no memory of a transaction after it printed

an invoice. Westview's device did not include every element of the claims, nor did it perform the same function as the claimed invention. Therefore, Westview did not infringe either literally or equivalently.

Although the court in *Markman* tried to bring common sense to a convoluted process, it ended up creating an unforeseen result. Its review of the terms and jargon surrounding the patent set a precedent for so-called "Markman hearings." These hearings, which come before trial, are intended to resolve "semantic antics." However, in some cases, the Markman hearings become as time-consuming as the trials themselves.

Patent Application Claims

As author T. Whitley Chandler has noted:

> Every patent decision today first pays homage to the exalted status of the claims. Why? Because the right to exclude does not turn on what was invented, but what is claimed.[2]

The January 2001 Federal Trial Court decision *Amgen, Inc. v. Hoechst Marion Roussel, Inc. and Transkaryotic Therapies, Inc.* dealt with a dispute over the claims portion of a patent application.

Amgen, Inc. owned five patents relating to a recombinant DNA product similar to natural erythropoietin (EPO), a hormone that stimulates the body's production of red blood cells. Amgen's drug was used in treating anemia, kidney failure and various conditions affecting bone marrow in humans—including some side effects of cancer chemotherapy.

Amgen reaped major profits as a result of the drug's usefulness in various medical treatments. In fact, Amgen's best-selling version of the drug, sold under the trade name Epogen, reached sales of $1.76 billion in 1999. As one would expect, Amgen sought to preserve its commercial success through a cluster of related patents that it defended aggressively.

[2] T. Whitley Chandler, Prosecution History Estoppel, the Doctrine of Equivalents, and the Scope of Patents, *Harv. J.L. & Tech.* (2000).

Hoechst Marion Roussel, Inc. and Transkaryotic Therapies, Inc. (collectively TKT) sought to capitalize upon apparent advances in genetic engineering by targeting the most lucrative commercial recombinant DNA products and designing around them.

As a result, Amgen filed a lawsuit against TKT in June 1999, alleging infringement of its patents pertaining to a recombinant DNA product similar to natural EPO. TKT immediately countered that Amgen's patents were invalid.

This turnaround happens a lot in patent cases. In fact, the legal references to patent disputes are often confusing—the patent holder looks like the defendant and the alleged infringer looks like the plaintiff—for this reason.

The issue came down to a basic question, also common to patent disputes: Was the patent applicant **too vague in its descriptions and claims** during the patent prosecution phase? Patent applicants are required to be "as precise as the subject matter permits." The degree of precision required "is a function of the nature of the subject matter."

The Federal Circuit Court of Appeals has explained:

> The amount of detail required to be included in claims depends on the particular invention and the prior art, and is not to be viewed in the abstract but in conjunction with whether the specification is in compliance with [U.S. patent law].

If the claims, read in the light of the specifications, reasonably apprise those skilled in the art both of the utilization and scope of the invention, and if the language is as precise as the subject matter permits, the courts can demand no more.

There's a good trade-off to all of this required detail: An issued patent has a strong presumption of validity, and an accused infringer who attacks the validity of the patent-in-suit bears the burden of showing patent invalidity by clear and convincing evidence.

Amgen relied on the notion that "first, and most importantly, the language of the claim defines the scope of the protected invention." Relatedly, ab-

sent a clear and specific statement in the patent specification giving a claim term a special definition, Amgen asserted that the court must adopt the plain and ordinary meaning given by persons experienced in the field.

In contrast, TKT relied most heavily upon a number of federal appeals court cases supporting the proposition that claims ought be construed so as to sustain their validity. TKT lawyers asked the trial court to reject Amgen's proffered interpretations because such broad interpretations were not adequately disclosed in the patents' specifications.

In short, TKT argued that while Amgen taught the production of the bone marrow drug using a precise process and specific cells, it went on to claim far beyond its teachings. So, if the court adopted a claim construction supported by the plain and ordinary meaning of the broad claim terms, its construction would run counter to the Federal Circuit's command that claims be construed so as to sustain their validity.

The court affirmed the standard guideline that the **scope of the patent claim was a matter of law** to be determined by the court while the jury determines whether, given the scope of the claims, infringement exists.

As a result, Amgen and TKT both had to prepare for a pretrial hearing in which the trial court would decide the issue of claim construction. During this pretrial phase (the Markman hearing), evidence concerning the language in the patent specification and claims is reviewed as well as the prosecution history file. The court then determines how the patent claim is interpreted and creates a jury instruction to be used if the issue of infringement is determined at trial.

Claim construction can be decisive in infringement cases. Often, after the court makes a determination in claim construction, the question of infringement is summarily decided.

This case was important because it was one of the first district courts—after *Markman*—to conduct the pretrial hearing. In fact, the judge in this case was so proud of how well he pulled off the procedural approach that he actually paused for a moment to emphasize the importance of the timing and approach the court used in conducting the Markman hearing:

This Court's *Markman* procedure turns on what this Court sees as the crucial distinction between construing patent claims in the context of considering motions for summary judgment as opposed to construing the patent claims without regard to the alleged infringement issue presented in the summary judgment motion. With this distinction in mind, this Court scrupulously kept the issues separate in order to avoid conflating the legal explication required by Markman with the fact finding that the Seventh Amendment ultimately reserves for the American jury... .

Amgen consistently pushed for the "ordinary meaning" of a particular claim term, while TKT sought to insert a limitation, arguing that without limiting the definitions of the terms, the claim would be invalid for lack of adequate description. And Amgen tried to persuade the court to adopt the broadest possible interpretation in order to sweep within its patents' span the greatest possible amount of its competitors' activities. TKT meanwhile proffered limiting interpretations to distinguish its products and process from the scope of the patents' language.

These strategies for claim construction are so well-known, that they are often ridiculed in the patent subculture.

Amgen and TKT each cited case law that supported their conflicting views, creating the impression that the case law itself was contradictory. A close examination, however, revealed that TKT's approach—though accepted in some limited circumstances—was inappropriate.

According to the appeals court:

> Simply put, the doctrine does not grant courts the power to employ validity arguments to limit claim terms where such claim terms, even considering all alternative definitions, could not reasonably be construed to incorporate such limits.

Still, the court heard arguments from both sides on a number of definitions included in the patent. For example, Amgen contended that the term *vertebrate cells* contained in several claims meant "cells originating from an animal having a backbone," whereas TKT argued that it meant "nonhuman cells that originate from an animal having a backbone."

Amgen argued for the broad meaning of the term and TKT argued that the term needed to be limited by including the word *nonhuman*.

The reason for the distinction? In order to make EPO, TKT activated the native human EPO gene in a human cell. As a result, it is easy to see why TKT offered, and Amgen opposed, a construction of the term *vertebrate* that excluded human cells. If the court had adopted TKT's definition, it would have been bound to issue, upon proper motion, summary judgment of non-infringement—at least as to literal infringement.

TKT's construction was **contrary to the ordinary meaning of the term vertebrate**. However, it argued that "the terms of a claim cannot be construed in a vacuum." It asked the court to interpret the claims in accordance with the specification and the prosecution history and, set in this context, vertebrate cells were not meant to encompass human cells even though humans are admittedly a subset of vertebrates.

Despite this, the court held TKT's contention untenable. Even if significant intrinsic evidence pointed toward a more limited definition of vertebrate:

> the claim construction inquiry...begins and ends in all cases with the actual words of the claim.... [T]he resulting claim interpretation must, in the end, accord with the words chosen by the patentee to stake out the boundary of the claimed property.

The court determined that the term vertebrate cells meant "cells from an animal having a backbone."

The argument was nearly the same for other terms, including: mammalian cells; mature; fully processed; nonhuman; purified mammalian cells; grown in culture; operatively linked, non-naturally occurring, glycosylation which differs, human urinary erythropoietin, etc. Each of these terms was marched into court.

Following the Markman hearing, the court considered Amgen's pending motion for summary judgment. In April 2000, the Court heard oral argument regarding whether TKT's activities literally infringed on Amgen's patents.

Amgen sought to enforce five patents, which each included claims for:

- products (usually cells designed to generate various forms of erythropoietin glycoprotein);

- the processes by which these products were made; and

- pharmaceutical compositions comprising a therapeutically effective amount of the erythropoietin glycoprotein products.

In this case, the pretrial hearings that set the terms for the nonexpert judges and juries to follow worked for the patent holder. In light of the ample and uncontradicted evidence submitted by Amgen, the court determined that TKT had infringed on three out of five of Amgen's EPO patents.

In all, the Amgen decision shows that **patent disputes are often decided long before the actual trial starts**—because so much emphasis is placed in the legal scope of the claims made in the original patent and in the definition of terms made in the Markman hearing.

Process Patents

In the 1998 David Mamet film *The Spanish Prisoner*, a whole paranoid plot was based on the attempts to steal a patented business idea from a small, scrappy start-up firm. The movie never explained what the business idea was—it concentrated on the intrigues swirling around it.

Business ideas—in certain, narrowly defined circumstances—can be patented. The technical term for these protections is "process patent." And the stories around them can be pretty intriguing.

The April 2001 Federal Trial Court decision *System Management Arts, Inc. v. Avesta Technologies, Inc. and David Zager* dealt with a process patent application.

System Management Arts, Inc. (Smarts) owned a patent for complex system diagnostic software. In May 1994, Smarts had filed a process patent application with the PTO. The application described:

> a method and apparatus for efficiently determining…the source
> of problems in a complex system based on observable events.
> [The method] has broad application to any type of complex sys-
> tem, including computer networks, satellites, communication sys-
> tems, weapons systems, complex vehicles such as spacecraft,
> medical diagnosis and financial market analysis.

The Smarts patent application described a computer program that used a four-step process to analyze these problems. The application went on to make a number of specific claims for how this program worked.

One of the major claims described:

> Apparatus for use in analyzing events in a system having a plural-
> ity of components arranged in a particular configuration, each
> component belonging to one of a plurality of component classes,
> the apparatus comprising: means for converting…[certain infor-
> mation] into a causality mapping comprising a mapping between
> events in the system and likely causes thereof.

Another covered:

> A machine programmed with a computer program which receives
> (i) a set of events…(ii) a set of propagations of events…and (iii) a
> configuration specification…wherein the computer program con-
> verts the set of events and the set of propagations of events into a
> causality mapping on the basis of the particular system configura-
> tion, wherein the causality mapping comprises a mapping between
> events in the system and likely causes thereof.

The causality mapping was the key to the Smarts program. It was the part of the program most **like the human thought process**, because:

> [it] may associate with causal relations probabilities, or other mea-
> sures of likelihood, that certain events cause each other. It may
> also associate other performance measures that may be useful in
> correlating events, such as the expected time for the causal rela-
> tions among events to happen.

In other words, it suggested solutions.

In October 1997, Smarts sued competitor Avesta for patent infringement; Avesta counterclaimed that the patent was invalid for indefiniteness and for **failure to satisfy the definiteness requirement** of patent law. Both sides asked the court to issue summary judgment in their favor.

Avesta asked the court for a ruling that all but one of Smarts's process patent claims were invalid because it failed to satisfy the "clear and definite" requirement of patent law. Specifically, the term "likely causes," as it appeared throughout Smarts' patent application was indefinite.

According to patent law:

> The [patent application] specification shall conclude with one or more claims particularly pointing out and distinctly claiming the subject matter which the applicant regards as his invention.

This provision, the definiteness requirement, imposes on patent applicants a duty to "clearly circumscribe what is foreclosed from future enterprise." The primary purpose of the definiteness requirement is to alert adequately the public to what the patentee has claimed, thereby putting potential infringers on notice as to what might constitute infringement.

To determine whether a claim is invalid under the definiteness requirement, a court must consider whether those skilled in the art would understand what is claimed.

According to Avesta, the meaning of likely causes could not be derived from the intrinsic evidence and was subject to multiple, mutually exclusive interpretations—rendering the claims at issue indefinite to a person of ordinary skill in the art. Further, Avesta argued that the extrinsic evidence—namely, the testimony of both its own and Smarts's experts—confirmed that likely causes was indefinite.

Smarts, however, argued that likely causes meant "those which bring about or produce events according to a likelihood measure."

The court determined that Avesta's proposed interpretation, while not entirely unreasonable, failed to satisfy its **burden to show indefiniteness by clear and convincing evidence**.

The Value of a Good Idea

Although Smarts made some errors in its defense of the process patent, the court ruled that it did point out correctly that no doctrinal rule exists that requires it to define "likely" with mathematical precision. Moreover, the intrinsic evidence revealed that Smarts's product was intended to apply to a broad range of systems, and that in any given system the degree of precision with which likelihood is assessed and mapped varies.

As a result, the court determined that whether or not the definition of "likely causes" as "those which bring about or produce events according to a likelihood measure" was as accurate a definition as the subject matter permits was thus a critical question for the indefiniteness inquiry.

Alleged inconsistencies within the testimony of a patentee's expert is a relatively weak form of evidence in claiming indefiniteness. However, the court admitted that Avesta had made some valid points:

> Bearing in mind the heavy evidentiary burden on a party claiming patent invalidity…the extrinsic evidence is sufficient to give rise to a genuine issue of material fact as to indefiniteness.

So, the court declined to issue a summary judgment for either side. Although the facts seemed to be leaning toward a win for Smarts, the dispute would have to go to trial for any further conclusion.

Although, upon publication of this book, the Smarts case hadn't yet reached the level of technical conclusion that would resolve the process patent dispute, federal courts do consider indefiniteness fairly often—so we can guess how the case might have gone.

In the 1986 Federal Appeals Court decision *Orthokinetics v. Safety Travel Chairs*, the court considered an indefiniteness challenge to a patent claim that used the term "so dimensioned."

The invention was a travel chair for disabled persons, and the patent claimed a travel chair "wherein said front leg portion [of the chair] is so dimensioned as to be insertable through the space between the doorframe of an automobile and one of the seats thereof."

The alleged infringer maintained that the term so dimensioned was indefinite because a user of ordinary skill could not determine the meaning of

that term "until he construct[ed] a model and test[ed] the model on vehicles ranging from a Honda Civic to a Lincoln Continental to a Checker cab."

The court held that the term was not indefinite because the specification made clear that:

> one desiring to build and use a travel chair must measure the space between the selected automobile's doorframe and its seat and then dimension the front legs of the travel chair so they will fit in that particular space in that particular automobile

And, through performance of this "task…one of ordinary skill in the art would easily have been able to determine the appropriate dimensions."

In every way, this was a victory for the patent holder and for a modest level of indefiniteness in patent applications.

Means-Plus-Function Patents

Although patents follow a few basic types, the types of legal issues that can be raised in patent disputes are many. One of the most complex—but popular among litigious patent lawyers—is the so-called "means-plus-function" claim.

This is like trying to patent an airplane. You need a fuselage, wings and a means for putting the wings onto the fuselage. The means of putting the wing onto the plane could be defined in specific terms (e.g. bolts)—but what if the same product can be achieved with rivets, screws, glue or tape? This is when means-plus-function claims come into play.

A means-plus-function claim **defines a structure by the function it performs** and is construed to encompass the structure disclosed in the written description as performing the recited function, and its equivalents. Thus, an equivalent to a rivet would be a screw or tape. Speaking more broadly about structures (i.e. calling it a "means" instead of "rivets," for example) has become very popular in computer-related patents, where generic nouns don't exist for many of the building blocks of hardware and software systems. And therein lies the potential problem.

The Value of a Good Idea

The Federal Circuit has been narrowing the definition of means-plus-function. The law governing means-plus-function elements provides that:

> An element in a claim for a combination may be expressed as a means...for performing a specified function without a recital of structure, material or acts in support thereof, and such claim shall be construed to cover the corresponding structure, material or acts described in the specification and equivalents thereof.

Recent case law has drawn a tighter pull on the "means" element, pulling it closer to the embodiments explicitly described in the patent. Those who aim to draft a patent claim—or have one drafted—are cautioned about using means-plus-function terms. It's better to include some independent claims without any means and the said function should be linked to the corresponding structure.

In *Accuscan, Inc. v. Xerox*, an oft-cited means-plus-function case, two corporations argued over technology patents. In the end, the infringement claims had no merit and the appeals court reversed the lower court's ruling. But it was a long battle that ultimately disregarded what a jury had painstakingly determined.

At issue here were **problems more for electrical and mechanical engineers** to figure out. Xerox, the famous brand for copiers, faxes, scanners and the like, was accused of using technologies in their products that were originally invented and patented by Accuscan, a closely-held New York company. Without getting into the nitty-gritty details of abstract physics and scientific jargon, know that the brunt of this battle was over a **method of calibrating electric signals** to allow fax machines, scanners and digital equipment to accurately reproduce shades of gray.

In the first trial, which started in April 1996 and ended in April 1998, Xerox was slapped with a $40 million judgment. The U.S. District Court in New York, however, threw out the award because it was based on erroneous damage estimates by Accuscan's expert witness. Then a federal jury ordered Xerox to pay $9.7 million. Finally, in the last round of appeals, Xerox came out on top and the earlier rulings were reversed.

One particular patent—the '144 patent—lay at the heart of the matter. It was titled "Methods and Apparatus for Automatic Background and Contrast Control."

In the first verdict against Xerox, the jury found that four of Xerox's product lines infringed this patent. Among the products: the DocuTech publishing system; the 5775 color printer; the SA4 scanner; and the 7017/20/21 facsimile machine. Accuscan particularly honed in on two things: **an apparatus claim and a method claim**. These two claims were what Accuscan said Xerox had infringed. To understand these inventions—and their claims—is to understand logarithms, computer language, circuitry and capacitors. That's not the point here. The apparatus claim used means-plus-function language, outlining the means for storing signals; the method claim focused on methods of operation.

The district court's judgment for Accuscan would have amounted to $16 million in royalties and interest payments; but the appeals court reversed the ruling. On appeal, the court found that none of the products could be held to infringe either patent claims both literally or under the doctrine of equivalents. Xerox also contended that an IBM technical disclosure had anticipated the '144 patent, but the appeals court didn't agree. Xerox tried again, this time arguing that the patent was invalid based on the on-sale bar. Because the invention was allegedly offered for sale by Accuscan more than a year prior to the patent application, Xerox tried to show the patent was invalid from the start. It turned to previous case law.

In the 1998 U.S. Supreme Court decision *Pfaff v. Wells Electronics*, the old "substantially complete" standard for determining whether the on-sale bar has been triggered was streamlined into a two-prong test:

1) whether the patented invention was the subject of a commercial offer for sale; and

2) whether the patented invention was "ready for patenting" prior to the critical date.

Although the ultimate determination of invalidity due to application of the on-sale bar is a question of law, the facts underlying satisfaction of both of these conditions are issues of fact.

Citing the *Pfaff* decision, the appeals court in *Accuscan* wrote:

> The issue of whether the invention of the '144 patent was on sale prior to the critical date was tried to the jury on two separate occasions, and in both trials the jury ruled that the '144 patent was not invalidated by the on-sale bar.

More critical to this ruling, however, was the fact that testimony pointed to the sale not having been related to the '144 patent. So, the appeals court validated the integrity of the patent, but ruled that none of Xerox's products infringed upon it.

Computers and Patentability

As we mentioned in the first chapter, computer programs can be copyrighted, but much of computer-based technology falls under patent law...and it's a very esoteric field of intellectual property. Those who draft claims for computer technologies must be expertly trained in many fields of engineering and computer programming. This is because the mere mechanics and language of a technology-based patent can make or break its patentability. To remark on every type of technology-based patent would exceed the scope of this book, but there is one recent decision that has set a new tone in one particular area: software inventions. And it's worth a brief study.

There are **four subject matter categories** for every claimed invention, and anything that cannot fall within one of these categories is not patentable. The four categories are:

1) process;
2) machine;
3) manufacture; and
4) composition of matter.

These classes encompass practically everything made by man and the processes for making products. *Process* refers to a process or method, usually industrial or technical. *Manufacture* relates to articles made, and

includes all manufactured articles. Any chemical compositions, including mixtures of ingredients and new chemical compounds, are *compositions of matter*.

Excluded from patent protection are abstract ideas, laws of nature and natural phenomena.[3] And, within these so called non-statutory subject matters are two subcategories: **mathematical algorithms and business methods**. Algorithms are mathematical procedures for solving mathematical problems; business methods include accounting schemes, marketing plans and promotional strategies. Courts have generally found these two types of subject matters unpatentable, but in July 1998, the federal circuit set some ground rules for these two subject matters in *State Street Bank & Trust Co. v. Signature Financial Group, Inc.* The court ruled that a general purpose computer programmed to employ a business-oriented process can be patented. Therefore, any software that runs on a standard PC is patentable if it provides a "useful, concrete and tangible result."

Under scrutiny in *State Street* was a system for monitoring and recording financial information. State Street patented a particular system for calculating the flow of funds and, as explained by the court, State Street had set up:

> [a] partner fund financial services configuration [that] essentially allows several mutual funds, or "Spokes," to pool their investment funds into a single portfolio, or "Hub," allowing for consolidation of…the costs of administering the fund combined with the tax advantages of a partnership.

Signature Financial didn't think State Street had a right to patent such a program that simply executes an investment structure by manipulating numbers—and without transforming the structure to anything physical. Signature Financial sued State Street in a Massachusetts district court, also alleging that the system constituted a business method and was thus un-

[3]The Supreme Court identified these three categories in *Diamond v. Diehr* in 1981, when it ruled in favor of software that aided in the curing of rubber. Judge William Renquist wrote: "Whoever invents or discovers any new and useful process, machine, manufacturer or composition of matter, or any new and useful improvement thereof, may obtain a patent thereof… ."

patentable. The district court agreed with Signature Financial, holding that "[t]he invention does nothing other than present and solve a mathematical algorithm and, therefore, is not patentable." When the case reached the federal circuit, however, this decision was reversed.

In the Federal Circuit Court of Appeals, the court rejected the district court's need for something physical to have resulted from the structure, and it simply rejected the business method exception. The appeals court said:

> Today, we hold that the transformation of data, representing discrete dollar amounts, by a machine through a series of mathematical calculations into a final share price, constitutes a practical application of a mathematical algorithm, formula or calculation, because it produces "a useful, concrete and tangible result"—a final share price momentarily fixed for recording and reporting purposes and even accepted and relied upon by regulatory authorities and in subsequent trades.

In short, the machine programmed with the Hub and Spoke software is said to produce a useful, concrete and tangible result even though that result is expressed in numbers (i.e., price, profit, percentage, cost or loss). Interestingly, the appeals court had awakening words to say in regards to the business methods exception. It said:

> Since the 1952 Patent Act, business methods have been, and should have been subject to the same legal requirements for patentability as applied to any other process or method. The business method exception has never been invoked by this court, or the [Court of Customs and Patent Appeals], to deem a patent unpatentable.

So, what does this mean for patents in the future? The *State Street* decision opens the door to a **broader platform for software-based technology protection**. All types of general purpose computer software, such as systems of e-commerce computer-generated financial instruments, could be eligible for patent protection.

Other Requirements

If you've got a fancy piece of software that you want to patent, the decision in *State Street* won't make it any easier on you if you don't already meet the other requirements when it comes to protecting inventions.

In addition to your invention falling under a category of patentable subject matter, your invention must be, according to patent law:

- new;

- non-obvious; and

- useful.

Any invention must be new. Any invention that is known, used by others or previously described in a publication more than a year prior to the application for a patent cannot be patented. **Non-obviousness** refers to an invention **not being a mere extension of already-existing art**. You cannot, for example, change the size of something or substitute one of its components to render an entirely new, patentable invention. Finally, any patentable invention must provide some use or purpose.

Conclusion

As we'll see in this next chapter, obtaining a patent is relatively easier than defending one in a court of law once someone infringes your patent and attempts to invalidate it. As we'll see in the next chapter, although infringing upon someone else's patent is a serious action, patent holders are often put on the defense, having to defend their patents to near-death in messy court proceedings. Chapter 11 takes a look at some of the more important court cases that have dealt with new, non-obvious and useful patents, but whose decisions have laid down a foundation for patent law.

Patent law is never as easy as one might think. This is why we've reduced our discussion of patents to the basics, and among the basics is patent infringement.

The Value of a Good Idea

CHAPTER 11: PATENT INFRINGEMENT

As we explained in Chapter 10, patents essentially represent a legal monopoly. Setting the specific boundaries to that monopoly is what the claims part of the patent defines. Remember, claims define or describe a product or process and make a patent enforceable. A patent may contain one claim or several claims. For courts, patent infringement is an inquiry involving the construction of the claims, and the application of those claims to an allegedly infringing product or process. For inventors, it's the battleground for their livelihood.

A potentially infringing product or process—an accused device—may infringe on a patent in one of two ways: **literally** or under the **doctrine of equivalents**. Literal infringement requires that the construction of the claim for the accused device contain the exact language (i.e., limitations) as the original patent's claim. In other words, the potentially infringing product or process either directly corresponds to an existing patent's claims or not. Any deviation precludes a finding of literal infringement.

An accused device that does not infringe literally may still infringe under the doctrine of equivalents. This can happen if the patent holder shows that the accused device performs substantially the same function in substantially the same way to produce substantially the same result as the patented invention. The doctrine of equivalents is tricky. Individual courts may apply it in different ways.

In this chapter, we consider each type of infringement in turn.

Literal Infringement

In determining whether an accused device or process infringes a valid patent, a court will **turn first to the words of the claim**. If the accused device's claim falls clearly within the original claim, infringement is established and the matter is resolved. That's literal infringement.

The April 2001 Federal Trial Court decision *C.R. Bard v. Medtronic* offers a fairly straightforward example of literal infringement.

C.R. Bard, Inc. owned a patent for a blood filter, which the company described as having "filter element support located within the housing and centrally disposed with respect to the toroidal flow path."

Medtronic, Inc.—a competitor of Bard's—developed a blood filter that included many of the Bard filter's distinctive design elements.

Bard sued Medtronic for infringement of the patent.

The case went through the trial process pretty quickly. A jury returned a verdict for Bard, finding that Medtronic had infringed several claims of the blood filter and that the infringement was willful.

Medtronic appealed, challenging the trial court's construction of the terms "housing" and "filter element support" from Bard's patent application claims. Specifically, in the housing claim, Bard had written:

> The housing (although not necessarily toroidal in shape) must determine with precision a fluid flow path having the shape of a substantially closed curve which rotates about, but does not intersect or contain, an axis in its own plane.

And, in the filter element support claim, Bard had written that the support included "the upper and lower potting material," but did not require "support from the top by a structure descending from the housing cap."

Medtronic argued that its blood filter was substantially different than Bard's on both claims. The appeals court agreed with Medtronic. With respect to the housing claim, it held:

Although the patent states that "shapes other than a toroid may be used for further embodiments," it does not indicate that a housing of any other shape would "define a substantially toroidal flow path," as recited in the claims. The only structure described in the patent as providing a toroidally shaped flow path is a toroidally shaped housing. We therefore construe the housing limitation as requiring that the housing itself be toroidally shaped.

And, on the filter element support claim, the appeals court concluded that an infringing filter would have to include:

a structural support for the filter element (not just potting material) that is centrally disposed with respect to the toroidal flow path, at the top of the filter element.

Because Medtronic's filter copied neither of these elements precisely, the appeals court reversed the trial court's conclusions and sent the case back for reconsideration—under "correct claim construction."

The appeals court's ruling wasn't completely for Medtronic, though.

The PTO examiner had equated Bard's "toroidal flow path" with an older patent's "circular flow path." Consistent with this interpretation and because it focused on the "fluid flow path" and not on the structure defining such, Bard characterized its invention as simply "enhancing" such a fluid flow path. And, on this count, the appeals court admitted that:

a claim may consist of all old elements...for it may be that the combination of the old elements is novel and patentable. Similarly, it is well established that a claim may consist of all old elements and one new element, thereby being patentable.

Virtually all inventions are combinations and virtually all are combinations of old elements. But when the combinations are exactly the same as those of the original patent, the device more than likely has infringed on the original patent.

Back in the trial court, Medtronic repeated its arguments that its filter's housing was not toroidally shaped and its filter had no filter element sup-

port in the space between the filter cap and the ceiling of the housing because "the space between the filter cap and the housing cap is empty." Therefore, Medtronic argued, there could be no literal infringement.

But Medtronic didn't want to go back in front of a jury. It asked the court to review the dispute as a matter of law the second time around. The trial court noted that the appeals court had denied Medtronic's request and sent the case back for a determination of the infringement issue under the correct claim construction." That determination could not occur until Bard had been fully heard—again—on the infringement issue. And that meant going back before a jury.

Even though there were major questions as to whether the filters were really alike enough to support an infringement claim, the prospect of facing another jury gave Medtronic a strong incentive to settle Bard's claims.

The Doctrine of Equivalents

Everybody gets heated when it comes to defining what "equivalent" means. The doctrine, which originated almost a century ago, holds strong and is consistently applied by both the Supreme Court and the lower federal courts when the proper circumstances arise.

The U.S. Supreme Court first approved of the doctrine of equivalents in its 1854 decision *Winans v. Denmead*. In that decision, the court described the doctrine of equivalents as **growing out of a legally implied term in each patent claim**. In other words, "the claim extends to the thing patented, however its form or proportions may be varied," the court said.

In this light, application of the doctrine of equivalents involves determining whether a particular accused product or process infringes upon the patent claim, where the claim takes the form—partly expressed, partly implied—of "X and its equivalents."

In the later decision *Union Paper-Bag Machine v. Murphy* (1877), the Supreme Court summed up the theory on which the doctrine of equivalents was founded:

> If two devices do the same work in substantially the same way, and accomplish substantially the same result, they are the same, even though they differ in name, form or shape.

In essence, the doctrine of equivalents states that one may not practice a fraud on a patent. If the essential predicate of the doctrine of equivalents is the notion of identity between a patented invention and its equivalent, there is no basis for treating an infringing equivalent any differently from a device that infringes the express terms of the patent. Application of the doctrine of equivalents, therefore, is **akin to determining literal infringement**, and neither requires proof of intent.

A finding of equivalence is a determination of fact. Proof can be made in any form: through testimony of experts or others versed in the technology; by documents, including texts and treatises; and, of course, by the disclosures of the prior art.

Like any other issue of fact, final determination requires a balancing of credibility, persuasiveness and weight of evidence. It is decided by a trial court and that court's decision, under general principles of appellate review, should not be disturbed unless clearly erroneous.

We've tried to keep the case studies in this book fairly recent; but, the case that defined the doctrine of equivalents for the modern era was the May 1950 U.S. Supreme Court decision *Graver Tank & Manufacturing, et al. v. Linde Air Products.*

At the heart of the case were two electric welding compositions or fluxes: Linde's Unionmelt Grade 20 and Graver Tank's Lincolnweld 660.

Graver Tank's composition was similar to Linde's, except that it substituted silicates of calcium and manganese—the latter not an alkaline earth metal—for silicates of calcium and magnesium. In all other respects, the

two compositions were alike. The mechanical methods in which these compositions are employed were similar, too. They produced the same kind and quality of weld.

The trial judge determined that Graver Tank's Lincolnweld flux and Linde's composition were **substantially identical in operation and in result**. He found also that Lincolnweld was in all respects equivalent to Unionmelt for welding purposes. And he concluded that:

> for all practical purposes, manganese silicate can be efficiently and effectively substituted for calcium and magnesium silicates as the major constituent of the welding composition.

That "for all practical purposes" qualifier loomed large; the two flux compounds were not—strictly speaking—identical. Still, the trial court ultimately determined that the flux claims were valid and that Graver Tank had infringed the patents.

Graver Tank appealed. The Court of Appeals for the Seventh Circuit affirmed the findings of validity and infringement. The Supreme Court granted a rehearing on the question of infringement of the valid flux claims and to the applicability of the doctrine of equivalents to this case.

To determine whether an accused product or method infringes a valid patent, the high court pointed to the fact that:

> courts have also recognized that to permit imitation of a patented invention which does not copy every literal detail would be to convert the protection of the patent grant into a hollow and useless thing.

> One who seeks to pirate an invention, like one who seeks to pirate a copyrighted book or play, may be expected to introduce minor variations to conceal and shelter the piracy. Outright and forthright duplication is a dull and very rare type of infringement. To prohibit no other would place the inventor at the mercy of verbalism and would be subordinating substance to form. It would deprive him of the benefit of his invention and would foster concealment rather than disclosure of inventions, which is one of the primary purposes of the patent system.

In the end, the high court concluded that the two fluxes were so similar that they were, practically, the same.

Graver Tank confirmed the so-called three element test for equivalents: that a product or method—viewed as a whole—would infringe if it:

1) had the same or substantially the same function;

2) operated in the same or substantially the same way; and

3) produced the same or substantially the same result.

Graver Tank was decided over a vigorous dissent. In that dissent, Justice Hugo Black set the tone for doctrine of equivalents critics who worry that it will result in an explosion of crazy claims:

> I heartily agree with the Court that "fraud" is bad, "piracy" is evil and "stealing" is reprehensible. But in this case, where petitioners are not charged with any such malevolence, these lofty principles do not justify the Court's sterilization of Acts of Congress and prior decisions, none of which are even mentioned in today's opinion.... One need not be a prophet to suggest that today's rhapsody on the virtue of the "doctrine of equivalents" will...make enlargement of patent claims the "rule" rather than the "exception."

The Evolution of Equivalents

Since the Supreme Court's *Graver Tank* decision, the doctrine of equivalents has evolved into the biggest factor in patent infringement law—though not quite as badly as Justice Black predicted.

The game has become to convince a court, typically a jury, that even if an accused product does not infringe the claims as written, the claimed invention and the accused product have only "insubstantial differences," a wonderfully indeterminate phrase, lending itself to making every decision under the doctrine an individualistic choice, if not simply a flip of the coin.

In an attempt to make the phrase less indeterminate, courts have continued to resort to the old "function-way-result" formulation, indicating that

in appropriate cases—whatever that might mean—the answer could be found through those lenses.

Though "function" and "result" are in many cases reasonably straightforward, the "way" of an accused product compared to that of the patented invention has proved to be no more precise a criterion in its application than insubstantial differences, for which it was supposed to be a useful surrogate.

Worse yet, whether the court was judge or jury, the decision about infringement under the doctrine of equivalents does not always end with a trial. Given the indeterminate nature of the test, it is not difficult for the losing party to make a plausible argument on appeal that there was "clear error" or that "no reasonable jury could have thought such a thing," as the case may be.

The net effect has been that all too often there is no way to know whether a particular product infringes under the doctrine until a court says so; the rule of analysis gives little real guidance, and equally little predictability.

The doctrine doesn't always work in favor of the patent holder, though. In some cases, the doctrine favors the **secondary invention consisting of a combination of old ingredients that produces new results**—although the area of equivalence may vary under the circumstances. For example, if a device is so far changed in principle from a patented device that it performs the same or a similar function in a substantially different way, but nevertheless falls within the literal words of the claim, the doctrine of equivalents may be used to defend against infringement charges.

Perhaps the most widely-quoted doctrine of equivalents case since *Graver Tank* was the March 1997 Supreme Court decision *Warner-Jenkinson Company v. Hilton Davis Chemical Co.* This decision updated and expanded the application of the doctrine.

Warner-Jenkinson and Hilton Davis were both companies that manufactured dyes from which chemical impurities had to be removed constantly. A Hilton Davis patent—issued in 1985—claimed as its invention an improvement in the ultrafiltration process, which it described as:

subjecting an aqueous solution…to ultrafiltration through a membrane having a nominal pore diameter of 5 to 15 Angstroms under a hydrostatic pressure of approximately 200 to 400 p.s.i.g., at a pH from approximately 6.0 to 9.0, to thereby cause separation of said impurities from said dye….

Hilton Davis limited its claim's pH element during patent prosecution because the PTO examiner objected to an overlap with another patent, which disclosed an ultrafiltration process operating at a pH above 9.0.

In 1986, Warner-Jenkinson developed its own ultrafiltration process, which operated at a pH level of 5.0. Hilton Davis sued for infringement of its patent, relying solely on the doctrine of equivalents.

At trial, Warner-Jenkinson argued the technical, legalistic point that the doctrine of equivalents was an equitable matter to be applied by the court—not by a jury. Still, the issue of equivalence was included among those sent to the jury.

The jury found that Hilton Davis's patent was valid and that Warner-Jenkinson infringed upon it under the doctrine of equivalents. But the jury contended that Warner-Jenkinson had not intentionally infringed and, therefore, awarded only 20 percent of the damages sought by Hilton Davis.

Warner-Jenkinson appealed, again focusing on the argument that an equivalents question should be handled by a judge, not a jury.

A split appeals panel affirmed the trial court's decision. In that decision, there were three separate dissents written by five of the 12 judges on the panel. Four of the five judges viewed this interpretation of the doctrine of equivalents as allowing an improper expansion of claim scope, contrary to numerous holdings that it is the claim that defines the invention and gives notice to the public of the limits of the patent monopoly.

Warner-Jenkinson pressed the case to the Supreme Court and argued that it did not learn of Hilton Davis's patent until after it had begun commercial use of its ultrafiltration process. Furthermore, it stressed that its process occurred at a pH level lower than Hilton Davis's lower limit.

The Value of a Good Idea

According to Hilton Davis, the lower limit was added to its patent because, below a pH of 6.0, the patented process created "foaming" problems that rendered it ineffective.

Warner-Jenkinson, however, contended that its process was successfully tested to pH levels as low as 2.2 with no effect on the process because of foaming.

The court started its review by reiterating some of the considerations that go into applying the doctrine of equivalents:

> What constitutes equivalency must be determined against the context of the patent, the prior art and the particular circumstances of the case. Equivalence, in the patent law, is not the prisoner of a formula and is not an absolute to be considered in a vacuum. It does not require complete identity for every purpose and in every respect. In determining equivalents, things equal to the same thing may not be equal to each other and, by the same token, things for most purposes different may sometimes be equivalents.

To many people—even most legal experts—that's an extremely broad conceptual framework within which to make consistent decisions. But, as if anticipating the concern, the court refined the context:

> An important factor is whether persons reasonably skilled in the art would have known of the interchangeability of an ingredient not contained in the patent with one that was.

So **expert opinion is key**. A skilled practitioner's knowledge of the interchangeability between disputed elements is not relevant for its own sake, but rather for what it tells a court about the similarities or differences between those elements. Much as the perspective of the hypothetical "reasonable person" gives content to concepts such as "negligent" behavior, the perspective of a skilled practitioner provides content to, and limits on, the concept of "equivalence."

According to Warner-Jenkinson, any surrender of subject matter during patent prosecution—regardless of the reason for such surrender—precludes recapturing any part of that subject matter, even if it is equivalent to

the matter expressly claimed. Because, during its patent prosecution, Hilton Davis had limited the pH element of its claim to pH levels between 6.0 and 9.0, Warner-Jenkinson would have those limits form bright lines beyond which no equivalents may be claimed.

The Supreme Court didn't agree:

> Mindful that claims do indeed serve both a definitional and a notice function, we think the better rule is to place the burden on the patent holder to establish the reason for an amendment required during patent prosecution.... Were no explanation is established, however, the court should presume that the patent applicant had a substantial reason related to patentability for including the limiting element added by amendment. In those circumstances, prosecution history estoppel would bar the application of the doctrine of equivalents as to that element.

Warner-Jenkinson's arguments were based on the concern that the doctrine of equivalents had expanded into an out-of-control lawsuit juggernaut. This was the same concern voiced by Justice Black in his *Graver Tank* dissent. But, in 1997, the Supreme Court wasn't so worried. It held:

> Each element contained in a patent claim is deemed material to defining the scope of the invention, and thus the doctrine of equivalents must be applied to individual elements of the claim, not to the invention as a whole. It is important to ensure that the application of the doctrine, even as to an individual element, is not allowed such broad play as to eliminate that element in its entirety.

The high court adhered to the doctrine of equivalents and held that the doctrine of equivalents:

1) is not inconsistent with the Patent Act;

2) must be applied to individual elements of patent claims, not to inventions as a whole;

3) does not require proof of intent; and

4) is not limited to equivalents disclosed within the patent itself.

More specific to the case, the court ruled that Hilton Davis's addition of a lower pH limit during application process precluded application of the doctrine of equivalents to that element—so, the court sent the case back to the trial court to determine whether reason for **amending the patent claim** to add a lower pH limit was sufficient to support a broader reading of the patent.

Prosecution History Estoppel

The Supreme Court noted in *Warner-Jenkinson* that the doctrine of equivalents has "taken on a life of its own, unbounded by the patent claims." That's a bit of rhetorical flourish.

You probably tripped over the phrase "prosecution history estoppel" a few paragraphs ago. This term—known somewhat less formally as "file wrapper estoppel"—is the main control that has prevented the doctrine of equivalents from exploding as Justice Hugo Black predicted.

The **doctrine of prosecution history estoppel** means that a patent holder can't make legal claims in a way that would resurrect patent elements previously surrendered during prosecution of the patent. And, under certain circumstances, it prevents a patent holder from enforcing its claims against otherwise legally equivalent structures. For example, if you amend your claim in your patent in order to distinguish it from someone else's patent (i.e., prior art), you are thereafter estopped from asserting dominion over anything you've "surrendered" or given up as part of your invention. (This is the problem that Bose faced in its legal dispute with JBL that we considered in the last chapter.)

The key components of a prosecution history estoppel analysis are determining what subject matter was surrendered, and the reason that it was surrendered. The legal standard for determining the first component is an objective one, measured from the vantage point of what a competitor was reasonably entitled to conclude, from the prosecution history, that the applicant gave up to procure issuance of the patent.

Once the subject matter surrendered is identified, courts look to the reasons behind that surrender. This can get a little blurry. The Supreme Court declined to adopt a bright line rule when it comes to reasons for surrender. Instead, it has held that:

> any surrender of subject matter during patent prosecution, regardless of the reason for such surrender, precludes recapturing any part of that subject matter, even if it is equivalent to the matter expressly claimed.

This means you cannot take back parts to your patent that you gave up when you honed your claims during the application process. You are free to amend your claims—clarify the language or format, correct mistakes and prevent objections from the Patent Office—but any and all such actions constitute the prosecution history. Your prosection history affects your patent in the long term.

The November 2002 U.S. Federal Circuit Court of Appeals decision *Festo Corp. v. Shoketsu Kinzoku Kogyo Kabushiki Co., et al.* is a huge, complex case dealing with various patent issues—but it discusses prosecution history estoppel particularly well. We'll consider that aspect of the very broad decision.

Festo Corp. owned two patents relating to magnetically coupled rodless cylinders used in heavy machinery. The rodless cylinders were composed of three basic parts: a piston, a cylinder and a sleeve. In basic terms, the piston is on the inside of the cylinder, and is moved by fluid under pressure. The sleeve is on the outside of the cylinder, and is magnetically coupled to the piston. The magnetic attraction between the sleeve and the piston causes the sleeve to follow the piston when it moves along the inside of the cylinder. The sleeve is used to move objects on a conveying system.

Festo sued the Japanese manufacturing giant Shoketsu Kinzoku Kogyo Kabushiki (known internationally as SMC Corp.) for infringement of the two patents, based largely on doctrine of equivalents theories. A federal trial court in Massachusetts granted a summary judgment for Festo on one of its counts and accepted a jury verdict on the others.

The Value of a Good Idea

SMC Corp. appealed—but the appeals court agreed with the trial court. The appeals court held:

> Our approach is consistent with *Warner-Jenkinson*'s requirement that an amendment "does not necessarily preclude infringement by equivalents of that element." Thus, if a patent holder can show from the prosecution history that a claim amendment was not motivated by patentability concerns, the amendment will not give rise to prosecution history estoppel.

The federal appeals court started its decision with a review of the things it had written before on the subject, including:

- an amendment that narrows the scope of a claim for any reason related to the statutory requirements for a patent will give rise to prosecution history estoppel with respect to the amended claim.

- "voluntary" claim amendments are treated the same as other claim amendments; therefore, any voluntary amendment that narrows the scope of a claim will give rise to prosecution history estoppel.

- when a claim amendment creates prosecution history estoppel, no range of equivalents is available for the amended claim element.

- "unexplained" amendments are not entitled to any range of equivalents.

The claim elements that were found to be infringed by equivalents were added during prosecution of the Festo patents. The amendments that added those elements **narrowed the scope of the claims**. Festo had not established explanations unrelated to patentability for these amendments; accordingly, no range of equivalents was available for the amended claim elements. Because the parties had agreed that SMC did not produce a device that literally satisfied those claim elements, the judgment of infringement had to be reversed.

The appeals court noted that:

> the doctrine of equivalents is subservient to [prosecution history] estoppel. The logic of prosecution history estoppel is that the pat-

entee, during prosecution, has created a record that fairly notifies the public that the patentee has surrendered the right to claim particular matter as within the reach of the patent.

Additionally, the Patent Act requires that the patent "specification describe, enable and set forth the best mode of carrying out the invention." The Act also requires that the claims set forth the subject matter that the applicant regards as his invention and that the claims particularly point out and distinctly define the invention. The Patent Office will reject a patent application that fails to satisfy any one of these statutory requirements.

Both Festo patents went through several rounds of review and criticism by PTO examiners.

The SMC devices that were found to infringe on the Festo patents under the doctrine of equivalents had two notable differences from the structures claimed in the patents.

First, the SMC devices, although having pistons with two hard plastic guide rings, had only a single resilient two-way sealing ring, located on one end of the pistons. Thus, while the Festo patents disclosed and claimed devices with a pair of sealing rings, the SMC devices had only single two-way sealing rings.

Second, the outer portion of the sleeves of SMC's devices was made of an aluminum alloy, a material that the parties agreed was not a magnetizable material. Thus, while one of the Festo patents disclosed and claimed a sleeve made of a magnetizable material, the SMC devices had sleeves that were not made of a magnetizable material.

For all of these reasons, the court wrote:

> Festo has not established explanations for these amendments unrelated to patentability. The amendments therefore gave rise to prosecution history estoppel. Under these circumstances, the amended claim elements are entitled to no range of equivalents. Thus, they cannot be infringed by equivalents. The court's judgment of infringement under the doctrine of equivalents of both [Festo] patents is therefore reversed.

At this point in the case, the foundation of patent law shook, as the enforceability and value of thousands of patents diminished. The reversal of the lower court's decision effectively **weakened the notion of equivalents** and made the idea of prosecution history estoppel more important. The federal appeals court deemed any modification to a patent an action that can invoke prosecution history estoppel. Thus, even if you *voluntarily* amend your claim, you may be barred from later alleging that other substantially similar devices are equivalent to your product or process. The result: fewer lawsuits because patent owners are unable to go after potential infringers. Crafty copyists could review your prosecution history, locate a minor clerical change to the claim language and then modify their product or process to the extent it escapes infringement.

Festo has two huge sides to its case, pulling in supporters and detractors from corporations, academic institutions and bar associations. The U.S. Solicitor General hopes the Supreme Court overturns the federal circuit's ruling. The case's complete history includes two full trials in a Boston federal court, plus five decisions and four appeals. When SMC pressed the case up to the Supreme Court, and the high court granted certiorari, the hearing was set for January 8, 2002. Experts agree that the final outcome will **set a global precedent** for patent law.

The Federal Circuit

One of the chief accomplishments of the *Festo* decision was to give some clarity to the Federal Circuit U.S. Court of Appeals.

Congress specifically created the federal circuit to resolve issues unique to patent law, such as those regarding prosecution history estoppel, which is a judicially created doctrine. The results have been decidedly mixed.

Congress contemplated that the federal circuit would "strengthen the United States patent system in such a way as to foster technological growth and industrial innovation." Issues such as prosecution history estoppel are reserved for the Federal Circuit Appeals Court.

The federal circuit first addressed the range of equivalents that is available when prosecution history applies in its 1983 decision *Hughes Aircraft Co. v. United States*. In that case, it recognized that, prior to creation of the federal circuit, some regional circuits had followed a so-called "flexible bar approach" to prosecution history estoppel, whereas others had applied a strict rule of complete surrender when prosecution history estoppel applied.

The federal circuit decided to **apply prosecution history estoppel as a flexible bar**, stating that prosecution history estoppel "may have a limiting effect" on the doctrine of equivalents "within a spectrum ranging from great to small to zero."

Less than a year after *Hughes*, however, a five-judge panel decided *Kinzenbaw v. Deere & Co.* The claimed invention in *Kinzenbaw* was "[a]n apparatus for forming seed planting furrows." The claim element at issue related to "a pair of depth gauge compacting wheels" that controled the depth of the furrow created by the planter. During prosecution, in order to overcome an examiner's rejection and to obtain his patent, the inventor narrowed his claims by specifying, among other things, that the gauge wheels had to have a radius less than that of the radius of the blades of the planter (also called discs).

On the accused device, the gauge wheels had a radius greater than that of the discs. Consequently, the accused device could not literally infringe. As a result, Deere sought to prove infringement under the doctrine of equivalents. The district court concluded that prosecution history estoppel precluded Deere from relying upon the doctrine of equivalents. The court determined that, as far as the gauge wheels were concerned, the inventor had **intentionally narrowed his claims**; it refused to permit Deere to avoid, through the doctrine of equivalents, the limitation that the inventor had placed on his claims.

On appeal, Deere urged that prosecution history estoppel did not apply because the inventor's limitation of his claims to devices in which the gauge wheels had a smaller radius than that of the discs was unnecessary to distinguish the prior art.

Specifically, Deere contended that only that portion of the claim that provided that the radius of the gauge wheels had to exceed the distance from the axes of the wheels to the rear edges of the discs was necessary in order to render the claims patentable over the prior art. The five-judge panel rejected Deere's argument. It stated:

> We decline to undertake the speculative inquiry whether, if [the inventor] had made only that narrowing limitation in his claim, the examiner nevertheless would have allowed it.

The court therefore affirmed the district court's judgment of noninfringement.

The federal circuit has accomplished some useful ends. It developed a methodology called "hypothetical claim analysis" to assist courts in determining whether the prior art prevents application of the doctrine of equivalents to a particular claim.

Under hypothetical claim analysis, the inquiry is twofold. First, the court visualizes a hypothetical patent claim broad enough in scope to literally cover the accused device. Second, the court examines whether the PTO would have allowed that hypothetical claim over the prior art at the time of invention.

If the hypothetical claim would have been allowed, then prior art is not a bar to infringement by equivalents; if the claim would not have been allowed, the prior art bars a finding of infringement by equivalents. As the court has explained:

> [Hypothetical claim analysis] allows use of traditional patentability rules and permits a more precise analysis than determining whether an accused product (which has no claim limitations on which to focus) would have been obvious in view of the prior art...it [also] reminds us that [the patentee] is seeking coverage beyond the limits considered by the PTO examiner.

The Economic Arguments

There are some compelling economic reasons to allow prosecution history estoppel to work as a brake on equivalents lawsuits.

Although there is burgeoning literature on technological intellectual property rights, the doctrine of equivalents has not, of itself, been a major focus of economic scholarship. This is due to the complexity of the issue, the variety of factual applications, the diversity of technologies, the breadth of interacting influences on patentees' and competitors' activities, and the **complex nuances** of competition at the edge of the products of others.

The doctrine of equivalents tends to diminish incentives for competitors, but it also encourages competitors to make "leapfrogging" advances instead of simply copying at the edge of the claims.

Infringement under the doctrine of equivalents is available only against what is indeed the same invention with only insubstantial change, as contrasted with issues of broad claims for broad but undeveloped concepts. **Equivalency is a judge-made response** to the pernicious literalism of the system of claiming, not an enlargement of the scope of the invention.

If prosecution history estoppel acts as a complete bar to application of the doctrine of equivalents, both the patent holder and the public are on notice as to the scope of protection provided by a claim element narrowed for a reason related to patentability. The patent holder and the public can look to the prosecution history—a public record—to determine if any prosecution history estoppel arises as to any claim element. If so, that element's scope of protection is clearly defined by its literal terms.

A complete bar to the doctrine of equivalents for unexplained amendments would give, as the Supreme Court stated in *Warner-Jenkinson*, "proper deference to the role of claims in defining an invention and providing public notice."

> Regardless of whether the amendment is explained or unexplained, if the amendment narrows the scope of the claim for a reason related to patentability, a complete bar to the doctrine of equivalents provides the public and the patentee with definite notice as to the scope of the claimed invention.

With this approach, technological advances that would have remained in an unknown, undefined zone around the literal terms of a narrowed claim under the flexible bar approach will not go wasted and undeveloped due to fear of litigation. The public will be free to improve on the patented technology and design around it without being inhibited by the threat of a lawsuit because the changes could possibly fall within the scope of equivalents left after a claim element has been narrowed by amendment for a reason related to patentability.

This certainty will stimulate investment in improvements and so-called "design-arounds" because the risk of infringement will be easier to determine.

Conclusion

Doctrine of equivalents claims are likely to remain the most common—and most controversial—patent infringement lawsuits in the future. U.S. courts will have to shave away at the circumstances in which the claims can work. This will be an ongoing concern to patent holders…and their inventions. And it will keep patents a complex arena in which small companies will need **considerable legal advice and support**.

PART FOUR:
OTHER TYPES OF
INTELLECTUAL PROPERTY

CHAPTER 12: SUBMISSION, IMPLIED CONTRACTS AND OTHER ISSUES

To most people, an idea represents something real and substantial, but actually—and legally—an idea constitutes **intangible property**. And intangible property is **tough to manage and evaluate**. Just ask the people working for any of the dot.com companies that went bust in 1999 and 2000. Many of them had good ideas; but intangible assets—like good ideas—don't pay the bills. And they can be tough to borrow against.

This is by design. As we noted early in this book, Supreme Court Justice Louis Brandeis wrote that ideas should be as "free as the air."

The central idea behind intellectual property law is that ideas can't be protected; only specific expressions of ideas can be. This leaves some gray areas in the early stages of developing an idea into an expression.

The purpose of laws pertaining to the protection of ideas must reconcile the public's interest in access to new ideas with the perceived injustice of permitting some to exploit commercially the ideas of others. In seeking the middle ground, courts recognize that "there can be circumstances when neither air nor ideas can be gained without cost."[1] As one court put it:

> Generally speaking, ideas are as free as the air and as speech and the sense, and as potent or weak, interesting or drab, as the experiences, philosophies, vocabularies and other variables of the speaker and listener may combine to produce, to portray or to

[1] See *Reeves v. Alyeska Pipeline Service Co.*, Supreme Court of Alaska (Nov. 1996).

> comprehend.... The diver who goes deep in the sea, even as the pilot who ascends high in the troposphere, knows full well that for life itself he, or someone on his behalf, must arrange for air...to be specifically provided at the time and place of need. The theatrical producer likewise may be dependent for his business life on the procurement of ideas from other persons as well as the dressing up and portrayal of his self-conceptions; he may not find his own sufficient for survival.

Another example: A software developer may be dependent in his business on the procurement of ideas from other developers—as well as the development and packaging of these ideas. If he's buying someone else's ideas, the developer may purchase the conveyance of an idea alone or a program giving an idea form, adaptation and expression. There's a big difference between these two kinds of deals. Buying a complete property is relatively easy...buying the conveyance of an idea can get complicated.

An idea is usually not regarded as property, because the **common law concept of property** implies something that may be owned and possessed to the exclusion of all other persons. As Justice Brandeis noted, immediately before his famous "free as air" quote:

> An essential element of individual property is the legal right to exclude others from enjoying it. If the property is private, the right of exclusion may be absolute; if the property is affected with a public interest, the right of exclusion is qualified.

However, U.S. courts have noted—as Brandeis proceeded to do, himself—**ideas can't be exclusive** because all sentient beings may conceive and evolve ideas through their powers of thought.

So, if an idea can't be property, who owns it before it becomes a program, script or novel?

Rights Beyond Copyrights, Trademarks or Patents

The basic distinction between the rights in and to literary productions as they exist at common law and as they are granted by statutory copyright is

that the common law protects only a property right…while the copyright statute grants a limited monopolistic privilege.

We've considered copyright claims at length. In this section, we're interested in the property rights—other than copyrights, trademarks and patents—available in a literary idea or creative effort.

It has been said (and does not appear to have been successfully challenged) that there are only **36 fundamental dramatic situations**, various facets of which form the basis of all human drama.

Literary property that is protectable may be created out of unprotectable material such as historical events. History both in broadly significant and in very personal aspects has furnished a wealth of material for screenplays and novels. The Crusades, the French Revolution, the Civil War, the lives—or events from the lives—of rulers, ministers, doctors, lawyers, politicians and military men, among others, all have been the basis of renowned works.

A literary composition does not depend upon novelty of plot or theme to achieve the status of property. The terms "originality" and "novelty" have often been confused—or used without differentiation.

A literary composition may be original, at least in a subjective sense, without being novel. To be original it must be a creation or construction of the author, not a mere copy of another's work. The author, of course, must almost inevitably work from old materials—from known themes or plots or historical events, because, except as knowledge unfolds and history takes place, there is nothing new with which to work.

But creation, in its technical sense, is not essential to vest one with ownership of rights in intellectual property. Thus, as we've seen, a compiler who merely gathers and arranges, in some concrete form, materials that are open and accessible to all who have the mind to work with like diligence

is as much the owner of the result of his labors as if his work were a creation rather than a construction.

As Supreme Court Justice Oliver Wendell Holmes wrote in the 1903 decision *Bleistein v. Donaldson Lithographing Co.*:

> Others are free to copy the original. They are not free to copy the copy.... The copy is the personal reaction of an individual upon nature. Personality always contains something unique. It expresses singularity even in handwriting, and a very modest grade of art has in it something irreducible, which is one man's alone. That something he may copyright unless there is a restriction in the words of the act.

Any literary composition, conceivably, may possess value in someone's estimation and be the subject of contract or—conversely—it may be considered totally devoid of artistic, historic, scientific or any practical value.

Whatever the aesthetic judgment, the following elements—in varying quantities and proportions—must exist in any literary composition:

- the time of the author;
- his resourcefulness in, opportunity for and extent of, research;
- his penetration in perception and interpretation of source materials;
- the acumen of his axiological appraisals of the dramatic; and
- his skill and style of composition.

If these elements can be established, literary property rights can be transferred by contract.

Contracting for Ideas

Ideas and property rights in creative efforts aren't protected by copyrights. But they can be exchanged under contract—and are, all the time.

The lawyer or doctor who applies specialized knowledge to a state of facts and gives advice for a fee is **selling and conveying an idea**. In

doing that he is **rendering a service**. The lawyer and doctor have no property rights in their ideas, as such, but they do not ordinarily convey them without solicitation by client or patient.

Usually the parties will expressly contract for the performance of and payment for such services, but, in the absence of an express contract, when the service is requested and rendered the law does not hesitate to infer or imply a promise to compensate for it.

In other words, the recovery may be based on contract—either express or implied. The person who conveys a valuable idea to a producer who commercially solicits the service or who voluntarily accepts it knowing that it is tendered for a price should likewise be entitled to recover.

Can freelance writers or contract programmers be held to the same standard of obligation as doctors and lawyers? The legal consensus—going back to the 1950s and 1960s used to be "no." In an economy increasingly dedicated to creative production, however, that answer has gradually morphed into "yes."

A **literary property is an intellectual production** afforded protection by the common law, by federal statute pursuant to constitutional authorization and by state law. The terms can apply to everything from the components of a new virtual reality program to an Iris Murdoch novel.

What Happens Legally When You Submit an Idea

Ideas and creative efforts mean various things in various industries. Ideas used in movies are among the litigated, so they have the most established paper trail to study. And, since ideas used in movies are ideas in a very pure sense, their treatments by courts can be instructive.

The 1956 California Supreme Court decision *Desny v. Wilder* has stood the test of time to become one of the classic cases dealing with the value of an idea—in its purest sense. The case forced the court to clear up some of the murkiness surrounding the legal value of ideas and to settle the question of how the courts should deal with this and similar issues.

The Value of a Good Idea

In November 1949, freelance screenwriter Victor Desny called the offices of Billy Wilder, a well-known writer, producer and director at Paramount Pictures. Wilder's secretary answered the call. Desny asked for an appointment with Wilder; at the secretary's insistence, Desny explained that he wanted to pitch a "fantastic, unusual story" to Wilder. He **described the plot** of his story to the secretary.

Desny's story idea was based on the life of Floyd Collins—a boy who had become trapped in an 80-foot-deep cave. This story had dominated regional headlines for weeks, Desny told the secretary, but apparently no movie based on the case had been made.

The secretary reacted enthusiastically to Desny's pitch, but when she learned that the script was 65 pages long, she informed Desny that Wilder would not read it. He only read stories in synopsis form, she told Desny.

This was standard procedure at the studio. Any property under consideration—be it a script, a magazine article or a Broadway play—would first be sent to the script department. There—if indeed it was fantastic and unusual—it would be shortened to three or four pages before being handed over to producers and directors like Billy Wilder.

Desny asked if he could prepare the synopsis of his script himself. Wilder's secretary, a little hesitant, agreed that she would show a synopsis to her boss. Two days later, Desny telephoned Wilder's office a second time. He connected again with Wilder's secretary, who asked him to **read the synopsis to her over the phone**—she could take it down in shorthand, put it in **memo form** and give it to Wilder.

Something about this proposition struck Desny as strange. He stressed to the secretary that Wilder and Paramount could use the story only if they paid him its "reasonable value" and stressed that he "wrote the story and…wanted to sell it."

The secretary replied that if Paramount used the story, "naturally [they would] pay…for it."

Despite the secretary's interest, Desny never got a call from Paramount or Wilder. His only other contact with the company was a telephone call—

that he made—to the secretary in July 1950 to protest the alleged use of his idea in the movie titled "Ace in the Hole," produced by Wilder.

The script for "Ace in the Hole" closely paralleled both Desny's synopsis and the historical material concerning the life and death of Floyd Collins. But this didn't mean that Wilder had stolen Desny's idea—after all, the story was based on true events. But Desny claimed one more damning thing: The script also included a fictional incident that had appeared in Desny's synopsis and was Desny's creation.

Desny decided to sue, asking for $150,000 as "reasonable payment" for his work.

You might think that Desny's first and best claim would be for plagiarism—the theft of his work. The problem with that claim was that plagiarism doesn't apply to ideas; it only applies to theft of verbatim text. Even by Desny's account, Wilder and Paramount hadn't done that.

So, Desny argued that Wilder and Paramount had broken a contract—a **verbal contract**, under which they had promised to pay for Desny's idea if they used it. Wilder and Paramount said Desny's claims should be dismissed. A trial court in Los Angeles County agreed.

Desny appealed.

The state appeals court allowed the suit to go forward. It agreed that ideas submitted for consideration could be the subject of a contract in California and, thus, could be protected under contract law.

Having allowed the case to proceed, the appeals court had to consider the facts. Immediately, there was one major issue to resolve: Was Desny's synopsis a literary composition, to which property rights would apply? Or was it an **abstract and unprotectable summary of an idea**?

Desny suggested—weakly—that a middle ground existed between an abstracted idea and a literary composition. The court found it unnecessary and undesirable to recognize such a hybrid: Desny's case had to be resolved based on existing rules applicable to ideas and literary property.

Wilder and Paramount conceded that "the act of disclosing an unprotectable idea, if that act is in fact then bargained for exchange for a promise, may

be consideration to support the promise." However, they argued that the law allowed anyone to use an idea that had been disclosed without being protected by a contract. And they claimed that Desny had disclosed his material before they did—or could do—anything to indicate a willingness or unwillingness to pay for the disclosure.

The court was careful to point out that Wilder and Paramount's argument might not always be true. Under certain circumstances, someone could make a contractual promise to pay for an idea before considering it. However, those circumstances didn't exist in Desny's case.

The court concluded that Wilder and Paramount had not implied a contract to pay for the abstract photoplay. And, it ruled, nothing the producer or the studio did could have led Desny to conclude that such a contract existed. So, Wilder and Paramount were free to use the abstract idea if they saw fit and to develop the abstract to the point of a usable script.

Desny appealed again, pressing the case to the state's high court.

The high court agreed with the preliminary analysis the lower court had made but hedged the **synopsis-versus-abstract distinction** a bit. It ruled that Desny's submission included both a synopsis and an abstract. It agreed to consider each item in turn.

It largely agreed with the trial court's conclusions about the abstract. But, when it continued on to an analysis of the synopsis, it ruled that the question of whether Wilder and Paramount developed the story on their own or used Desny's synopsis remained to be resolved.

Furthermore, if Wilder and Paramount had indeed used the synopsis, the court needed to determine whether they had accepted the terms on which Desny had offered it?

First, the court considered the question of whether Wilder and Paramount had used Desny's synopsis.

Desny had **no property right to the facts** concerning Floyd Collins—which were in the public domain. However, Desny's use of public domain material did not give Wilder and Paramount the right to appropriate his story.

316

Chapter 12: Submission, Implied Contracts and Other Issues

Wilder and Paramount submitted their script for comparison to Desny's. They also submitted extracts from a magazine and newspaper, which Desny testified he'd also used in preparing his story.

After an exhaustive comparison of the two scripts and background documents, the court found that it was implausible that Wilder and Paramount could have come up with such a similar story so quickly. And—despite Paramount and Wilder's argument that their script, its characters, plot and development were entirely fictional—the court ruled that their movie obviously bore a remarkable similarity to Desny's story.

Second, the court considered whether Wilder and Paramount had made an **implied-in-fact contract** or so-called "**quasi-contractual obligation**."

Paramount submitted affidavits declaring that neither Wilder nor Wilder's secretary had authority to negotiate contracts for the purchase of scripts. The court rejected this argument, noting:

> If the secretary had accepted any other item of merchandise, such…as office supplies, which [Desny] left with her with the statement that he was offering them for sale and that if used by defendants [Desny] expected to be paid therefore, [Wilder and Paramount's] subsequent use of such property would be held to give rise to an inferred or so-called implied-in-fact promise on their part to make payment.

It ruled for Desny, ordering Wilder and Paramount to compensate Desny for the use of his synopsis. The best summary of the decision was offered by the court itself:

> A promise, made in advance of disclosure, to pay for the act of conveyance or disclosure of an idea which may or may not have value is one thing. A promise, made after conveyance of the idea to the promisor, to pay reasonable value for an idea which does have value to the promisor and which has been conveyed to, and has been used by, him is another….

The first kind of promise was not enforceable; the second was. Billy Wilder and Paramount—through Wilder's secretary—had made that kind of promise.

This is the reason that so many publishers, producers and intellectual property companies remain aloof from average Joes and Janes with scripts in their pockets. If a producer is not commercially soliciting—and is not willing to accept an obligation to pay for—ideas, he does not need to read manuscripts that he knows are submitted on any other terms. And he doesn't need to have his secretary take dictated synopses of stories offered on other terms.

Quasi Contracts vs. Implied-in-Fact Contracts

Talking about ideas can create legal problems on various levels. We've seen the "ideas" problems in most of their shades. The California Supreme Court considered the "talking" problems in the Desny decision.

As you might guess, the *Desny* case was a big deal in Hollywood circles. Several groups—including the Association of Motion Picture Producers, Inc. and the National Broadcasting Company (NBC)—filed legal briefs in support of Wilder and Paramount's position.

These groups feared that **quasi-contractual situations** (under which the law presumes on the part of someone a promise which he not only did not make but never intended to make) would be **confused with "proper" implied-in-fact contracts** (actual meeting-of-the-minds but unspoken agreements).

The elements requisite for informal contracts are identical whether they are expressly stated or implied in fact; the difference between the two being largely in the **character of the evidence** by which they are established.

Quasi-contractual obligations are imposed by the law for the purpose of bringing about justice without reference to the intention of the parties.

An implied-in-fact contract, as the term is used by some lawyers and others, may be found although there has been no meeting of the minds. Even an express contract may be found where there has been no meeting of minds.

However, the *Desny* court noted:

> If it were not for precedent we should hesitate to speak of an implied-in-fact contract. In truth, contracts are either made in fact or the obligation is implied in law. If made in fact, contracts may be established by direct evidence or they may be inferred from circumstantial evidence.

The groups supporting Wilder and Paramount made two arguments to the court:

1) One party cannot, by unilateral words or deeds, thrust upon another a contractual relationship unless the latter has, by his own words or deeds, consented thereto; and

2) In the absence of manifest assent to the same thing upon the same terms by both parties, there is no contract.

The court agreed "unqualifiedly" with the first point. Its agreement with the second point depended on what was meant by the term "manifest assent."

The court acknowledged that conveyance of an idea can constitute valuable consideration and can be bargained for—in contract—before it is disclosed to the proposed recipient. But, once it's conveyed, it becomes the recipient's (or, for that matter, anyone else's who knows it) and he may work with it and use it as he sees fit.

Following this logic, a producer may properly and validly agree that he will pay for the service of conveying to him ideas which are valuable and that he can put to profitable use.

Furthermore, where an idea has been conveyed with the expectation by the purveyor that compensation will be paid if the idea is used, there is no reason why the recipient/producer may not then promise to pay a reasonable compensation for the past service of furnishing the idea. But he's not under any legal obligation to do so.

The point that the court stressed was that the idea purveyor cannot prevail in a lawsuit to recover compensation for an abstract idea unless: 1) before or after disclosure she has obtained an express promise to pay; or 2) the

circumstances preceding and attending disclosure, together with the conduct of the recipient, show an implied-in-fact obligation.

Such an implied obligation, if it is to be found at all, must be based on circumstances which were known to the recipient/producer at and preceding the time of disclosure of the idea to him. And he must voluntarily accept the disclosure, knowing the conditions on which it is tendered.

The hope or expectation that some obligation will ensue later doesn't work for the idea purveyor. The **law won't imply a promise to pay** for the idea from demands stated after the unconditioned disclosure of an abstract idea. And the law won't imply a promise to pay for an idea from the mere facts that the idea was conveyed, is valuable and has been used for profit.

As the *Desny* court famously wrote:

> The idea man who blurts out his idea without having first made his bargain has no one but himself to blame for the loss of his bargaining power.

Harsh but true. Even five decades later.

A Swampy Confusion of Ideas and Styles

Speaking of leverage, the 1994 U.S. Supreme Court decision *John C. Fogerty v. Fantasy, Inc.* dealt with musical ideas in their broadest sense. Fantasy—a record company—claimed that it **owned the style of music** that Fogerty—a singer—had made famous. And it tried to prevent him from making music in that style.

The case, which bounced through various generations of appeals, took the strange form of the singer being sued for plagiarising…himself.

Many music fans are familiar with John Fogerty and his work. Fogerty was the lead singer and songwriter for the band Creedence Clearwater Revival (CCR)—widely recognized as one of the greatest American rock-and-roll bands. The band's style and Fogerty's music is often called "swamp rock," because of its heavy southern blues influence.

Chapter 12: Submission, Implied Contracts and Other Issues

After a short, tempestuous reign at the top of the record charts, CCR stopped recording in the early 1970s. For more than a decade, Fogerty stayed away from the music industry.

He made an acclaimed comeback in the mid-1980s, releasing the first of several albums of new songs that generated both critical praise and strong sales. Critics and fans both liked the fact that Fogerty hadn't lost the swamp rock touch.

In 1985, Fantasy—which had purchased the copyrights to the older CCR songs and recordings—sued Fogerty for copyright infringement, alleging, among other things, that Fogerty's new song "The Old Man Down the Road" infringed the copyright of the earlier CCR song, "Run Through the Jungle."

Fantasy alleged that Fogerty had copied the music, changed the lyrics and released it as a new song.

The music press mocked the lawsuit as a greedy corporation pushing a preposterous legal theory—that a songwriter could be **guilty of copyright infringement by plagiarizing himself**.

The courts came to the same conclusion, although more slowly. Through three years of claims, counterclaims and motions, Fogerty successfully defended himself against the copyright infringement claims. The case involved so many legal actions that the courts hearing them began to refer to various parts by numbers—"Fogerty I" and "Fogerty II," etc. This is a sure sign that a case has achieved an elite level of litigious complexity.

The courts (at least two trial courts, one appeals court and, glancingly, the U.S. Supreme Court) finally concluded that Fogerty's style of music represented an abstract musical idea that couldn't be restricted or protected by copyright. Without specific, detailed copying of lyrics and chords—which Fantasy tried to prove but couldn't—the claim couldn't stand.

The courtroom victory meant that Fogerty could continue composing music in the swamp rock style. The legal theory: This would further the purposes of the Copyright Act by assuring the **greatest public access to a distinctive subgenre of music**.

Legal Fees

Fogerty is notable for something more than just the metaphysically bizarre claim at its core.

At the end of all the legal wrangling, the trial court awarded Fogerty $1,347,519.15 in attorneys' fees. Fantasy immediately appealed the award…and, true to form, the appeal went all the way up to the U.S. Supreme Court.

John Fogerty's lingering legal anguish does offer a good look at how legal fees are awarded in intellectual property cases.

Different federal laws make the award of legal fees more or less easy, depending on the public policy ends the laws are designed to achieve. For instance, in the civil rights context, poor plaintiffs cannot afford to litigate their claims against wealthier defendants. Congress sought to correct this imbalance—and to encourage worthy lawsuits—by **treating successful plaintiffs more favorably than successful defendants** in terms of the award of attorneys' fees.

In other words, if you file a civil rights lawsuit and win, you're likely to get attorneys' fees, too; if you're sued in a civil rights case and win, you're not likely to get the attorneys' fees.

The primary objective of the Copyright Act is to encourage the production of original literary, artistic and musical expression for the good of the public. This doesn't suggest so clearly the kind of preference that civil rights law has. In copyright cases, it's been noted by several different courts that:

> Entities which sue for copyright infringement as plaintiffs can run
> the gamut from corporate behemoths to starving artists; the same
> is true of prospective copyright infringement defendants.

More importantly, the public policy goals of the Copyright Act are more complex than simply encouraging worthy suits for copyright infringement. The Constitution grants to Congress the power:

Chapter 12: Submission, Implied Contracts and Other Issues

> To promote the Progress of Science and useful Arts, by securing
> for limited Times to Authors and Inventors the exclusive Right to
> their respective Writings and Discoveries.

In its 1975 decision *Twentieth Century Music Corp. v. Aiken*, the Supreme Court recognized that the copyright protections authorized by Congress, while "intended to motivate the creative activity of authors and inventors by the provision of a special reward," are limited in nature and must ultimately serve the public good. More generally the high court wrote:

> Creative work is to be encouraged and rewarded, but private
> motivation must ultimately serve the cause of promoting broad
> public availability of literature, music and the other arts. The im-
> mediate effect of our copyright law is to secure a fair return for an
> "author's" creative labor. But the ultimate aim is, by this incentive,
> to stimulate artistic creativity for the general public good.

How does the award of attorneys' fees serve this purpose?

According to the Supreme Court, because copyright law enriches the general public through broader access to creative works:

> [D]efendants who seek to advance a variety of meritorious copy-
> right defenses should be encouraged to litigate them to the same
> extent that plaintiffs are encouraged to litigate meritorious claims
> of infringement.

The relevant section of the Copyright Act provides that in such an action "the court may...award a reasonable attorney's fee to the prevailing party as part of the costs."

That may cause some problems.

While most federal courts exercise their discretion in awarding attorneys' fees to prevailing copyright owners based on a finding of infringer's frivolousness or bad faith, **not all courts follow the Copyright Act's suggestion**.

Back to Fogerty's case: After his successful defense of the copyright infringement charges filed by Fantasy, the district court denied his request for attorneys' fees. In making its findings, the district court stated:

The Value of a Good Idea

Although the facts of this case did not present the textbook scenario of copyright infringement, the court has held that Fogerty could indeed be held liable for copyright infringement even where he also wrote the song allegedly infringed.... Nor does Fantasy's "knowledge of Fogerty's creativity" mean that this suit was brought in bad faith, where a finding of subconscious copying would have supported Fantasy's infringement claim.

The appeals court agreed, sticking to its "dual" standard for awarding attorneys' fees—under which prevailing plaintiffs are generally awarded attorneys' fees as a matter of course, while defendants must show that the original suit was frivolous or brought in bad faith. The appeals court explained:

The purpose of [the dual standard] rule is to avoid chilling a copyright holder's incentive to sue on colorable claims, and thereby to give full effect to the broad protection for copyrights intended by the Copyright Act.

The main alternative to the dual approach is the so-called "evenhanded" approach, in which no distinction is made between prevailing plaintiffs and prevailing defendants. And a number of federal appeals courts had adapted that approach.

The Supreme Court agreed to consider Fogerty's case (again) to resolve this inconsistency among appeals courts. It ruled that the evenhanded approach should be used in copyright and other intellectual property cases. Specifically, it wrote:

By predicating an award of attorneys' fees to prevailing defendants on a showing of bad faith or frivolousness on the part of plaintiffs, the "dual" standard makes it more difficult for prevailing defendants to secure awards of attorneys' fees than prevailing

plaintiffs.... [A] successful defense of a copyright infringement action may further the policies of the Copyright Act every bit as much as a successful prosecution of an infringement claim by the holder of a copyright.

Of course, the Supreme Court admitted the "may" in the Copyright Act meant that courts could use their discretion in awarding attorneys' fees. But it suggested that its logic be used to guide courts' discretion—and make sure decisions remain faithful to the purposes of the Copyright Act "and are applied to prevailing plaintiffs and defendants in an evenhanded manner."

This meant Fogerty could collect his $1.3 million in legal fees; and he would continue to collect more fees every time Fantasy took him to court.

Several specific factors contributed to the court's ruling in favor of Fogerty:

1) Fogerty's vindication of his copyright in "The Old Man Down the Road" secured the public's access to an original work of authorship and paved the way for future original compositions—by Fogerty and others—in the same distinctive swamp rock style and genre.

2) Fogerty's defense furthered the purposes underlying the Copyright Act and therefore should be encouraged through a fee award.

3) A fee award was appropriate to help restore to Fogerty some of the lost value of the copyright he was forced to defend.

4) Fogerty was a defendant author and prevailed on the merits rather than on a technical defense, such as the statute of limitations...or the copyright registration requirements.

5) Finally, the benefit conferred by Fogerty's successful defense was not slight or insubstantial relative to the costs of litigation, nor did the fee award put a heavy burden on Fantasy, which was not lacking sufficient funds.

Conclusion

This chapter introduced some of the complaints that people make outside the general scope of copyrights, trademarks and patents. Submitted ideas and a rock star's style of music, however, are just two examples of odd ball things that come under the umbrella of other types of intellectual property. While you can't easily, for example, copyright a voice or trademark a reputation, these other things have been challenged in courts by famous and ordinary people alike. And the courts have responded by **widening the scope of rights** to include privacy, publicity and even reputation.

But these cases are still hard to establish and they often turn on the merits of your complaint or how widely known you are to accuse someone of tarnishing your public reputation…or invading your privacy. In the next chapter, we'll start with the right to privacy in relation to intellectual property. Privacy is among the most misunderstood rights, and when it comes to intellectual property, it often gets tangled up with the right to publicity.

CHAPTER 13:
RIGHT TO PRIVACY

Every photo tells a story. When Cynthia Cheatham's photo was taken at a bikers' festival, and later used in a magazine and on t-shirts, she sued alleging an invasion of privacy. Why the privacy claim? Well, the photo captured her while donning a design of her own making—cutout blue jeans that displayed her derriere through fishnet fabric. And, *Cynthia Cheatham v. Paisano Publications, Inc. and T-Shurte's* went way beyond a claim for privacy. In this chapter, we'll take a look at what Cynthia Cheatham alleged in her original complaint and why the court refused to let most of her actions proceed to trial.

Cheatham was a designer of clothing and created her unique outfits to display them at bikers' events. The event in question took place in Chillicothe, Ohio, in May 1993. Paisano's *Wind* magazine published a picture of Cheatham's backside as part of a photo essay covering the affair. Then, a year and a half later, in December 1994, Paisano's *Easyriders* magazine published t-shirt manufacturer T-Shurte's ad for a t-shirt printed with a drawing of a similarly-clad backside, which, Cheatham claimed, portrayed her likeness. Several hundred of these shirts were sold.

The drawing on the t-shirts and in the ad **precisely reproduced the photograph** of Cheatham that had appeared in *Wind* magazine, except that a Harley-Davidson logo on the original design had been eliminated in the drawing. While Cheatham was not actually embarrassed by the photograph and its use on a t-shirt, she was frustrated that she, too, didn't get to reap a profit from the photo. Cheatham took Paisano and T-Shurte's to court, asserting that they had committed the following:

1) invasion of privacy;

2) commercial exploitation of a likeness;

3) negligent licensing of an image without the owner's consent;

4) misappropriation of an image for commercial gain; and

5) unjust enrichment.

Later, Cheatham sought to add a claim for interference with prospective business relations and for intentional infliction of emotional distress. All of her claims, however, centered on her allegation that the magazine and t-shirt manufacturer had unjustly appropriated her image.

First, the court considered whether Paisano and T-Shurte's had unreasonably intruded upon Cheatham's seclusion—whether they had violated the famous **"intrusion upon seclusion"** clause. But, to Cheatham's dismay, the court rejected this claim. Cheatham was not a woman who sought to keep her designs secret and wear them only to very private functions, said the court. Instead, she wore her unusual clothing at large public events, namely bikers' conventions, and in front of large crowds of people. Her husband even noted that she never wore her designs at home.

According to the court, if Cheatham believed that these designs were truly unique, she should have expected that someone might photograph her in this clothing. Consequently, no reasonable jury could conclude that the taking of these photos was an unreasonable intrusion upon her seclusion.

The court also rejected Cheatham's second claim—that the magazine and t-shirt manufacturer had brought **unreasonable publicity** to her private life. Cheatham had stated that her designs were so unique that her friends and customers immediately recognized them. And, it followed that if she wore the clothing to attract attention to herself as well as to the designs, then she voluntarily took them out of her private life and injected them into public view. "Given the facts of this case, no reasonable jury could construe any attention given to [Cheatham's] wearing of these designs as unreasonable publicity of [her] private life," the court ruled.

Cheatham's third claim, that the publicity created by Paisano and T-Shurte's placed Cheatham in a **false light**, didn't convince the court either. A person making this claim must prove that: 1) the false light in which he or she was placed would be highly offensive to a reasonable person; and 2) the publisher has knowledge or has acted in reckless disregard of the falsity of the publicized matter. In addition, a sufficient claim must show that the publicity attributes false characteristics, conduct or beliefs to the plaintiff.

However, in this case, Cheatham voluntarily wore her unique clothing to public events, Paisano photographed her exactly as she appeared at the bikers' gathering, and the published photo essay didn't identify her. Hence, said the court, Paisano and T-Shurte's had not committed false light invasion of privacy.

Fourth, Cheatham argued that Paisano and T-Shurte's had committed an **invasion of privacy** by appropriating her likeness without authorization. She further alleged that Paisano and T-Shurte's **deprived her of the commercial benefit** of her "image." In other words, Cheatham wanted to be compensated for the use of her photo that had brought financial gain to both companies. This claim—while not easily supported—was the one that the court let stand—and the one that's important to our discussion in this chapter.

Although there were two distinct uses of Cheatham's likeness—in the magazine's photo essay and on the printed t-shirts—the court was only concerned with the t-shirts. Cheatham was precluded from recovering damages for the photo essay because the law protects the use of such material under an exception for newsworthy items. The court deemed the publication of her photo as part of the photo essay—a newsworthy item—protected under the First Amendment.

To prove that T-Shurte's had unfairly used her likeness and that this violated her right of publicity, Cheatham had to prove that she possessed a notoriety strong enough to have commercial value within an identifiable group. This, however, was a tough thing for Cheatham to establish, let alone prove. Her photo didn't show her face. The only reason the court

denied the defendants' motion to dismiss this claim was that friends and customers recognized her design in the photo.

Cheatham also faced hurdles in validating her claims of intentional infliction of emotional distress and intentional interference with prospective business relations. The emotional distress claim hinged on Cheatham's ability to prove that: 1) the conduct was intentional; 2) the conduct caused severe emotional distress; and 3) the conduct was outrageous. But, Cheatham couldn't prove any of these. According to the court, Paisano's conduct was not "outrageous" and there was no evidence of emotional distress. Cheatham had even admitted that she wanted to be compensated for the use of her photo that had brought the two companies financial gain.

To prevail on the business interference claim, Cheatham had to show that the defendants intentionally interfered with her business prospects and that this caused her to lose profits to which she would otherwise have been entitled. In addition, Cheatham had to prove that Paisano and T-Shurte's interfered by using improper means and that their actions prevented her from marketing and profiting from the same or similar designs. The court, however, found no indication that Cheatham had intended to market t-shirts herself or that the companies had deprived her of profits that she was entitled to. The court also emphasized that the argument that Cheatham might have received some benefit from her "unique" designs was not a sufficient basis to support a cause of action for intentional interference with prospective business relations.

So, the only claim Cheatham was allowed to argue was that of a wrongful appropriation of image.

Fair Use and Privacy

Kentucky is one state that has long recognized the invasion of privacy as an actionable tort. Over the years, this theory of law has evolved, and in 1981, the Kentucky Supreme Court formally adopted the definition from the Restatement (Second) of Torts (1976). Under this definition, four distinct causes of action exist, each of which is classified loosely as invasion

- unreasonable intrusion upon the seclusion of another…;

- appropriation of the other's name or likeness…;

- unreasonable publicity given to the other's private life; and

- publicity that unreasonably places the other in a false light before the public….

> **Not all jurisdictions recognize the tort of unauthorized appropriation of likeness. But Kentucky's Supreme Court has suggested that it is available by adopting this Restatement view of invasion of privacy. Kentucky courts have not specifically addressed the elements of proof required to support this cause of action, however.**

Other courts have referred to the unauthorized use of another's likeness as the "**appropriation of the right of publicity**." (We'll go into this in more detail in the next chapter.)

The courts also dealt with privacy and the right of publicity in another landmark case. In *Midler v. Ford Motor Company*, singer Bette Midler sued the automobile company and its ad agency for using a commercial with one of Midler's songs performed by a sound-alike—a woman who could sing almost exactly like Midler. Initially, a California district court entered a judgment in favor of Ford. On appeal, however, the court reversed its decision and held that under California law, Midler should prevail. This case became important because it set precedent for right of publicity actions.

The case centered on whether a famous voice should be protected from commercial exploitation without the singer's consent. The key question became whether a voice—an expression much more personal than any other work of authorship—could be copyrighted. Midler's legal action came after Ford started an ad campaign dubbed "The Yuppie Campaign."

The Value of a Good Idea

The year was 1985, and Ford commissioned ad agency, Young & Rubicam to create a series of 19 television commercials, each 30 to 60 seconds long.

The aim of the ad spots was to tap into the college memories of Yuppies to establish an emotional connection between this target group and Ford automobiles. Various popular songs of the 1970s were sung on each commercial. The agency tried to get the original artists who had popularized the songs to sing them, but most of the singers were not interested in lending their voice to sell cars, so the agency hired the sound-alikes to perform the songs. One of those sound-alikes sung like Bette Midler.

It doesn't take much to conjure images of Bette Midler, a nationally known actress and singer. She won a Grammy for Best New Artist in 1973. Midler records released since then have sold enough copies to reach Gold and Platinum-level status. She was nominated in 1979 for an Academy Award for Best Female Actress in the movie *The Rose*, in which she portrayed a pop singer. In its June 30, 1986 issue, *Newsweek* characterized Midler as an "outrageously original singer/comedian." *Time* hailed her in its March 2, 1987 issue as "a legend" and "the most dynamic and poignant singer-actress of her time." She wasn't a no-namer.

And, when Young & Rubicam presented its idea for the commercial with an edited version of Midler singing "Do You Want To Dance," taken from the 1973 Midler album *The Divine Miss M*, Ford accepted.

The agency contacted Midler's manager, Jerry Edelstein. The conversation went as follows: "Hello, I am Craig Hazen from Young and Rubicam. I am calling you to find out if Bette Midler would be interested in doing…? Edelstein: "Is it a commercial?" "Yes." "We are not interested."

Undeterred, Young & Rubicam sought out and acquired little-known singer Ula Hedwig for the job. The agency knew that Hedwig had been one of "the Harlettes," backup singers for Midler for 10 years. At the direction of Young & Rubicam, Hedwig then recorded "Do You Want To Dance" for the commercial and was told to "sound as much as possible like…Bette Midler."

Apparently Hedwig did her job well and convinced almost everyone. After the commercial aired, Midler was told by a number of people that it sounded exactly like her recording of "Do You Want To Dance." Hedwig, too, heard from many personal friends that they thought Midler was singing the song in the commercial. Ken Fritz, a personal manager in the entertainment business not associated with Midler, said that he heard the commercial on more than one occasion and had thought that it was Midler's voice, too. Midler sued.

At issue during the trial was only the protection of Midler's voice since neither her name nor her picture had appeared in the commercial. Moreover, Young & Rubicam had a license from the copyright holder to use the song. Although the district court chided Ford and its ad agency for behaving like "the average thief," it found no legal basis for preventing the imitation of Midler's voice.

The First Amendment protects much of what the media do in the reproduction of likenesses or sounds. A primary value is freedom of speech and press. The purpose of the media's use of a person's identity is central. If the purpose is "informative or cultural" the use is immune; if it serves no such function but merely exploits the individual portrayed, immunity will not be granted. Moreover, federal copyright law preempts much of the area. An imitation of a recorded performance would not constitute a copyright infringement even if the performer deliberately sets out to simulate another's performance as exactly as possible.

Midler appealed and the appeals court ultimately determined that Ford had violated Midler's property rights. Interestingly, the court ruled that Ford and the ad agency had stolen the *value* of Midler's identity as though they had stolen a piece of property from her. As the district court noted in its decision, Ford and the ad agency had utilized the "If we can't buy it, we'll take it" tactic.

While Midler's voice was at issue, she knew that her voice could not be copyrightable because sounds cannot be owned. Instead, Midler focused her case on Ford's deliberate use of her identity as embodied in the recorded sound of her voice—not only without her consent but after she

had expressly turned down the advertisers' request to sing for the commercial. She argued that the ad agency recognized that there was commercial advertising value in her identity as reflected in the distinctive sound of her voice.

Hence, in suing the agency, Midler was not trying to prevent other singers from doing take-offs on her style of singing. She simply opposed the unauthorized use of her personality—as embodied in the distinctive sound of her voice—to sell automobiles.

The appeals court found a relevant precedent in a previous case in which comic actor Bert Lahr sued Adell Chemical Co. for selling Lestoil—the household cleaning product—by means of a commercial in which an imitation of Lahr's voice accompanied a cartoon of a duck (*Lahr v. Adell Chemical Co.*, 1962). Lahr alleged that his style of vocal delivery was distinctive in pitch, accent, inflection and sounds. The First Circuit held that Lahr could claim that the commercial created unfair competition—or that "[Adell]'s conduct saturated [Lahr]'s audience, curtailing his market."

While this case was similar to the one at hand, wrote the court, the issue of competition had no bearing here:

> One-minute commercials of the sort the defendants put on would not have saturated Midler's audience and curtailed her market. Midler did not do television commercials. The defendants were not in competition with her.

Next, Midler tried to employ a California civil code that affords damages to a person injured by someone who uses his or her "name, voice, signature, photograph or likeness, in any manner." This argument was rejected as well. The agency did not use Midler's name or anything else that the statute prohibited them to use. The voice in the commercial was that of Hedwig—not that of Midler. According to the court, "the term 'likeness' refers to a visual image not a vocal imitation." However, the court also specifically stated that Midler was not precluded from making a case under the common law.

But Midler was not just an illustrious diva who went to court because of a broken ego. According to the court, since the agency asked Midler to sing, and, when she refused, acquired the services of a sound-alike to imitate Midler, her voice must have been of value to them. Hence, said the court, what the defendants sought was "an attribute of Midler's identity…and its value was what the market would have paid for Midler to have sung the commercial in person."

The court didn't want to go so far as to hold that every imitation of a voice to advertise merchandise is actionable. It wrote:

> We hold only that when a distinctive voice of a professional singer is widely known and is deliberately imitated in order to sell a product, the sellers have appropriated what is not theirs and have committed a tort in California.

Midler had successfully shown that Ford and its agency, for their own profit in selling a product, appropriated part of her identity. Or, more to the point, "[t]o impersonate her voice [was] to pirate her identity."

Midler won…and received an undisclosed settlement.

The companion statute protecting the use of a deceased person's name, voice, signature, photograph or likeness states that the rights it recognizes are "property rights." By analogy, the common law rights are also property rights. Appropriation of such common law rights is a tort in California.

For example, in *Motschenbacher v. R.J. Reynolds Tobacco Co.* (Ninth Circuit,1974), the tobacco company used a photograph of a famous professional race driver's racing car to promote Winston cigarettes. The number of the car was changed and a wing-like device known as a spoiler was attached to the car; the car's features of white pinpointing, an oval medallion and solid red coloring were retained. The driver, Lothar Motschenbacher, was in the car but his features were not visible. Some persons, viewing the commercial, correctly inferred that the car was his and that he was in the car and was therefore endorsing the product. The tobacco company had invaded a **"proprietary interest"** of Motschenbacher in his own identity.

Midler's case is different from Motschenbacher's in that he and his car were physically used by the tobacco company's ad; he made part of his living out of giv ing commercial endorsements. But, as Judge Koelsch expressed in *Motschenbacher*, California recognizes an injury from "an appropriation of the attributes of one's identity."

Thus, it was irrelevant that Motschenbacher could not be identified in the ad. The ad suggested that it was he. The ad did so by emphasizing signs or symbols associated with him. In the same way the ad agency used an imitation to convey the impression that Midler was singing for them.

A voice is more distinctive and more personal than the automobile accouterments protected in *Motschenbacher*. A voice is as distinctive and personal as a face. The human voice is one of the most palpable ways identity is manifested. We are all aware that a friend is at once known by a few words on the phone. At a philosophical level it has been observed that with the sound of a voice, "the other stands before me."

These observations also hold true of singing, especially singing by a singer of renown. The singer manifests herself in the song. To impersonate her voice is to pirate her identity.

Conclusion

As seen in this chapter, the right to privacy often goes hand-in-hand with the right to publicity, or the right to prevent others from commercially using an aspect of your persona. The *Midler* case set a tone for many courts having to decide on these two rights. But some decisions predate Midler's suit, as we'll see in Chapter 14, which looks further into this vague right of publicity and defines how you can prove that right in a court of law.

CHAPTER 14: RIGHT TO PUBLICITY

Celebrity has always been a key tool for marketing movies, television shows and music. The Hollywood studio system of the 1940s and 1950s was the golden age of carefully-crafted celebrities who used publicity to sell tickets to movies whose artistic merit was often thin. But the idea of using publicity as a sales tool traces back to 19th Century promoters like P.T. Barnum.

In the age of 24-hour celebrity television and thousands of Web sites that publicize celebrities major and minor, it's easy to mock breathless coverage of dim-witted actors. But publicity is an important thing—and one that can be tied closely to brand recognition and perceived value.

The 1980s and 1990s saw the creation and development of a new intellectual property claim: The **right to publicity**.

This new right grew out of a number of lawsuits in California that had to do with the images or other qualities of celebrities that were used abusively or without permission. The right to publicity was at first dismissed in some circles as a flaky California confection. But, in an economy that values brand identification, it didn't take long for other places to fall in line with the new idea.

We saw that Bette Midler attacked a car company for using a voice like hers in its commercials. And, while her case pressed a right to privacy claim most aggressively, it was also one of the first cases to press a right to publicity claim.

In short, Midler's publicity claim argued that a well-known person has the right to control the distinctive characteristics that make him or her well-known. If these characteristics (in Midler's case, her style of singing) are deliberately imitated in order to sell a product—without the person's permission or involvement—legal damages may follow.

Or, as the court in the *Midler* case wrote:

> When voice is a sufficient indicia of a celebrity's identity, the right of publicity protects against its imitation for commercial purposes without the celebrity's consent.... In California, sellers that have appropriated what is not theirs have committed a tort.

The *Midler* decision was a major milestone in the development of right of publicity claims. This case popularized the claim—making what had been an obscure corner of intellectual property law the kind of thing that shows up in popular novels and television shows. The number of right of publicity lawsuits filed each year rose sharply after the *Midler* decision.

History of Right of Publicity

In 1971, California passed a state law authorizing recovery of damages by any living person whose name, photograph or likeness has been used for commercial purposes without his or her consent. Some states offer no **postmortem statutory protection**, or they offer inconsistent and questionable protection. Although the Lanham Act prohibits the endorsement of commercial goods and services by people without their consent, the Act fails to specify the life of these rights. Paving the pathway to a right of publicity, California enacted Section 990 in 1984 to make the deceased's publicity rights transferrable. This means that the protection afforded by the law extends to heirs, studios and even third parties. Then, in the fall of 1999, Governor Gray Davis signed a bill that increased the period of protection to 70 years following the celebrities' death.

Specifically, Section 990 declares broadly that:

> Any person who uses a deceased personality's name, voice, signature, photograph or likeness in any manner, on or in products,

merchandise or goods, or for purposes of advertising or selling, or soliciting purchases of, products, merchandise, goods or services, without prior consent from the person or persons…shall be liable for any damages sustained by the person or persons injured as a result thereof.

The amount recoverable includes any profits from the unauthorized use, as well as punitive damages, attorneys' fees and costs.

The statute defines *deceased personality* as a person "whose name, voice, signature, photograph or likeness has commercial value at the time of his or her death," whether or not the person actually used any of those features for commercial purposes while alive.

The statute further declares that "[t]he rights recognized under this section are property rights" that are transferrable before or after the personality dies, by contract or by trust or will.

> Consent to use the deceased personality's name, voice, photograph, etc., must be obtained from such a transferee or, if there is none, from certain described survivors of the personality.

Any person claiming to be such a transferee or survivor must register the claim with the Secretary of State before recovering damages.

The right to require consent under the statute terminates if there is neither transferee nor survivor, or 70 years after the personality dies.

A few key exceptions narrowed the strength of the law in 1997, following *Astaire v. Best Film and Video Corp.* A use "in connection with any news, public affairs, sports broadcast or account, or any political campaign" does not require consent. Use in a **"commercial medium"** does not require consent solely because the material is commercially sponsored or contains paid advertising; "Rather it shall be a question of fact whether

The Value of a Good Idea

or not the use… was so directly connected with" the sponsorship or advertising that it requires consent."

Also exempt from the provisions of the statute:

- a play, book, magazine, newspaper, musical composition, film, radio or television program;

- a work of political or newsworthy value;

- a single and original works of fine art; or

- an advertisement or commercial announcement for the above works.

These exceptions weakened the original statute, creating problems in the protection of, for example, actors' rights. The right of publicity, like copyright, protects a form of intellectual property that society deems to have some social utility. But it's a type of property still under scrutiny in many courts.

According to the California Supreme Court's 1979 decision *Lugosi v. Universal Pictures*:

> Often considerable money, time and energy are needed to develop one's prominence in a particular field. Years of labor may be required before one's skill, reputation, notoriety or virtues are sufficiently developed to permit an economic return through some medium of commercial promotion. For some, the investment may eventually create considerable commercial value in one's identity.

While it may be of questionable philosophical certainty, one of the concurring opinions in *Lugosi* stated:

> Groucho Marx just being Groucho Marx, with his moustache, cigar, slouch and leer, cannot be exploited by others. Red Skelton's variety of self-devised roles would appear to be protectable, as would the unique personal creations of Abbott and Costello, Laurel and Hardy and others of that genre…. [W]e deal here with actors portraying themselves and developing their own characters.

In the 1977 decision *Zacchini v. Scripps-Howard Broadcasting Co.*—the first U.S. Supreme Court ruling to deal with right of publicity—the court faced a classic example of a publicity dispute.

Zacchini, the performer of a human cannonball act, sued a television station that had **videotaped and broadcast his entire performance without his consent**. The court held the First Amendment did not protect the television station against a right of publicity claim under Ohio common law. In explaining why the enforcement of the right of publicity in this case would not violate the First Amendment, the court stated:

> [T]he rationale for [protecting the right of publicity] is the straightforward one of preventing unjust enrichment by the theft of good will. No social purpose is served by having the defendant get free some aspect of the plaintiff that would have market value and for which he would normally pay.

The court also rejected the notion that federal copyright or patent law preempted this type of state law protection of intellectual property:

> [Copyright and patent] laws perhaps regard the "reward to the owner [as] a secondary consideration," but they were "intended definitely to grant valuable, enforceable rights" in order to afford greater encouragement to the production of works of benefit to the public. The Constitution does not prevent Ohio from making a similar choice here in deciding to protect the entertainer's incentive in order to encourage the production of this type of work.

The high court also wrote:

> The protection [afforded by state right of publicity laws] provides an economic incentive for him to make the investment required to produce a performance of interest to the public. The same consideration underlies the patent and copyright laws.

Zacchini was not an ordinary right of publicity case. The television station had appropriated the cannonball's entire act, a version of common law copyright violation. Nonetheless, two principles enunciated in *Zacchini* remain useful:

1) state law may validly safeguard forms of intellectual property not covered under federal copyright and patent law as a means of protecting the fruits of a performing artist's labor; and

2) the state's interest in preventing the outright misappropriation of such intellectual property by others is not automatically trumped by the interest in free expression or dissemination of information; rather, as in the case of defamation, the state law interest and the interest in free expression must be balanced, according to the relative importance of the interests at stake.

The Mechanics of Right of Publicity Lawsuits

When it comes to the right of publicity, no case better exemplifies the complex nature of the claim than the 2001 California Supreme Court decision *Comedy III Productions v. Gary Saderup, et al.*[1]

The precedent-setting decision involved the images of three icons of Old Hollywood—Larry, Moe and Curly. The Three Stooges.

Reselling vintage Hollywood is big business…and big trouble for people who think they can make some quick money selling clothes, posters or other items that include pictures, words or other things associated with vintage (read: dead) characters or actors.

But **using a celebrity's image for commercial purposes without permission** is risky—especially in California, where right to publicity laws are strong and regularly employed by the courts.

Gary Saderup, an artist with over 25 years of experience in making charcoal drawings of celebrities, created several original drawings of the Three Stooges. He then used these images in lithographic prints and silkscreened images on t-shirts.

[1] The case was one of the last decisions written by Stanley Mosk, the longest-serving judge in the history of the California State Supreme Court.

Without securing anyone's consent, Saderup sold the lithographs and t-shirts. These lithographs and t-shirts did not constitute an advertisement, endorsement or sponsorship of any product—they were sold in straight-forward commercial transactions.

Saderup's profits from the sale of the unlicensed lithographs and t-shirts were about $75,000 over the period of a few years.

Comedy III Productions was set up and run by Moe Howard's family to manage and control all intellectual property rights related to the Three Stooges (outside of the copyrights to their movies and short films, which remain the property of successors to the studios that produced them).

Comedy III was diligent about protecting the images and celebrity of the Three Stooges—the professional act made famous by Larry Fein, Moe Howard and Jerome "Curly" Howard. Repeatedly throughout the 1980s and 1990s, Comedy III sued companies that used the Stooges images or sayings without permission. In fact, it became one of the main advocates of publicity rights.

Along these same lines, Comedy III sued Gary Saderup.

The trial court found for Comedy III and entered judgment against Saderup awarding damages of $75,000…and attorneys' fees of $150,000. The court also issued a permanent injunction restraining Saderup from violating the statute by use of any likeness of the Three Stooges in lithographs, t-shirts, "or any other medium by which [Saderup's] art work may be sold or marketed." The injunction further prohibited Saderup from:

> Creating, producing, reproducing, copying, distributing, selling or exhibiting any lithographs, prints, posters, t-shirts, buttons or other goods, products or merchandise of any kind, bearing the photograph, image, face, symbols, trademarks, likeness, name, voice or signature of The Three Stooges or any of the individual members of The Three Stooges.

The sole exception to this broad prohibition was Saderup's original charcoal drawing from which the reproductions at issue were made.

The Value of a Good Idea

Saderup appealed. The appellate court modified the judgment by striking the injunction. It reasoned that Comedy III had not proved **a likelihood of continued violation** of the statute, and that the wording of the injunction was overbroad because it exceeded the terms of the statute and because it "could extend to matters and conduct protected by the First Amendment...."

Otherwise, the appellate court affirmed the judgment, upholding the award of damages, attorneys' fees and costs. It rejected Saderup's contentions that his conduct: 1) did not violate the terms of the statute; and 2) in any event was protected by the constitutional guaranty of freedom of speech.

The California Supreme Court granted review to address these two issues.

Saderup first argued that the California law creating a right to publicity applied only to uses of a deceased personality's name, voice, photograph, etc., for the purpose of advertising, selling or soliciting the purchase of, products or services.

He then stressed that his lithographs and t-shirts at issue in this case did not constitute an advertisement, endorsement or sponsorship of any product. He concluded the statute therefore did not apply.

The Supreme Court didn't agree.

It wrote that the right of publicity statute applied to any person who, without consent, uses a deceased personality's name, voice, photograph, etc., "in any manner, on or in products, merchandise, or goods, or for purposes of advertising, selling or soliciting purchases of, products, merchandise goods or services...."

The Supreme Court concluded:

> We agree with the Court of Appeal that Saderup sold more than just the incorporeal likeness of The Three Stooges. Saderup's lithographic prints of The Three Stooges are themselves tangible personal property, consisting of paper and ink, made as products to be sold and displayed on walls like similar graphic art. Saderup's t-shirts are likewise tangible personal property, consisting of fab-

ric and ink, made as products to be sold and worn on the body like similar garments.

By producing and selling such lithographs and t-shirts, Saderup had used the likeness of The Three Stooges on "products, merchandise or goods" within the meaning of the state law.

Saderup next argued that enforcement of the judgment against him violated his right of free speech and expression under the First Amendment.

This tension between the First Amendment and the right to publicity is a common one. The right of publicity is often invoked in the context of commercial speech when the appropriation of a celebrity likeness creates a false impression that the celebrity is endorsing a product. Because the **First Amendment does not protect misleading commercial speech**— and because even nonmisleading commercial speech is generally subject to somewhat lesser First Amendment protection—the right of publicity often trumps the right of advertisers to make use of celebrity figures.

But Saderup's work didn't concern commercial speech. His portraits of the Three Stooges were expressive works and not an advertisement for or endorsement of some other product.

The California high court found that Saderup's creations did not lose their constitutional protections because they were for purposes of entertaining rather than informing. And, nor did the fact that Saderup's art appeared in large part on t-shirts change that conclusion.

What decided the case was something different:

> The three comic characters [The Stooges] created and whose names they shared—Larry, Moe and Curly—possessed a kind of mythic status in our culture. In their arduous journey from ordinary vaudeville performers to the heights of slapstick comic celebrity, they created a distinct comedic trademark. It was through their talent and labor that constructed identifiable, recurrent comic personalities, which they then brought to the set.

The trial court, in ruling against Saderup, had stated that the commercial enterprise conducted by Saderup involved the sale of lithographs and t-

shirts which were not original single works of art and which were not protected by the First Amendment; the enterprise conducted by Saderup was a commercial enterprise designed to generate profits solely from the use of the likeness of the Three Stooges which were protected by the right of publicity.

The appeals court was more explicit in adopting this rationale. It concluded:

> Simply put, although the First Amendment protects speech that is sold, reproductions of an image, made to be sold for profit do not *per se* constitute speech.

The Supreme Court, however, found that this position had no basis in logic or authority. No one would claim, for example, that a published book, because it is one of many copies, receives less First Amendment protection than the original manuscript.

Because the California right to publicity law aims at preventing the illicit merchandising of celebrity images, and because single original works of fine art are not forms of merchandising, the Supreme Court said the state has little interest in preventing the exhibition and sale of such works—and the First Amendment rights of the artist should therefore prevail.

But, the California Supreme Court wrote:

> The inverse—that a reproduction receives no First Amendment protection—is patently false: a reproduction of a celebrity image that, as explained above, contains significant creative elements is entitled to as much First Amendment protection as an original work of art.

Last, Saderup argued that all portraiture involves creative decisions, that therefore no portrait portrays a mere literal likeness, and that accordingly all portraiture, including reproductions, is protected by the First Amendment.

The Supreme Court rejected any such categorical position. Without denying that all portraiture involves the making of artistic choices, the court

found it equally undeniable that when an artist's skill and talent is manifestly subordinated to the overall goal of creating a conventional portrait of a celebrity so as to commercially exploit his or her fame, then the artist's right of free expression is outweighed by the right of publicity.

In this case, the high court ruled:

> [Saderup's] undeniable skill was manifestly subordinated to the overall goal of creating literal, conventional depictions of The Three Stooges so as to exploit their fame.... We cannot perceive how the right of publicity would remain a viable right other than in cases of falsified celebrity endorsements.

Moreover, the marketability and economic value of Saderup's work derived primarily from the fame of the celebrities depicted. While that fact alone did not necessarily mean the work received no First Amendment protection, the court avoided that whole issue by ruling from the start that it "can perceive no transformative elements in Saderup's works that would require such protection.

Saderup further argued that it would be incongruous and unjust to protect parodies and other distortions of celebrity figures but not wholesome, reverential portraits of such celebrities. The court answered this argument:

> The test we articulate...does not express a value judgment or preference for one type of depiction over another. Rather, it reflects a recognition that the Legislature has granted to the heirs and assigns of celebrities the property right to exploit the celebrities' images—and that certain forms of expressive activity protected by the First Amendment fall outside the boundaries of that right.

Stated another way, the court was concerned not with whether conventional celebrity images should be produced but with who produces them and, more pertinently, who appropriates the value from their production. Thus, if Saderup wished to continue to depict the Three Stooges as he had done, he may do so only with the consent of the right of publicity holder.

The Value of a Good Idea

So, the $75,000 in damages was handed to Comedy III. Another small victory in its ongoing war against the wise guys who would moiderize intellectual property.

In conclusion, the court noted:

> Society may recognize, as the Legislature has done here, that a celebrity's heirs and assigns have a legitimate protectable interest in exploiting the value to be obtained from merchandising the celebrity's image, whether that interest be conceived as a kind of natural property right or as an incentive for encouraging creative work.

> Although critics have questioned whether the right of publicity truly serves any social purpose, there is no question that the Legislature has a rational basis for permitting celebrities and their heirs to control the commercial exploitation of the celebrity's likeness.

Right of Publicity vs. the First Amendment

As previously noted, California law grants the right of publicity to "successors in interest of deceased celebrities, prohibiting any other person from using a celebrity's name, voice, signature, photograph or likeness for commercial purposes" without the consent of those successors.

The United States Constitution prohibits the states from abridging, among other fundamental rights, freedom of speech.

These two laws come into conflict a lot.

The tension between the right of publicity and the First Amendment is highlighted by recalling the two distinct, commonly acknowledged purposes of the First Amendment:

1) "to preserve an uninhibited marketplace of ideas" and to repel efforts to limit the "uninhibited, robust and wide-open debate on public issues"; and

2)　to foster a "fundamental respect for individual development and self-realization. The right to self-expression is inherent in any political system which respects individual dignity."

The right of publicity has a potential for frustrating the fulfillment of both these purposes. Giving broad scope to the right of publicity has the potential of allowing a celebrity to accomplish through the vigorous exercise of that right the censorship of unflattering commentary that cannot be constitutionally accomplished through defamation actions.

Because celebrities take on public meaning, the appropriation of their likenesses may have important uses in uninhibited debate on public issues, particularly debates about culture and values. And because celebrities take on personal meanings to many individuals, the creative appropriation of celebrity images can be an important avenue of individual expression.

Most courts use some form of a "**balancing test" between the First Amendment and the right of publicity**, based on whether the work in question adds significant creative elements so as to be transformed into something more than a mere celebrity likeness or imitation.

In the 1981 New Jersey Federal Court decision *Estate of Presley v. Russen*, the court considered a New Jersey common law right of publicity claim by Elvis Presley's heirs against an impersonator who performed The Big El Show. The court implicitly used one such balancing test.

Acknowledging that the First Amendment protects entertainment speech, the court nonetheless rejected that constitutional defense:

> Entertainment that is merely a copy or imitation, even if skillfully and accurately carried out, does not really have its own creative component and does not have a significant value as pure entertainment.

As one authority has emphasized:

> The public interest in entertainment will support the sporadic, occasional and good-faith imitation of a famous person to achieve humor, to effect criticism or to season a particular episode, but it does not give a privilege to appropriate another's valuable at-

tributes on a continuing basis as one's own without the consent of the other.

Acknowledging also that the show had some informational value, preserving a live Elvis Presley act for posterity, the court nonetheless stated:

> This recognition that defendant's production has some value does not diminish our conclusion that the primary purpose of defendant's activity is to appropriate the commercial value of the likeness of Elvis Presley.

On the other side of the equation, the court recognized that the Elvis impersonation represented:

> what may be the strongest case for a right of publicity—involving, not the appropriation of an entertainer's reputation to enhance the attractiveness of a commercial product, but the appropriation of the very activity by which the entertainer acquired his reputation in the first place.

Thus, in balancing the considerable right of publicity interests with the minimal expressive or informational value of the speech in question, the *Estate of Presley* court concluded that the Presley estate's request for injunctive relief would likely prevail on the merits.

It is admittedly not a simple matter to develop a test that will unerringly distinguish between forms of artistic expression protected by the First Amendment and those that must give way to the right of publicity. Certainly, any such test must incorporate the principle that the right of publicity cannot, consistent with the First Amendment, be a right to control the celebrity's image by censoring disagreeable portrayals.

Once the celebrity thrusts himself or herself forward into the limelight, the First Amendment dictates that the right to comment on, parody, lampoon and make other expressive uses of the celebrity image must be given broad scope.

The necessary implication of this observation is that the right of publicity is essentially an economic right. What the right of publicity holder possesses

is not a right of censorship, but a right to prevent others from misappropriating the economic value generated by the celebrity's fame through the merchandising of the name, voice, signature, photograph or likeness of the celebrity.

The inquiry into whether a work is "**transformative**" appears to be necessarily at the heart of any judicial attempt to square the right of publicity with the First Amendment. As the above quotation suggests, both the First Amendment and copyright law have a common goal of encouragement of free expression and creativity, the former by protecting such expression from government interference, the latter by protecting the creative fruits of intellectual and artistic labor.

The transformative elements or creative contributions that require First Amendment protection are not confined to parody and can take many forms, from factual reporting to fictionalized portrayal, from heavy-handed lampooning to subtle social criticism.

In determining whether the work is transformative, courts aren't concerned with the quality of the artistic contribution—vulgar forms of expression fully qualify for First Amendment protection.

On the other hand, a literal depiction of a celebrity, even if accomplished with great skill, may still be subject to a right of publicity challenge. The inquiry is in a sense more quantitative than qualitative, asking whether the literal and imitative or the creative elements predominate in the work.

> When artistic expression takes the form of a literal depiction or imitation of a celebrity for commercial gain, directly trespassing on the right of publicity without adding significant expression beyond that trespass, the state law interest in protecting the fruits of artistic labor outweighs the expressive interests of the imitative artist.

The Value of a Good Idea

Another way of stating the inquiry is whether the celebrity likeness is one of the "raw materials" from which an original work is synthesized, or whether the depiction or imitation of the celebrity is the very sum and substance of the work in question.

In other words, when an artist is faced with a right of publicity challenge to his or her work, he or she may raise as affirmative defense that the work is protected by the First Amendment inasmuch as it contains significant transformative elements or that the value of the work does not derive primarily from the celebrity's fame.

Some reproductions of celebrity portraits are protected by the First Amendment. The silkscreens of Andy Warhol, for example, have as their subjects the images of such celebrities as Marilyn Monroe, Elizabeth Taylor and Elvis Presley. Through distortion and the careful manipulation of context, Warhol was able to convey a message that went beyond the commercial exploitation of celebrity images and became a form of ironic social comment on the dehumanization of celebrity itself.

Such expression may well be entitled to First Amendment protection. Although the distinction between protected and unprotected expression will sometimes be subtle, it is no more so than other distinctions courts are called on to make in First Amendment disputes.

Probably the most cited precedent case in the publicity-versus-First Amendment debate is the 1986 federal appeals court decision *Baltimore Orioles v. Major League Baseball Players Assn.* In that decision, the Seventh Circuit Court of Appeals ruled that the Copyright Act preempted baseball players' rights of publicity in their performances.

The court's conclusion turned on its controversial decision that performances in a baseball game were within the subject matter of copyright because the videotape of the game fixed the players' performances in tangible form.

Baltimore Orioles conceded that some form of the right of publicity is not preempted by the Copyright Act, e.g., where a company, without the player's consent, used his name to advertise its product or placed the player's photograph on a trading card.

The court disagreed, however, with the premise that a public figure's persona is not copyrightable because it cannot be fixed in a tangible medium of expression.

The court stated that:

> Because a performance is fixed in tangible form when it is recorded, a right of publicity in a performance that has been reduced to tangible form is subject to preemption.

Baltimore Orioles held that the baseball clubs—not the players—own the rights to baseball telecasts under copyright law, and the players can't use their state law right of publicity to veto the telecast of their performance. This was so even though the telecast (obviously) used the players' identities and likenesses.

The Seventh Circuit acknowledged that the state law right of publicity gave the players a property interest in their actual performances but held that this right could not trump the club's right under the Copyright Act to control the telecast. The Seventh Circuit recognized, as the panel here does not, that the players and the clubs were fighting over the same bundle of intellectual property rights:

> In this litigation, the Players have attempted to obtain ex post what they did not negotiate ex ante. That is to say, they seek a judicial declaration that they possess a right—the right to control the telecasts of major league baseball games—that they could not procure in bargaining with the Clubs.

The club owned both the right to sell tickets to see the games and the copyright to the telecast. The copyright preempted whatever state law rights the players claimed, at least insofar as state law would prevent ordinary use of the copyrighted work.

The decision, however, has been heavily criticized for holding that a baseball game is a protectable work of authorship simply because the performance was recorded on videotape that was itself copyrightable.

Likenesses, Names and Personas

As we've noted before, intellectual property rights—including rights of publicity—are based on the issue of control. Does a person have the right to control his or her name and likeness? On a practical level, this control usually comes down to exclusion. What can a person prohibit other people from doing with his or her likeness?

In a relevant case, a group of Texas musicians whose music had been sold and resold by several record companies made a right of publicity claim to separate their names and likenesses from the music. They based their claims on the state of Texas' right to publicity law, which treats violations of the right as "torts of misappropriation."

In the February 2000 Federal Appeals Court decision *Leonard Brown, et al. v. Roy C. Ames, et al.*, the musicians sued a record company for copyright infringement and misappropriation of their names and likenesses—and won.

Jerry and Nina Greene owned the Texas-based record company Collectibles, which specialized in repackaging vintage recordings.

Roy Ames, an independent music producer, specialized in Texas blues. Around 1990, Ames—who also operated as Home Cooking Records— licensed to Collectibles several master recordings that included performances by a number of veteran Texas bluesmen. (Leonard Brown, who would eventually lead the lawsuit, was one of this number.)

The license agreements between Collectibles and Ames gave Collectibles the right to use the names, photographs, likenesses and biographical material of the musicians whose performances were on the master recordings. Ames told Collectibles that he was entitled to convey these rights.

Using the master recordings, Collectibles manufactured and distributed cassettes and CDs, as well as music catalogs, with the names and sometimes the likenesses of the performers on or in them. While the records weren't Top 40 material, they sold reasonably well.

So well, in fact, that Ames set up a side business selling posters, t-shirts and other merchandise featuring the musicians. (By all accounts, Collectibles did not participate in this side venture.)

The musicians were frustrated that they weren't getting any of the money from the sales of the CDs and other stuff. They'd sold their rights in the music to Ames (or other producers from whom Ames had later purchased them); those deals were pretty solid. But their names and likenesses were another matter.

In 1994, the musicians sued Ames, Collectibles and Jerry and Nina Greene for copyright infringement, violations of the Lanham Act and for misappropriation of name or likeness under Texas state law. Ames and Collectibles tried to get the claims dismissed, but the Texas courts allowed the case to go to a jury trial.

The trial court eventually released Jerry and Nina Greene—as individuals—from the case; but their company was still a defendant. The jury found in favor of the record companies on the Lanham Act claims.

But the musicians won on several other claims.

In Texas, the tort of misappropriation provides protection from the unauthorized appropriation of one's name, image or likeness. To prevail, a property owner must prove that:

1) the [infringer] misappropriated the property owner's name or likeness for the value associated with it and not in an incidental manner or for a newsworthy purpose;

2) the property owner can be identified from the publication; and

3) the infringer derived some advantage or benefit.

The **tort for misappropriation of name or likeness** protects "the interest of the individual in the exclusive use of his own identity, in so far as it is represented by his name or likeness, and in so far as the use may be of benefit to him or to others."

The Value of a Good Idea

In other words, the tort of misappropriation of name or likeness protects a person's **persona**. A persona does not fall within the subject matter of copyright—it does not consist of a "writing" of an "author" within the meaning of the Copyright Clause of the Constitution.

The jury found that Ames and Collectibles had misappropriated the names and likenesses of the musicians and had infringed some of their copyrights. The jury awarded the musicians misappropriation damages of $127,000—$100,000 from Ames and $27,000 from Collectibles. In its final judgment, the court added damages of $27,000 against Ames and $1,800 against Collectibles. So, the total award to the musicians was over $155,000.

Collectibles and Ames appealed on several grounds, including:

1) that the Copyright Act preempted the misappropriation claims;

2) that the trial court should have enforced a separate—and broader—recording agreement between Ames and one of the musicians, Weldon Bonner;

3) that the district court improperly awarded a copyright to Leonard Brown for "Ain't Got Much" for a song that his wife had written; and

4) that the musicians did not present legally sufficient evidence to support the misappropriation damages award.

This was a typical appeal, mixing broad challenges with very specific corrections. The record companies argued that the trial court's ruling undermined the copyright system. The appeals court didn't agree. It held:

> The right of publicity that the misappropriation tort protects promotes the major objective of the Copyright Act—to support and encourage artistic and scientific endeavors.

The appeals court admitted that the right of publicity "ordinarily" allows an authorized publisher to use a name or likeness to identify the creator of the property. But that right didn't extend to posters and coffee mugs.

According to the appeals court, the contracts that most of the musicians had signed did not give permission to the record companies to market

their names or photographs. And they certainly didn't give Ames permission to market posters of the musicians.

Collectibles argued that the evidence was too speculative to support the damages verdict the jury had awarded the musicians. However, the court found that the damages were reasonable—based on fees the musicians were paid to perform at blues festivals and other gigs.

With regard to the separate contract that Ames said he'd signed with one of the musicians, the jury had found the document to be invalid. This came after the musician's daughter testified that the signature on the contract was forged. The appeals court saw no reason to overturn this conclusion.

With regard to the claim that Leonard Brown's wife had written the lyrics to one of his recordings, the court noted that the record companies hadn't brought it up at trial—so it refused to consider it on appeal.

So, in the end, the musicians won. They had a right to publicity…and a right to control their own name and likeness.

The Troubling Direction of Publicity Cases

Perhaps the largest right to publicity case in recent history involves characters from a popular television show, the actors who played them, a string of airport bars…and almost 10 years of litigation.

Most important: The case also shows how troubling the expansion of right of publicity claims can be for the development of intellectual property.

The next time you're in an airport and come across a Cheers bar, take a peek inside and see if you find any robotic replicas of Norm and Cliff, the chubby accountant and the dweeby mailman who were staples of the long-running TV comedy. The robots caused a lot of legal pondering about the limits of right of publicity claims.

At the center of the group of lawsuits usually referred to as *George Wendt, et al. v. Host International* was the question of whether the bars could use the characters without permission from the actors who'd played them. The case bounced around federal trial courts and appeals courts, finally

ending up at the U.S. Supreme Court—which only batted it back to trial again.

When *Cheers* ended its production run in 1993, Host International decided to tap the show's keg of goodwill by developing a chain of airport bars that replicated the bar that the show had made famous. Host negotiated a license agreement with Paramount Studios—which owns the copyrights to the show and its characters. To help get patrons into a *Cheers* mood, Host populated the bars with animatronic figures resembling Norm and Cliff: One was heavy-set; the other was dressed as a mailman.

These robots were life-size stuffed dolls that moved a little and spoke in prerecorded quips.

After learning that the actors would not agree to the use of their likenesses, Host altered the robots cosmetically and renamed them "Hank" and "Bob"—but refused to recast them into a "friendly neighborhood couple," as they were advised to do by Paramount.

The name change actually ended up backfiring. The actors conceded that they retained no rights to the characters Norm and Cliff; they argued that the figures, named "Bob" and "Hank," were not related to Paramount's copyright of the creative elements of the characters Norm and Cliff, and that it was the physical likeness to George Wendt and John Ratzenberger, not Paramount's characters, that had commercial value to Host.

Wendt and Ratzenberger, the only actors who ever portrayed Norm and Cliff, sued Host for **unfair competition** and **violation of their right of publicity**.

Paramount intervened, siding with Host and claiming that its copyright preempted any claim Wendt and Ratzenberger might have. A federal trial court agreed—in part because it found that the robots didn't look like the plaintiffs:

> There is [no] similarity at all... except that one of the robots, like one of the plaintiffs, is heavier than the other.... The facial features are totally different.

The actors appealed. And the appeals court agreed with them and sent the case back to trial.

This time, the trial court ruled for the actors, concluding that:

1) the actors had a statutory and common law right of publicity, which was violated; and

2) there was legitimate confusion created as to whether these actors endorsed the robots and, in turn, the bars.

Indeed, the matter of confusion is critical in celebrity endorsement disputes. In order to determine whether or not such confusion is likely to occur, federal courts have developed an eight factor test to be applied to celebrity endorsement cases. This test requires the consideration of:

1) the strength of the plaintiff's mark (In a case involving confusion over endorsement by a celebrity plaintiff, "mark" means the celebrity's persona and the "strength" of a mark refers to the level of recognition the celebrity enjoys.);

2) relatedness of the goods;

3) similarity of the marks;

4) evidence of actual confusion;

5) marketing channels used;

6) likely degree of purchaser care;

7) defendant's intent in selecting the mark; and

8) likelihood of expansion of the product lines.

The court used this test to determine that confusion did exist—that people might think Wendt and Ratzenberger had endorsed the Host bars.

Host appealed this decision...and the case worked its way up to the U.S. Supreme Court.

The high court focused the dispute on issues between Paramount—now allied with Host—and Wendt and Ratzenberger. It was a conflict between a copyright owner and contractors who'd helped develop the copyrighted work (though they helped in a way that placed them firmly in the public's

eye). Host and Paramount asserted their right under the Copyright Act to present the *Cheers* characters in airport bars; Wendt and Ratzenberger asserted their right under California law to control the exploitation of their likenesses.

To millions of viewers, Wendt and Ratzenberger were Norm and Cliff; and, the Supreme Court found it impossible to exploit the latter without also evoking thoughts about the former.

But did that mean that their right to publicity trumped Paramount's copyright?

The high court suggested that Paramount's copyright to *Cheers* carried with it the right to make derivative works based on its characters. The presentation of the robots in the Cheers bars was a derivative work—just like a doll, poster, board game or dramatic rendering of a scene from an episode. Thus, under federal law, Host—under its license with Paramount—had the right to present robots that resembled Norm and Cliff.

This would imply that the actors' right to control the use of their likeness was preempted by Paramount's right to exploit the Norm and Cliff characters however it saw fit. And that, if Wendt and Ratzenberger wanted to control how the *Cheers* characters were portrayed, they should have negotiated for that right beforehand.

But the Supreme Court sent the case back to trial…again…without ruling decisively.

The court referred to other cases involving the right to publicity—and specifically to *White v. Samsung*, the Ninth Circuit's July 1992 appeals decision in which TV game show hostess Vanna White won a lawsuit against the Korean electronics giant for using a robot bearing a likeness to White in one of its ads. Even though the robot looked nothing like her, a jury still awarded her $400,000.

The *White* decision remains highly controversial. It expanded—some say "exploded"—the right of publicity to include anything that brings the celebrity to mind. It's inevitable that so broad and ill-defined a property right will encroach on the rights of the copyright holder. Extending the logic of

the *White* decision, copyright holders will seldom be able to avoid trial when sued for infringement of the right to publicity.

In a dissent to one of the rulings in favor of Wendt and Ratzenberger, one federal appeals judge summed up the criticism of the direction that right of publicity cases are heading:

> Can Warner Brothers exploit Rhett Butler without also reminding people of Clark Gable? Can Paramount cast Shelley Long in *The Brady Bunch Movie* without creating a triable issue of fact as to whether it is treading on Florence Henderson's right of publicity? How about Dracula and Bela Lugosi? Ripley and Sigourney Weaver? Kramer and Michael Richards? When portraying a character who was portrayed by an actor, it is impossible to recreate the character without evoking the image of the actor in the minds of viewers.

> *Cheers* may not have the social impact of *Hair*, but it's a literary work nonetheless, worthy of the highest First Amendment protection from intrusive state laws like California's right of publicity statute.... Host did not plaster Wendt's face on a billboard with a Budweiser logo. It cashed in on the *Cheers* goodwill by creatively putting its familiar mise-en-scene to work. The robots [were] a new derivation of a copyrighted work, not unlike a TV series based on a movie or a Broadway play based on a novel. The novelty of using animatronic figures based on TV characters ought to prick up our ears to First Amendment concerns. Instead we again let the right of publicity snuff out creativity.

In June 2001, Wendt and Ratzenberger settled the dispute with Host, though both sides refused to disclose exactly what they agreed upon. To find out, consult your local Cheers bar the next time your en route to some destination. (Hint: Las Vegas, Cleveland and Kansas City airports.)

Unfortunately, the case didn't definitively answer the question of whether a copyright trumps a right to publicity. That's a dispute that will remain open for some time.

Conclusion

Closely linked to a person's right of publicity and right of privacy is a person's right to maintain a reputation. This is particularly the case when it comes to a famous person's personality. Although Wendt and Ratzenberger argued primarily over their right of publicity, surely they worried about the damage the robots caused to their reputation—and maybe even their characters' reputation.

When it comes to damages to reputation, it often involves public personalities and personas, as we'll see in the next chapter.

CHAPTER 15: DAMAGES TO REPUTATION

Celebrities or "**widely known**" persons create a value, or reputation, in their name and appearance just as businesses create a value or reputation in their name and products. Reputation as a property or asset separate and in addition to rights of publicity or privacy is an important—and complex—aspect of intellectual property law.

Some state laws provide for a right of action to "any person whose name…is used without first obtaining the written consent of such person…for advertising purposes or for the purposes of trade."

In most cases, the **unauthorized use of a person's image**, including photographs, video, film or images of a widely known person's likeness or recordings of a person's voice, as an integral part of advertising matter will land you in court. Today, even the unauthorized use of a person's name in a commercial Internet address is grounds for action. It's the logical progression resulting from the evolution of technology—the application of a well-established statutory right of action in a new context.

But in a time where people rarely use their full names even in formal legal documents, business letters and Internet addresses, opting to use a nickname or initials to identify themselves, these permutations muddy the waters of intellectual property rights.

Businesses—and individuals—need to be aware of how close their use of a celebrity's image is coming to commercial use.

The right of publicity statute, which we discuss in greater detail in Chapter 14, is found in only about half of the 50 states. These laws vary from state to state, and in some they are common law while in others they are statutes. In California, for example, there is both a statute and a common law…but there is no federal law for right of publicity.

The statutory right originated in Civil Code section 3344, enacted in 1971, authorizes recovery of damages by any living person whose name, photograph or likeness has been used for commercial purposes without his or her consent. Specifically, the statute makes liable any person who uses another's identity "in any manner, for purposes of advertising products, merchandise, good or services, or for purposes of solicitation of" such purchases.

Furthermore, the state governs the right of publicity for dead people under California Civil Code Section 990-998. This means your chart topping single won't wind up in a Purina Dog chow commercial long after you're dead and buried. That is, unless you have a weakness for singing Saint Bernards.

The International Trademark Association also hopes to include statutory postmortem protection in federal trademark law.

Nevada's law, however, allows "an attempt to portray, imitate, simulate or impersonate a person in a live performance" without permission.

Use of a Name and Voice Misappropriation

Despite a particular state's take on the law, like trademark holders, celebrities have a "reasonable interest" in having their work product properly identified with their name. And, if a company uses **images of a person or a person's likeness or recordings of a person's voice**, without his or her permission, it often leads to claims of damage to reputation.

Tom Waits, for example, is best known for his bluesy, raspy voice that has gathered critical acclaim in the music industry. Since the early seventies, Waits has generated loyal fans around the world, many of who would recognize his style in the flash of a single tune. Although he's been seen in

various movies (e.g. R.M. Renfield in Coppola's *Dracula*) and has composed soundtracks (e.g. *Dead Man Walking* and *The End of Violence*), he is best known for his Grammy-winning singing career. He has recorded more than 17 albums and has played to sold-out audiences in the U.S., Canada, Europe, Japan and Australia. And, like Better Midler, his voice is arguably a bankable asset. When a company imitated his unique voice for a radio commercial, Waits sued for big bucks…and won.

Tom Waits's professional achievements included both commercial and critical success. In 1987, Waits received *Rolling Stone* magazine's Critic's Award for Best Live Performance, chosen over other noted performers such as Bruce Springsteen, U2, David Bowie and Madonna. *SPIN* magazine listed him in its March 1990 issue as one of the 10 most interesting recording artists of the last five years. Waits appeared and performed on such television programs as *Saturday Night Live* and *Late Night with David Letterman*, and has been the subject of numerous magazine and newspaper articles appearing in such publications as *Time*, *Newsweek*, and the *Wall Street Journal*.

One thing Tom Waits did not do, however, was commercials. Instead, he rejected numerous lucrative offers to endorse major products and made his is anti-commercial policy public by expressing his views in magazine, radio and newspaper interviews. It is his philosophy that musical artists should not do commercials because it detracts from their artistic integrity, ruining their reputation.

The bad guys in this case were Frito-Lay and its advertising agency, Tracy-Locke. In developing an advertising campaign to introduce Frito-Lay's new "SalsaRio Doritos," Tracy-Locke found inspiration in a 1976 Waits song, "Step Right Up."

Ironically, the song was a parody on commercialism and consisted of a succession of humorous ad pitches. Waits even characterized the song as an indictment of advertising. It ended with the line, "What the large print giveth, the small print taketh away."

The commercial the ad agency wrote echoed the rhyming word play of the Waits song. In its presentation of the script to Frito-Lay, Tracy-Locke

had the copywriter sing a preliminary rendition of the commercial and then played Waits's recorded rendition of "Step Right Up" to demonstrate the feeling the commercial would capture. Frito-Lay approved the overall concept and the script.

In order to find a singer who could imitate Waits's gravelly voice, the ad agency auditioned a number of people before coming across Stephen Carter. Although the commercial's musical director warned Carter that he probably wouldn't get the job because he sounded too much like Waits (which could pose legal problems), Carter got the job.

At the recording session for the commercial, David Brenner, Tracy-Locke's executive producer, became concerned about the legal implications of Carter's skill in imitating Waits, and attempted to get Carter to "back off" his Waits imitation. Neither the client nor the members of the creative team, however, liked the result. After the session, Carter remarked to Brenner that Waits would be unhappy with the commercial because of his publicly avowed policy against doing commercial endorsements and his disapproval of artists who did. Brenner acknowledged he was aware of this, telling Carter that he had previously approached Waits to do a Diet Coke commercial and "you never heard anybody say no so fast in your life."

Brenner conveyed to Robert Grossman, Tracy-Locke's managing vice president and the executive on the Frito-Lay account, his concerns that the commercial was too close to Waits's voice. As a precaution, Brenner made an alternate version of the commercial with another singer.

On the day the commercial was due for release, Grossman phoned Tracy-Locke's attorney, asking him whether there would be legal problems with a commercial that sought to capture the same feeling as Waits's music. The attorney noted that there was a "high profile" risk of a lawsuit in view of recent case law recognizing the protectability of a distinctive voice.

Based on what Grossman had told him, however, the attorney did not think such a suit would have merit, because a singer's style of music is not protected. Grossman then presented both the Carter tape and the alternate version to Frito-Lay, noting the legal risks involved in the Carter

version. He recommended the Carter version, however, and noted that Tracy-Locke would indemnify Frito-Lay in the event of a lawsuit. Frito-Lay chose the Carter version.

The commercial aired in September and October 1988 on over 250 radio stations located in 61 markets nationwide, including Los Angeles, San Francisco and Chicago. Waits heard it during his appearance on a Los Angeles radio program, and was shocked. He realized "immediately that whoever was going to hear this and obviously identify the voice would also identify that [Tom Waits] in fact had agreed to do a commercial for Doritos."

In November 1988, Waits sued Tracy-Locke and Frito-Lay, alleging claims of misappropriation under California law and false endorsement under the Lanham Act. The case was tried before a jury in April and May 1990. The jury found in Waits's favor, awarding him $375,000 compensatory damages and $2 million punitive damages for voice misappropriation, and $100,000 damages for violation of the Lanham Act. The court also awarded Waits attorneys' fees under the Lanham Act.

Infringement of Voice

On appeal, the defendants argued that voice misappropriation was preempted by the Copyright Act, which states that because **a voice is not "fixed" and not "tangible,"** it cannot be protected under the Copyright Act. The judges, however, contended that:

> [Wait's claim] is for infringement of voice, not for infringement of a copyrightable subject such as sound recording or musical composition. Moreover, the legislative history…indicates the express intent of Congress that "[t]he evolving common law rights of "privacy," "publicity" and trade secrets… remain unaffected [by the preemption provision] as long as the causes of action contain elements, such as an invasion of personal rights…that are different in kind from copyright infringement." Waits's voice misappropriation claim is one for invasion of a personal property right: his right

of publicity to control the use of his identity as embodied in his voice.

Voice vs. Style

The trial focused on the elements of voice misappropriation—whether the defendants deliberately imitated Waits's "voice" rather than simply his "style" and whether Waits's voice was sufficiently distinctive and widely known to give him a protectable right in its use. The court did not consider these elements the same as those in a copyright infringement case challenging the unauthorized use of song or recording. Waits's voice misappropriation claim, therefore, was not preempted by federal copyright law.

The defendants argued that, although they had consciously copied Tom Waits's style in creating the commercial, they had not deliberately imitated his voice. They tried to show a difference between a voice and a style.

The district court rejected this argument. Instead, the court instructed the jury to decide whether Waits's voice was distinctive, whether his voice was widely known, and whether the defendants had deliberately imitated his voice. The defendants didn't like this instruction, and proceeded to argue on trivial points such as the court's definition of *distinctive*, *widely known* and *imitating*. This, of course, was a boondoggle for the defendants…and they ultimately lost their appeal.

The jury awarded Waits the following compensatory damages for voice misappropriation: $100,000 for the fair market value of his services; $200,000 for injury to his peace, happiness and feelings; and $75,000 for injury to his goodwill, professional standing and future publicity value.

The defendants contested the latter two awards, disputing both the availability of such damages in a voice misappropriation action and the sufficiency of the evidence supporting the awards. In response to this contest, the court said: "[I]t is quite possible that the appropriation of the identity of a celebrity may induce humiliation, embarrassment and mental distress." (Not to mention the fact that they had ruined his running reputation as a noncommercial artist.)

Waits testified that when he heard the ad, he was shocked and very angry. These feelings "grew and grew over a period of a couple of days" because of his strong public opposition to doing commercials.

Added to his shock, anger and embarrassment was the strong inference that, because of his outspoken public stance against doing commercial endorsements, the Doritos commercial humiliated Waits by making him an apparent hypocrite. This evidence was sufficient both to allow the jury to consider mental distress damages and to support their eventual award.

The jury awarded Waits a total of $2 million in punitive damages for voice misappropriation: $1.5 million against Tracy-Locke and $500,000 against Frito-Lay. Although punitive damages are not usually available in cases of first impression, the right of a well-known professional singer to control the commercial use of a distinctive voice was not an issue of first impression in this case. The right had been established clearly in *Midler v. Ford*. Briefly, *Midler* declared that "[w]hen voice is a sufficient indicia of a celebrity's identity, the right of publicity protects against its imitation for commercial purposes without the celebrity's consent."

But Tracy-Locke was familiar with the *Midler* decision. In other words, the ad agency couldn't play dumb and ignorant—or it just didn't interpret *Midler* right. It made a conscious decision to broadcast a vocal performance imitating Waits in markets across the country.

So, Waits got his reward. The snack manufacturer and the ad agency had to dish out a healthy sum of money for playing Russian Roulette.

False Association and False Advertising

The purposes of the Lanham Act, two of which are relevant to this chapter, are: to make "actionable the **deceptive and misleading use of marks in…commerce**" and "to protect persons engaged in…commerce against unfair competition."

Section 43(a) of the Act provides two bases of liability:

1) false representations concerning the origin, association or endorsement of goods or services through the wrongful use of

another's distinctive mark, name, trade dress or other device (false association); and

2) false representations in advertising concerning the qualities of goods or services (false advertising).

A false endorsement claim based on the unauthorized use of a celebrity's identity is a type of false association claim. This type of claim alleges the misuse of a trademark, i.e., a symbol or device such as a visual likeness, vocal imitation or other uniquely distinguishing characteristic, which is likely to confuse consumers as to a person's sponsorship or approval of the product.

So, standing, as we mentioned earlier, therefore, does not require "actual competition"; it extends to a purported endorser who has an economic interest akin to that of a trademark holder in controling the commercial exploitation of his or her identity.

Moreover, **the wrongful appropriator is in a sense a competitor of the celebrity**, even when the celebrity has chosen to disassociate himself or herself from advertising or endorsing products. They compete with respect to the use of the celebrity's name or identity. They are both utilizing or marketing that personal property for commercial purposes, affecting the person's reputation.

Interpreting the Midler Standard

How do you determine if someone is "widely known"?

Some argue that the term widely known in and of itself is too vague to guide a jury in making a factual determination of the issue.

A professional singer's voice is widely known if he or she is known to a large number of people throughout a relatively large geographic area.

If this were the case, Tom Waits, or any other minor celebrity that has yet to achieve the status of superstardom, could be viewed by some as a singer known only to music insiders and to a small but loyal group of fans. This would mean that singers aren't widely known if they are only recognized by their own fans, or fans of a particular sort of music or a small segment of the population. And, because Waits has not achieved the level of celebrity Bette Midler has, they would argue, he is not well known under the Midler standard.

But the legal underpinnings of this proposed instruction are questionable because it excludes from legal protection the voices of many popular singers who fall short of superstardom. *Well known* is a relative term, and differences in the extent of celebrity are adequately reflected in the amount of damages recoverable.

According to *Waits*, in order to be liable for voice misappropriation, imitation must be so good that "people who were familiar with [the celebrity]'s voice who heard the commercial believed [the celebrity] performed it. In this connection it is not enough that they were reminded of [the celebrity] or thought the singer sounded like [the celebrity]... ."

A person's voice is **distinctive** "...if it is distinguishable from the voices of other singers...if it has particular qualities or characteristics that identify it with a particular singer."

Some have tried to argue that identifiability depends, not on distinctiveness, but on the listener's expectations; that distinctiveness and recognizability are not the same thing; and that recognizability is enhanced by style similarity. This argument that distinctiveness is a separate concept from

identifiability, while supported by some experts, has no basis in law. Rather, identifiability is properly considered in evaluating distinctiveness. In fact, it is a central element of a right of publicity claim.

Name Misappropriation and the Internet

So, what if you're not a singer, you're merely a minor-celebrity in the ranks of superstardom and someone's appropriated your name to endorse their services?

Section 43(a) provides, in part:

> Any person who shall affix, apply or annex, or use in connection with any goods or services…a false designation of origin, or any false designation or representation…shall be liable to a civil action…by any person who believes that he is or is likely to be damaged by the use of such false designation or representation.

> Courts have recognized false endorsement claims brought by plaintiffs, including celebrities, for the unauthorized imitation of their distinctive attributes, where those attributes amount to an unregistered commercial "trademark."

In *Crump v. D.J. Forbes*, another right of publicity case, a minor celebrity in the horse-racing world got worked over by an ex-business partner in a Web site development and promotional deal…and wound up fighting a legal battle over her own name.

Diane Crump was the first female to ride in the Kentucky Derby, and was thus an equestrian of national renown. Aside from her jockeying, however, she was a self-employed businesswoman with a horse brokerage and consulting firm. In the summer of 1998, she contracted with D.J. Forbes to create a Web site for the business; Forbes was to receive a 10 percent commission on all gross sales.

About a year later, after the Web site was up and running successfully, Forbes took the Web site address to his own competing business and did so without informing Crump. He basically dissented from Crump's busi-

ness but decided to pirate her name—and fame—for his own good. There-
after, all inquires using Crump's name were directed to Forbes's Web
site. Crump didn't find out about this theft until September 1999 and im-
mediately demanded that her name be removed from his site. Among her
demands was that Forbes cease using the name Crump and the Web
location comprised of the letter combination "dcrump" in any Internet ad-
vertising, promotion or Web address, or in any other medium.

When he refused to discontinue use of the letter combination, Crump filed
a lawsuit. (Instead, Forbes inserted a disclaimer stating that the site was
not affiliated with Diane Crump or her business.)

Although Forbes filed a motion to dismiss, the trial court allowed her claim
of misappropriation to go to trial. The following were her four counts
against Forbes:

1) a statutory right of action for the unauthorized use of her name;

2) a common law right of publicity action;

3) a conversion action; and

4) a quasi-contract action.

A Virginia code provided for a right of action to "any person whose
name…is used without first obtain[ing] the written consent of such
person…for advertising purposes or for the purposes of trade." The use
of dcrump to advertise Forbes's business was clearly a use for trade pur-
poses. But the court had to determine if dcrump constituted a name, be-
cause "[t]he unauthorized use of a person's name as an integral part of
advertising matter 'has almost uniformly been held actionable.'" On this
matter, the court held:

> While the use of a person's name in a commercial Internet ad-
> dress may not have been contemplated when the statute was en-
> acted, the statute's application to this situation is a logical pro-
> gression in its evolution in a changing world. It is simply the appli-
> cation of a well established statutory right in a new context.

Forbes used dcrump in commerce to promote his new and competing
horse brokering business. The only historical use of the name dcrump in

the horse brokering market was by the business in which Crump was engaged, and in which the clear intent was to trade on the fame associated with her name in horse circles.

Typically, the association of a name with a particular person in a specific context gives the name both its practical significance and determines the scope of its legal protection. But what happens when the Internet is involved?

The court acknowledged how names are regularly associated on the Internet:

> On the Internet today, persons regularly use their first initial and last name, as was done in this case to identify their internet address. In the instant case, the use of the name "dcrump" was clearly intended to be a name that would lead interested horse buyers to the defendant's Web page. In the context of a Web address, "dcrump" is a name. Since it was used to promote the defendant's business, its use without permission was prohibited by Virginia Code... .

Thus, Crump won on this count. Because no Virginia court had ever recognized a common law right of publicity, Crump cited cases from other jurisdictions and urged the court to "venture where no Virginia court has ever trod." The court, however, didn't want to trod. For various reasons, it dropped the right to publicity action as well as Crump's other counts. With regard to her invasion of property rights, the court said "the exclusive remedy for the invasion of the right and wrongful appropriation of the name in commerce is the statutory action."

In all, Crump won on her first, and most important count—the appropriation of her name. This case demonstrates that it's clearly wrong for someone to take a name and the fame, or reputation that goes with it, to another business for one's own pursuits and profit.

Celebrities like Tom Waits and Diane Crump, however, are not the only ones entitled to protection against damage to their reputation. Businesses,

as we mentioned earlier, can create a value or reputation in their name or products as well.

Take, for example, the 1989 Supreme Court case *Bonito Boats, Inc. v. Thunder Craft Boats*, which involved a Florida statute that gave perpetual patent-like protection to boat hull designs already on the market, a class of manufactured articles expressly excluded from federal patent protection. Although Bonito Boats ultimately lost the case (the high court ruled that the Florida statute was preempted by federal patent law because it directly conflicted with the comprehensive federal patent scheme), it won its battle on another front and brought its reputation as a manufacturer of boat hull designs one step closer to being afforded protection under state law.

In reaching its decision, the high court cited several earlier decisions, including *Sears Roebuck & Co. v. Stiffel Co.* (1964), and *Compco Corp. v. Day-Brite Lighting* (1964), for the proposition that "**publicly known design and utilitarian ideas** which were unprotected by patent occupied much the same position as the subject matter of an expired patent," i.e., they are expressly unprotected.

Thunder Craft Boats saw this as a reaffirmation of the sweeping preemption principles for which these cases were once read to stand.

Bonito Boats, however, saw it another way: It cautioned against reading *Sears* and *Compco* for a "broad preemptive principle." It also cited subsequent Supreme Court decisions retreating from such a sweeping interpretation, including one which stated that:

> The Patent and Copyright Clauses do not, by their own force or by negative implication, deprive the States of the power to adopt rules for the promotion of intellectual creation.

As a result, the high court reaffirmed the right of states to "place limited regulations on the use of unpatented designs in order to prevent consumer confusion as to source." *Bonito Boats*, thus cannot be read as endorsing or resurrecting a "broad preemptive principal."

Competitive Injury and False Representation

To have a valid reputation claim under the Lanham Act, a person does not need to be in actual competition with the alleged wrongdoer. Rather, the dispositive question in determining standing is whether a person or business for that matter "has a **reasonable interest to be protected against false advertising**."

On the other hand, in the 1987 Ninth Circuit Court of Appeals case *Halicki v. United Artists Communications, Inc.*, the court dismissed a movie producer's claim because he had failed to show "competitive injury." The producer had entered into a contract with a film distributor under which his movie would be advertised with a "PG" rating. But when the ad came out, it was labeled with an "R" rating, curtailing its market among young audiences. The most significant part of the complaint was that the ad misrepresented the film's content. The court rejected the producer's contention that to state a claim under the Lanham Act, all he need do was "show that the [film distributor] made a false representation about his film and that he was injured by the representation." Rather, he had to show that the type of injury he sustained is one the Lanham Act is intended to prevent.

An express purpose of the Lanham Act is to protect commercial parties against unfair competition. Thus, in order "[t]o be actionable, [the distributor's] conduct must not only be unfair but must in some discernible way be competitive," said the court.

So, the ad's misrepresentation, while possibly actionable as breach of contract, was not actionable under the Lanham Act inasmuch as the movie producer had not been injured by a competitor. This result accords with congressional intent, because if such a limitation were not in place the Lanham Act would become a "federal statute creating the tort of misrepresentation."

Implied Endorsement

A **musical composition cannot serve as a trademark** for itself. If a song could achieve the status of trademark for itself, it would stretch the definition of trademark too far and would cause disruptions as to reasonable commercial understandings.

For example, the 1970 Ninth Circuit Court of Appeals case *Sinatra v. Goodyear Tire & Rubber Co.* rejected a claim filed by singer Nancy Sinatra that the song she sang had been "...so popularized by [Sinatra] that her name is identified with it; that she is best known by her connection with the song [and] that said song...has acquired a secondary meaning" such that another person could not sing it in a commercial.

Some courts, however, have protected the "persona" of an artist against false implication of endorsement generally resulting from the use of look-alikes or sound-alikes.

As we mentioned earlier, singers aren't the only ones afforded protection under the Lanham Act. In addition to Waits's false implied endorsement claim for use in a snack-food commercial of a singer who imitated his singing style while praising Doritos's product, the Ninth Circuit has upheld other celebrities' claims involving reputation, among them:

- Vanna White's false implied endorsement claim brought after the hostess of the "Wheel of Fortune" game show's likeness was used on a look-alike caricature robot endorsing an advertisement for VCRs; and

- Woody Allen's claim of false implied endorsement for a look-alike used in an advertisement for a video-rental store.

Courts have also ruled that a musical work cannot serve as a trademark because the protection of a musical work "falls under the rubric of copyright, not trademark law."

However, the fact that a musical composition is protected by copyright law should not stand in the way of it also qualifying for protection as a trademark. Graphic designs are protected by copyright, too, but that does not make them ineligible for protection as trademarks.

The Value of a Good Idea

The Lanham Act defines a *trademark* as including:

> any word, name, symbol or device, or any combination thereof used by a person…to identify and distinguish his or her goods…from those manufactured or sold by others and to indicate the source of the goods.

A musical composition can serve as a **symbol or device to identify a person's goods or services**, just as a particular shape, sound or scent can identify goods or services. In fact, the 1995 Supreme Court decision *Qualitex Co. v. Jacobson Products Co.* even considered whether a color could serve as a mark. The court said it could, observing that the courts and the Patent and Trademark Office have authorized trademark protection for "a particular shape (of a Coca-Cola bottle), a particular sound (of NBC's three chimes) and even a particular scent (of plumeria blossoms on sewing thread)."

NBC's three chimes, which the Supreme Court referred to as "a particular sound" is of course not a single sound; it is three sounds, in a specified order, with a specified tempo, on a specified instrument—in short, a brief musical composition. For many decades it has been commonplace for merchandising companies to adopt songs, tunes and ditties as marks for their goods or services, played in commercials on the radio or television.

But what happens when an artist tries to protect his reputation through a trademark claim that involves a copyrighted work belonging to someone else? It doesn't work, but what might work is a right to publicity claim in state court.

Frito-Lay came to its defense again in another suit involving a recording artist who claimed the potato chip seller infringed the artist's trademark rights. It was the case known as *Astrud Gilberto v. Frito-Lay, Inc., et al.*

In 1964, Gilberto recorded "Ipanema" accompanied by Stan Getz, on saxophone, and her then-husband, Joao Gilberto, on the guitar. The 1964 recording became world famous.

Chapter 15: Damages to Reputation

In 1996, Frito-Lay began to market "Baked Lays" Potato Crisps, a low-fat baked potato chip. It introduced the product with a 30-second television advertisement created by its advertising agency, BBDO Worldwide, Inc. You may remember the ad: It showed several famous models reclining by a swimming pool, with "Ipanema" playing in the background. As the camera panned from one model to the next, each looked crestfallen that the bag of Baked Lays in her hands was empty. The camera moved on to Miss Piggy, also reclining by the pool, who had been eating the chips and passing the empty bags to the models, while singing along with the song.

A voice-over identified Baked Lays, and added, "With one and a half grams of fat per one ounce serving, you may be tempted to eat like a—"

"Don't even think about it!" Miss Piggy interrupted.

"Ipanema" was written by Vinicius de Moraes and Antonio Carlos Jobim. Jobim registered the composition with the U.S. Copyright Office in 1963, and renewed the registration in 1991. Norman Gimbel composed the English lyrics for the song and registered a U.S. copyright for them in 1963, renewing it in 1991.

The 1964 recording was made for the recording company Verve, which was, at the time of trial, a subsidiary of PolyGram Records, Inc. PolyGram Records claimed to own the master of the recording. It distributed the recording, along with Gilberto's rendition of several other popular songs, on various albums and CDs under the Verve Records label.

In order to use the recording in the Baked Lays commercial, BBDO purchased the synchronization rights from Duchess Music Corporation on behalf of Jobim and Gimbel Music Group on behalf of Gimbel. BBDO also purchased a license to use the master recording from PolyGram Records. It paid more than $200,000 for the licenses. Apparently believing that Gilberto had retained no rights in the recording, BBDO did not seek her authorization to use it in the ad.

Gilberto was not involved in the production of the 1964 recording other than as lead singer. She did not compose the music, write the lyrics or

produce the recording. In addition, she did not sign any contract or release with the recording company or the producers; and she was not employed by them.

Gilberto received a Grammy award for the recording, which immediately became a smash hit and launched a long career. She claimed that as the result of the huge success of the 1964 recording, and her frequent subsequent performances of "Ipanema," she became known as "The Girl from Ipanema" and was identified by the public with the 1964 recording.

Further, she claimed as a result to have earned trademark rights in the 1964 recording, which she contended the public recognized as a mark designating her as a singer. She contended, therefore, that Frito-Lay could not lawfully use the 1964 recording in an advertisement for its chips without her permission.

Gilberto filed a complaint for "**false implied endorsement**" under the Lanham Act, as well as five claims under New York law, including unfair competition and interference with her right of publicity. When the defendants moved to dismiss, the district court granted the motion as to the five state law claims but denied the motion as to the Lanham Act claim.

The court did not dismiss the Lanham Act claim because it was "not entirely implausible" that she could prove that the audience might interpret the inclusion of the 1964 recording in the ad as implying Gilberto's endorsement of Baked Lays—something she considered to tarnish her reputation. The claim for unfair competition was dismissed because the court said Gilberto failed to allege a property right in the recording.

In 1964, federal copyright law gave no protection to recorded performances; as for any common law rights Gilberto had possessed in the recording, the court concluded that she had relinquished them upon publication of the work. Noting, however, that by pleading exceptional circumstances, she might be able to overcome the presumption of relinquishment upon publication, the court granted her leave to replead the unfair competition claim.

As to the claim for interference with her right to publicity, the court dismissed on the ground that the statute applied only to the use of a name, portrait or picture, and Gilberto did not allege such a use.

Gilberto then failed to get the court to reconsider her unfair competition claim.

As to the right of publicity claim, however, the court noted that in 1995, the year before the defendants aired the commercial, New York's relevant law was amended to include not only unauthorized use of a name, portrait and picture, but also the unauthorized use of a person's voice. The court therefore allowed Gilberto to make a claim on the wrongful use of her voice, which she did. This time, however, the claim was framed in significantly broader terms—not merely for "false implied endorsement," but more generally, for "capitaliz[ing] on Plaintiff's valuable reputation and goodwill" in a way "likely to cause confusion or to deceive as to the affiliation, connection, association of Defendants with Plaintiff, or as to the sponsorship or approval of Defendants' goods by Plaintiff."

In addition, she raised one claim of trademark dilution and five state law claims, two of which were, once again, for unfair competition and violation of a civil rights law. The complaint also raised a new state law claim for unjust enrichment. And, when the defendants moved to dismiss, the court granted the motion.

It dismissed the dilution claim because in the court's view, "there is no Federal trademark protection for a musical work." As to the right of publicity claim, the court ruled that no valid claim was pleaded because an exception to liability arises when the plaintiff has "sold or disposed of the voice embodied in the production."

According to the court's reasoning, by recording "Ipanema" without a contract, Gilberto placed her recorded voice in the public domain, and had thus "disposed of" her rights in her recorded voice. The court dismissed the claims for unfair competition and unjust enrichment on the theory that both claims required Gilberto to plead a common law property right in the recording, and she had failed to do so.

The Value of a Good Idea

The defendants seemed to be winning up to this point. Now it came down to arguing over the Lanham Act. On February 10, 2000, the district court granted the defendants' motion and dismissed the entire case giving two reasons—first, that Gilberto lacked standing to raise a Lanham Act claim because "the record disclose[d] no competitive or commercial interest affected by the conduct complained of," and second, that "no reasonable jury could find for plaintiff on her claim of implied endorsement." Judgment was entered in favor of the defendants and Gilberto appealed.

On appeal, Gilberto challenged the dismissal of her claims…and lost. What the appeals process did clarify, however, was whether or not a musical composition can be protected under trademark law. The lower court had said no, but the appeals court reversed this conclusion and said:

> We can see no reason to doubt that such musical compositions serve as marks, protected as such by the Lanham Act. We do, however, affirm the district court's dismissal of the trademark infringement claim for a slightly different reason.

According to the court, the law did not accord her trademark rights in the recording of her signature performance. She failed to cite a single precedent throughout the history of trademark supporting the notion that a performing artist acquires a trademark or service mark signifying herself in a recording of her own famous performance. The "**signature performance**" that a widespread audience associates with the performing artist was not unique to Gilberto.

Although many famous artists have recorded such signature performances that their audiences identify with the performer, in no instance was such a performer held to own a protected mark in that recording.

The use of her recorded song did not take her persona, and she could not claim implied endorsement. The appeals court held:

> We cannot say it would be unthinkable for the trademark law to accord to a performing artist a trademark or service mark in her signature performance. If Congress were to consider whether to extend trademark protection to artists for their signature perfor-

mances, reasons might be found both for and against such an expansion.

In other words, for a court to suddenly recognize the previously unknown existence of such a right would be profoundly disruptive to commerce. That is, it would have opened a can of worms for numerous other lawsuits among other artists. The court could "see no justification for [sic] altering the commercial world's understanding of the scope of trademark rights in this fashion."

With regard to her claims to right of publicity, unfair competition and unjust enrichment, the appeals court vacated the lower court's dismissal of these state claims. It noted:

> [T]he admission that plaintiff recorded the song without a contract with the producers or the record company does not admit that at the time of recording, she had no beneficial contract rights with anyone securing some interest in her performance. Nor further does it admit that, having made the recording, she released it without contractual protections. A recording artist might record a song without a contract for many different reasons—to try out an arrangement or style, to try out a band or accompanist, to make a demo tape. The making of a recording does not constitute consent to the public release of the recording.

Furthermore, because the only claim justifying federal jurisdiction was dismissed, and because the state law claims presented issues of state law that were not clearly decided by the New York courts, the appeals court believed that supplemental jurisdiction was not appropriately exercised and that the district court should have dismissed the state law claims so as to allow Gilberto to replead them in the New York state courts.

She'd have to go back to court again.

Advertising Slogans and Common Use

Companies often come with advertising slogans and logos. Think of UPS's "Moving at the Speed of Business"; BMW's "The Ultimate Driving Ma-

chine"; and "AT&T's "Reach Out and Touch Someone." All of these catchy phrases aim to make consumers identify with a company; they are a way a company can employ the First Amendment and speak of themselves how they wish for their own benefit. Trademark issues arise all the time—particularly when one company thinks another has stolen its prized slogan.

Boston Beer Company, the brewers of Samuel Adams Beers, sought to register "The Best Beer in America" as its trademark. When the Patent and Trademark Office rejected its application, the company appealed. Again, the key question was **whether the term was too common to be registered**.

The challenge started on November 30, 1993, when Boston Beer filed an application to register the phrase on the principal register for "beverages, namely beer and ale." Boston Beer claimed to have used the mark since 1985 and that the words had acquired distinctiveness. With this mark, the company had annual advertising expenditures in excess of $10 million and annual sales of approximately $85 million. Specifically, Boston Beer spent about $2 million on promotions and promotional items that included the phrase "The Best Beer in America."

In support of its claims, the company's founder and co-president, James Koch, asserted that the words had developed a secondary meaning as a source indicator for its goods by virtue of extensive promotion and sales of beer under the mark since June 1985.

The company also submitted an advertisement for a competitor's product, Rolling Rock Bock beer, which included an invitation to sample "the beer that bested 'The Best Beer in America,'" as evidence that Rolling Rock regards "The Best Beer in America" as Boston Beer's trademark.

The proposed mark was rejected as being **merely descriptive**. It was also shown that several other beer companies had used the mark and that all of the beers mentioned had either won comparison competitions or had been touted as the best in America by their makers or others.

Boston Beer responded by submitting articles showing its use of the proposed mark to refer to its product and in promoting its beer as a winner of

the Great American Beer Festival, an annual competition in Denver. Additionally, it argued that if marks such as "Best Products" and "American Airlines" could be registered even though they were also used descriptively, then the proposed mark should be similarly registered. This didn't help, however, as the application for the mark was refused, namely because Boston Beer failed to establish that the mark had become distinctive.

Boston Beer appealed to no avail. The trademark office noted that the company sought to register the mark *after* it had received awards at the competition. An examining attorney on behalf of the trademark office determined that "The Best Beer in America" was "the name of a genus of goods, namely 'beers brewed in America that have won taste competitions or were judged best in taste tests.'" This attorney submitted evidence that Boston Beer had adopted the mark and put it on its Web site *after* it had won such competitions. The trademark office rejected the proposed mark as generic and thus incapable of registration.

Boston Beer wasn't happy about this rejection, and further argued on the genericness point. Boston Beer asserted that its proposed mark was not generic because there was no single category at the Great American Beer Festival and thus no "Best Beer in America" award. The trademark board still rejected this argument, albeit not on the "generic" comment. On the other hand, the board said that the proposed mark was merely descriptive, laudatory and "simply a claim of superiority, i.e., trade puffery."

The board held that the proposed mark inherently could not function as a trademark because such "claims of superiority should be freely available to all competitors in any given field to refer to their products or services." Finally, the board said that:

> Even if [it] were to find this expression to be capable of identifying applicant's beer and distinguishing it from beer made or sold by others, [the board] also would find, in view of the very high degree of descriptiveness which inheres in these words, that applicant has failed to establish secondary meaning in them as an identification of source.

A final appeal took place. Ruling on this case relied on whether the company, through its use of the term "The Best Beer in America," had acquired distinction. The appeals court said no and that Boston Beer had failed to show that the proposed mark has acquired secondary meaning.

Boston Beer did not dispute that its proposed mark was generally a **laudatory phrase**. And while the court acknowledged that some companies have successfully trademarked laudatory phrases, every case is different. In the words of the court:

> As in this case, a phrase or slogan can be so highly laudatory and descriptive as to be incapable of acquiring distinctiveness as a trademark. The proposed mark is a common, laudatory advertising phrase which is merely descriptive of Boston Beer's goods. Indeed, it is so highly laudatory and descriptive of the qualities of its product that the slogan does not and could not function as a trademark to distinguish Boston Beer's goods and serve as an indication of origin. The record shows that "The Best Beer in America" is a common phrase used descriptively by others before and concurrently with Boston Beer's use, and is nothing more than a claim of superiority.

Misappropriating a Likeness

Finally, we come to this last case that involved a famous character and one powerful actor. It was the case of *Dustin Hoffman v. Capital Cities/ABC, Inc. and Los Angeles Magazine, Inc.* and it centered around the 1982 movie *Tootsie*. Twenty years after the movie became a hit, a magazine tapped into its appeal by digitally altering a photograph of Hoffman's cross-dressing character. Hoffman never agreed to this idea and, when the magazine landed on the newsstands, he sued.

For those who don't remember *Tootsie* or didn't see it, Dustin Hoffman played a man who dresses as a woman to get a part on a television soap opera. One memorable still photograph from the movie showed Hoffman in character in a red long-sleeved sequined evening dress and high heels,

posing in front of an American flag. The still carried the text, "What do you get when you cross a hopelessly straight, starving actor with a dynamite red sequined dress? You get America's hottest new actress."

In March 1997, *Los Angeles Magazine* (LAM) published the "Fabulous Hollywood Issue!" An article from this issue used computer technology to alter famous film stills to make it appear that the actors were wearing Spring 1997 fashions. The 16 familiar scenes included movies and actors such as *North by Northwest* (Cary Grant), *Saturday Night Fever* (John Travolta) and *The Seven Year Itch* (Marilyn Monroe).

The final shot was the *Tootsie* still. The American flag and Hoffman's head remained as they appeared in the original, but Hoffman's body and his long-sleeved red sequined dress were replaced by the body of a male model in the same pose, wearing a spaghetti-strapped, cream-colored, silk evening dress and high-heels.

LAM omitted the original caption. The text on the page identified the still as from the movie *Tootsie*, and read, "Dustin Hoffman isn't a drag in a butter-colored silk gown by Richard Tyler and Ralph Lauren heels."

LAM did not ask Hoffman for permission to publish the photograph. Nor did LAM secure permission from Columbia Pictures, the copyright holder.

In April 1997, Hoffman filed his lawsuit, alleging that LAM's publication of the altered photograph misappropriated his name and likeness in violation of: 1) the California common law right of publicity; 2) the California statutory right of publicity; 3) the California unfair competition statute, Business and Professions Code; and 4) the federal Lanham Act.

After a bench trial, the district court found for Hoffman and against LAM on all of Hoffman's claims, rejecting LAM's defense that its use of the photograph was protected by the First Amendment.

The court awarded Hoffman $1,500,000 in compensatory damages, and held that Hoffman was entitled to punitive damages as well. After a hearing, the court awarded Hoffman $1,500,000 in punitive damages. It also held that ABC, LAM's parent, was not liable for any of LAM's actions.

The Value of a Good Idea

Hoffman moved for an award of $415,755.41 in attorneys' fees. The district court granted the motion, but reduced the amount to $269,528.50.

LAM, of course, appealed.

LAM's pivotal argument employed the First Amendment. It asserted that the "Grand Illusions" article and the altered "Tootsie" photograph were an expression of editorial opinion, entitled to free speech.

Hoffman, a public figure, had to show that LAM acted with "actual malice," that is, with knowledge that the photograph was false, or with reckless disregard for its falsity.

Hoffman did not contest his public figure status. In fact, Hoffman alleged that he was a readily identifiable individual whose persona had commercial value under his right of publicity claim.

The district court ruled on the following two important issues.

First, it concluded that the magazine article was commercial speech not entitled to constitutional protection. It said, "[t]he First Amendment does not protect the exploitative commercial use of Mr. Hoffman's name and likeness." Second, the court found that LAM acted with actual malice, and "the First Amendment does not protect knowingly false speech.

On its final appeal, however, the district court's opinion didn't hold. Contrary to what the district court said, the appeals court couldn't find a way to categorize Hoffman's photo as pure commercial speech.

Hoffman pointed out that the body double in the photo was identified as wearing Ralph Lauren shoes and that there was a Ralph Lauren advertisement (which did not feature shoes) elsewhere in the magazine. He also pointed to the "Shopper's Guide" in the back of the magazine, which provided stores and prices for the shoes and gown. These facts were not enough to make the *Tootsie* photograph pure commercial speech. Thus, Hoffman couldn't make a claim similar to that of Bette Midler and Tom Waits, or bar the magazine from First Amendment protection.

LAM did not use Hoffman's image in a traditional ad printed merely for the purpose of selling a particular product. To the contrary, the article as a

whole was a combination of fashion photography, humor and visual and verbal editorial comment on classic films and famous actors. Any commercial aspects were "inextricably entwined" with expressive elements, and so they could not be separated out "from the fully protected whole."

The district court also concluded that the article was not protected speech because it was created to "attract attention." The appeals court disagreed: A printed article meant to draw attention to the for-profit magazine in which it appears…does not fall outside of the protection of the First Amendment because it may help to sell copies.

While there was testimony that the Hollywood issue and the use of celebrities was intended in part to "rev up" the magazine's profile, that did not make the fashion article a purely "commercial" form of expression.

In sum, the appeals court couldn't find a reason to call the altered photograph commercial speech. It found that the magazine was entitled to full First Amendment protection accorded noncommercial speech. Following this finding, the appeals court had to rule on whether malice was involved, in which case Hoffman would be able to recover damages.

It was not enough to show that LAM misled readers into thinking Hoffman had actually posed for the altered photo. Mere negligence, according to the courts, is not enough to demonstrate actual malice.

On the other hand, the appeals court said:

> The evidence must clearly and convincingly demonstrate that LAM knew (or purposefully avoided knowing) that the photograph would mislead its readers into thinking that the body in the altered photograph was Hoffman's.

There wasn't enough evidence for Hoffman to win. When the appeals court reviewed the "totality of [LAM's] presentation," it determined that the article did not intended to suggest falsely to the ordinary reader that he or she was seeing Hoffman's body in the altered *Tootsie* photograph.

All but one of the references to the article in the magazine made it clear that digital techniques were used to substitute current fashions for the clothes worn in the original stills. Although nowhere did the magazine state that

models' bodies were digitally substituted for the actors' bodies, the appeals court thought this would be abundantly clear given that the vast majority of the featured actors were deceased.

Hoffman tried to argue that the photo created the false implication that he approved the use of his name and likeness in the altered photograph or that he was somehow associated with the designers. The district court did not address this claim in making its determination that LAM acted with actual malice.

At any rate, Hoffman did not explain how the evidence or testimony showed that LAM subjectively intended that the reader believe Hoffman had endorsed the use of his name or likeness or the selection of the clothes, and so the appeals court saw no clear and convincing evidence of such intent.

In all, the appeals court totally reversed the earlier rulings. It concluded that the magazine was entitled to the full First Amendment protection awarded noncommercial speech, and that Hoffman did not show by clear and convincing evidence, which is "far in excess of the preponderance sufficient for most civil litigation," that LAM acted with actual malice in publishing the altered *Tootsie* photograph.

LAM managed to also get back its attorneys' fees.

Attorneys' Fees and the Lanham Act

Another key reason to add a Lanham Act claim to your list of complaints in a case of damage to reputation—it includes attorneys' fees by statute. If the defendant acted with oppression, fraud or malice, the plaintiff may be entitled to reasonable attorneys' fees under the Lanham Act. Section 35 of the Lanham Act authorizes attorneys' fee awards for prevailing plaintiffs in "**exceptional cases**". Exceptional cases include those in which the defendants' conduct is "malicious, fraudulent, deliberate or willful."

Conclusion

A reputation is a hard thing to develop...but an easy thing to lose. It's amazing to think that a voice, a style or an alleged reputation (of even a brewing company) can be a commodity. But as this section has shown, there's a lot more to intellectual property than merely copyrights, trademarks and patents.

Saved for the final chapter of the book is the topic of trade secrets. This requires a slight shift in thought, because these past four chapters have been closely linked together by similar issues—publicity, privacy, reputation, etc. And those accusations often come from famous people.

When it comes to trade secrets, however, the usual case involves a company that feels it has lost its competitive edge through the loss of a trade secret. Trade secrets are unique because unlike the forms of intellectual property discussed thus far in the book, you cannot obtain a right to a trade secret. That is, you cannot do anything to protect your trade secret other than keep it secret. Knowing the trade secret is enough...and you cannot gain back much once the secret is out. A trade secret disclosed is exactly that—a lost trade secret. Sound confusing? It can be, and it's the reason for devoting an entire chapter to this last, albeit important, piece of the intellectual pie.

The Value of a Good Idea

CHAPTER 16: TRADE SECRETS

Trade secrets are tools that can make one company better than the competition. Think about the recipe for Mrs. Fields' cookies or the way Microsoft turned the Altaire box of blinking lights into the everyday personal computer via an operating system and software that would make it perform useful computing tasks. These companies started small…in garages and kitchens…but slowly built business empires on simple models, sound tactics and a few good secrets.

Trade secrets can be protected. But when a secret is unleashed, and becomes the advantage of another company, litigation often ensues.

Because trade secrets are vital to the life of a company, they are also important to the overall U.S. economy and the competitiveness of the American industry. Every year, companies spend millions of dollars to create and protect trade secret information from competitors. These secrets, themselves broadly defined, include a host of things, stemming from the financial side of a company to the business, scientific, technical, economic and engineering side. They are economic and noneconomic assets and can include formulas, client lists and materials.

As we'll later see, the illegal use or misappropriation of a trade secret can mean anything from concealment, fraud and deception to duplication, copying, transmitting or mere communication of a trade secret. Today's digital world makes it too easy to unleash a trade secret. Beyond the basic definitions of what constitutes a trade secret and the common complaints at-

tached to their misappropriation, we'll also see how courts deal with situations where trade secrets are wrongly, but inadvertently shared. A look at a few cases will help demonstrate the wide, unusual strata of trade secret law within the stratum of intellectual property law.

Trade Secrets and the Courts

Intellectual property law recognizes the importance of trade secrets. According to the Supreme Court:

> The right to exclude others is generally one of the most essential sticks in the bundle of rights that are commonly characterized as property…[and] [w]ith respect to a trade secret…central to the very definition of the property interest.

However, the Supreme Court also acknowledges that a misappropriation or loss of a trade secret constitutes a loss of property interest. It has held:

> Once the data that constitutes a trade secret are disclosed to others, or others are allowed to use those data, the holder of the trade secret has lost his property interest in the data.[1]

So, **if your trade secret is disclosed, it's no longer a secret**. Furthermore, if a competitor learns the secret and no fraudulent or illegal action occurred, then there's no protection afforded the original owner. How could this happen? If you hit the Send key and mistakenly e-mail all your friends the crux of your trade secret, you cannot do anything legally and would have to cry over spilt milk. It's a double-edged sword: a trade secret can potentially last forever, but once the secret is out, it's out. And if you want to recover damages from a loss, you most likely won't be able to recover for future losses as a result of your secret's disclosure. As case studies in this chapter will show, there's no fair way for the courts to remedy a company that has lost a trade secret, making it all the more imperative for companies to do their best to protect against any disclosure.

[1] *Ruckelhaus v. Monsato Co.* (1984).

Unlike patents, trademarks and copyrights, which are protected by federal law, trade secrets are governed by state laws. Nonetheless, 41 states have enacted statutes modeled after the Uniform Trade Secrets Act (UTSA), which followed the efforts by the National Conference of Commissioners on Uniform State Laws and the intellectual property bar. Alabama and Massachusetts have separate state statutes protecting trade secrets; the remaining seven (Missouri, New Jersey, New York, Pennsylvania, Tennessee, Texas and Wyoming) protect secrets under common law.

As defined by Louisiana's UTSA:

> "Trade secret" means information, including a formula, pattern, compilation, program, device, method, technique or process, that: a) derives independent economic value, actual or potential, from not being generally known to and not being readily ascertainable by proper means by other persons who can obtain economic value from its disclosure or use; and b) is the subject of efforts that are reasonable under the circumstances to maintain its secrecy.

It's important to note that trade secrets cover a variety of things, some of which people may not necessarily see as a trade secret. Other examples include: plans, designs, prototypes, customer lists, vendor lists, identity of suppliers, choice in fabric or materials, patterns, codes, processes, techniques, business models, formulas, procedures, compilations, how-to manuals, ways of storing, filing, delivering and communicating, program devices, systems and even recipes.

In short, **anything that gives one company competitive advantage over another** is a trade secret.

Because trade secrets are so broadly defined, and laws are so thinly drawn, courts resort to a meticulous analysis in each case when deciding whether to award a plaintiff damages.

Also defined alongside trade secret is *misappropriation*:

> "Misappropriation" means acquisition of a trade secret of another by a person who knows or has reason to know that the trade secret was acquired by improper means...by a person who: 1) used improper means to acquire knowledge of the trade secret; or 2) at the time of disclosure or use, knew or had reason to know that his knowledge of the trade secret was...acquired under circumstances giving rise to a duty to maintain its secrecy or limit its use.

Underneath allegations of trade secret misappropriation is the notion of **loyalty**. But, as the court in *Van Prods. Co. v. Gen. Welding & Fabrication Co.* noted back in 1965, the starting place in every case is not whether there was a confidential relationship, but whether, in fact, there was a trade secret to be misappropriated.

Common Complaints

This brings us to the items a plaintiff must prove in order to recover damages. Again, we employ the Louisiana Uniform Trade Secrets Act, which states that a complainant must prove:

1) the existence of a trade secret;

2) a misappropriation of the trade secret by another; and

3) the actual loss caused by the misappropriation.

Although trade secret misappropriation is the most common complaint, plaintiffs will attach other claims, including unfair competition and breach of contract, fiduciary duty and non-compete agreement. Defendants, on the other hand, try to prove that there was no trade secret, that it was public information or that there was no proof of any wrongdoing with regard to that secret. And this is where the courts must examine the mechanics of each case separately.

Trade secret cases can get grisly, but if a plaintiff can prove all three of the above points, they may recover damages.

Take, for example, the case of Molly Strong. In January 1989, Molly Strong invented what she believed to be a better shoe. It was a winter boot, dubbed "Yeti," incorporating innovations to maximize traction, warmth and dryness. By September 1992, she had a patent for her invention.

In early 1993, Strong incorporated an entity called "Yeti by Molly, Ltd." At about the same time, she began a business relationship with a man who could help her mass produce her products. He was a self-described "old shoe dog" named James E. Granville, and he signed a **nondisclosure agreement** before Strong discussed anything of substance with him. After he signed the agreement, she provided him with secrets embodied in a yet unrevealed second patent application, samples of her product and confidential details about the company's attempts to expand production and sales. In response, Granville sent Strong a letter full of praise and hopeful predictions.

In September 1993, Granville told Peter Link, Vice President of Deckers Outdoor Corporation—the maker of the popular Teva sandals—about Strong and the Yeti. Link then hired Granville as a shoe consultant to Deckers; this was the beginning of a fruitful relationship, and Granville eventually became a Director of Project Development for Deckers. Strong was unaware of the initial conversation between Peter Link and Granville, but Link called her the same month and told her that Deckers was looking for winter footwear products. Before discussions began, Strong had Link sign a nondisclosure agreement, after which two months of steady negotiations ensued. During this time, Link pleaded with Strong not to sign any deals with other companies until Deckers could evaluate her products and make her an offer.

After learning many of Strong's secrets, Link made overtures to her about acquiring the company. Many letters were exchanged in an attempt to finalize terms, and on November 8, 1993, Strong accepted what she believed was an oral agreement to do business with Deckers.

Because Strong believed that a formal signing would eventually occur, she abandoned negotiations with another entity called S & K Electronics to

produce the Yeti. Then, the day after Strong presented the Yeti to Deckers' sales representatives, the company reneged, telling her that they would have to renegotiate. The two sides were never able to come to terms.

In the fall of 1994, Molly Strong began to suspect that Deckers had incorporated her and her company's trade secrets into its products. So, she sued Granville and Deckers in federal court alleging various things: breach of contract, contractual and tortious breach of the implied covenant of good faith and fair dealing, fraud, deceit, trade secret misappropriation and civil conspiracy.

After a 10-day trial, a jury found in favor of both Molly Strong and her company for the most part. Although she couldn't win on fraud and breach of oral contract—nor for Granville's claims—the court ruled in her favor for breach of nondisclosure contract, breach of implied covenant of good faith and fair dealing, deceit, misappropriation of trade secrets and civil conspiracy claims. It found that Deckers was liable to Strong's company for $1,360,000 and to her personally for $425,000. Because the jury couldn't find that Deckers had acted with actual fraud or malice, the court denied punitive damages. On appeal, Strong cross-appealed in the hopes of receiving exemplary damages and attorneys' fees.

Going back to the genesis of the problems, it's worth noting some things. First, Strong and her company resided in Montana. Granville was a citizen and resident of California, where Deckers did (and still does) most of its business. When Deckers appealed in the Ninth Circuit, one of their primary arguments had to do with the way the trial court allowed expert witnesses to testify about the actual damages. For example, Strong produced a substantial report of her damages from an economist. Deckers, on the other hand, failed to submit the proper materials in the timely fashion—and the court ultimately rejected its damages expert as a result. By excluding Deckers' report, it was impossible for the company to rebut Strong's calculations. And, even though Deckers tried its hardest to get the appeals court to hear the expert, the court wouldn't make any exceptions. It said the district court was right in excluding the Decker's expert testimony.

Another finding that Deckers tried to reverse on appeal was the district court's allowing the disclosure of its annual overall gross sales and gross sales of Teva products. Deckers hadn't wanted the jury to hear about its apparent success…fearing that evidence of the company's big profits would "inflame the jury." Complaining about this, however, didn't sway the appeals court and it affirmed the district court's disclosure of that evidence.

Deckers further asserted that there was not enough evidence to support the jury's damages findings. The appeals court didn't agree. First, Strong's damages report showed that she had suffered $8,062,099 in lost opportunities. If Strong could have licensed her trade secrets to other footwear manufacturers and gathered royalties, her company would have seen millions of dollars.

To further her case, Strong also introduced **evidence of profits lost** when the deal with S & K was lost. All of this evidence taken into consideration made her case and led the appeals court to affirm the district court's damages awards.

There was also enough evidence to support the jury's finding that Deckers had misappropriated trade secrets owned by Strong. Among these secrets was the identity of suppliers. For example, Strong had testified that she told Link about Malden Mills for Polar-Tec fleece material and revealed the precise type of Polar-Tec that she preferred. She never transferred this secretly maintained list of suppliers to Yeti by Molly. And, in a memo introduced into evidence, Link told Deckers' employees to use Malden Mills as its supplier and to use the type of Polar-Tec that Strong had specified.

The appeals court declined to address Deckers' argument that any of Strong's secrets were not "trade secrets." It affirmed the jury's combined award of $80,000 as a remedy for Deckers' deceit. Finally, on Strong's attempt to recover attorneys' fees and exemplary damages, the appeals court reversed the lower court's refusal and sent the case back for further proceedings.

This case shows that it's possible to win a trade secret case, but that in doing so, you might have to call in economist experts and witnesses who

can attest to your losses. Molly Strong put a lot of effort into establishing her case—and luckily got something in return.

Manuals, Formulas and Operations

Trade secrets nowadays go far beyond client lists, contact names and preferences in fabrics or materials. Amid high-tech innovations and revolutionary inventions in today's technology age, every morsel of a company's product is critical to the success of the business. Likewise, every step a company takes to get that product to the market—from manufacturing and producing it—is critical and in some respects, a trade secret. A decision that came down in the summer of 2001 illustrates this very point. It was the case of *Minnesota Mining & Manufacturing Company v. Ronald Pribyl, et al.* When three previous employees of 3M decided to start their own company—based on what they had learned and done for 3M—they didn't get away with it.

3M, short for Minnesota Mining & Manufacturing, the company that makes Post-it notes and Scotch tape, started manufacturing carrier tape in 1986. Carrier tape is used to transport sensitive electronic components; it is made principally from a thin layer of plastic called resin sheeting into which pockets are molded to fit the components to be transferred. Three individuals who were integral to 3M's development and production of resin sheeting and carrier tape were Ronald Pribyl, Thomas Skrtic and James Harvey.

Pribyl, who began working for 3M in 1989 as its Manager of Manufacturing for North America, supervised the production of all of 3M's resin sheeting and carrier tape in North America. Skrtic, an employee of 3M's Surface Mount Supplies Division from 1986, was the primary developer of 3M's resin sheeting manufacturing process.

Finally, Harvey, who worked as 3M's quality supervisor, was the principal author of a series of 3M manuals documenting the operating, training, and quality control procedures for producing resin sheeting and carrier tape.

In 1996, 3M announced that it was moving its carrier tape business from Menominee, Wisconsin to Hutchinson, Minnesota. For a variety of reasons, Pribyl, Skrtic and Harvey did not wish to relocate to Minnesota. Thus, in 1997, the trio, while still working for 3M, formed Accu-Tech. Accu-Tech set out to manufacture and sell resin sheeting to various companies, including those who used the product to manufacture carrier tape. (Accu-Tech itself did not produce carrier tape.) Then, for approximately two years, Pribyl, Skrtic and Harvey operated Accu-Tech while still working for 3M. It was not until March of 1999 that 3M discovered their clandestine operation and terminated them.

On April 23, 1999, 3M brought a suit against Pribyl, Skrtic, Harvey and Accu-Tech in a Wisconsin district court. 3M asserted a litany of claims, including breach of fiduciary duty, breach of employment contracts and misappropriation of trade secrets. 3M also alleged that Accu-Tech, as a corporate entity, had misappropriated trade secrets, engaged in unfair competition, tortiously interfered with prospective contractual relationships and tortiously induced Skrtic to breach his employment contract with 3M.

On most of these claims, the district court granted summary judgment in favor of Accu-Tech and its founders. However, when the liability portion of the case proceeded in a separate trial, a jury returned a verdict, finding that:

1) Accu-Tech's founders had each breached a duty of loyalty to 3M;

2) 3M owned four trade secrets; and

3) Accu-Tech and its founders had misappropriated or threatened to misappropriate two of those four trade secrets.

The two trade secrets, which the jury determined the defendants had misappropriated, were:

1) the operating procedures, quality manuals, training manuals, process standards and operator notes for using plaintiff's equipment that makes resin sheeting; and

2) the customized resin formulations that enhance the sheeting and thermoforming capability of resin.

Then, the jury returned its findings on damages. On 3M's claim for breach of the duty of loyalty, the jury determined that Pribyl was liable in the amount of $126,875, while Harvey and Skrtic each owed 3M $46,000. The jury additionally awarded damages against Accu-Tech and its founders in the amounts of $83,000 for misappropriation of 3M's trade secret for customized resin formulations and $187,500 for misappropriation of 3M's trade secret in the operating procedures and manuals.

Shortly thereafter, the defendants asked for a new trial. Meanwhile, 3M asked for a permanent injunction. On February 9, 2000, the district court partially granted 3M's motion, permanently enjoining the defendants from disclosing any of the four trade secrets found by the jury. However, the court denied 3M's request for a permanent injunction against the use of 3M's customized resin formulations and operating procedures and manuals. So the defendants could *use* the trade secrets, but not *disclose* them.

On March 2, 2000, another round in the district court left both parties unhappy. Both sides cross-appealed. The defendants didn't believe that 3M's operating procedures and manuals were trade secrets, or that anything within them constituted trade secrets. Furthermore, they thought being prohibited from disclosing these procedures and manuals violated a civil code. On the other side, 3M wanted more from these guys—particularly a permanent injunction against them for even using the alleged trade secrets.

The appeals court backed the jury's finding that 3M had a bona fide trade secret in the operating procedures, quality manuals, trade manuals, process standards and operator notes for using 3M's equipment that made resin sheeting.

Further, the appeals court agreed with the district court that there was sufficient evidence to support a powerful inference that defendants used 3M's operating procedures and manuals in establishing Accu-Tech's operations.

While it took 3M six years and countless resources in order to make its carrier tape operation efficient and profitable, Accu-Tech was able to almost immediately operate its resin sheeting line effectively. To add insult to injury, testimony at trial suggested that Accu-Tech was disclosing to 3M customers and competitors processes detailed in 3M's manuals. Given all of this evidence, the appeals court refused to accept Accu-Tech's motion for judgment as matter of law. Accu-Tech would have to pay.

Damages and Injunctions

Unlike trademark law, which makes it easy for courts to grant permanent injunctions against proven trademark infringers, it's harder for the courts to grant injunctions when it comes to trade secrets. This is because **courts use injunctions as vehicles for preventing injury—and not as punitive tools**. According to most state trade secret law, a court may grant injunctive relief against a person who misappropriated a trade secret, but should continue that injunction only for the period of time reasonable to eliminate any commercial advantage that the person who misappropriated a trade secret derived from the violation.

Returning to the 3M case, there was a reason why the court refused to permanently enjoin Accu-Tech and its founders from using 3M's trade secrets. First, it noted:

> The purpose of a permanent injunction is to protect trade secret owners from the ongoing damages caused by the future use of trade secrets, rather than to compensate for those damages.

Moreover, the appeals court said:

> In this instance, the district court made a factual determination that Accu-Tech would have been able to independently develop 3M's trade secret in a period of less than two years—a conclusion which 3M does not dispute. Given that Accu-Tech's founders were the individuals responsible for creating the materials for 3M in the first place, it would be nonsensical to suggest that they would not have been able to duplicate the materials on their own. As

such, by the time the district court was faced with determining whether to enjoin Accu-Tech's use of 3M's trade secret, the court believed that Accu-Tech would have discovered 3M's trade secret.

To simplify the confusing array of secrets between 3M and Accu-Tech, the appeals court made some lists of what Accu-Tech was forbidden to use and disclose. In the end, the only 3M trade secret that Accu-Tech could use was the company's trade secret in the operating procedures and manuals. And they were forced to repay 3M the cost of development. It's important to note that the heart of this case wasn't so much about the actual technology, but the fact these men developed the technology using 3M's help. So despite their contribution, the rights of ownership to the specifics detailed in the operating procedures and manuals belonged to 3M.

The Value of a Client List

As previously mentioned, some of the most valuable noneconomic assets to a company include **lists to vendors, clients, customers and contacts**. So, what happens when an employee walks out of a job with a copy of one of those lists…and uses it to start another business? That's what happened in *Fireworks Spectacular, Inc. and Piedmont Display Fireworks, Inc. v. Premier Pyrotechnics, Inc. and Matthew P. Sutcliffe*.

Fireworks Spectacular, Inc. and Piedmont Display Fireworks were, for all practical purposes, one in the same company specializing in the sale of fireworks and shows that display fireworks. Based in Kansas, the companies catered to a wide variety of customers, from wholesale distributors to private individuals who shoot their own fireworks shows. After a time during which Matthew Sutcliffe purchased fireworks from Fireworks Spectacular, he began to establish a business relationship with the company.

It began in 1996 when the president of the company, Michael Collar, approached Sutcliffe about shooting off fireworks displays. After shooting three shows for the company, Sutcliffe approached Collar about the possibility of selling fireworks shows for Collar's company. Collar agreed

to pay Sutcliffe a commission for any sales that he made and the deal was made.

In March of 1997, Sutcliffe began working for the company in Pittsburg, Kansas. Within a few months, Fireworks Spectacular approached Sutcliffe about entering into a non-compete agreement. Although Sutcliffe expressed a willingness to do so, neither party discussed the specific terms for any such agreement. And, as it turned out, no agreement was ever signed between the two parties despite the attempts made and the alleged interests. In June of 1997, Fireworks Spectacular had its attorney draft a written employment agreement, which contained, among other things, a covenant not to compete. This was a very detailed and specific agreement, but was never signed by Sutcliffe. At the time the plaintiffs presented the document, Sutcliffe had some issues regarding it and refused to sign. No further attempt was made to get his signature until a few months later when the plaintiffs re-negotiated the terms of Sutcliffe's employment and agreed to pay him a base salary of $20,000 per year, plus a specified sales commission and bonus. In exchange, Sutcliffe agreed, among other things, to sign a non-compete agreement. Throughout 1997 and 1998, Sutcliffe worked for Fireworks Spectacular…but never signed that agreement because he was never presented with it.

In the fireworks industry, the most common and useful way to acquire customers is through "cold-calling," an often lengthy and costly process. Fireworks Spectacular **maintained computerized lists containing detailed information about its customers**. Keeping these lists confidential was company policy, and access to them was always limited to certain employees—including Sutcliffe, who knew about keeping customer information confidential.

While soliciting sales for the company, Sutcliffe made notes in a personal logbook concerning the customers with whom he came into contact. Those notes were similar to those contained in the computerized lists.

On January 6, 1999, Sutcliffe quit his job at Fireworks Spectacular and started a competing business of his own—Premier Pyrotechnics—in Missouri. He didn't leave his previous employment empty-handed, however; Sutcliffe left and established his own business with those critical and very

coveted client lists. By using those lists, Premier Pyrotechnics immediately established itself as a competing company.

Fireworks Spectacular sued, and on February 23, 2000, a court issued an order enjoining Sutcliffe from "soliciting, marketing, promoting, introducing or attempting to sell products or services to any…customer listed on [the computerized lists] on behalf of Premier Pyrotechnics or any other fireworks provider" and his company from "appropriating, copying, using or disclosing any of [their] customer lists," written or computerized.

Fireworks Spectacular took further action by sending notices to their customers about the court order. To their dismay, however, their office manager mistakenly sent copies of the client list with the letters.

To correct this mistake, they immediately informed the 11 recipients of those letters, asking for the lists back and threatening legal action for messing with their "trade secret." Ten of the 11 customers immediately returned the lists; the eleventh customer did not return the lists; however, he did not disclose the lists or their contents to anyone other than his family, Sutcliffe and Sutcliffe's wife.

At trial, Fireworks Spectacular attempted to enforce the written non-compete agreement that Sutcliffe had refused to sign. They argued that the agreement was enforceable because Sutcliffe had orally agreed to its terms. The court, however, concluded that **even if Sutcliffe had orally agreed to its terms, the agreement was unenforceable**. The court held serious doubt as to whether Sutcliffe ever orally agreed to the terms of the written agreement.

Fireworks Spectacular alleged that Sutcliffe and his company misappropriated their trade secrets in violation of the Kansas Uniform Trade Secrets Act. They also contended that their computerized lists and the notes kept by Sutcliffe constituted protected trade secrets. The court agreed.

Referring to Georgia's 1979 decision *Robert B. Vance & Assocs., Inc. v. Baronet Corp.*, the court wrote:

> Customer lists containing merely public information that can easily be compiled by third parties will not be protected as trade se-

crets; however, where the party "compiling the customer lists, while using public information as a source…expends a great deal of time, effort and expense in developing the lists and treats the lists as confidential in its business, the lists may be entitled to trade secret protection."

The court concluded that the lists and the notes constituted protected trade secrets. They **derived economic value from the fact that they contained valuable customer information** that was not generally known or readily ascertainable by persons in the fireworks industry. It wrote:

> Fireworks Spectacular invested a great amount of time, effort and expense in developing their customer information—including hundreds of hours of "cold-calling…." Moreover, [Fireworks Spectacular made] efforts that [were] reasonable under the circumstances to maintain the secrecy of the customer information. [They] limit[ed] the access of their lists to certain employees, and maintain[ed] a strict policy of keeping all customer information confidential.

It was irrelevant that the lists were created in part by Mr. Sutcliffe, and that the notes were kept by him in a personal logbook. In that sense, the court found the lists and notes to be of Fireworks Spectacular's property. It was also irrelevant that the company had inadvertently disclosed copies of the lists to some customers.

Sutcliffe and Premier Pyrotechnics were liable. The court determined that the Fireworks Spectacular sustained damages of lost profits in the total amount of $82,217.53, noting that it was the tangible customer lists and notes—as opposed to the customers themselves—that were the protected trade secrets. The court did not, however, find willful and malicious misappropriation, and thus did not award exemplary damages or reasonable attorneys' fees.

Sutcliffe was allowed to engage in fair competition, using fair and proper means, to solicit any and all customers, but he was not allowed to use or refer to any of those stolen lists. (He'd have to construct a new list for his new business.)

Reasonable Royalties

In Molly Strong's case against Deckers, she was able to prove her losses and damages fairly easily. Often, it's a lot trickier to gather all the relevant evidence, such as a competitor's profits from using your trade secret. And it's not necessarily kosher to demand to see a competitor's financials when the competitor wasn't the trade secret infringer. A brief look at the March 1999 Ninth Circuit Appeals Court decision *Cacique, Inc. v. Robert Reiser & Company, Inc.*, sheds light on the role royalties play in trade secret cases.

In *Cacique*, a cheese manufacturer sued a vendor of food processing equipment, alleging improper disclosure of their trade secrets to a competitor. The district court permitted **discovery of the competitor's sales figures** for the purpose of establishing a reasonable royalty sought by the cheese manufacturer, and, after the competitor refused to comply with the subpoena, the court entered a civil contempt order.

On appeal, the court held that California law didn't entitle the cheese manufacturer to a remedy of reasonable royalty and that the competitor's sales information was not relevant anyhow.

Interestingly, California law specifies when a business can recover a reasonable royalty: when both actual damages and unjust enrichment are unprovable. Specifically, California's version of the UTSA states:

> A complainant may recover damages for the actual loss caused by misappropriation. A complainant also may recover for the unjust enrichment caused by misappropriation that is not taken into account in computing damages for actual loss.... If neither damages nor unjust enrichment caused by misappropriation are provable, the court may order payment of a reasonable royalty for no longer than the period of time the use could have been prohibited....

Note that California law differs on this point from both the general UTSA and Federal patent law, neither of which requires actual damages and

unjust enrichment to be unprovable before a reasonable royalty may be imposed.

But, in the *Cacique* case, the appeals court articulated, "There is simply no reason to believe that **unjust enrichment** could not be proved." It was an unusual situation of a party suing an upstream capital goods manufacturer for trade secret infringement. If Reiser were guilty of misappropriation, the threat to Cacique's profits would not have coincided with an increase in Reiser's sales, but rather an increase in sales of Cacique's competitors—Reiser's customers.

Because California law limits access to reasonable royalties, and this case didn't meet the law's requirements, the appeals court ruled that Cacique did not have a claim for a royalty. The court wrote:

> Cacique's only claim of unfair competition is Reiser's disclosure of the trade secret to Cacique's competitors. Cacique has not attacked this conclusion and has not claimed any other form of unfair competition on appeal.

Clearly, Cacique should have approached its lawsuit differently.

Patents and Trade Secrets

The relationship between patents and trade secrets can get fuzzy. Trade secrets themselves are usually not written down in tangible form and labeled with the words "trade secret." This is what makes it hard sometimes to prove the existence of a trade secret in court. And once it's out in the open, it's no longer protected as a trade secret. Patents, on the other hand, are published and available to anyone. A patent, in and of itself, protects the intellectual property without much dispute. A question to ask: What happens when an inventor fills out a patent application for his trade secret? Answer: The **publication of the patent application effectively destroys the trade secret status**. The following case is a good example of this scenario.

You've probably never wondered how complicated the process of curling ribbon can be—especially given the politics of inventing an automated

machine. In *Group One, Ltd. v. Hallmark Cards, Inc.*, the issue was whether Hallmark had ripped off the machine and method for producing curled and shredded ribbon for decorative packaging from another company. In the lawsuit, misappropriation of trade secrets was also added to the claim. Hallmark, of course, counterattacked, asserting that the two patents in question were invalid.

Group One, a corporation registered in the United Kingdom, was principally run and owned by Frederic Goldstein. And, while Goldstein was a U.S. citizen, he resided in Sweden. He invented an automated ribbon curling and shredding device and obtained the proper patents. On November 14, 1991, Goldstein filed a patent application in the U.K. for his device; he subsequently filed a U.S. patent application on May 13, 1994. This application eventually was issued as the '492 patent on May 21, 1996. A continuation of this U.S. application was issued as the '752 patent on January 27, 1998.

The '752 patent claimed a method for curling and shredding ribbon on a mass basis, and the '492 patent claimed a machine for performing the method. Prior to Goldstein's conception, ribbon had been sold in a form that was suitable for curling, but was not so curled until curled by the consumer. Goldstein perceived a market for pre-curled ribbon—for use, for example, as filler in a gift package or gathered in a bow—and decided to exploit that market.

In order to generate interest, and before filing his patent applications, Goldstein began a series of communications with Hallmark, among others. On June 24, 1991, he wrote to Hallmark:

> We have developed a machine which can curl and shred ribbon so that Hallmark can produce the product you see enclosed—a bag of already curled and shredded ribbon.... We could provide the machine and/or the technology and work on a license/royalty basis.

Hallmark expressed some interest, and the parties continued their correspondence. They arranged a meeting to discuss details of the curling and shredding machine for February 17, 1992. Prior to the meeting, the par-

ties negotiated a **Confidential Disclosure Agreement** regarding the technology to be discussed at the meeting. However, despite essential agreement on the terms of the CDA, Hallmark never signed it. On February 14, 1992, shortly before the scheduled meeting, Goldstein had a telephone conference with a Hallmark engineer, in which the parties discussed details of Group One's machine and method. At the time, Goldstein had signed the CDA and (incorrectly) believed it to be in effect.

Hallmark then canceled the planned February 17 meeting, deciding it would instead evaluate its own internal capability of producing a curling and shredding machine.

On June 6, 1992, Goldstein got the news: Hallmark had developed its own machine for curling and shredding ribbon, and therefore was no longer interested in purchasing his machine. Hallmark informed Goldstein of this in a letter, which went on to state "we would like to thank you[r] firm for suggesting the curled ribbon product to us by paying you $500." Apparently anticipating a claim of misappropriation, the letter specifically pointed out that Hallmark had never signed the CDA "pending our internal consideration of such product," and requested that Goldstein sign a release "on account of our use of the curled ribbon idea" in return for the $500 payment. The letter made no mention of the telephone conference of February 14, 1992 or the information Hallmark obtained during the conference.

Goldstein declined the $500 and did not sign the release.

According to Hallmark, the company temporarily abandoned the project and did not again begin developing a fully suitable curling and shredding machine until April 1994. Sometime in March or April 1995, it began producing its "Curl Cascade" product, which was a clump of curled ribbon attached to a card, and its "Curl Fill" product, which was a gift-bag stuffing comprised of strands of curled ribbon. The machine used to make these products, the Curl Cascade machine, was the bone of contention.

On August 4, 1997, Group One filed suit in Missouri, where Hallmark was located. The company hit Hallmark with four counts: two for patent infringement and two relating to theft of trade secrets.

Hallmark then tried to redefine "trade secret." According to Hallmark, once formerly secret material was published (i.e., in a patent application), it ceased to be a secret, and therefore could not be misappropriated—regardless of whether the party accused of misappropriation was aware of the publication.

The district court agreed with this thinking. It found that the publication of Goldstein's original patent on May 27, 1993, destroyed the trade secret status of the confidential disclosures, and therefore Hallmark could not be liable for any activity after that date. The court held, nonetheless, that Hallmark would be **liable for damages for any "head-start" it obtained by having access to the confidential information** in the time period between the date of the confidential disclosure and the date of the patent publication. Group One subsequently said it would be unable to prove any such damages, and the counts were then dismissed.

Oddly, the district found Group One's patents invalid, stating that its communications with Hallmark more than one year before the filing date of the application for the '492 patent constituted an offer for sale—thus invalidating them under a U.S. code.

The federal appeals court had a hard time referring to previous case law because most of the previous cases addressed trade secrets in the context of a former employee. Here, Hallmark's knowledge of Group One's trade secret was acquired during a normal, albeit confidential relationship; furthermore, the use of the alleged trade secret happened a long time after their meetings. On appeal, the court affirmed the district court's ruling and held:

1) the correspondence and other interactions between the parties did not add up to a commercial offer to sell the invention; and

2) the Missouri Supreme Court would likely adopt the property theory of trade secrets, under which the publication of…[a] patent application destroyed the trade secret status of the confidential disclosures, so that alleged infringer could not be liable for any activity after that date, even though it was unaware of the publication.

This case proves how you shouldn't "speak so soon" about ideas that another can easily take and execute. Hallmark took an idea for a machine and ran with it—creating its own version and cutting out the true inventor.

Conclusion

A point to take away from the above case, as well as end this chapter: Trade secrets can potentially last forever…but only if you, as an inventor or trade secret holder, protect against their disclosure. There is no inherent right to a trade secret. That is, if you unintentionally disclose a trade secret, you essentially give up any rights to your trade secret.

We saved trade secrets for the last chapter of this book because they are an oddball type of intellectual property for which you cannot file an application, but they are equally important as any other type. And by now, you should have an understand of this and the place of many types of intellectual property in the world.

The Value of a Good Idea

Conclusion:

The Value of a Good Idea

Intellectual property is rarely a topic of conversation at cocktail parties or dinners. People don't take pleasure in talking about the legalese of copyrights or the fine points of a patent. But they do read Steven King novels, listen to Sheryl Crow's music, drink Heineken beer and drive BMWs. Though perhaps not in that order.

So, in a practical sense, intellectual property is everywhere. Economists explain that, in modern commercial systems, information is the critical method of exchanging value. This means that a good idea is itself the essence of commercial value.

In a strictly legal practical sense, intellectual property is a nebulous subject, hard even for the lawyers to master and puzzling for everyone else—including the people who come up with good ideas. One thing is for certain, however: The market for intellectual property generates an enormous amount of money. And this money comes from all fronts, from those who own valuable intangible assets to those who make a living out of lawyering, maintaining and managing the intangible assets of others.

Even the government pockets money when it registers copyrights, grants trademarks and approves of patents. Whether you're drinking a designer coffee, reading a best-selling book, downing some aspirin or just brushing your teeth with a sonic toothbrush...you're "consuming" someone else's good idea like any faithful consumer would. The exchange of goods and services—commerce—is simply the trading of good ideas...of units of

intellectual property that sustain societies. And it's no wonder intellectual property is a driving force of the economy. For this very reason, it's important to have a working knowledge of the subject, even if you don't think you'll ever have an idea good enough to protect and profit from. (But that surely cannot be the case.)

In June 2001, a company entered into an agreement with a man named Jack E. Daniels, who owned the water rights to 1,700 acres in California. The man had nothing to do with the famous Kentucky-based distillery that brands whiskey. But the company must have seen an opportunity, because it began producing "Jack Daniel's" bottled water. A good idea? The whiskey company sued for trademark dilution. The water company countersued for libel and for filing a frivolous lawsuit. The outcome of the case was still pending when this book went to press…and probably will be three editions from now.

Good ideas don't have to be technical, overly creative or founded by the approval stamp of an expensive MBA. They can be as simple as water, and they can potentially make a lot of money…and cost a lot of money. The difference is knowing a little bit about intellectual property.

The value of a good idea is, of course, subjective. It doesn't matter if you're a one-man shop, a small business owner, a CEO to a large company or merely a curious individual; intellectual property affects some aspect of your livelihood. Every idea has potential and every realized good idea in commerce is what the body of intellectual property serves to protect. The cases in this book alone demonstrate this fact, as well as show how wide the scope of intellectual property is.

Surprisingly, the number of federal trademark suits filed fell by about 17 percent in fiscal 2001, which ended in September. We noted several trademark cases in this book that revolve around domain name disputes. With the implosion of the dot.com boom, domain names no longer take center stage in the economy…and they certainly don't dominate the court dockets like they used to in the 90s. Some disputes still remain, but many are now settled more quickly and cheaply via online alternative dispute resolution forums. Clearly, the methods of managing intellectual property de-

velop alongside intellectual property itself. In the new millennium, not only will new types of intellectual property emerge from good ideas, but new and better ways of protecting those good ideas will result as well. The key is to stay abreast of the subject.

Because of the monetary impact intellectual property has on the world, intellectual property experts are among the most sought-after professionals today, and will continue to be in high-demand with the evolution of ideas and technology. Those experts are the best source of information and advice, in addition to the resources available through the Office of Copyrights and the PTO. As noted earlier, patents are by far the trickiest type of property, and your best resource for dealing with anything related to patents is a patent attorney. On the following pages you'll find some appendices that can guide you (if you're ready) to the next step, and give you some more contact information. There is no bible on this topic, which, as we said, is in perpetual motion.

This book has been a brief glance—even at more than 400 pages—at the basics of intellectual property. If it works, you will have the tools to deal with business associates (and lawyers, if you must) in an informed way. It should also inspire you to acknowledge and protect the value of your good ideas by highlighting some of the problems that come to people who don't. In short, it should help you appreciate the value of a good idea.

And maybe add something interesting to the cocktail party banter.

The Value of a Good Idea

APPENDIX A:
LIST OF RESOURCES

In the U.S., intellectual property is managed by the Library of Congress in Washington D.C. and the Patent and Trademark Office (PTO) in Arlington, Virginia. You can contact these offices in a variety of ways, as the following lists show. Although the online system is well-equipped to deliver forms, manuals and information to you for every type of intellectual property, there are other avenues to use. If ever you feel lost in the mess, consult an attorney who specializes in intellectual property and who can help you weave your way through the paperwork.

Copyrights

Library of Congress's **Office of Copyrights**: *www.loc.gov/copyright/*

This site makes available all copyright registration forms, many in fill-in format; all informational circulars; the Register's testimony; announcements; general copyright information; and links to related resources. The site also provides a means of searching copyright registrations and recorded documents from 1978 forward.

Office of Copyrights Contact Information:

Fax: Circulars and other information (but not application forms) are available from Fax-on-Demand at (202) 707-2600.

Telephone: For general information about copyright, call the Copyright Public Information Office at (202) 707-3000. The TTY number (for the

hearing impaired) is (202) 707-6737. Information specialists are on duty from 8:30 A.M. to 5:00 P.M. Monday through Friday, eastern time, except federal holidays. Recorded information is available 24 hours a day. Or, if you know which application forms and circulars you want, request them from the Forms and Publications Hotline at (202) 707-9100 24 hours a day. Leave a recorded message.

Visiting Address: The office is also open during these hours for you to visit. The office is located in the Library of Congress, James Madison Memorial Building, Room 401, at 101 Independence Avenue, S.E., Washington, D.C., near the Capitol South Metro stop. Information specialists are available to answer questions, provide circulars and accept applications for registration. Access for disabled individuals is at the front door on Independence Avenue, S.E.

Mailing Address: Send any correspondence to the Library of Congress, Copyright Office, Publications Section, LM-455, 101 Independence Avenue, S.E., Washington, D.C. 20559-6000.

For a list of other material published by the Copyright Office, request Circular 2, "Publications on Copyright."

NewsNet: To subscribe to *NewsNet*, a free electronic mailer that provides information on the subject of copyright (hearings, deadlines for comments, new and proposed regulations, new publications and other copyright-related subjects of interest), send a message to *listserv@loc.gov*. In the body of the message indicate: subscribeUSCopyright. You will receive a standard welcoming message indicating that your subscription to *NewsNet* has been accepted.

Other Useful Sites:

- **FA©E (Friends of Active Copyright Education)**: *www.law.duke.edu/copyright/face/*

- **American Society of Composers, Authors and Publishers**: *www.ascap.com*

- **The Harry Fox Agency, Inc.** (an information source, clearinghouse and monitoring service for licensing musical copyrights): *www.nmpa.org/hfa.html*

- **Broadcast Music Incorporated**: *www.bmi.com*

- **Motion Picture Licensing Corporation**: *www.mplc.com*

- **Copyright Clearing Center**: *www.copyright.com*

- **National Writers Union**: *www.nwu.org*

- **Authors Registry**: *www.authorsregistry.com*

- **WATCH** (Writers, Artists, and Their Copyright Holders): *www.hrc.utexas.edu/watch/watch.html*

- **World Intellectual Property Organization**: *www.wipo.org*

Trademarks

General inquiries about trademarks, as well as the products and services of the U.S. Patent and Trademark Office, should be mailed to General Information Services Division, U.S. Patent and Trademark Office, Crystal Plaza 3, Room 2C02, Washington, D.C. 20231.

Online: Go to *www.uspto.gov* and go to Trademarks. Applicants are encouraged to use e-mail for trademarks.

Filing: To file an application online using the Trademark Electronic Application System (**TEAS**): *www.uspto.gov/teas/index.html*. This is the preferred method.

Patent and Trademark Depository Library: If you do not have Internet access, you can access TEAS at any PTDL throughout the United States. These are libraries that provide many PTO services, located in regional areas. Information about the Patent and Trademark Depository Library Program, as well as a list of these libraries, are available online at *www.uspto.gov/web/offices/ac/ido/ptdl/index.html*

The Value of a Good Idea

Mail or Hand-Delivery: Send or deliver correspondence to the Commissioner for Trademarks, Box-New App-Fee, 2900 Crystal Drive, Arlington, VA 22202-3513.

Automated Telephone Line: To obtain a printed form, call (703) 308-9000 or (800) 786-9199. You may NOT submit an application by fax.

Trademark Trial and Appeal Board: To contact this division, call (703) 308-9300 or write to 2900 Crystal Drive, Arlington, VA 22202.

Trademark Applications and Registrations Retrieval (TARR): To retrieve information about pending and registered trademarks, go to *http:// tarr.uspto.gov/*

Useful Phone Numbers:

Assignment Division, for recording assignments

phone (703) 308-9723; fax (703) 308-7124

Certification Division, for certified copies of registrations

phone (703) 308-9726; fax (703) 308-7048

Copy Sales Department, for copies of files and registrations

phone (703) 305-8716; fax (703) 308-8759

Government Printing Office, for copies of the Official Gazette and other USPTO publications

phone (202) 512-1800; fax (202) 512-2250

Intent to Use/Divisional Unit, for filing Statements of Use, Extension Requests and Requests to Divide Applications

phone (703) 308-9550; fax (703) 308-7196

Office of the Commissioner for Trademarks, for filing petitions to the Commissioner

phone (703) 308-8900; fax (703) 308-7220

Post Registration Division, for filing post registration documents

> phone (703) 308-9500; fax (703) 308-7178

Publication and Issue Division, for original certification of registration

> phone (703) 308-9401; fax (703) 305-4100

Trademark Assistance Center, for general trademark information and printed application forms

> phone (703) 308-9000; fax (703) 308-7016

Trademark Trial and Appeal Board, for filing notices of opposition and petitions to cancel registrations

> phone (703) 308-9300; fax (703) 308-9333

Patents

Like trademarks, general inquiries should be mailed to General Information Services Division, U.S. Patent and Trademark Office, Crystal Plaza 3, Room 2C02, Washington, D.C. 20231.

Online: Go to *www.uspto.gov* and go to Patents.

The **Patent Assistance Center (PAC)** at the U.S. Patent and Trademark Office provides information services to the public concerning any general questions regarding patent examining policies and procedures. You can reach this office at 800-PTO-9199 (800-786-9199) or 703-308-HELP (703-308-4357), Monday - Friday 8:30 A.M. to 5:00 P.M. (Eastern Time Zone). You can fax this center at 703-305-7786.

Because the patent process is particularly challenging, it's best to visit the PAC first and be directed to further resources.

The Office of Independent Inventor Programs (OIIP) was established in March 1999 in order to meet the special needs of independent inventors. The OIIP establishes new mechanisms to better disseminate information about the patent and trademark process and to foster regular communication between the USPTO and independent inventors.

The Value of a Good Idea

Mailing Address: You can write the OIIP at the Director—United States Patent and Trademark Office, Office of Independent Inventor Programs, Box 24, Washington, D.C. 20231.

Telephone: 703-306-5568

Fax: 703-306-5570

E-mail: independentinventor@uspto.gov

Remember: The USPTO's home page is *www.uspto.gov.* And you can send e-mail directly at *uspto@uspto.gov,* and indicating "Patent" or "Trademark" in the Subject box.

APPENDIX B:
PROPERTY DURATIONS

Copyright

The Sonny Bono Copyright Term Extension Act of 1998 changed the duration of copyright protection in 1998. Most copyrights have expired on all U.S. works registered or published prior to 1923, which means these have entered into the **public domain**. Durations for copyrights depend on when a work is created and the date of publication.

Works created on or after the first of January, 1978:

- Individually authored works: **life + 70 years** after author's death.

- Joint work that is not a work-for-hire: 70 years after last author's death.

- Works-for-hire, anonymous works and pseudonymous works (unless otherwise indicated by Copyright Office): **95 years from publication or 120 years from creation**, whichever is shorter.

Works created before the first of January, 1978, but not published by that date:

These works have been brought automatically under federal copyright protection. Their durations are computed in the same manner as for works created on or after the first of January, 1978. Copyrights for works in this category will not expire before the 31st of December, 2002. Works published on or before that date will not expire before the 31st of December, 2047.

Works created and published or registered before 1 January 1978:

- The laws that governed copyrights before 1978 protected works for a first term of **28 years**. During the 28ᵗʰ year, the copyright could be renewed for another 28 years.

- Now, the copyright law has extended the renewal term from 28 to 67 years for copyrights that existed as of 1 January 1978. These works are eligible for a total term of protection of **95 years**. You don't need to file a renewal to extend the original 28-year copyright term to 95 years, but there are some benefits to renewing during the 28ᵗʰ year of the original term.

Trademarks

Registrations filed prior to 16 November 1989 have a **20-year term**. Their renewals also have a 20-year term.

Registrations granted on or after 16 November 1989 have a **10-year term**. Their renewals also have a 10-year term.

To maintain a valid trademark, you must file an **Affidavit of Use**: 1) between the fifth and sixth year following registration; and 2) within the year before the end of the every 10-year period after the date of registration. You can file this affidavit within a grace period of six months after the end of the sixth or tenth year, with an additional fee.

You must also file a **renewal application** within the year before the expiration date of a registration, or within a grace period of six months after the expiration date, with an additional fee.

Patents

Terms of patents are generally **20 years** from the date on which the application was filed in the U.S. A **maintenance fee** is due 3.5, 7.5 and 11.5 years after the original grant for all patents filed on or after 12 December 1980. Design Patents have a special term of only **14 years** from grant,

and you do not have to submit a maintenance fee. Only one claim is permitted.

The rules for extending terms and adjusting patents are extensive. Contact an attorney or go to *www.uspto.gov* for more information.

The Value of a Good Idea

Index

430